FACE IT

First published 2013

by Focal Press

70 Blanchard Road, Suite 402, Burlington, MA 01803

Simultaneously published in the UK

by Focal Press

2 Park Square, Milton Park, Abingdon, Oxon OX14 4RN

Focal Press is an imprint of the Taylor & Francis Group, an informa business

Notices
Knowledge and best practice in this field are constantly changing. As new research and experience broaden our understanding, changes in research methods, professional practices, or medical treatment may become necessary.

Practitioners and researchers must always rely on their own experience and knowledge in evaluating and using any information, methods, compounds, or experiments described herein. In using such information or methods they should be mindful of their own safety and the safety of others, including parties for whom they have a professional responsibility.

Product or corporate names may be trademarks or registered trademarks, and are used only for identification and explanation without intent to infringe.

Library of Congress Cataloging in Publication Data

Beckmann-Wells, Patricia.

Face it : a visual reference for multi-ethnic facial modeling / Patricia Beckmann-Wells.

pages cm

1. Computer animation. 2. Face--Computer simulation. 3. Facial expression--Computer simulation. I. Title.

TR897.7B4436 2013

006.6'96--dc23

2012039541

ISBN: 9780240823942 (pbk)

ISBN: 9780240824000 (ebk)

Printed in the United States of America by Courier, Kendallville, Indiana

FACE IT

A Visual Reference for Multi-Ethnic Facial Modeling

PATRICIA BECKMANN-WELLS

TUTORIALS BY SCOTT WELLS

Focal Press
Taylor & Francis Group

NEW YORK AND LONDON

Patricia Beckmann-Wells

Patricia Beckmann-Wells is an award-winning artist and professor with a doctorate in Educational Psychology from the University of Southern California.

Her background includes progressive managerial experience in technology and education. Patricia was the founding Chair of the Savannah College of Art and Design Animation Department, and has held executive leadership positions at both DreamWorks SKG and the Walt Disney Animation Studios. These positions required extensive travel, and allowed her to participate with film industry in India, Asia and Europe. She is an invited speaker at film festivals around the world, including Annecy, the Stuttgart Animation Festival, and Ottawa Animation Festival. Her graduate MFA in Cinema is from the University of Southern California and she has received international awards for her short film and interactive media work. Her recent work has won semi-final recognition in the 'Adobe Design Achievement Awards, 2012', and a 2012 MEDIA OF THE YEAR AWARD by Creative Child Magazine.

Patricia served as SIGGRAPH Conference level Committee Chair for multiple years. In 2007–2010, she created FJORG!, the first student centered animation contest for SIGGRAPH. Fjorg! invited teams of students from all over the world to create animation, under the mentorship of academy award winning industry professionals, on site at the conference. These events were sponsored by Walt Disney Animation Studios, DreamWorks SKG, Sony Image works, and Hewlett Packard. Patricia was Educators Chair in 2005, and created the Incubator room showcasing realized educational technologies. She continues this research with Bunsella Studios, creating online-learning technologies based on motivation research.

Scott Wells

Scott Wells is a character artist and sculptor with 22 years' experience in games, film, television and digital media.

Scott is currently a Senior Character Artist at Treyarch Activision/Blizzard in Santa Monica, CA. His most recent published game title is *Call of Duty: Black Ops* 2. His prior projects at Treyarch include *Call of Duty: Black Ops* and *007: Quantum of Solace*.

Before Treyarch, Scott was a creature modeler at Rhythm & Hues. His film credits at R&H include *Night at the Museum*, *Golden Compass*, *Evan Almighty*, and *Superman Returns*.

Scott is originally from Boston where he was a designer, animator and art director on interactive media and television projects for a variety of clients including PBS, the Discovery Channel, Ford, and Volkswagen. He also worked on music DVD title packages for artists including They Might Be Giants and Everclear.

Scott has been recognized individually for his work with 2 Emmy nominations, a Telly award and a MIMC Award. He has also been a member of creative teams on a number of award-winning projects.

Thank you to Bone Clones for allowing us to use images of their skulls.

Thank you to Nina Nieves for her support and kindness. Without her efforts, this volume would have been much too difficult to produce.

Thank you Joseph Puralewski for assisting on shooting days.

The companion website for *Face It* can be found at:

www.focalpress.com/9780240823942

This website contains all of the resources used in the tutorials.

CONTENTS

THE BASIC SKULL

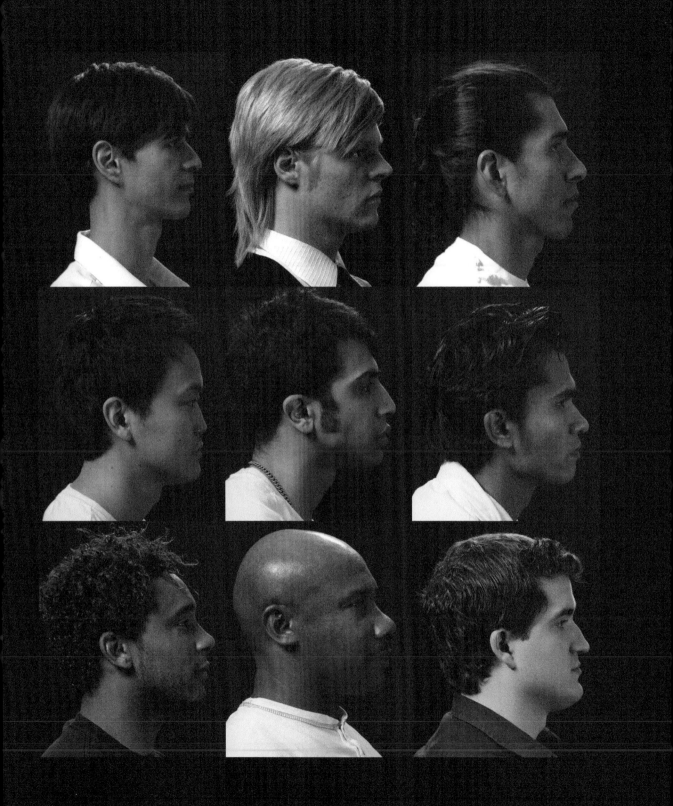

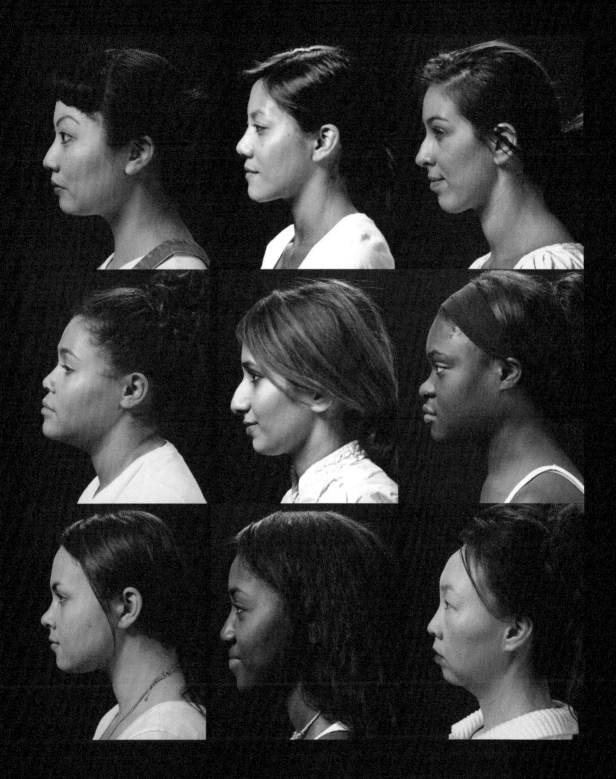

*We are all very much alike—but our faces portray unique differences,
as demonstrated by these people who claim ancestry from around the world.*

THE HUMAN FACE

All humans have a common ancestry. Our faces and bodies may portray unique differences, but we are all very much alike. A clear explanation of where we all come from is not yet agreed upon by human society—though social and behavioral anthropologists, religious institutions, science fiction writers, and cultural philosophers have all chimed in. We cannot say for certain how and where our minute differences in physical construct originated. We only know that people from different parts of the world show tendencies common to the founding families of their communities. To mix things all up, humans have wandered off to new lands to make families in faraway communities each and every generation since humans could travel.

The author's perspective in this book is that the earth is one giant ball of meshed genes. In areas where lines of a family have existed for centuries, certain physical attributes may dominate a human settlement. These attributes are further enhanced by the diet of that region (for example, whether meat is a staple), how much sunlight is experienced in a common day, and what mutations survive in this environment. Forensic anthropology supplies us with rich information and empirical data on regional characteristics. These physical attributes are tools for character designers whose game, toy, and film products are now on the world stage. It is more important than ever for character designers to research the communities they wish to portray. Why? The people who live in those regions want to be respected through the accurate portrayal of their physical characteristics. People will bond with characters they identify with. The character designer is a critical link to creating international appeal.

In this text, we explore the unique features present in the human face, and provide comparison to skulls found near a model's claim of ancestral lineage. We will present models from all over the world for you to analyze for regional traits as a stepping stone into creating your own research. The results of our photo shoot study are fascinating. We consider this book an important snap

shot in time cataloging what a piece the human looks like today. In another generation, our genes will have pooled again—taking us another giant step further away from regional identification.

In some cases, we can readily identify someone's ancestral lineage as having resided in regions around Asia, Africa, the Americas, or Europe, among others. In some cases, we cannot readily identify someone as having ancestors born in or near any region—as the model will show characteristics common to several regions. This is valuable to know too, as it makes us aware that we cannot stereotype a feature to a region. Our study will also explore what makes the typical female face unique to the typical male face. Structural differences between the two are sometimes very subtle, depending on the individual. We have provided the measurements of every face so that you can compare and contrast features on your favorite models.

The next generation born will make a huge change in our physical identity. Transportation has become much cheaper and safer. We have models in this text claiming globally opposite genetic heritage—lineage from countries as far away from each other as Ireland and Malaysia, or Africa, the Philippines, and the United States. We are no longer isolated communities of limited gene pools.

A family from China.

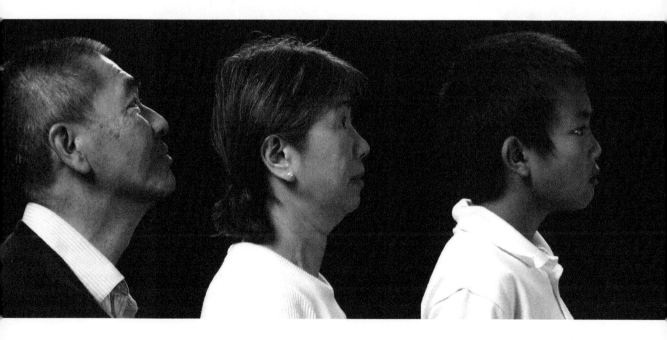

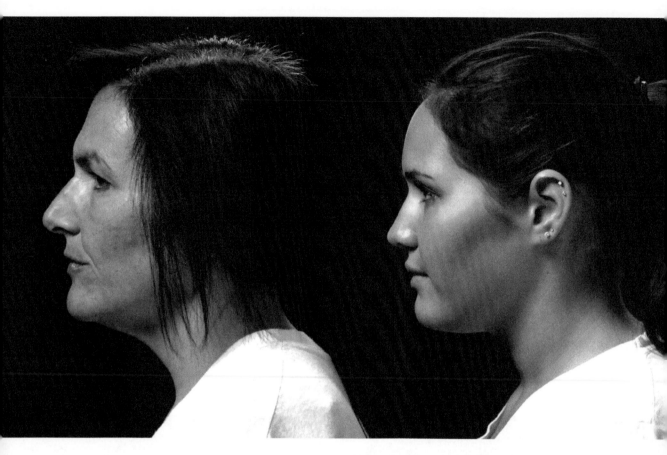

Mother and daughter.

It may appear unusual to you that we are organizing people by self-identified region of ancestry instead of ethnicity. Race is a recent classification of people, and some consider it an unfair method. Human evolution, racial mapping, and ethnicity are hotly debated topics amongst anthropologists. The authors of this text are not anthropologists. We are artists in search of research material to provide a greater depth to our character designs. We are in search of identifiable physical characteristics typical in some ancestral lineages, whose understanding will allow us to create a believable diversity in 3D character modeling. Our goal is to gather visual information about the many diverse populations living on earth and use this information to discover the rich details that make us each unique race. We do not create this text to identify one ethnicity with tiny noses, thin lips, or bulbous ear lobes. Rather, we seek to celebrate the unique features that provide information about how our ancestors traveled, and how these travels influence character design.

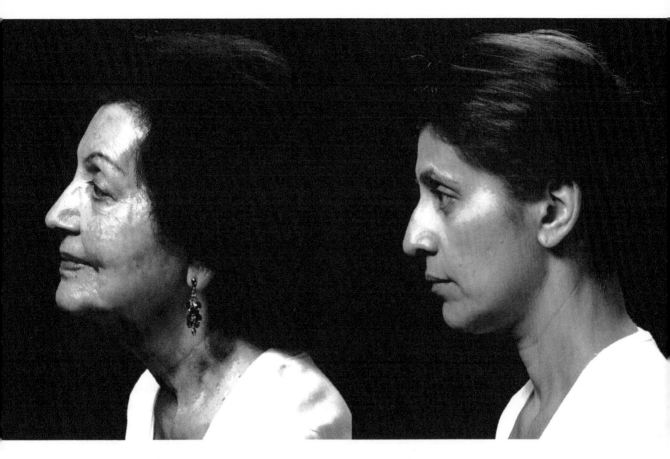

Humans do not have physical differences based on which side of
a country's border they are born on. The border was not always there.
And, as in the case of Russia, borders can change in just one generation.
So, we will avoid stating that a person looks a certain way because it is a
common trait in a certain country. We will instead map our models to different
regions in the world, and hope in time to grow a large database of such images
that all artists can draw from. For the sake of our study, we will allow all of
the models to self-identify their ancestral homes by the name of the country
their parents came from. We were unable to cover every country in the world
with our small sample, but we do have a disparate sample from around the
globe. We hope this is enough to raise awareness of morphological variation
in the human species.

Mother and daughter.

Historically, the organization of regional ancestral lineage was based on a method of categorization initiated by Dr. W.W. Howells (1973, 1989, 1995) and his long-term study of craniometric variation in modern humans. He categorized ancestral lineage from six world regions: Europe, Sub-Saharan Africa, Australasia, Polynesia, the Americas, and the Far East.

Today, the United Nations has unofficially categorized member states into five geopolitical regional groups, and one non-UN member group. These groups are: the African group, the Asia-Pacific group, the Eastern European group, the Latin American and Caribbean group, the Western European and others group, and the non-UN state or territory. The groups span across continents, but Africa's region stays central to its continent.

Anthropologists once used Typology to categorize members of the human species by physical traits such as head shape, skin color, hair form, body build and stature back in the late 19th and early 20th centuries. Caleton S. Coon created the five classifications. The typological model divided people from different ethnic regions into races. He labeled them, in 1962, as: Negroid race, Caucasoid race, Mongoloid race, Australoid race, and Capoid race. Typology is now considered by some a contributor to racism and no longer used to categorize people.

Empirical evidence has shown that geographic variation actually has very little to do with why we look different from each other. Professor John Relethford, from the State University of York College at Oneonta, states that previous studies of genetic markers and mitochondrial DNA have found that the amount of variation among major geographic groupings of *Homo sapiens* is relatively low, accounting for roughly 10% of total variation (Relethford, 1994). These data were derived from six core areas: Europe, Sub-Saharan Africa, Australasia, Polynesia, the Americas, and the Far East. An additional set of analyses was performed using a three-region subset (Europe, Sub-Saharan Africa, and the Far East) to provide comparability with several genetic studies. Relethford (1994) determined that there is little limited variation in modern human skulls among major geographic regions.

Howells, W. W. 1973 *The Pacific Islanders*. London: Weidenfeld and Nicolson.

Howells, W. W. 1989 *Skull Shapes and the Map: Craniometric Analysis in the Dispersion of Modern Homo. Papers of the Peabody Museum of Archaeology and Ethnology, Vol. 79.* Cambridge: Harvard University Press.

Howells, W. W. 1995 *Who's Who in Skulls: Ethnic Identification of Crania From Measurements. Papers of the Peabody Museum of Archaeology and Ethnology, Vol. 82.* Cambridge: Harvard University Press.

Relethford (1994) states that a great deal of genetic variation is among individuals within groups, and physical differences are not due to variation among groups. This further negates the Typology system of racial classification. Authors Stringer and Andrews (1988) state that humans show "great morphological variation. However, in contrast to this, genetic variation between human populations is low overall" (p. 1264).

If we are all so similar, why is it we are able to distinguish the features of people from regions other than our own, and identify them as from a different part of the world? Our eye is finely tuned to this small percentage of genetic and sexual variation. Let's look at the structure of a basic human skull so that we have a common ground to base our comparisons.

UNITED NATIONS REGIONAL GROUPS

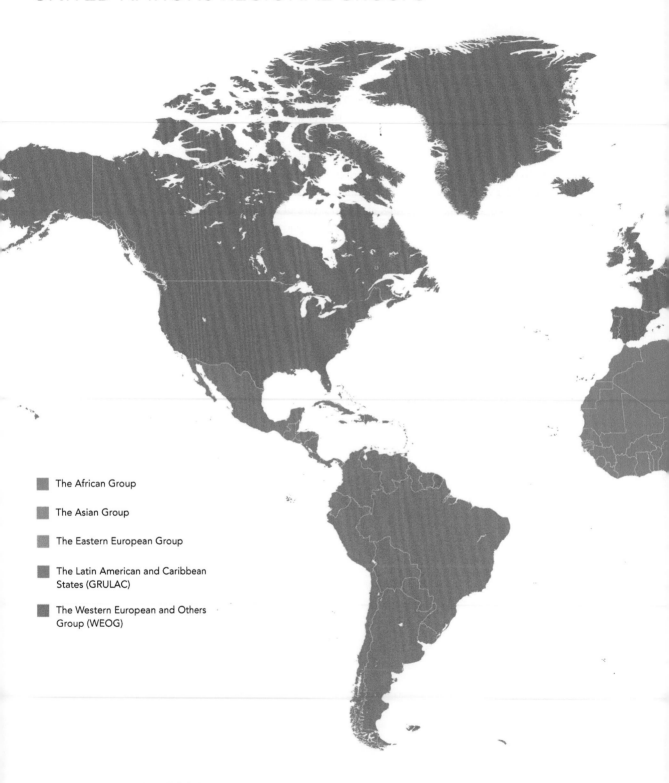

The African Group

The Asian Group

The Eastern European Group

The Latin American and Caribbean States (GRULAC)

The Western European and Others Group (WEOG)

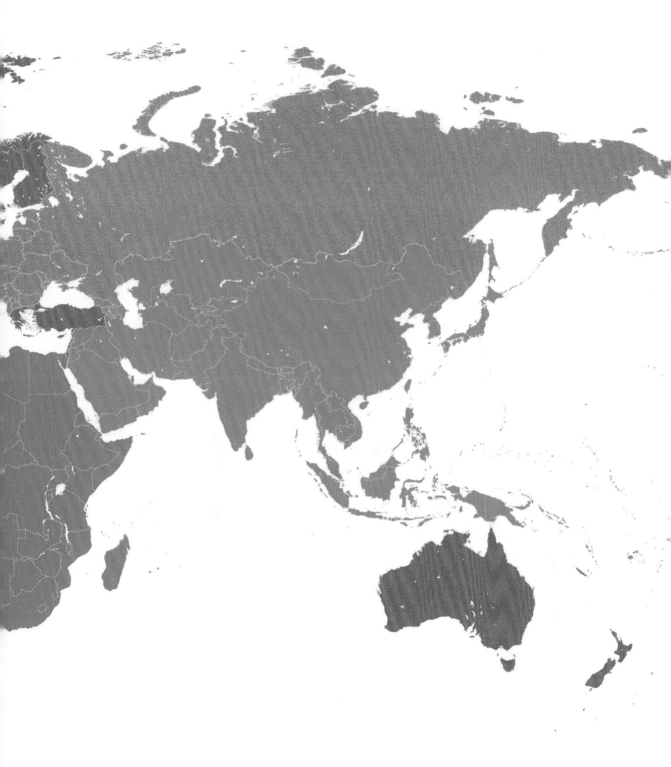

Anatomists have determined from head and skull shape that there are three types of heads. Look for them in the following photos. They use a term for measurement of the head, cephalic index, to determine these head types. The three classifications are:

1. Dolichochocephalic: long head
2. Mesocephalic: medium head
3. Brachycephalic: broad head

ANATOMY OF THE HUMAN HEAD: ESTABLISHING A VOCABULARY

These are three images of a human skull. I won't tell you the region this is from yet. It looks like a basic human skull right? How would you know what part of the world it came from? Markers exist on this skull that will allow you to identify features typical to human identity form different regions around the world. We hope to provide you with an introductory understanding of these markers so that you can be aware of how they structurally influence facial characteristics, and have been found in larger samples to provide evidence of characteristics typical to a region.

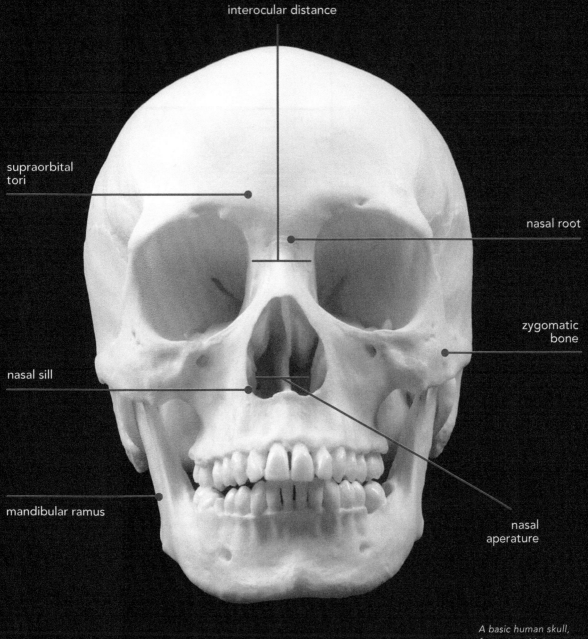

interocular distance

supraorbital
tori

nasal root

zygomatic
bone

nasal sill

mandibular ramus

nasal
aperature

*A basic human skull,
front view. Major terms
demonstrated.*

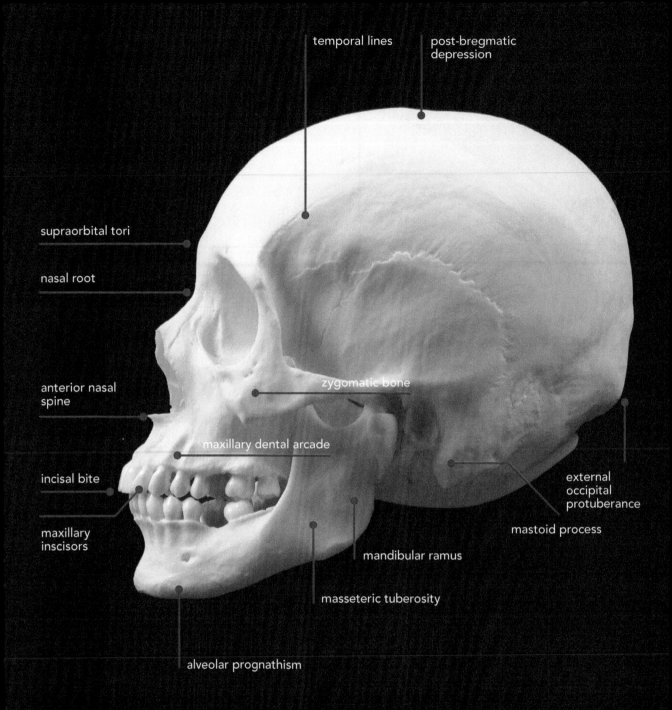

temporal lines

post-bregmatic depression

supraorbital tori

nasal root

anterior nasal spine

zygomatic bone

maxillary dental arcade

incisal bite

maxillary inscisors

external occipital protuberance

mastoid process

mandibular ramus

masseteric tuberosity

alveolar prognathism

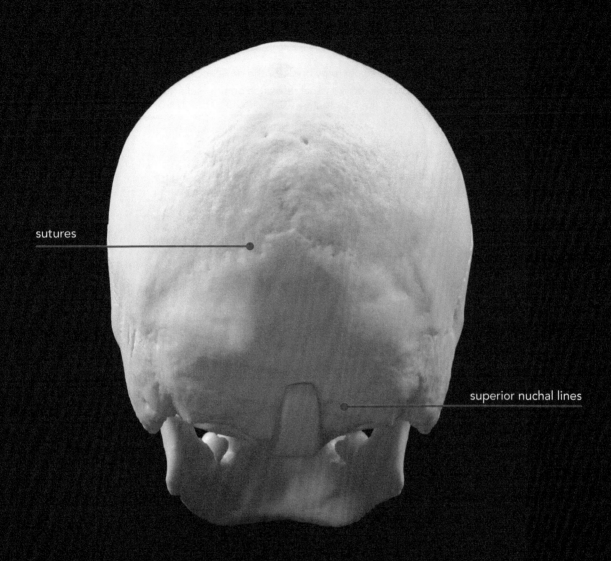

sutures

superior nuchal lines

A basic human skull, back view. Major terms demonstrated.

GENERAL TERMS

Please consult an anatomy book for the most accurate description of terms. The terms are listed for visual reference on the skulls, followed by a general description of their location.

- Anterior—toward the front of the body
- Lateral—extending away from the middle, moving towards the side of the body
- Median—midline, going through the center of the head
- Medial—extending towards the middle, moving away from the side of the body
- Posterior—toward the back of the body
- Superior—toward the top
- Inferior—toward the bottom

Interocular distance: this measurement is the distance between the eyes, and is also commonly referred to as the interpupillary distance.

Nasal root: the nasal root is found at the top of the nose. It is where the nasal bone meets the frontal bone.

Zygomatic bone: this is the term for the cheek bone.

Nasal aperture: the nasal aperture describes the width, length and depth of the nose, seen when looking upward at the nostrils.

Anterior nasal spine: this is at the bottom of the nose above the teeth, and is a small sharp protrusion from the skull.

Nasal sill: this is the floor of the nasal opening. It is best viewed upwards facing the nostrils. It is the bottom of the nose, with the nostrils above it and the tip of the nose above the nostrils.

Maxillary dental arcade: this is the bone that holds the upper teeth of the mouth.

Maxillary incisors: front teeth in the upper jaw.

Incisal bite: this refers to how the upper and lower teeth meet—the bite.

Alveolar prognathism: jaw protruding forward.

Post-bregmatic depression: a dent in the top of the skull.

Sutures: these are the fibrous joints in the skull. There are many of them that join together the many pieces of the skull.

Nuchal lines: these lines are four curved ridges on the occipital bone, found on the back bottom of the skull.

External occipital protuberance: this runs between the nuchal lines.

Mastoid process: this is the bony protrusion found behind the ear.

Temporal lines: these two lines cross the middle of the parietal bone.

Supraorbital tori: this is the bony ridge above the eye sockets.

Masseteric tuberosities: this refers to the rough surface on the mandible bone.

Occipital condyles: these are flat surfaces under the occipital bone.

Supramastoidal crest: this is the ridge that forms at the root of the zygomatic process of the temporal bone.

Mandibular ramus: part of the jaw.

Knowing these key terms and where these features are located will give us a starting place to compare other skulls too. This comparison will allow us to identify features that are different in different faces. We will often refer to this anatomical vocabulary when making observations about human faces. Memorize these terms and what they represent, as they will be used extensively in Chapter 2. Please find additional anatomy books that detail the human skull for additional information. We are artists, and specialists in anatomy will give you more information on specific bones than we can.

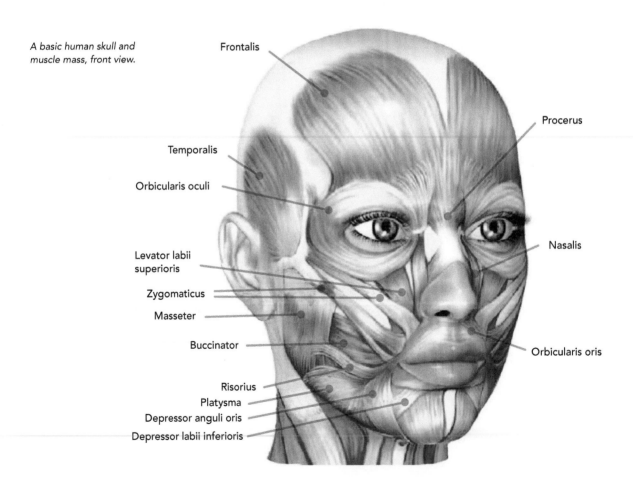

A basic human skull and muscle mass, front view.

Frontalis

Procerus

Temporalis

Orbicularis oculi

Levator labii superioris

Zygomaticus

Masseter

Buccinator

Risorius

Platysma

Depressor anguli oris

Depressor labii inferioris

Nasalis

Orbicularis oris

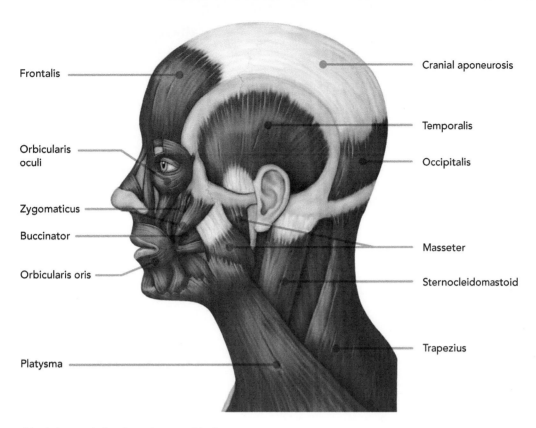

Frontalis

Cranial aponeurosis

Temporalis

Orbicularis oculi

Occipitalis

Zygomaticus

Buccinator

Orbicularis oris

Masseter

Sternocleidomastoid

Platysma

Trapezius

A basic human skull and muscle mass, side view.

These are illustrations of basic muscle groups attached to the skull. The size of these groups may vary in different faces. Fat deposits rest on top of these muscle groups, further impacting the facial features of our models. Facial anatomy is very extensive, and I urge you to couple your study of these faces with a facial anatomy text book. Our observations will only consult the basic skull.

REFERENCES AND SUGGESTED READING

Coon, Carleton S. (1962), *The Origin of Races*, Alfred A. Knopf, Inc., 1st edition (June 1962) New York.

Relethford, J.B. (1994), "Craniometric variation, genetic theory, and modern human origins," *American Journal of Physical Anthropology* 95: 53–62.

Stringer, C.B., and Andrews, P. (1988), "Genetic and fossil evidence for the origin of modern humans," *Science* 239: 1263–1268.

Gill, George W. and Rhine, Stanley, eds. (1990), *Skeletal Attribution of Race: Methods for Forensic Anthropology.* Maxwell Museum of Anthropology, Anthropological Papers No. 4 (Albuquerque, NM).

SKULLS

The skull molds the face.

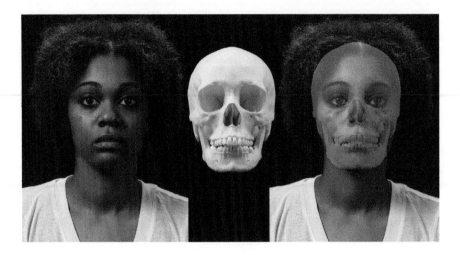

SKULLS FROM AROUND THE WORLD

Let's look at a sample of skulls collected from around the world. Note that skulls and their attributes need to be evaluated from a large sample. These attributes are not indicative of every human from that region. They are attributes measured and compared to a larger sample. Please see pages 65-67 for measurements for each of the skulls in the following sample.

Map of six regions, and a callout to each of the skulls identified. A pin denotes the region each one was found in.

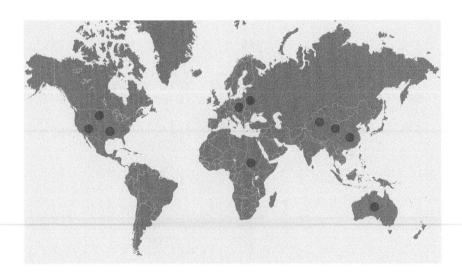

AUSTRALIAN ABORIGINAL MALE SKULL

This skull was found in 1905 near the lower Darling River in New South Wales, Australia, and was known to be from a very stout 50-year-old male of the Bindaboo Tribe.

Features of this skull:

The *interocular distance* is broad.

The *nasal root* is depressed and the *nasal angle* is obtuse.

The *zygomatic bones* retreat posteriorly from the plane of the face.

The *nasal aperture* is broad superiorly and inferiorly.

The *anterior nasal spine* is short, and the inferior margin of the nasal aperture has a bilateral gutter (right greater than left).

There is no *nasal sill*.

The *maxillary dental arcade* is rectangular.

There is moderate *alveolar prognathism*.

The *maxillary incisors* are peg-like (because of severe attrition).

There is no *post-bregmatic depression*.

The *calvarial sutures* are focally complex.

Features of sex:

There is marked prominence of the cranial sites for musculofacial attachment including especially:

- the nuchal lines
- the external occipital protuberance
- the mastoid processes of the temporal bones
- the temporal lines (slight)
- the supraorbital tori
- the masseteric tuberosities of the mandible
- the occipital condyles
- the supramastoidal crest

There is a broad ascending mandibular ramus. The nasion is markedly rough, and the supraorbital margins are blunted. The inferior border of the mandible is square.

www.boneclones.com, Dr. Evan Matshes, BSc MD.

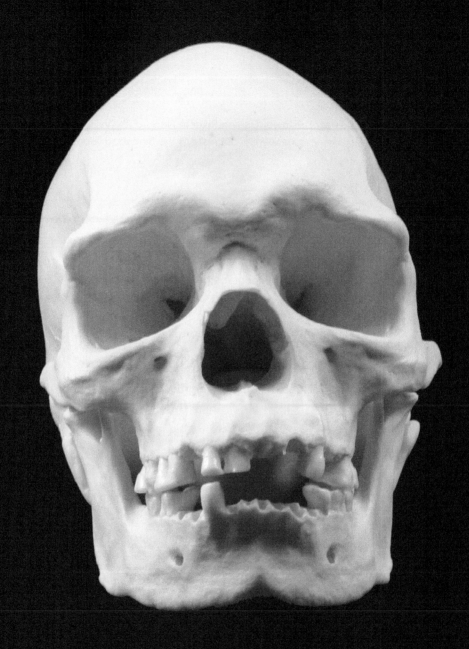

Australian Aboriginal male.

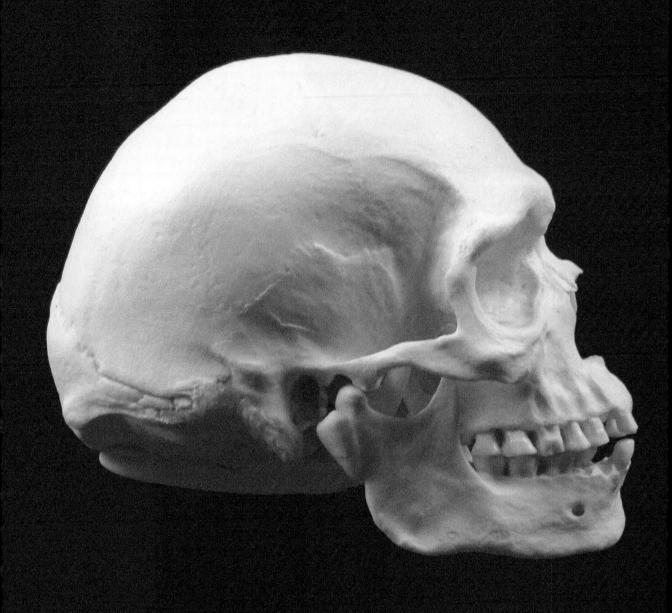

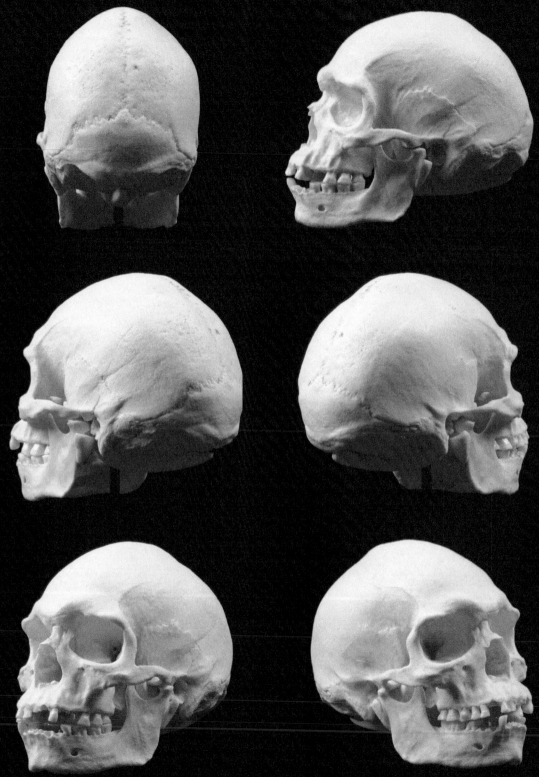

Australian Aboriginal male.

AFRICAN AMERICAN FEMALE SKULL

Features of this skull:

The interocular distance is slightly widened.

The nasal root is not prominent and the nasal angle is obtuse.

The zygomatic bones retreat posteriorly from the plane of the face.

The nasal aperture is broad superiorly and inferiorly.

The anterior nasal spine is somewhat prominent, and the inferior margin of the nasal aperture has a sharp (nasal) sill, and a very slight suggestion of a right gutter.

The maxillary dental arcade has a rectangular shape.

There is moderate alveolar prognathism.

The maxillary incisors are blade-like, but there is the slightest suggestion of shoveling of the 1.2 [#7], 2.1 [#9], and 2.2 [#10] teeth.

There is no edge-on-edge incisal bite.

There is a slight post-bregmatic depression.

The calvarial sutures are predominantly simple.

Features of the sex:

There is no significant prominence of the cranial sites for musculofascial attachment.

Slight prominence is seen at:

- the external occipital protuberance
- the mastoid processes of the temporal bones
- the temporal lines
- the supramastoidal crests

There is a somewhat broad ascending mandibular ramus. The nasion is smooth, and the supraorbital margins are blunted. The inferior border of the mandible is somewhat rounded.

Estimated age: 40–60 years old.

www.boneclones.com_Dr. Evan Matshes, BSc MD.

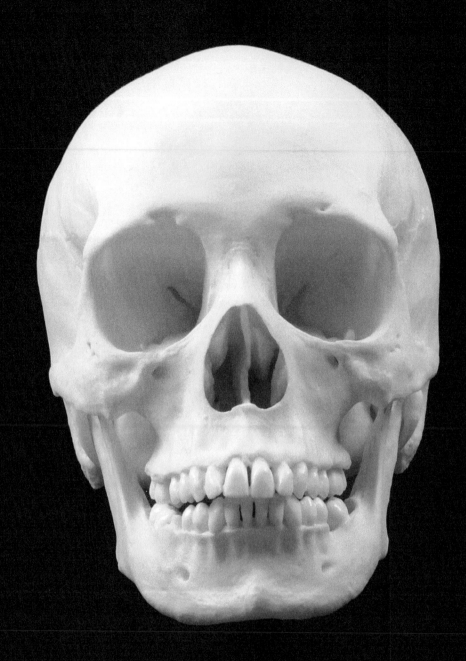

African American female.

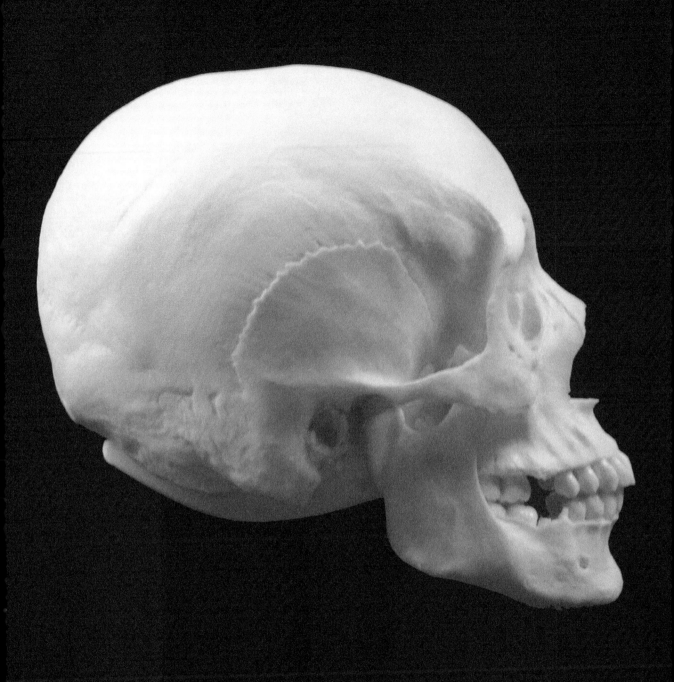

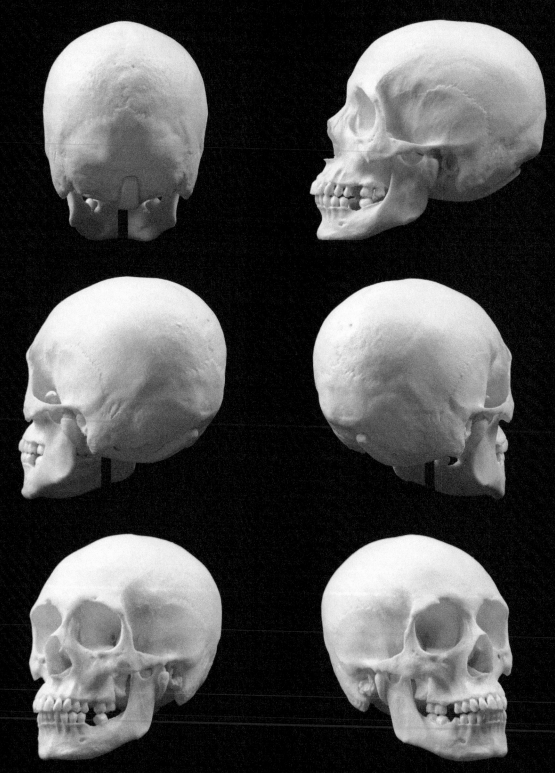

African American female.

AFRICAN AMERICAN MALE SKULL

Features of this skull:

The interocular distance is broad.

The nasal root is depressed and the nasal angle is obtuse.

The zygomatic bones retreat posteriorly from the plane of the face.

The nasal aperture is narrow superiorly and broader inferiorly.

The anterior nasal spine is short, and the inferior margin of the nasal aperture has a bilateral gutter.

The maxillary dental arcade has a somewhat rectangular shape.

There is prominent alveolar prognathism, and the skull is elongated in the anteroposterior plane. The maxillary incisors are blade-like.

There is no edge-on-edge incisal bite.

There is a post-bregmatic depression.

The calvarial sutures are focally complex.

Features of the sex:

There is moderate prominence of the cranial sites for musculofascial attachment including especially:

- the nuchal lines
- the external occipital protuberance
- the mastoid processes of the temporal bones
- the temporal lines
- the supraorbital tori
- the masseteric tuberosities of the mandible
- the supramastoidal crest

There is a broad ascending mandibular ramus. The nasion is somewhat rough, and the supraorbital margins are blunted. The inferior border of the mandible is square.

Estimated age: 30–50 years old.

www.boneclones.com_Dr. Evan Matshes, BSc MD.

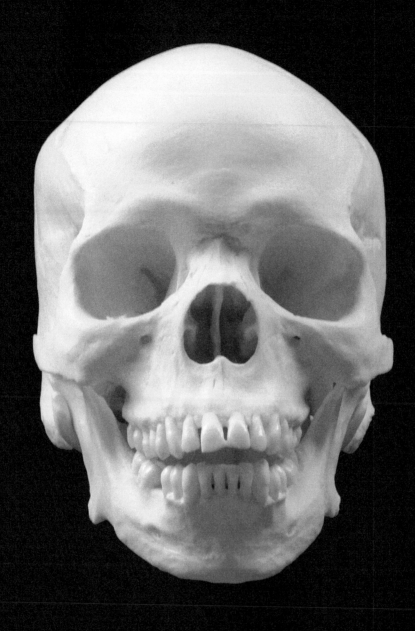

African American male.

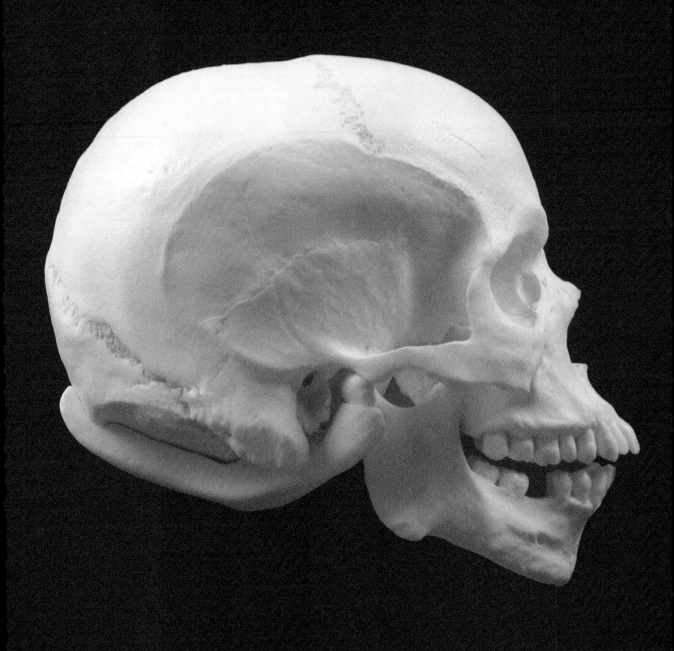

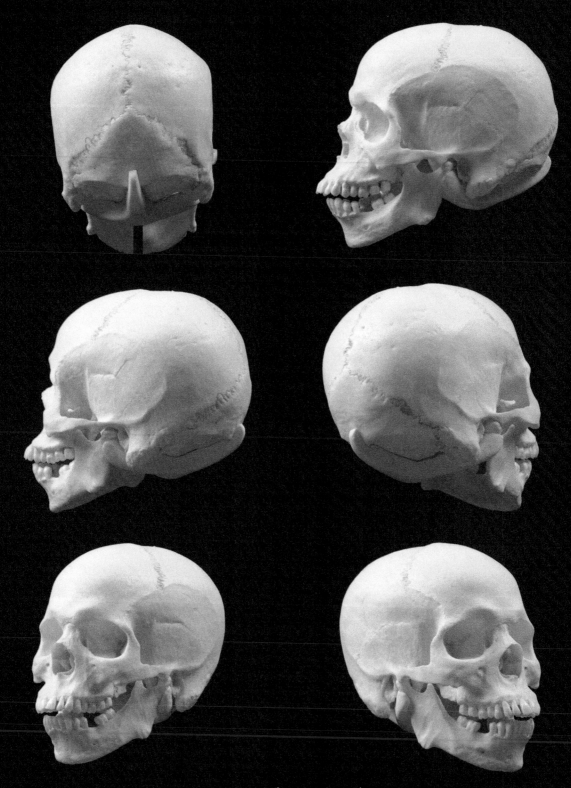

African American male.

AFRICAN MALE SKULL

Features of this skull:

The interocular distance is broad.

The nasal root is depressed and the nasal angle is obtuse.

The zygomatic bones retreat posteriorly from the plane of the face.

The nasal aperture is markedly broad both superiorly and inferiorly.

The anterior nasal spine is short, and the inferior margin of the nasal aperture has a bilateral gutter, and there is no nasal sill. The maxillary dental arcade has a somewhat rectangular shape. There is mild to moderate alveolar prognathism.

The maxillary incisors are blade-like; however, there is a slight suggestion of shoveling on 2.1 [#9].

There is no edge-on-edge incisal bite.

There is no post-bregmatic depression.

The calvarial sutures are very slightly complex.

The skull is somewhat elongated in the antero-posterior plane.

Features of the sex:

There is moderate prominence of the cranial sites for musculofascial attachment including especially:

- the nuchal lines
- the external occipital protuberance
- the mastoid processes of the temporal bones
- the supraorbital tori
- the masseteric tuberosities of the mandible with gonial eversion bilaterally
- the supramastoidal crests

There is a broad ascending mandibular ramus. The nasion is smooth, and the supraorbital margins are blunted. The inferior border of the mandible is somewhat square.

Estimated age: 30–50 years old

www.boneclones.com, Dr. Evan Matshes, BSc MD.

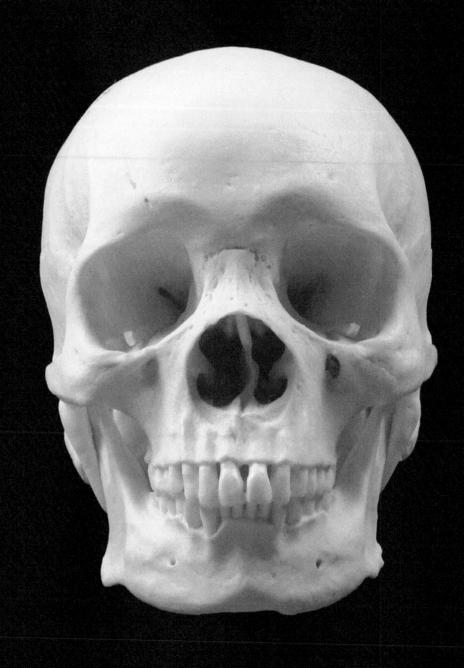

African male.

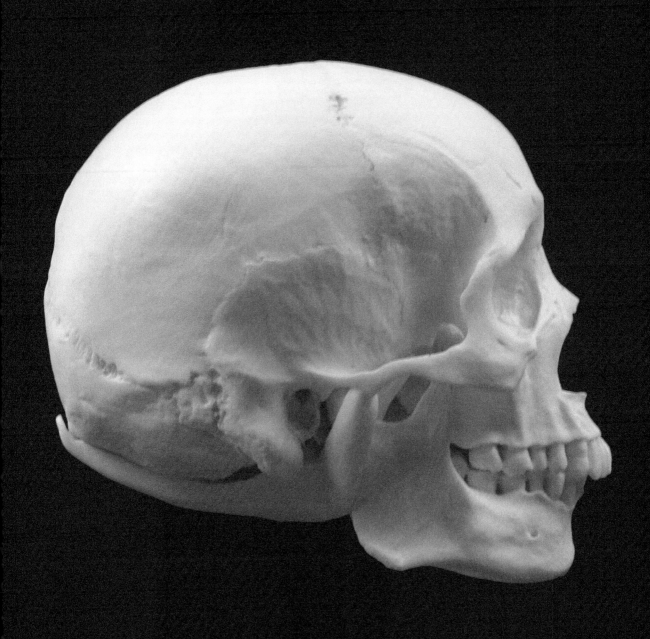

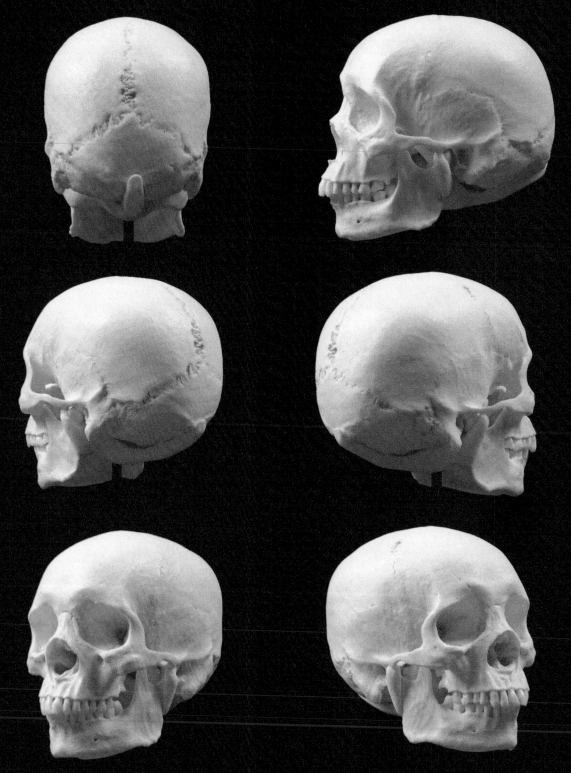

African male.

ASIAN FEMALE SKULL

Features of this skull:

The interocular distance is not significantly widened.

The nasal root is flat and the nasal angle is obtuse.

The zygomatic bones retreat posteriorly from the plane of the face.

The nasal aperture is broad superiorly and inferiorly.

The anterior nasal spine is short, and the inferior margin of the nasal aperture is smooth on the left and somewhat sharp on the right, with the suggestion of a bilateral nasal gutter (right greater than left); there is no nasal sill.

The maxillary dental arcade is somewhat rounded.

There is mild to moderate alveolar prognathism.

The maxillary incisors are shovel-like.

There is no edge-on-edge incisal bite.

There is a slight post-bregmatic depression.

The calvarial sutures are complex.

Features of the sex:

There is mild prominence of the cranial sites for musculofascial attachment including especially:

- the nuchal lines
- the mastoid processes of the temporal bones
- the temporal lines
- the supraorbital tori
- the masseteric tuberosities of the mandible

There is a broad ascending mandibular ramus. The nasion is smooth, and the supraorbital margins are sharp. The inferior border of the mandible is somewhat squared.

Estimated age: 30–50 years old

www.boneclones.com_Dr. Evan Matshes, BSc MD.

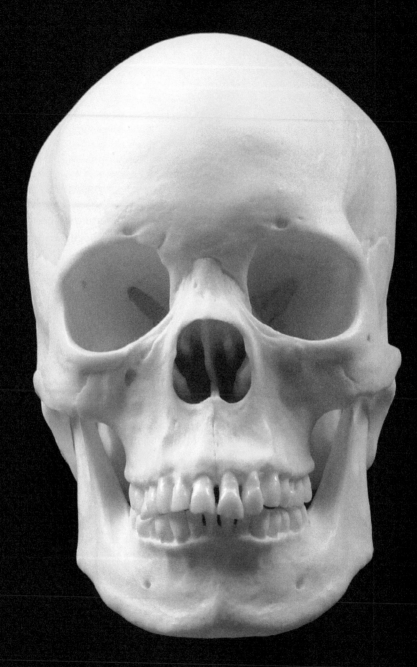

Asian female.

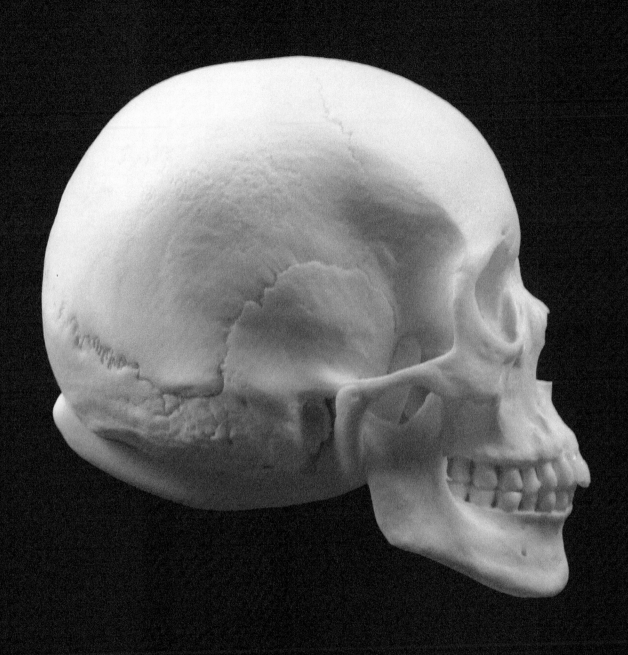

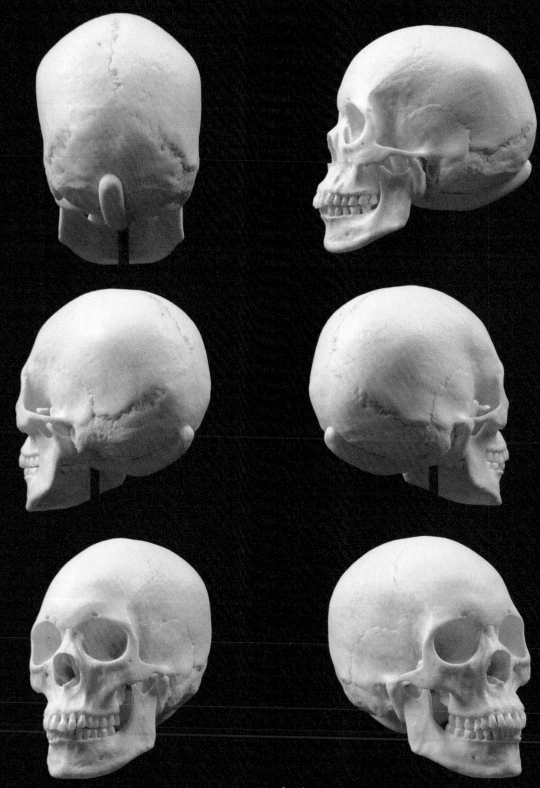

Asian female.

ASIAN MALE SKULL

Features of this skull:

The interocular distance is broad.

The nasal root is flat and the nasal angle is obtuse.

The zygomatic bones are broad.

The nasal aperture is broad superiorly and inferiorly.

The anterior nasal spine is short, and the inferior margin of the nasal aperture is blunt; there is no gutter.

The maxillary dental arcade has somewhat of a rounded shape.

There is prominent alveolar prognathism.

The maxillary incisors are prominently shovel-shaped.

There is no edge-on-edge incisal bite.

There is a very slight post-bregmatic depression.

The calvarial sutures are focally complex.

Features of the sex:

There is mild prominence of the cranial sites for musculofascial attachment including especially:

- the nuchal lines
- the external occipital protuberance
- the mastoid processes of the temporal bones
- the temporal lines (slight)
- the supraorbital tori (prominent)
- the masseteric tuberosities of the mandible, with slight right gonial eversion (prominent)
- the occipital condyles
- the supramastoidal crest

There is a broad ascending mandibular ramus. The nasion is somewhat rough (difficult assessment due to metopic suture), and the supraorbital margins are blunted. The inferior

border of the mandible is square.

Estimated age: 30–50 years old

www.boneclones.com._Dr. Evan Matshes, BSc MD.

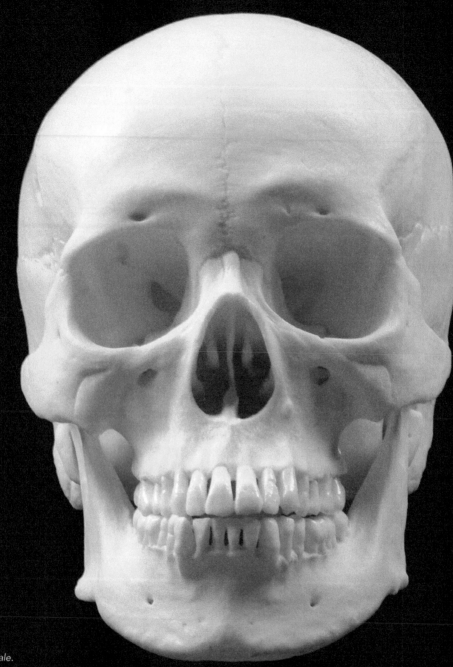

Asian male.

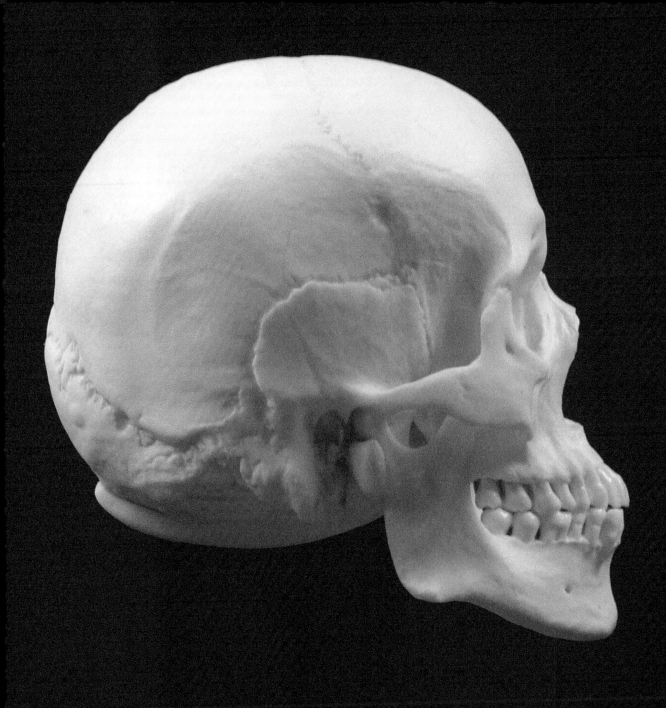

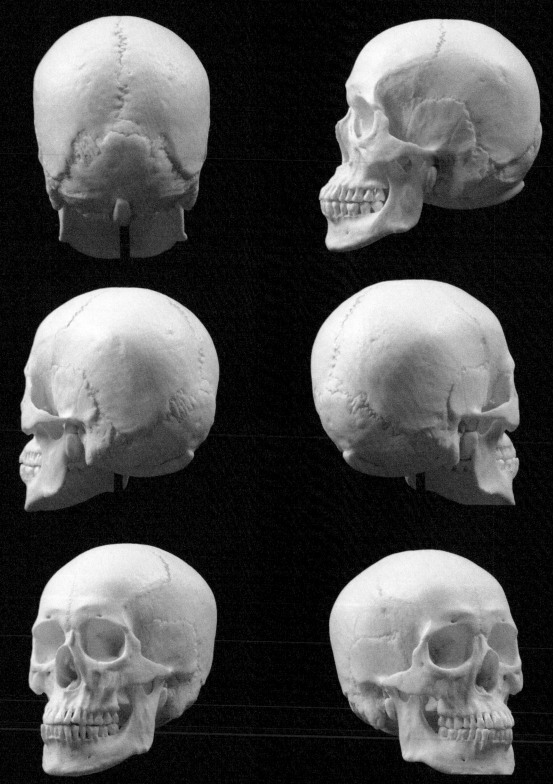

Asian male.

ASIAN MALE ROBUST SKULL

Features of this skull:

The discriminate function analysis program, FORDISC 3.0, classifies the skull as American Indian with a posterior probability of 0.996. This classification is further substantiated by the presence of shovel-shaped incisors and multiple Wormian bones in lambdoidal suture. The face is broad, and the nasal aperture is wide. The nasal sill is smooth and guttered. Differentiation of Asian and American Indian is difficult, if not impossible, given the information available.

The nasal aperture is somewhat rounded, not vertical as in persons of European origin. The nasal sill flows inward across a mild gutter from the alveolar ridge. The nasal spine is present but not prominent. These are traits associated with persons of non-European origin.

Posterior View of Skull Multiple Wormian bones (sutural bones) can be seen within the lambdoidal suture. This condition is typical in individuals of Asian origin.

Note also the extremely large external occipital protuberance and crest-like inferior nuchal lines, both masculine traits.

Features of the sex:

The skull displays extreme masculine traits. The supraorbital ridge is large, the supraorbital margin is rounded, and the jaw is massive. The gonial angle is close to 90 degrees and strongly flared.

Frontal View of Skull The skull displays extremely masculine traits. The supraorbital ridge is large, the supraorbital margin is well-rounded, and the jaw is massive. The gonial angle is strongly flared.

Lateral View of Neurocranium The lateral and posterior views of the skull are also impressively masculine. The suprameatal crest (also called a "zygomatic arch extension") is sharply defined, and the mastoid processes are large. The external occipital protuberance is enormous, and the inferior nuchal lines are almost crest-like.

Estimated age: Early 20s

www.boneclones.com, Dr. Karen Ramey Burns, PhD.

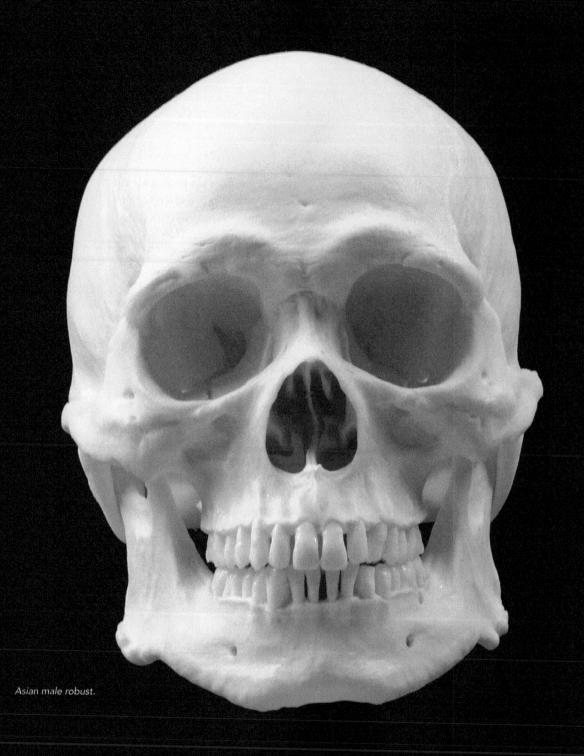

Asian male robust.

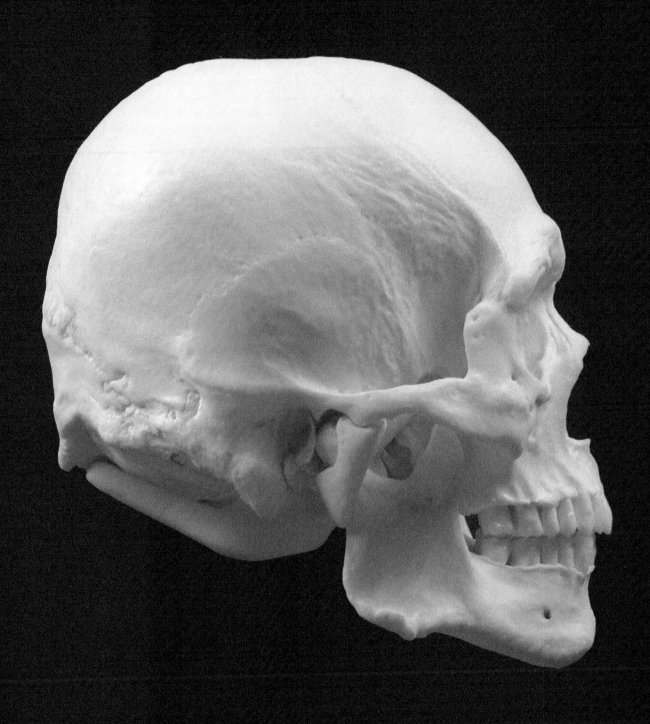

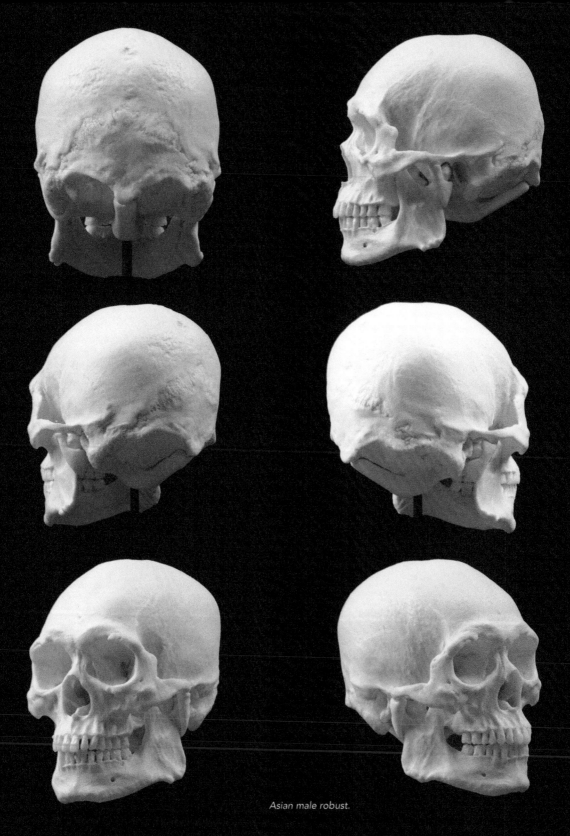

Asian male robust.

AMERICAN INDIAN FEMALE SKULL

Features of this skull:

The interocular distance is not prominently widened. The nasal root is depressed and the nasal angle is obtuse. The robust zygomatic bones are broad. The nasal aperture is somewhat narrow superiorly and inferiorly. The anterior nasal spine is very short, and the inferior nasal margin is smooth and depressed; there are no gutters, nor is there a sill.

The maxillary dental arcade has a somewhat round-to-rectangular shape. There is no alveolar prognathism. Due to the severe degree of attrition, it is not possible to assess for a shovel-shape on the single remaining maxillary incisor (2.1 [#9]). There is no post-bregmatic depression. The calvarial sutures are complex.

Features of the sex:

There is mild prominence of the cranial sites for musculofascial attachment including especially:

- the nuchal lines
- the mastoid processes of the temporal bones (slight)
- the temporal lines (slight)
- the supraorbital tori (slight)
- the occipital condyles
- the supramastoidal crest

There is a broad ascending mandibular ramus. The gonion angles flare slightly. The nasion is smooth, and the supraorbital margins are blunted. The inferior border of the mandible is rounded.

Estimated age: 47–57 years old

www.boneclones.com, Dr. Evan Matshes, BSc MD.

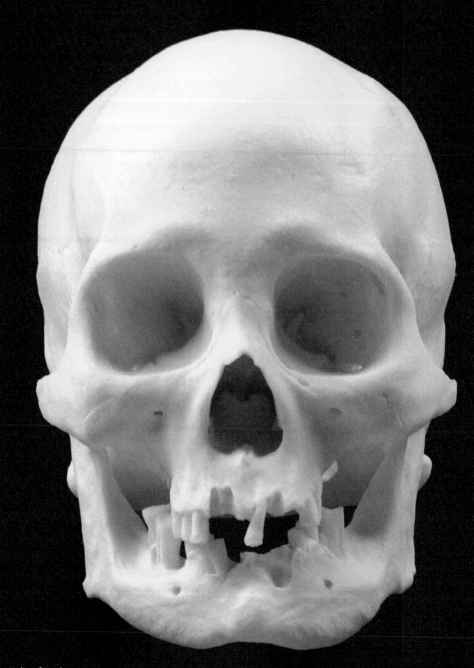

American Indian female.

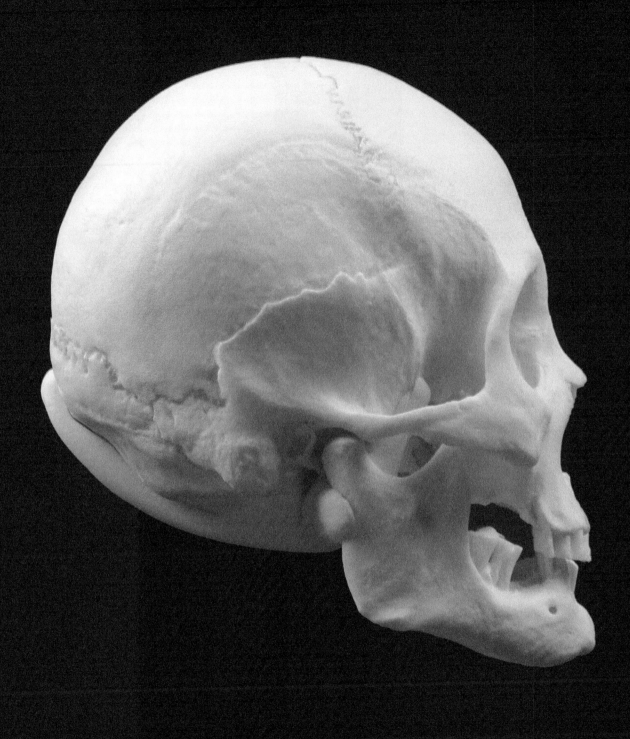

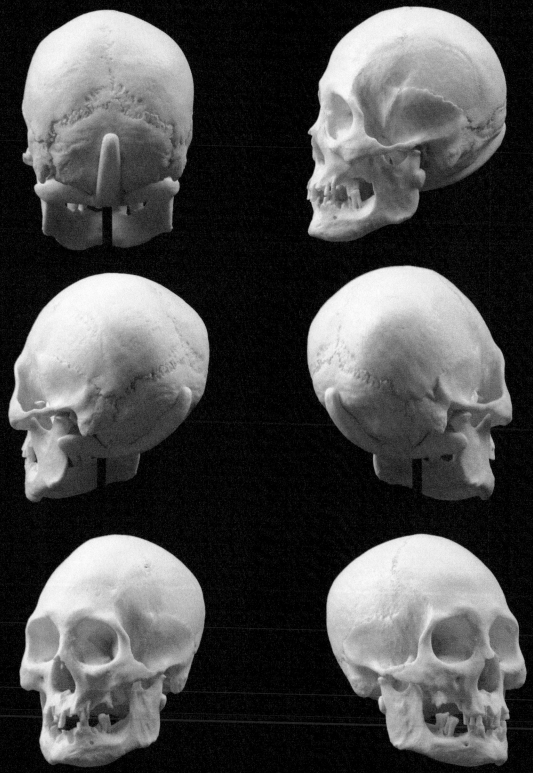

American Indian female.

EUROPEAN FEMALE SKULL

Features of this skull:

The interocular distance is not prominently widened. The nasal root is prominent and the nasal angle is acute. The zygomatic bones retreat posteriorly from the plane of the face.

The nasal aperture is narrow superiorly and broader inferiorly. The anterior nasal spine is short, and the inferior margin of the nasal aperture has a sharp (nasal) sill with a very vague impression of bilateral gutters. The maxillary dental arcade has somewhat of a V shape.

There is very slight alveolar prognathism. The maxillary incisors are blade-like.

There is no edge-on-edge incisal bite. There is no post-bregmatic depression. The calvarial sutures are predominantly simple.

Features of the sex:

There is moderate prominence of the cranial sites for musculofascial attachment including especially:

- the nuchal lines
- the external occipital protuberance
- the mastoid processes of the temporal bones
- the temporal lines (slight)
- the supraorbital tori
- the masseteric tuberosities of the mandible
- the occipital condyles
- the supramastoidal crest (slight)

There is a somewhat broad ascending mandibular ramus. The nasion is rough, and the supraorbital margins are blunted. The inferior border of the mandible is somewhat square.

www.boneclones.com_Dr. Karen Ramey Burns, PhD.

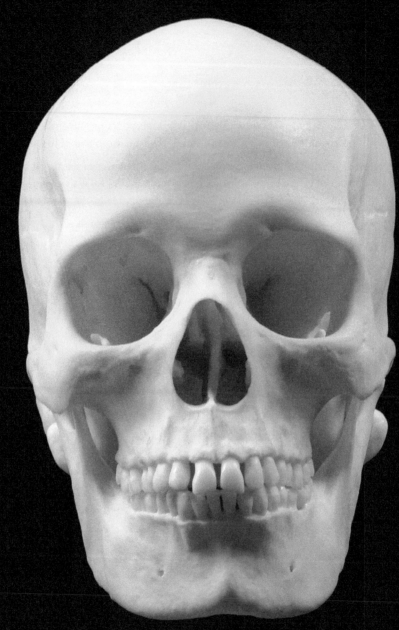

European female.

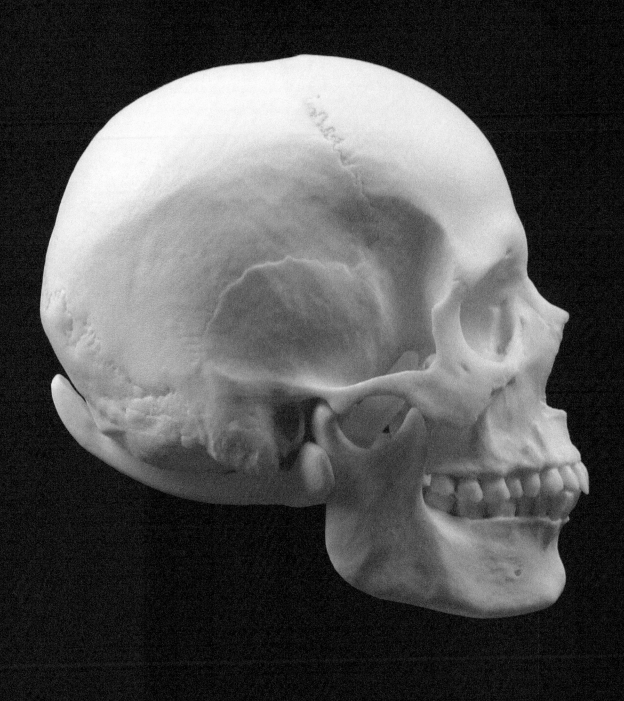

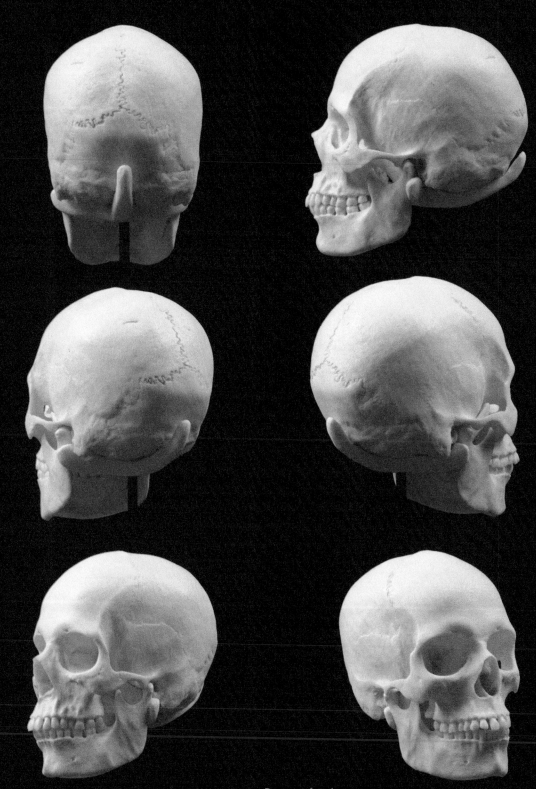

European female.

EUROPEAN MALE SKULL

Features of this skull:

The interocular distance is not prominently widened. The nasal root is prominent and the nasal angle is acute. The zygomatic bones retreat posteriorly from the plane of the face.

The nasal aperture is narrow superiorly and broader inferiorly. The anterior nasal spine is short, and the inferior margin of the nasal aperture has a sharp (nasal) sill with a very vague impression of bilateral gutters. The maxillary dental arcade has somewhat of a V shape.

There is very slight alveolar prognathism. The maxillary incisors are blade-like.

There is no edge-on-edge incisal bite. There is no post-bregmatic depression. The calvarial sutures are predominantly simple.

Features of the sex:

There is moderate prominence of the cranial sites for musculofascial attachment including especially:

- the nuchal lines
- the external occipital protuberance
- the mastoid processes of the temporal bones
- the temporal lines (slight)
- the supraorbital tori
- the masseteric tuberosities of the mandible
- the occipital condyles
- the supramastoidal crest (slight)

There is a somewhat broad ascending mandibular ramus. The nasion is rough, and the supraorbital margins are blunted. The inferior border of the mandible is somewhat square.

Estimated age: 33–60 years old.

www.boneclones.com_Dr. Karen Ramey Burns, PhD.

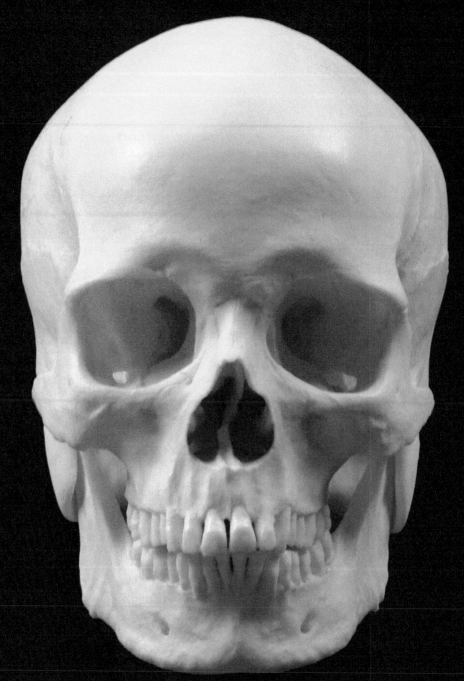

European male.

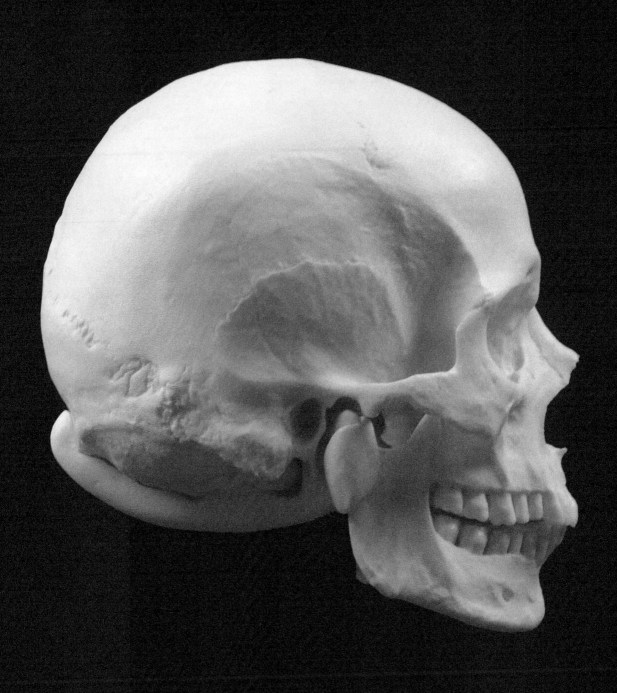

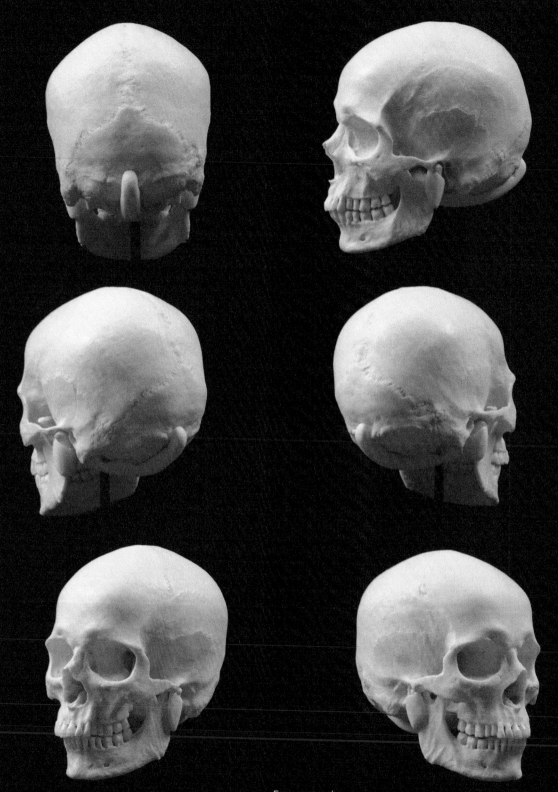

European male.

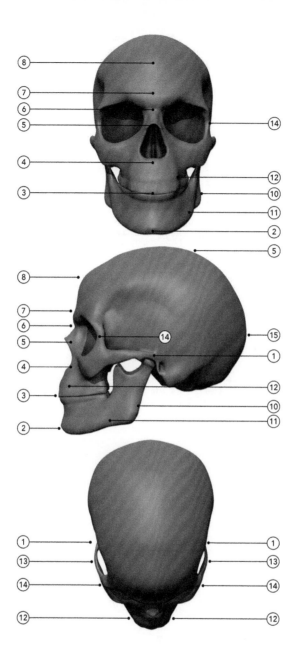

Take a look at this chart. The measurements of each skull are identified. Notice the disparity between each measurement and each skull. No two skulls are alike. Look at the female measurements as a whole, and compare them to the male measurements. Does one group appear larger? Does one group appear smaller? This chart should emphasize the value of measuring your subjects with calipers and recording the data.

	European male	European female	African American female	African American male	Asian male	Asian female	Aboriginal male	American Indian female	African male	Robust Asian male
1 left–1 right: Tragus* to tragus (point on zygomatic arch above condyle process of mandible)	4 9/16	4 7/16	4 3/4	4 15/16	5 3/16	4 3/8	4 3/4	5	4 5/8	5 9/16
1–2: Tragus* to chin (defined as center of triangle of chin)	4 9/16	4 9/16	4 7/8	4 15/16	5 1/4	4 9/16	5 1/4	4 7/8	4 3/4	5 3/8
1–3: Tragus to lower edge of top front teeth	4 5/16	4 3/16	4 7/16	4 7/8	4 1/2	4 1/8	4 3/4	4 3/8	4 1/2	5 7/8
1–4: Tragus to base nasal cavity (not including anterior nasal spine)	3 13/16	4 11/16	3 11/16	4 1/8	3 13/16	3 5/16	4 1/8	3 3/4	4 7/8	4 3/16
1–5: Tragus to top nasal cavity	4	3 7/8	3 4/5	4 1/4	3 13/16	3 1/2	4 1/4	3 7/8	4	4 1/4
1–6: Tragus to nose bridge (furthest posterior point in silhouette or suture point between nasal bone & brow if area relatively flat)	3 3/4	3 5/8	3 5/8	4 1/16	3 3/4	3 7/16	4 1/16	3 3/4	3 7/8	4 1/8
1–7: Tragus to brow center/high point in side silhouette	3 7/8	3 3/4	3 3/4	4 1/4	4 1/8	3 9/8	4 1/4	3 7/8	4 1/16	4 3/8
1–8: Tragus to apex frontal eminence	4 3/8	4 1/4	4 1/8	4 7/8	4 3/4	4 1/16	4 9/16	4 3/8	4 7/16	4 5/8
1–9: Tragus to crown	5 3/16	4 13/16	5 1/16	5 1/2	5 1/2	5 1/8	5 1/16	5 3/16	5 7/8	5 7/16
10 left–10 right: Posterior Mandible width (end of vertical segment back of jaw)	3 11/16	3 5/16	3 3/8	3 5/8	4 1/16	3 11/16	3 7/8	4 3/16	4 7/16	4 3/4
11 left–11 right: Inferior Mandible width at rear molar	2 7/8	2 7/8	3 3/16	3 1/8	3 5/8	3 1/8	3 3/16	3 3/8	3	3 7/8

	European male	European female	African American female	African American male	Asian male	Asian female	Aboriginal male	American Indian female	African male	Robust Asian male
12 left – 12 right: Maxila width at canine	1 1/2	1 7/16	1 1/2	1 11/16	1 1/2	1 1/2	1 5/8	1 7/8	1 5/8	1 11/16
13 left – 13 right: Zygomatic arch widest point	4 13/16	4 5/8	4 15/16	5 5/16	5 3/8	4 5/8	5 1/4	5 5/16	4 15/16	6
14 left – 14 right: Middle orbital cavity width (at angle change in orbital bone, slightly outside opening)	3 7/8	3 11/16	3 13/16	4 1/4	4 1/4	3 7/8	4 1/2	4 15/16	4 1/16	4 5/16
2–3: Chin to lower edge of top front teeth	1 5/16	1 3/8	1 3/8t	2 1/8	1 5/8	1 1/2	1 1/2	1 1/16	1 1/4	1 1/2
2–4: Chin to nasal cavity base	2 3/16	2 3/8	2 3/8	3 1/8	2 3/4	2 3/4	2 1/2	2	2 1/4	2 5/8
2–5: Chin to nasal cavity top	3 3/8	3 11/16	3 3/4	4 1/8	4 1/8	3 3/4	3 3/4	3 1/4	3 7/16	3 15/16
2–6 Chin to nose bridge	4 1/16	4 1/8	4 3/8	4 3/4	5 7/8	4 3/8	4 3/8	4 1/8	4 3/16	4 1/2
2–8: Chin to frontal eminence apex	5 3/4	5 3/4	5 15/16	6 5/8	6 3/4	4 13/16	6 1/8	6 1/8	5 3/4	6 1/2
2–7: Chin to center brow	4 1/2	4 1/2	4 7/8	5	5 7/16	4 7/8	4 5/8	4 3/4	4 5/8	5 1/16
2–9: Chin to crown	8 3/8	8 5/16	8 5/8	9 1/8	9 3/8	8 11/16	8 3/4	8 3/4	8 3/16	9 1/4
7–8: center brow to frontal eminence apex	1 5/16	1 1/4	1 3/16	1 5/8	1 3/8	1 1/4	1 5/8	1 1/2	1 1/8	1 1/4
8–9: frontal eminence apex to crown	4 1/4	4	4 1/16	4 13/16	4 1/2	4 9/16	3 7/8	4 1/4	3 7/16	4 7/16
9–15: crown to furthest point rear skull (occipital region)	4	3 3/4	3 1/2	3 3/4	4 15/16	3 1/16	4 3/8	3 1/16	3 1/4	3 1/8
5–15: top nose to furthest point rear skull (occipital region)	7 1/4	7	7 1/16	7 3/4	7 3/16	7	7 5/8	6 3/4	7 1/8	7 1/4

THE BASIC SKULL

The first tutorial is designed to get you thinking about bones, specifically the major bony landmark forms of the skull that lie under all the soft tissue and how they differ amongst diverse populations. In this tutorial we are going to build a basic skull similar to the one shown above based on our Bone Clones reference. At the end of the tutorial you will be directed to the resources to repeat this process for three more variants of the human skull. These are intended to be useful for you to refer back to in the future when observing different facial features.

For this tutorial we will focus on the Asian male skull. At the end of the tutorial you will repeat the process with the Asian female, African male, and Australian Aboriginal male skulls. It is important to remember that there is no definitive set of facial characteristics that represent any population in their entirety. The majority of individuals you will observe may have some combination of features unique to themselves. These examples begin to give you tools for comparison, not absolute definitions.

When trying to identify characteristic differences related to ancestral populations, consider the following features:

■ Relative robustness—gracile qualities of the cranium.

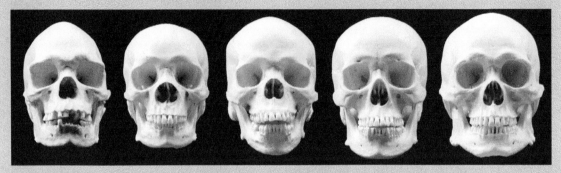

Front views of Aboriginal, African male, African American male, Asian male, Asian robust male.

■ Nasal root: the bridge of the nose—does it insert high or low into the brow and what is the angle of the nasal bone in profile?

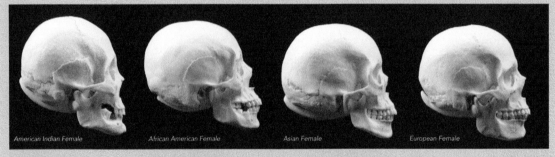

American Indian Female African American Female Asian Female European Female

American Indian female, African American female, Asian female, European female.

■ Interocular distance: basically, how wide the eyes are set, but also how far apart the medial edge of the left orbital opening is from the right (tear duct to tear duct in basic terms).

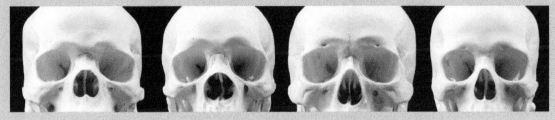

Interocular distance, left to right: African American Male, African Male, Asian Male, European Male.

- Relative squareness/roundness of the orbital cavities.

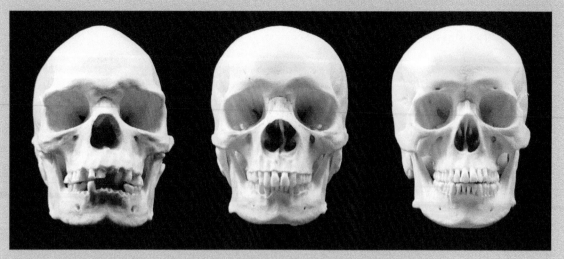

Front view: Aboriginal, African and Asian skulls.

- Sweep of the zygomatic bones—are they sweeping backward away from the front plane of the face or staying primarily in the plane of the face?

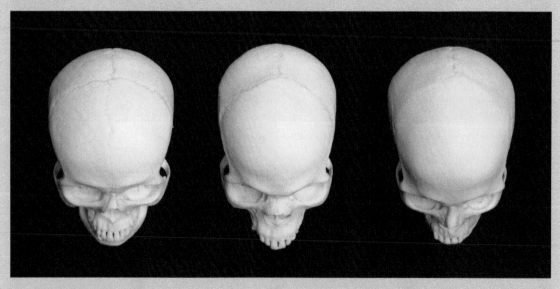

View looking down: Asian, African, Caucasian.

■ Prognathism—basically how far forward are the upper and lower jaws relative to the rest of the skull? This can also involve the relative forward angle of the front teeth. In profile this would be the basic tilt of the face between the forehead and jaw

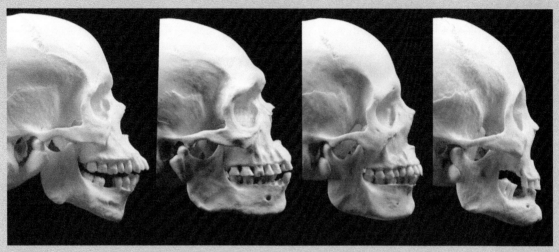

Side view: African American Male, Aboriginal Male, European Female, American Indian Female.

■ Supraorbital Tori—prominence of the brows
—Asian male, African American male, Aboriginal male

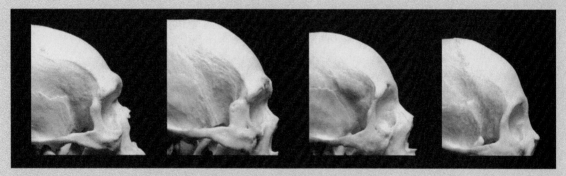

Aboriginal Male, Asian Male (Robust), African American Female, American Indian Female.

Use the following images as visual reference for the locations and basic forms listed on the previous page:

All the tutorials in this book are written non-application specific. The reader can approach these tutorials in the way that they are most comfortable with, either digital or traditional techniques. Files for a base model:

\tutorials\tutorial1\base_skull.obj

as well as image planes

\tutorials\tutorial1\image_planes

and corresponding markers

\tutorials\tutorial1\skull_markers

are provided on the companion website for users of digital sculpting and modeling applications.

The measurements provided in the chart earlier in this chapter can be used with calipers for readers who are working in clay.

One of the trickier aspects in the digital model creation process is matching exactly source photography to a digital model in a synthetic camera. While there are various techniques and specialized tools used in studio environments, in the major digital sculpture applications you cannot exactly match real world cameras and the barrel distortion created by lenses. So, you should not expect to get an exact 1:1 relationship between your model and reference photographs. Ideally you want to know the focal length of the camera lens that the photos were shot with and try to match that as best you can. This is why (as you will see in the following tutorials) the authors recommend using reference photography in combination with the provided measurement markers along with your eye to evaluate the model. For traditional sculptors this will be more familiar.

TUTORIAL:
THE BASIC ASIAN MALE SKULL

We are focusing on the larger landmark forms of the skull in this tutorial, as such we will not be diving into the small details. Once the student feels comfortable with their results, they should feel free to go into as much detail as they wish.

Open your application of choice. Import the following images from the companion website as image planes for reference:

\tutorials\tutorial1\front_asian_male.jpg

\tutorials\tutorial1\side_asian_male.jpg

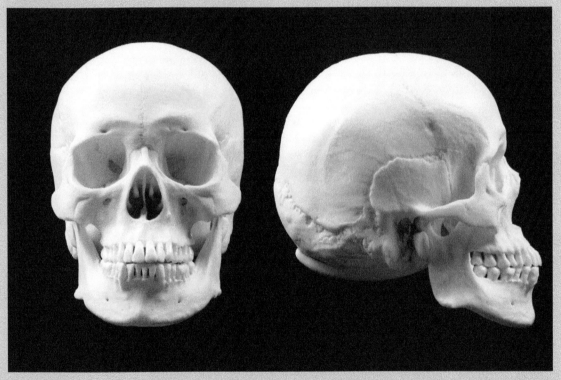

Asian male skull.

Now import:

\tutorials\tutorial1\markers\asian_make_markers.obj

If necessary, align the image plane to the marker geometry:

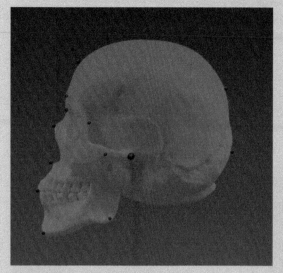

Markers aligned with reference image.

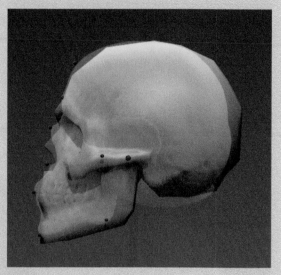

Skull starter geometry basically aligned with markers.

Import the file:

\tutorials\tutorial1\base_skull.obj

The skull starter geometry should sit very roughly within the marker geometry and the skull shape of the image plane. If for any reason it doesn't , move/scale the skull geometry with the side view image plane so that with the external acoustic meatus (ear hole) aligned between the image and model the crown to chin height of the geometry matches the photo.

The starter skull geometry is generic in its proportions. Notice both the forward tilt of the face from brow to chin in this example (prognathism) as well as the depth of the anterior (front) plane of the cheek bones in the photo reference.

Using your applications move tool with a large diameter/fall off, begin to match the basic silhouette of the geometry to the skull being careful to ignore the skull stand at the base of the skull. Refine the silhouette by gradually reducing the size of your move tool to get the finer angles after the big forms are in place.

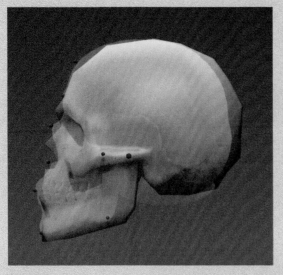

Starting point.

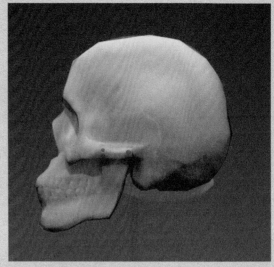

First step - align silhouette.

Once the profile is accurate, what is left is locating the depth of certain landmark points in horizontal space. To do this we will use a combination of the front view, the markers, and the 3/4 view. The method that we are going to use is to have the imported markers overlaid on the starter skull with the front image plane offset to the side to evaluate your progress on reshaping the skull. The markers were generated from measurements off one side of the skull, so they are set up symmetrically. The skull is not perfectly symmetrical, so the positions of the markers are an approximate guide. The photographs should be your ultimate guide for evaluation.

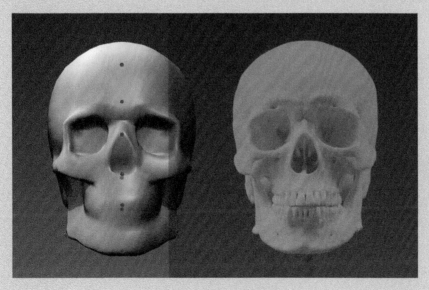

Suggested setup for evaluating front view.

You should switch back and forth between the front and side views to evaluate your progress. Once you're basically satisfied with your front and side views, you should import one or more of the front angle views to do a final evaluation before we move on to focus on finalizing the landmark forms.

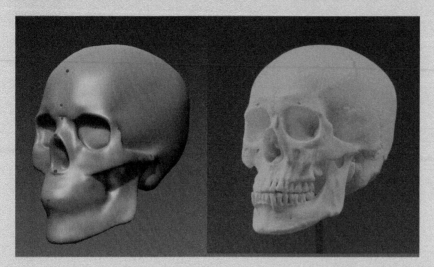

Suggested setup for evaluating 3/4 view.

What you should have at this point is a loose approximation of the Asian male skull. Now we are going to start to "chisel into the planes and forms that will help you to begin to understand what's at the core of making each face look like a face and how the position and proportions vary.

The first area we are going to clearly define is the zygomatic region (cheek bone and most of eye socket). Referring to the images below and the reference photography of the Asian male skull, attempt to refine the region indicated:

Zygomatic region on skull.

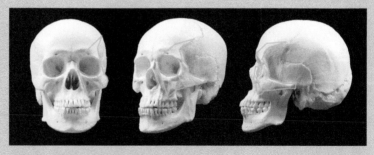

Zygomatic region.

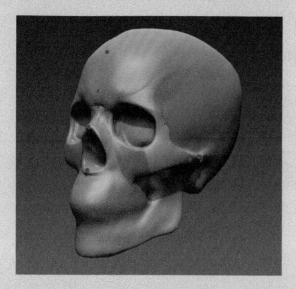

Zygomatic blocked in.

A couple of important things to keep in mind as you work:

The eye socket in this individual is fairly round. Eye sockets vary from round to square between sexes and ethnic groups. As mentioned earlier, the anterior plane of the cheek bone is fairly front facing. In the side view, the outer corner of the plane is not much further back than where it inserts at the maxilla. This "sweep" of the outer corner of the zygomatic will retreat more or less towards the rear of the skull in different ethnic groups.

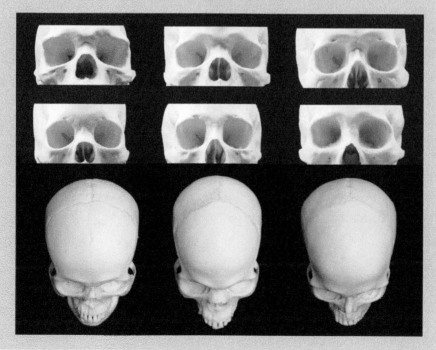

Images demonstrating shape of eye socket and zygomatic sweep.

Next we will define the planes of the nasal cavity.

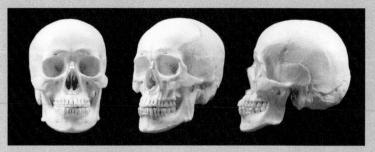

Nasal cavity forms on skull.

Result: nasal cavity.

Now proceed to refining the brow and forehead region:

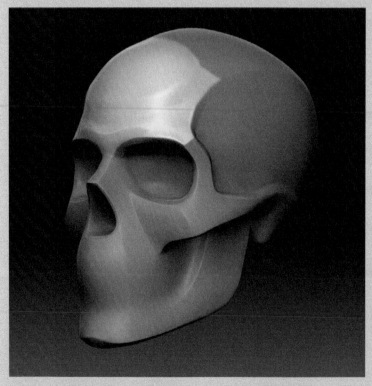

Brow and forehead region.

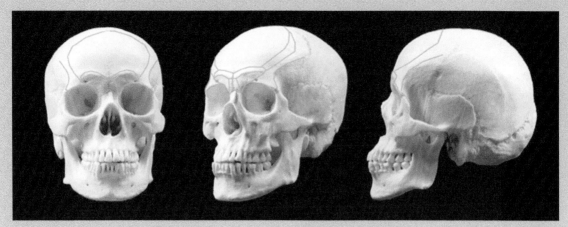

Brow and forehead forms on skull.

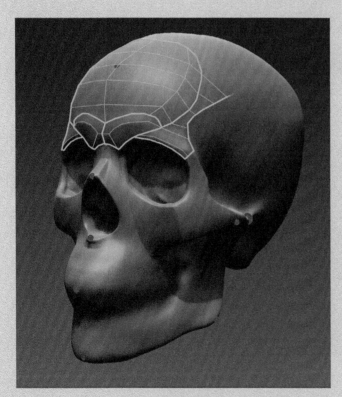

Forehead and brow forms on model.

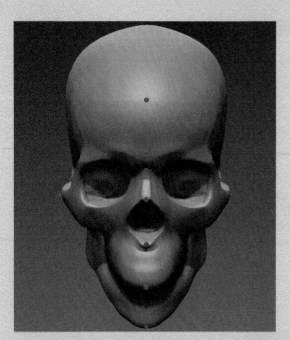

Front view.

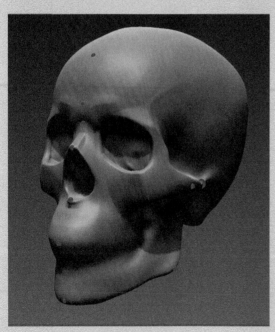

Finished.

Next move on to the barrel of the mouth and jaw region:

Jaw region.

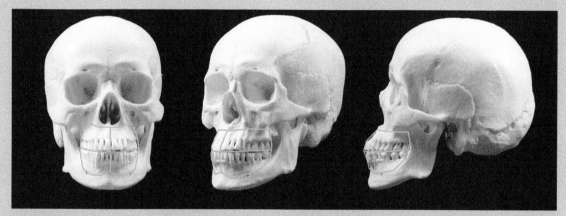

Jaw planes on skull.

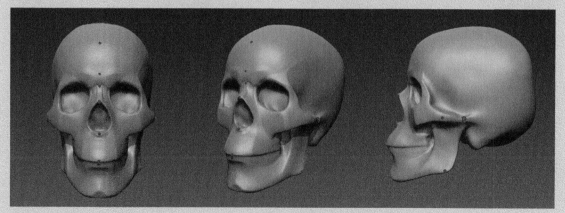

Jaw planes added to model.

While the focus of this book is primarily on the face, we will take a moment to look at the posterior forms of the skull:

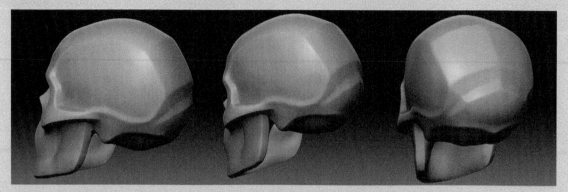

Image of basic geometric forms of back of skull.

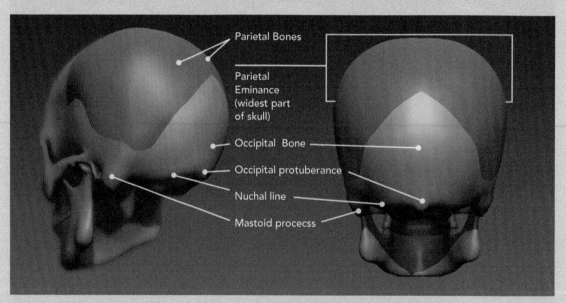

Parietal Bones

Parietal Eminance (widest part of skull)

Occipital Bone

Occipital protuberance

Nuchal line

Mastoid procecss

Simple bones of the back of the skull.

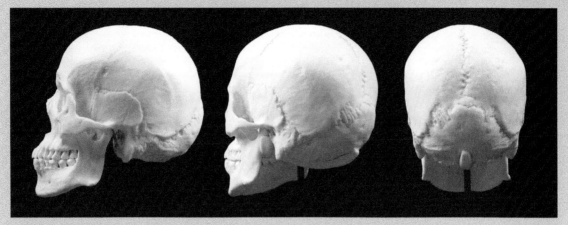

Image of Asian male skull matching previous image.

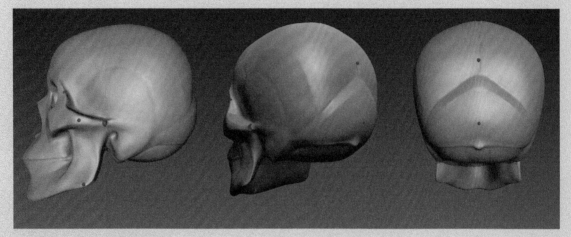

Image of tutorial skull completed.

Now that you have walked though one simple example, use the resources provided online for this chapter's tutorial to complete three more skull studies of an Asian female and an African male and an Aboriginal male.

\tutorials\tutorial1\base_skull.obj

\tutorials\tutorial1\image_planes\asian_female\
\tutorials\tutorial1\skull_markers\asian_female\

\tutorials\tutorial1\image_planes\african_male\
\tutorials\tutorial1\skull_markers\african_male\

\tutorials\tutorial1\image_planes\aboriginal_male\
\tutorials\tutorial1\skull_markers\aboriginal_male\

FEMALE FACES

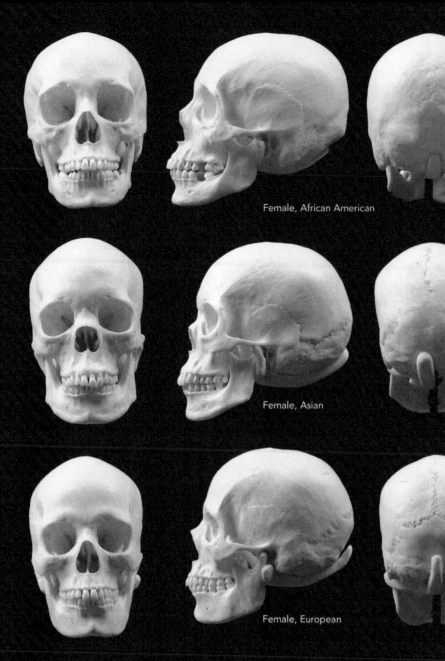

Female, African American

Female, Asian

Female, European

Female, Native American

The female face is featured in this chapter. Each female will be featured in a turn-around. Each model's description will include measurements taken with calipers, and the country the person claims ancestry from.

Chapter 2 demonstrated the difference in size found between the sample male and female skulls we have. What did you notice?

The female face is usually smaller and softer than the male face. The forehead is a bit more upright and smooth. The female mandible is proportionally smaller, the angle of the jaw is less defined, and the chin is more pointed. Did you notice that even the teeth are smaller on the female than on the male counterpart?

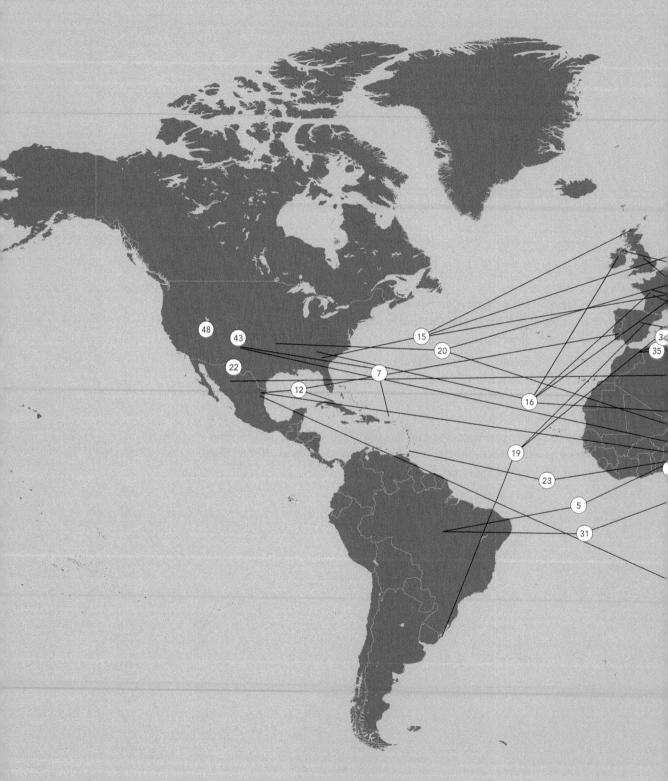

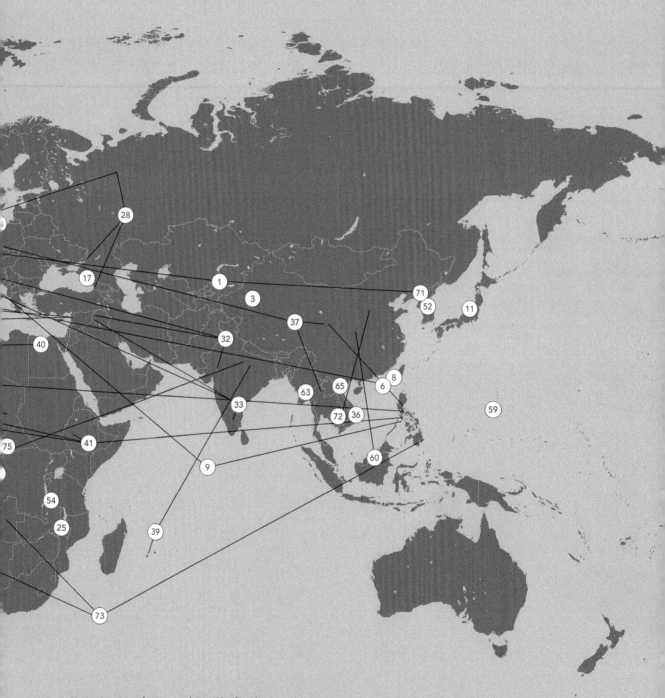

Approximation of ancestry claimed by females.

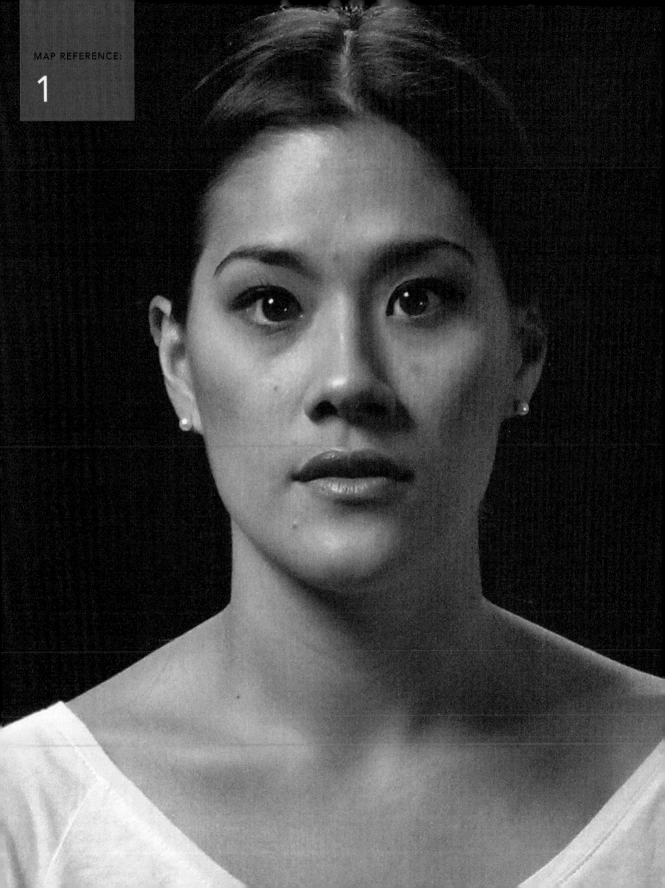

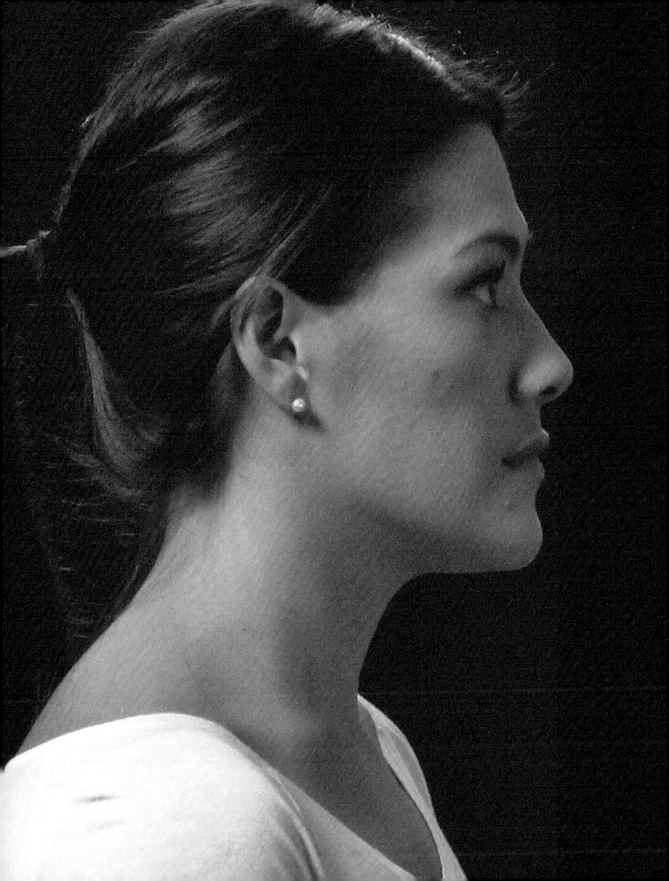

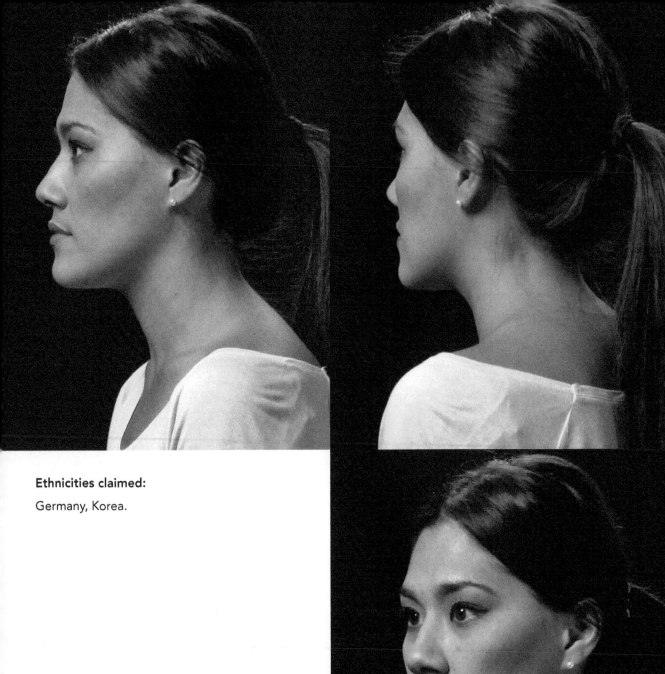

Ethnicities claimed:

Germany, Korea.

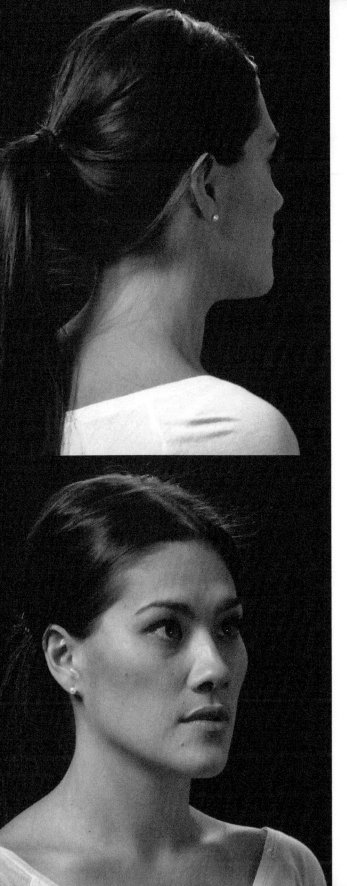

Head measurements (in):

A: 5 5/8
B: 5 1/8
C: 4 5/8
D: 5
E: 6 1/4
F: 3 1/2
G: 4 1/8
H: 5
I: 7 3/8
J: 5 1/5

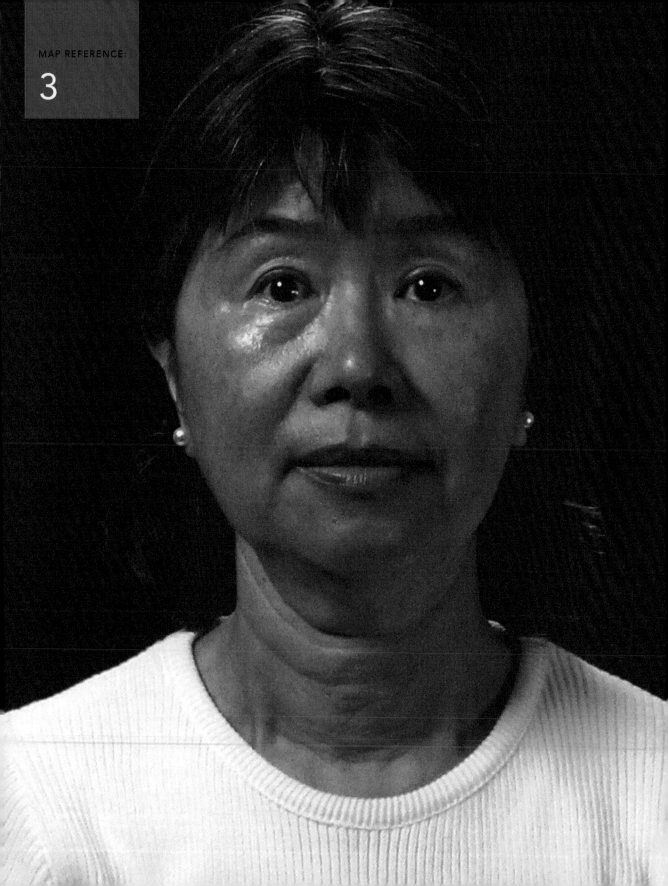

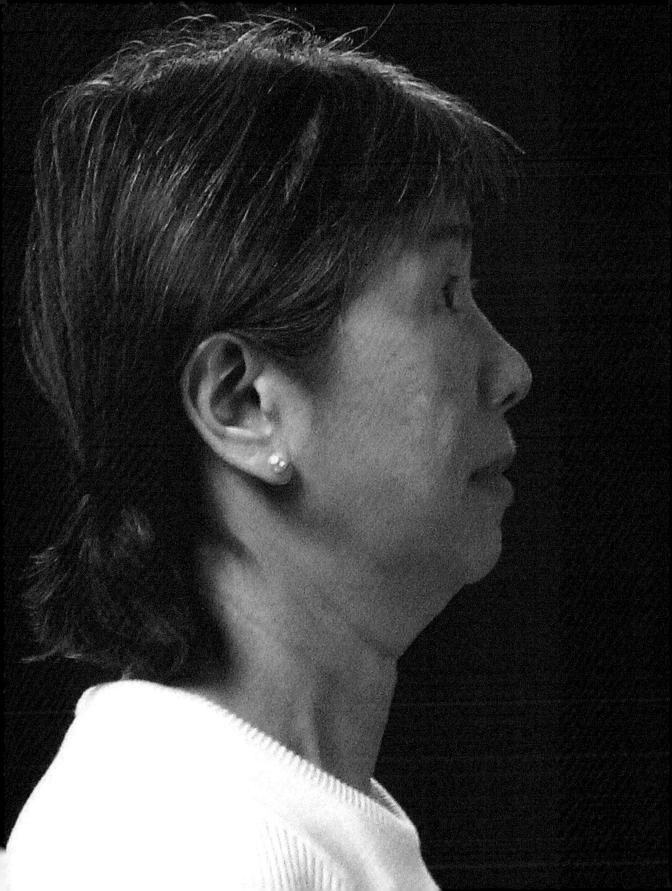

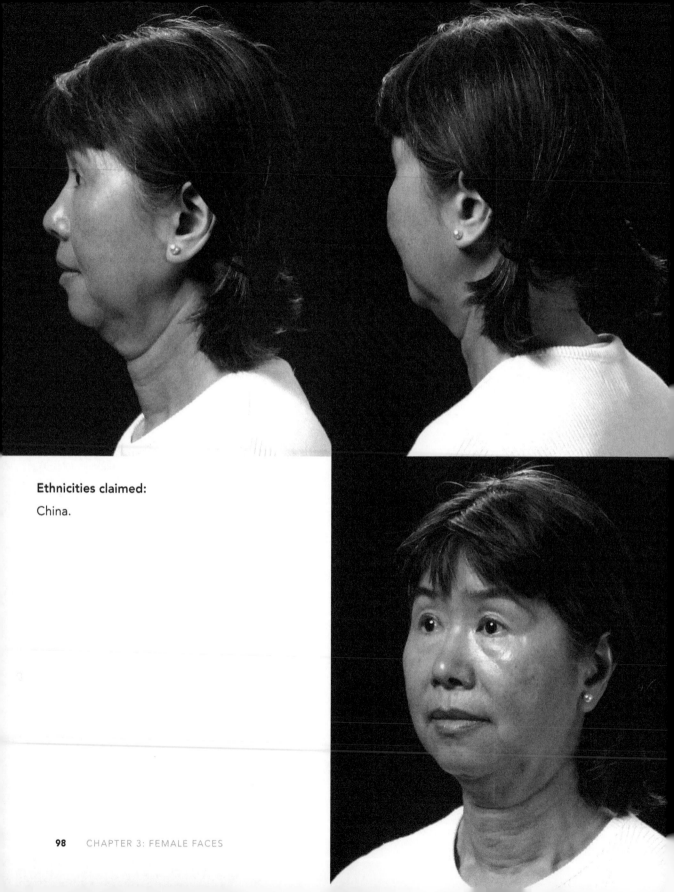

Ethnicities claimed:

China.

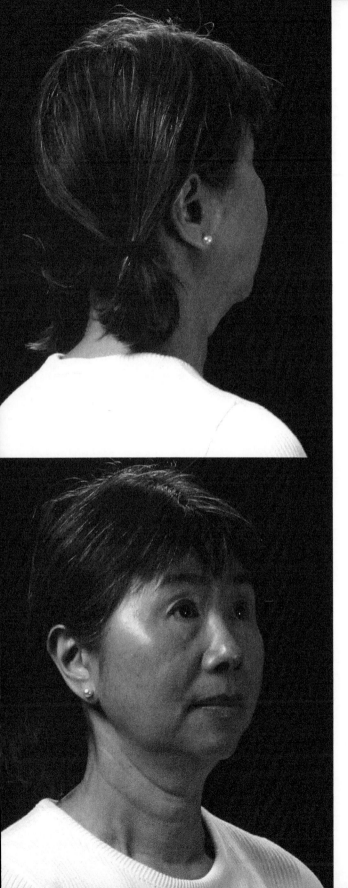

Head measurements (in):

A: 5
B: 5 1/8
C: 4 1/2
D: 4 7/8
E: 5 3/4
F: 3 3/8
G: 4 1/4
H: 5 1/8
I: 7 1/4
J: 4

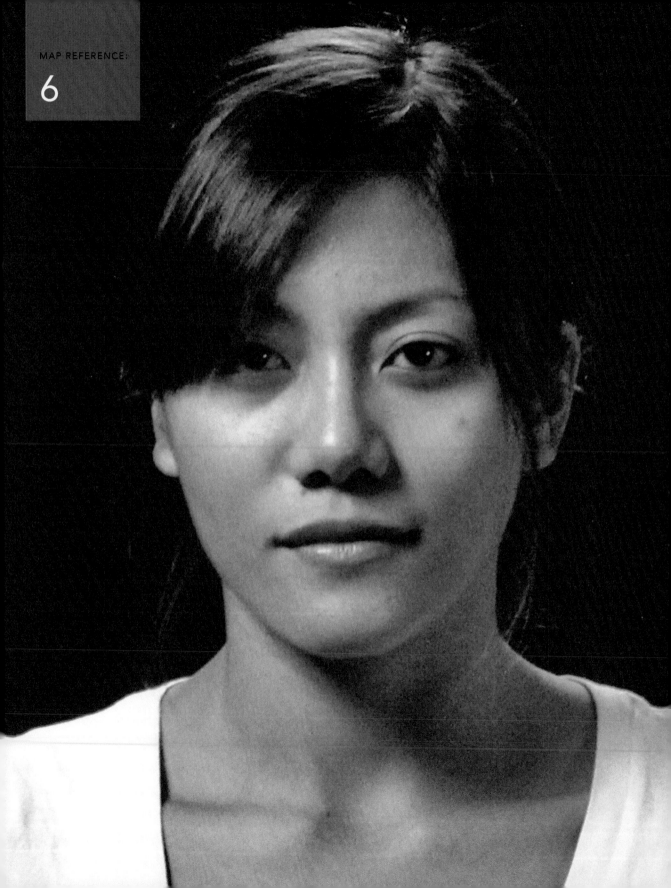

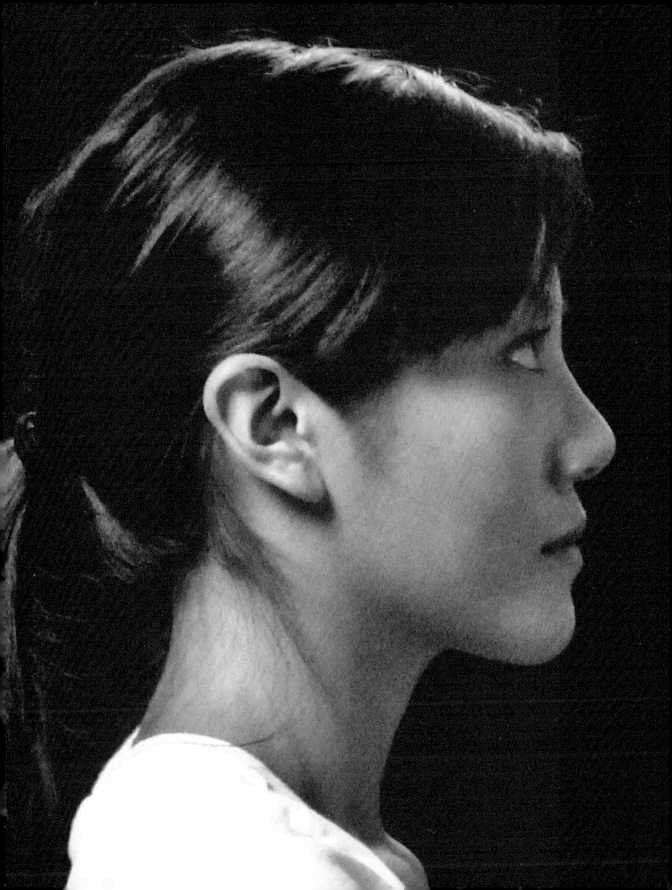

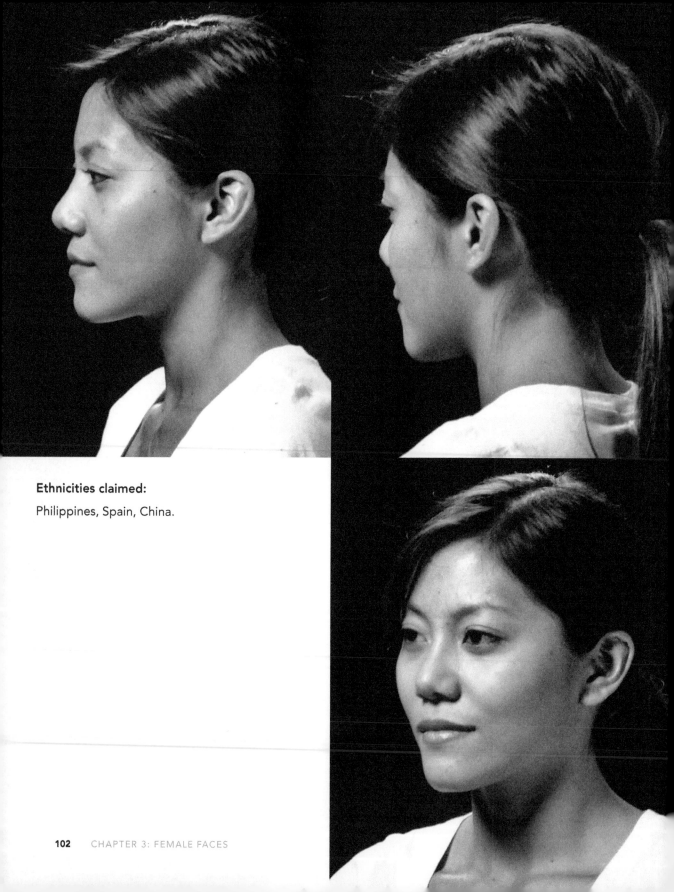

Ethnicities claimed:

Philippines, Spain, China.

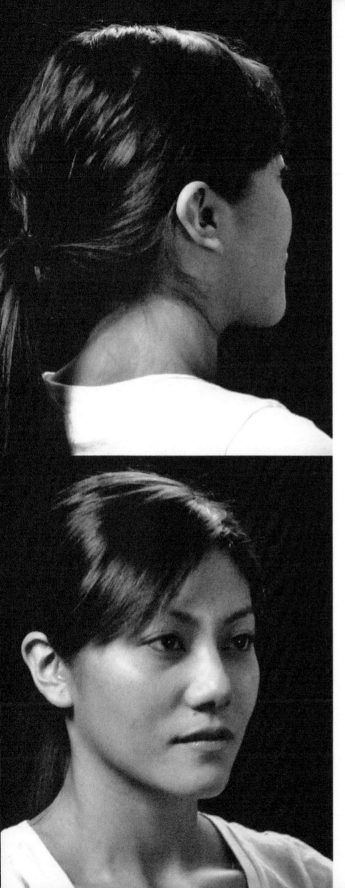

Head measurements (in):

A: 4 3/4

B: 5

C: 4 5/8

D: 5

E: 5 5/8

F: 3 3/8

G: 4 3/8

H: 5

I: 7 3/8

J: 5 1/8

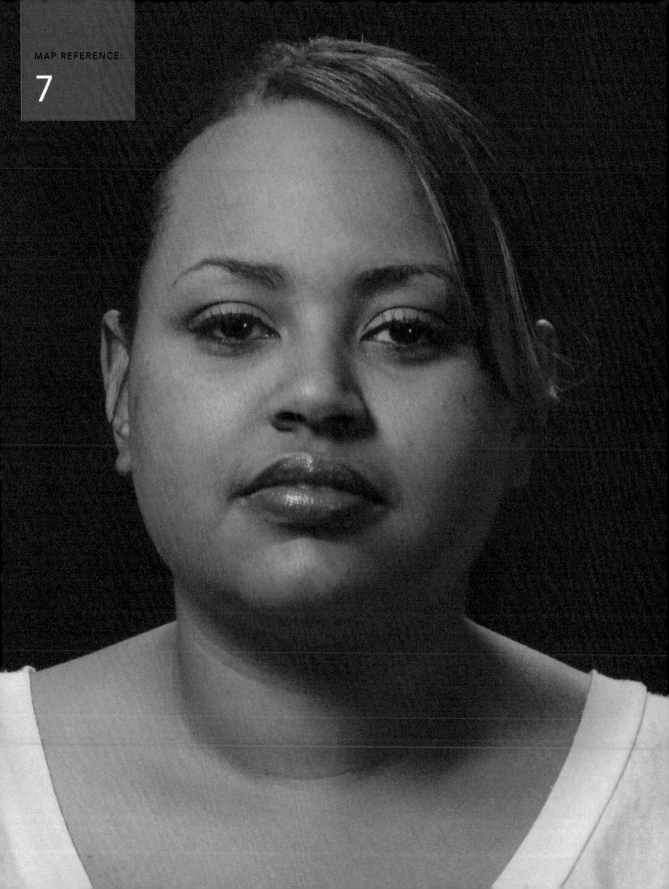

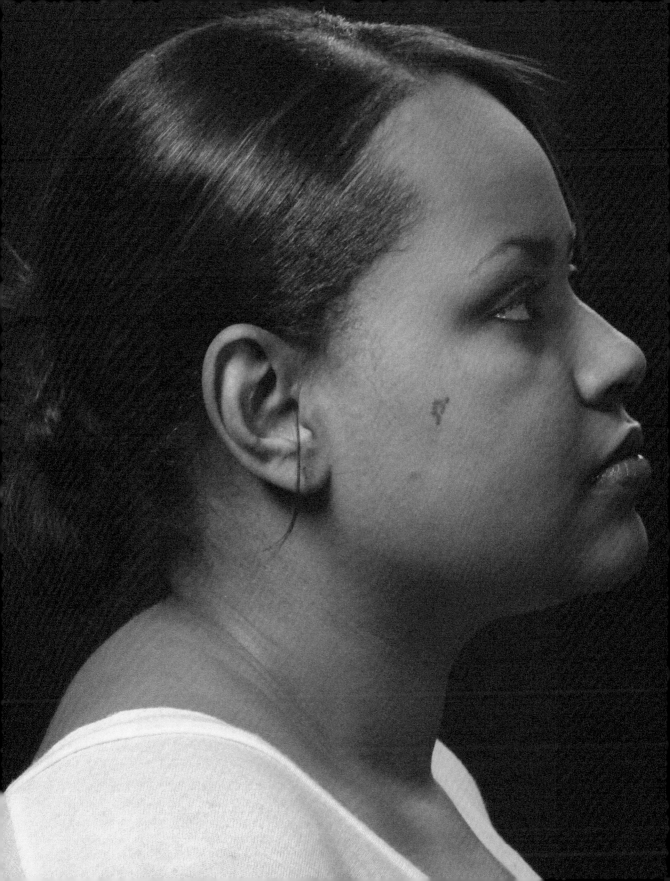

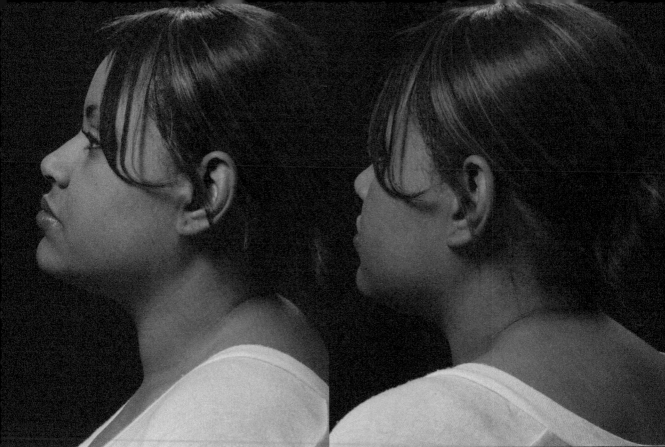

Ethnicities claimed:

Caya—Puerto Rica, America—Choctaw Indian.

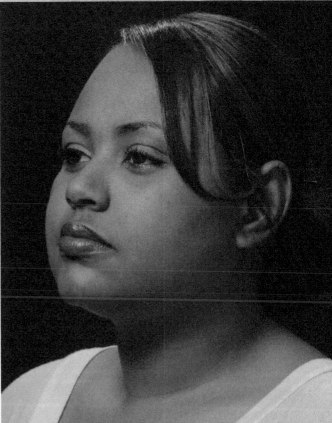

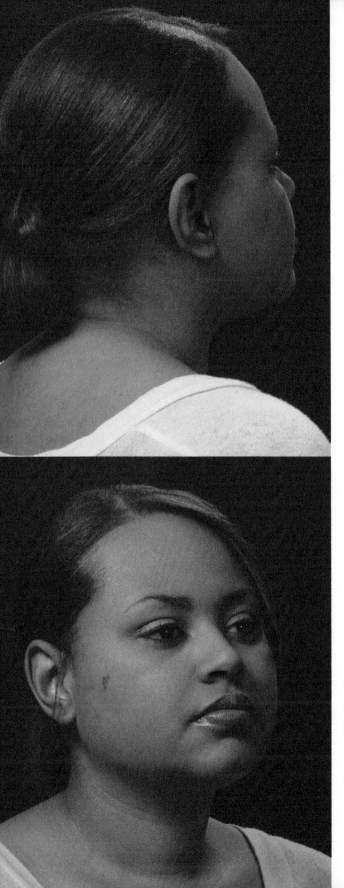

Head measurements (in):

A: 5 3/8

B: 5

C: 4 3/4

D: 4 5/8

E: 6 1/2

F: 3 3/8

G: 4

H: 4 3/4

I: 7 5/8

J: 5 1/2

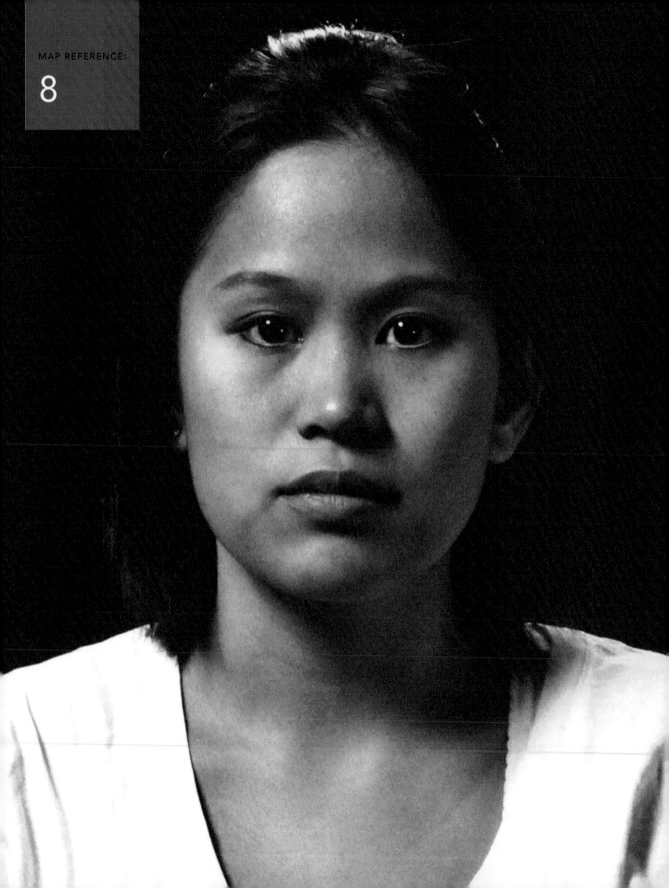

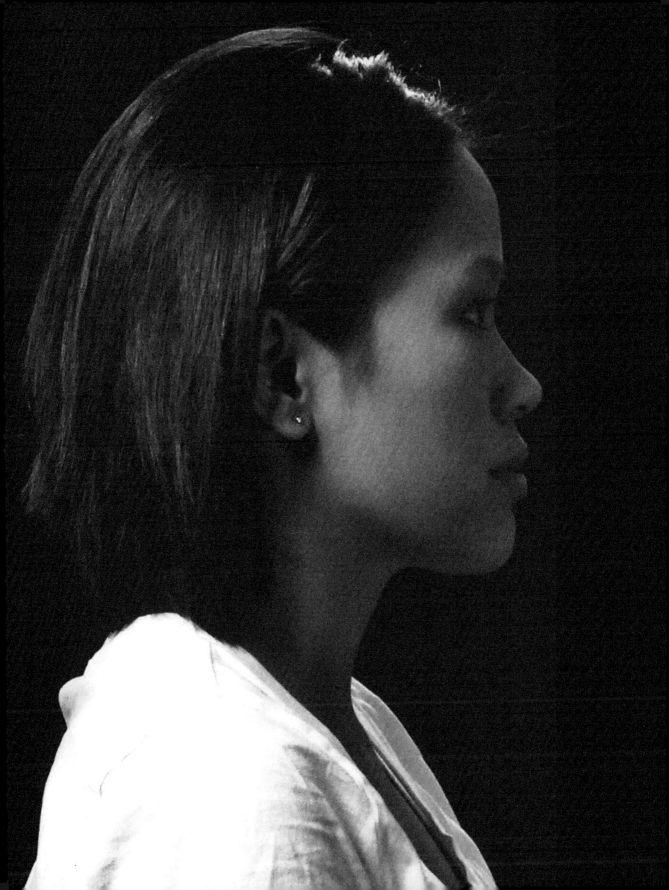

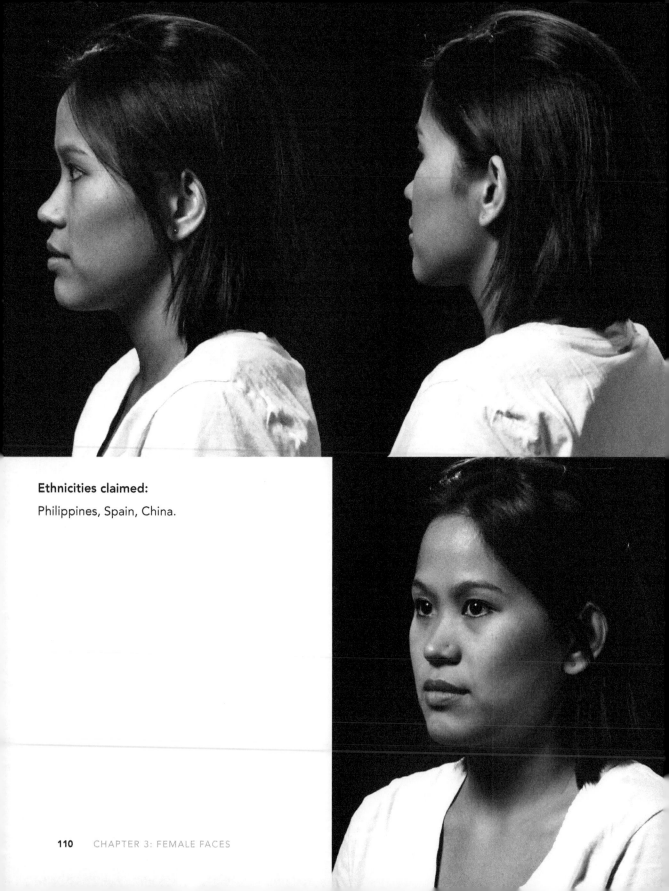

Ethnicities claimed:

Philippines, Spain, China.

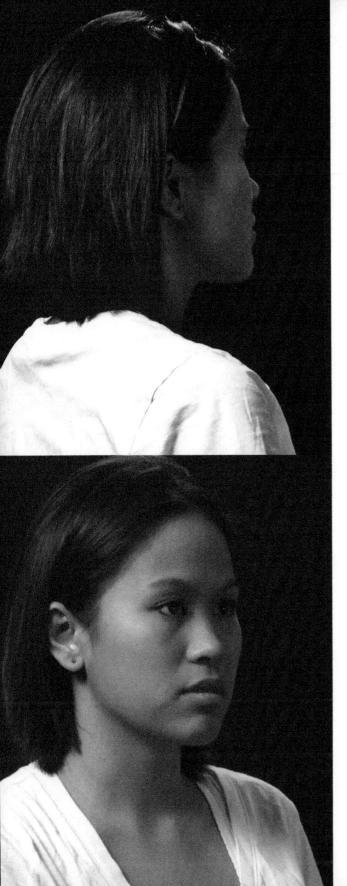

Head measurements (in):

A: 5 1/4
B: 4 1/4
C: 4 5/8
D: 4 3/4
E: 6 3/8
F: 3 3/8
G: 4 1/4
H: 5
I: 7 1/2
J: 5 5/8

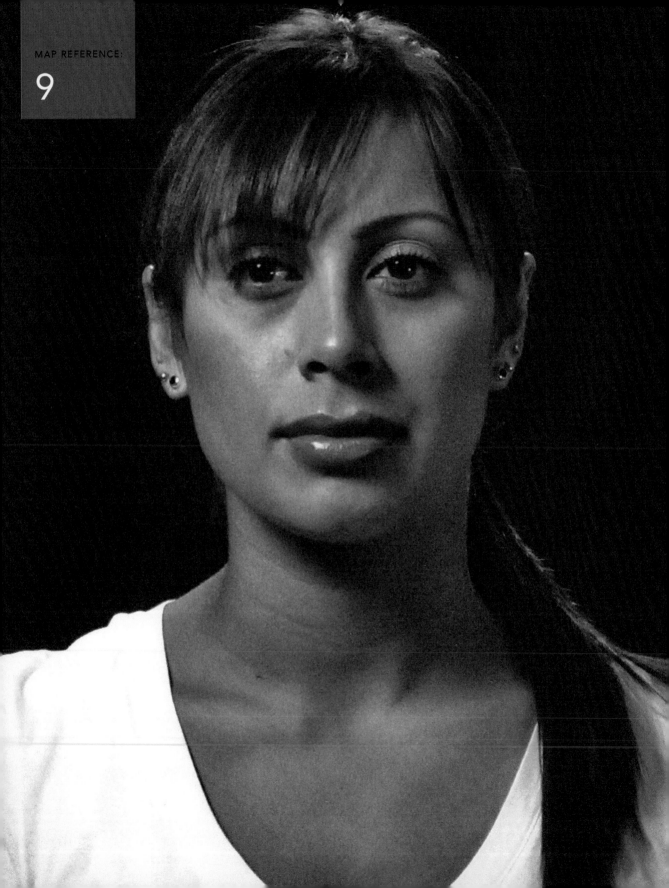

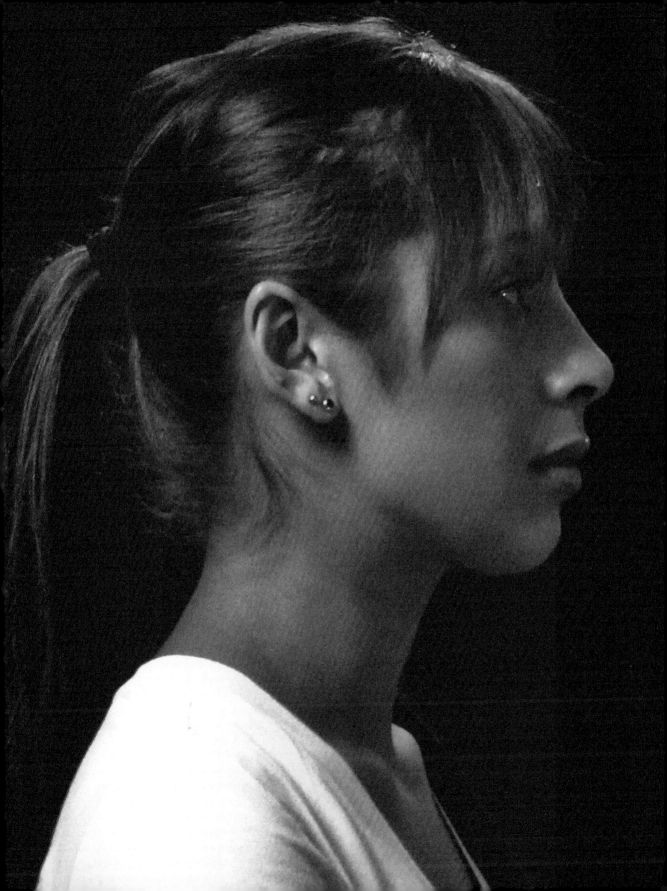

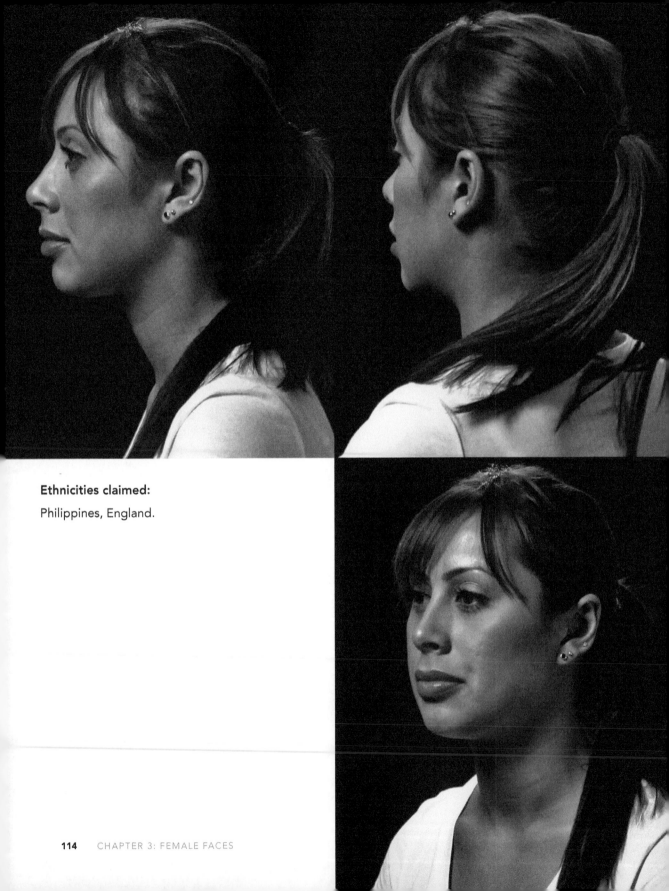

Ethnicities claimed:

Philippines, England.

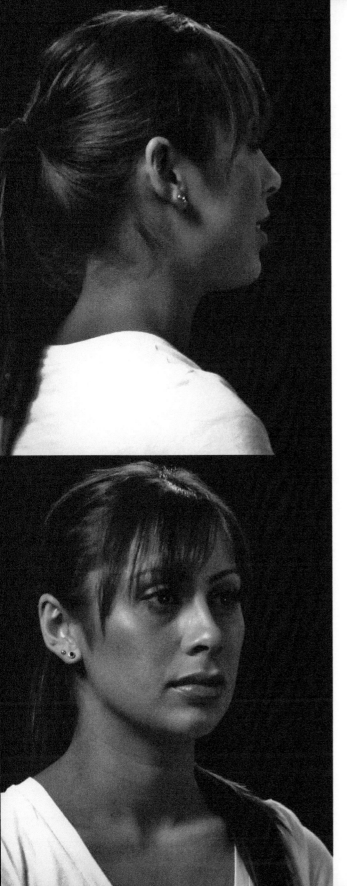

Head measurements (in):

A: 5 1/8
B: 4 7/8
C: 4 3/4
D: 4 3/4
E: 6 1/4
F: 3 1/2
G: 4 1/2
H: 5 1/4
I: 7 1/8
J: 5 3/8

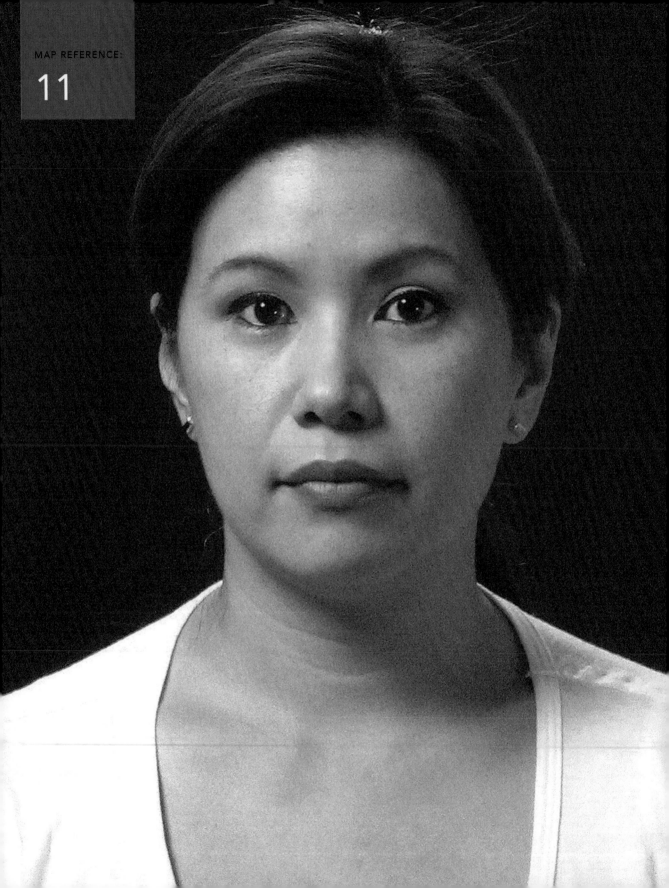

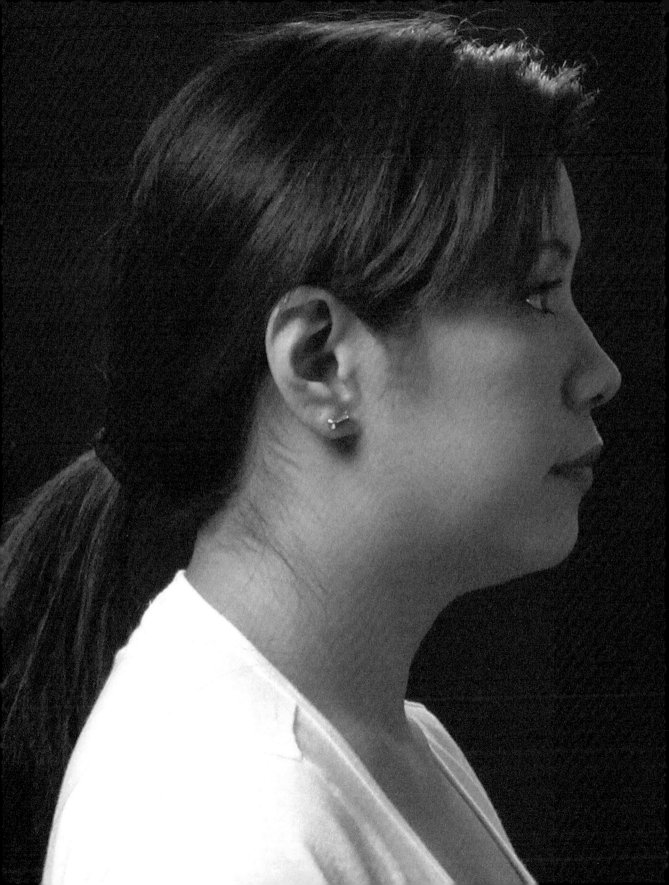

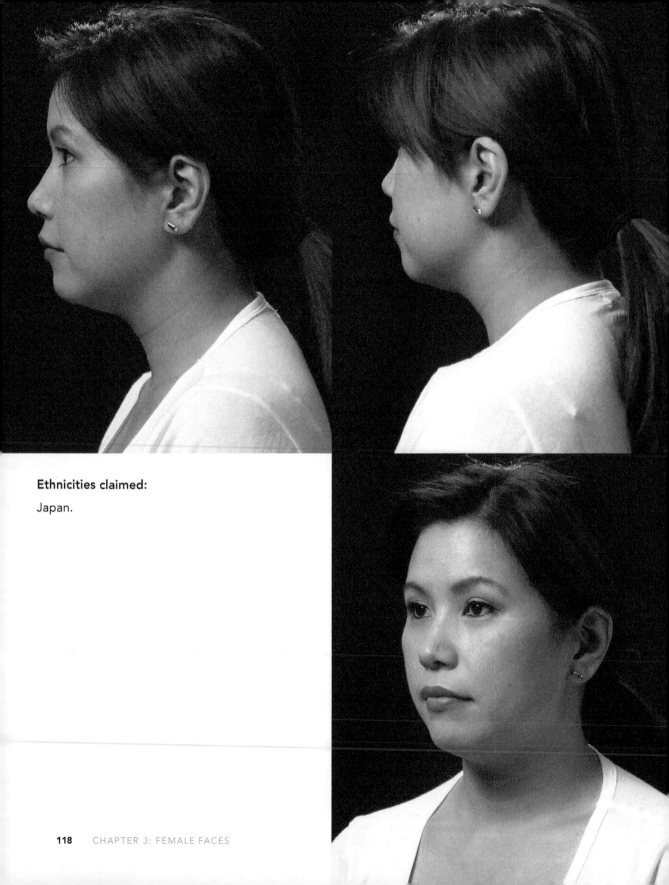

Ethnicities claimed:

Japan.

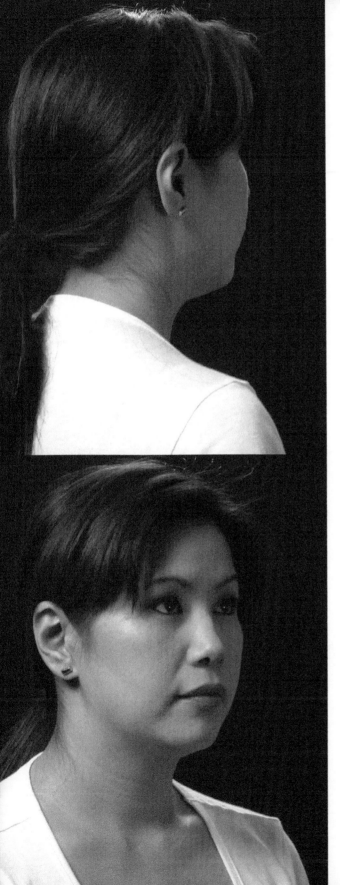

Head measurements (in):

A: 5 1/8
B: 5 3/8
C: 5
D: 5 1/2
E: 6
F: 3 3/8
G: 4 3/8
H: 5 3/8
I: 7 3/4
J: 5 5/8

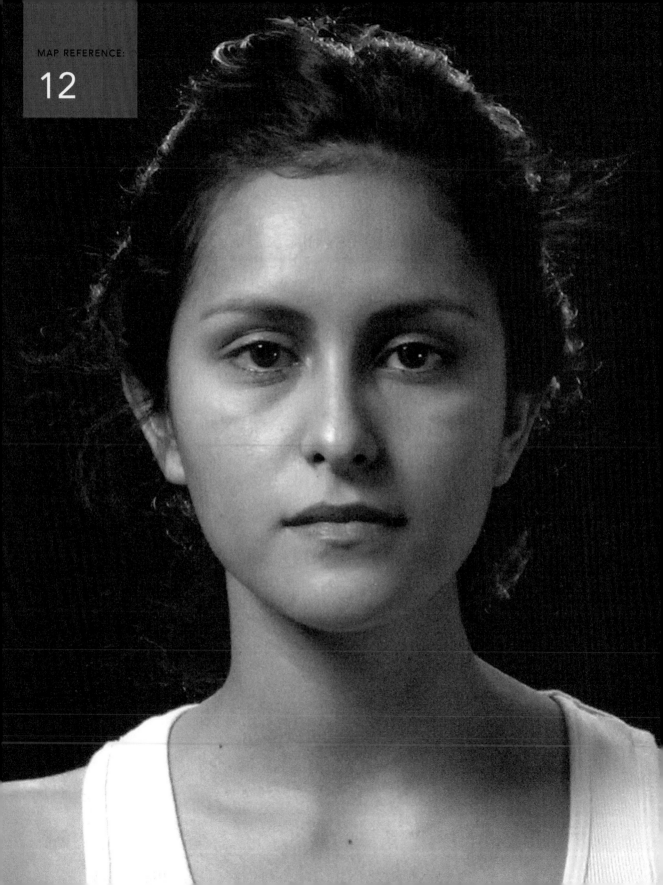

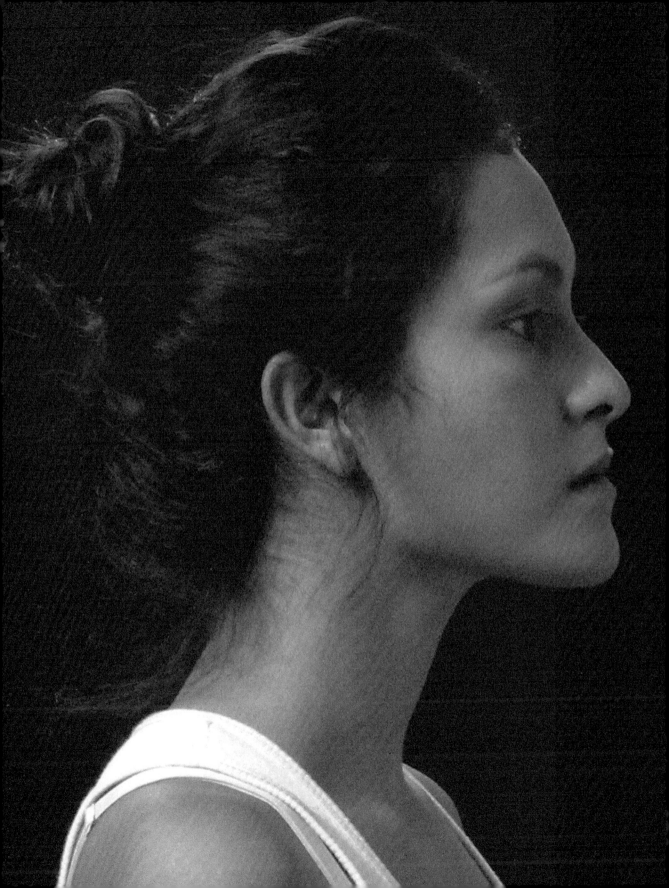

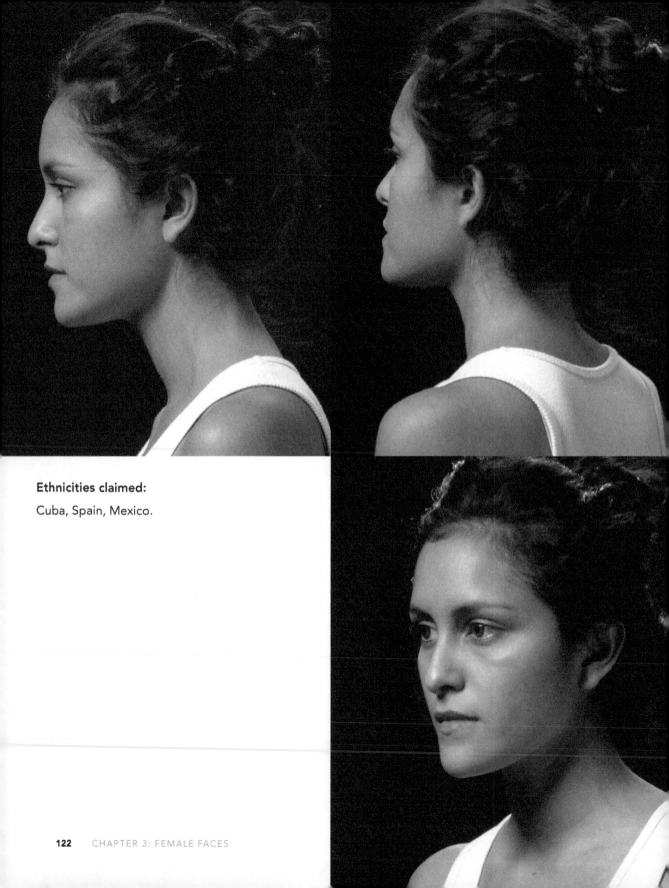

Ethnicities claimed:

Cuba, Spain, Mexico.

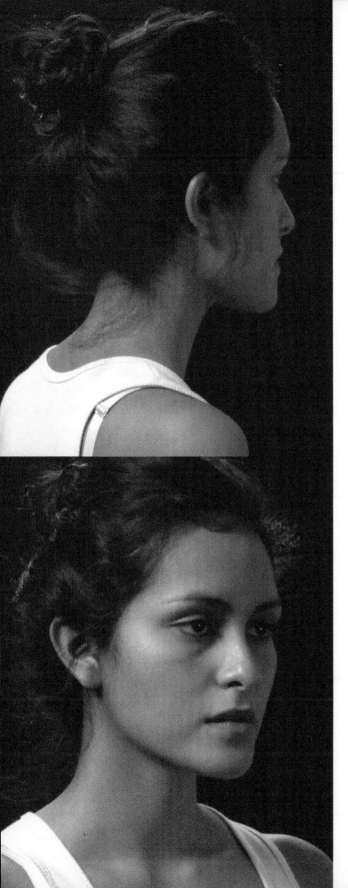

Head measurements (in):

A: 5 1/4
B: 4 1/2
C: 4 3/8
D: 4 3/4
E: 6 1/8
F: 3 3/8
G: 4 1/8
H: 5
I: 7 1/4
J: 5 1/8

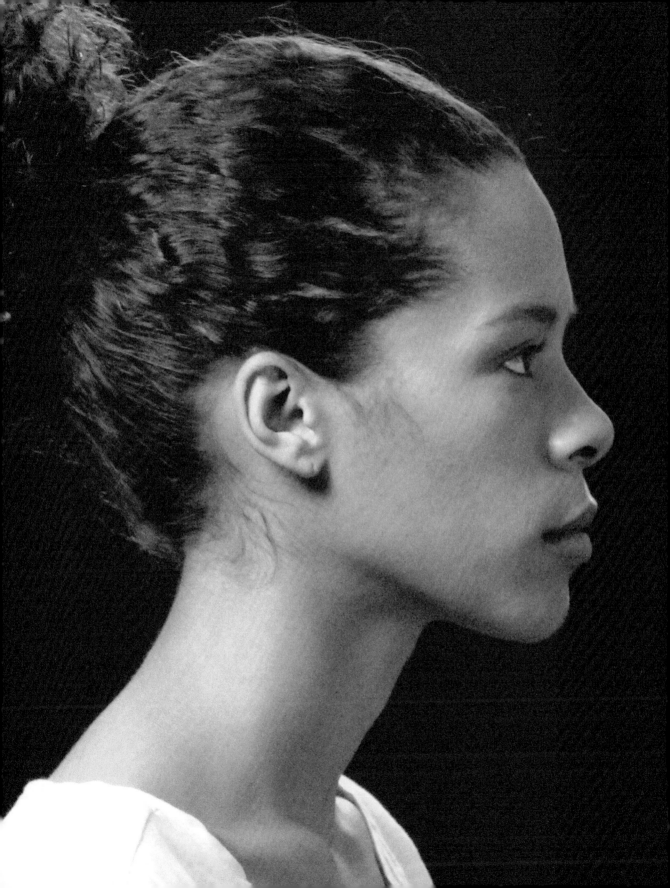

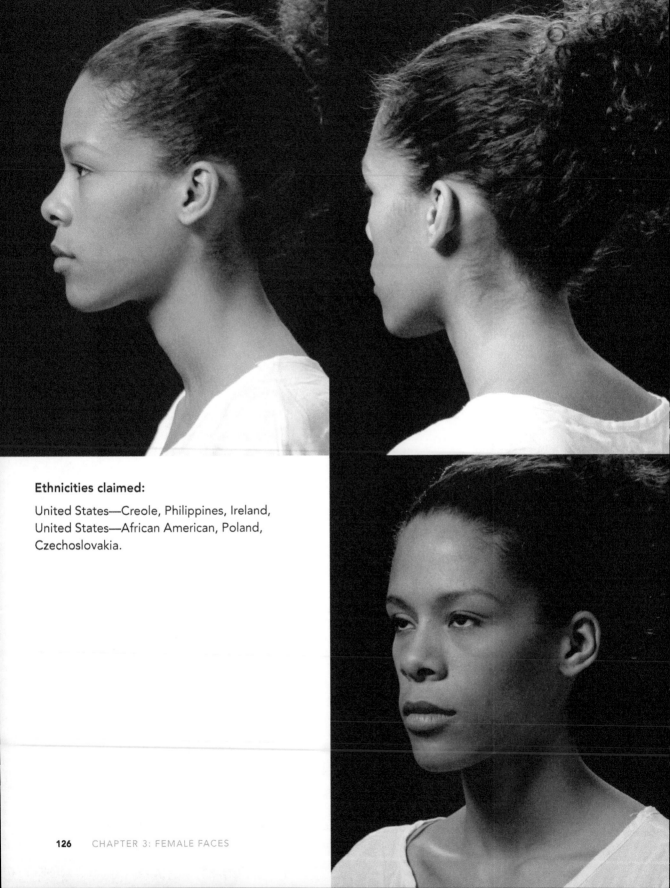

Ethnicities claimed:

United States—Creole, Philippines, Ireland, United States—African American, Poland, Czechoslovakia.

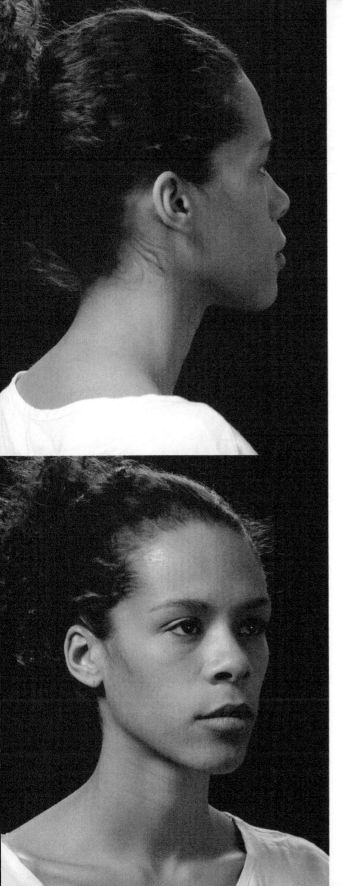

Head measurements (in):

A: 5 1/4
B: 5 3/8
C: 5
D: 5 1/8
E: 6 1/4
F: 3 1/4
G: 4 1/2
H: 5 1/4
I: 7 5/8
J: 5 3/4

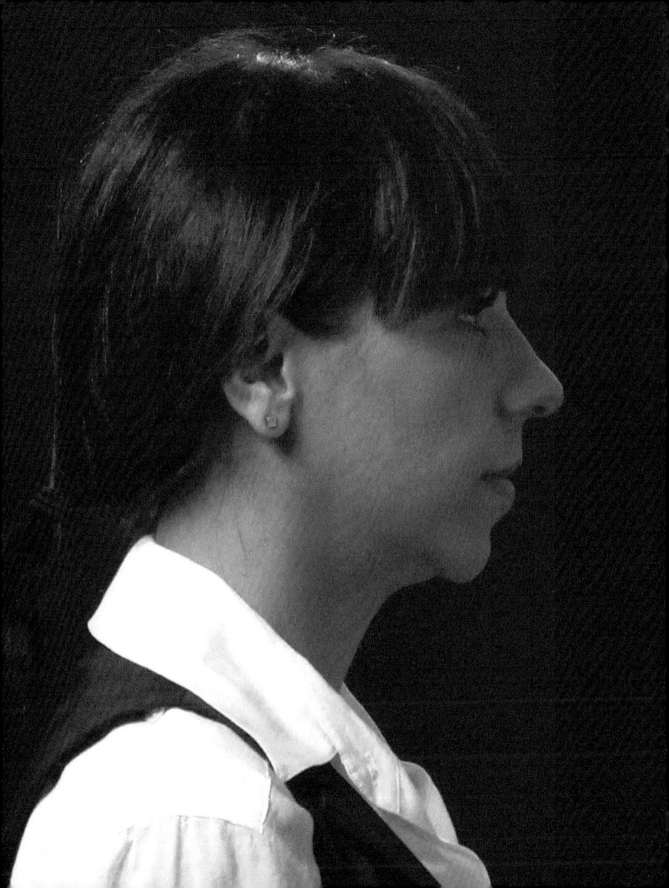

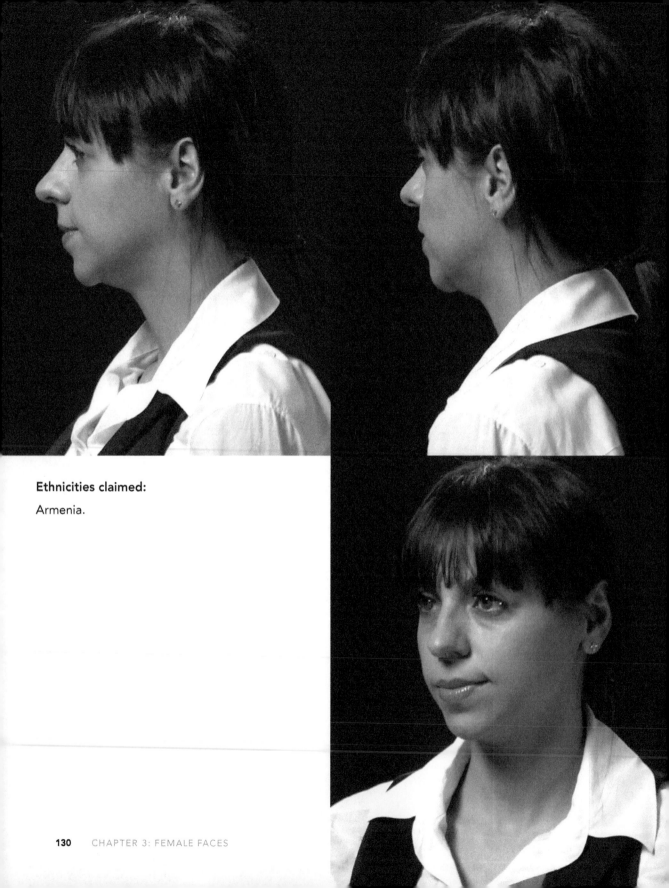

Ethnicities claimed:

Armenia.

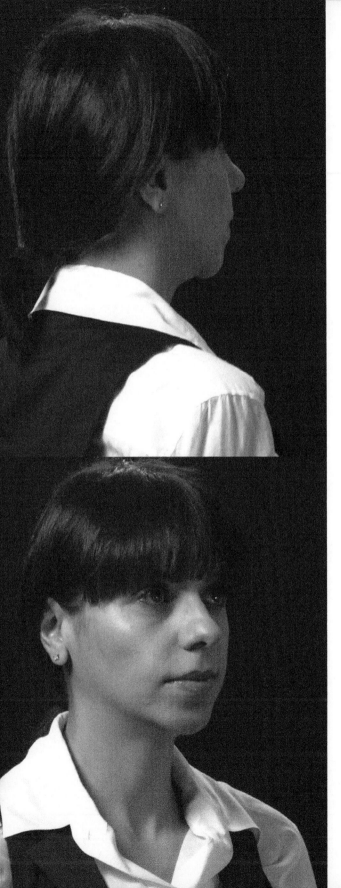

Head measurements (in):

A: 5
B: 5 1/4
C: 5
D: 5 1/8
E: 5 3/4
F: 3 1/2
G: 4
H: 4 7/8
I: 7
J: 5 3/4

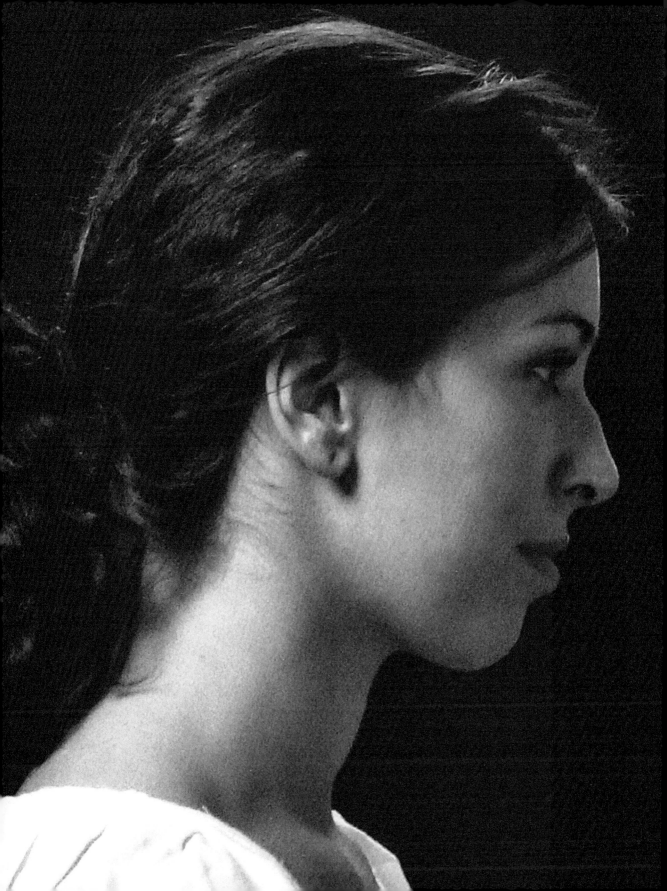

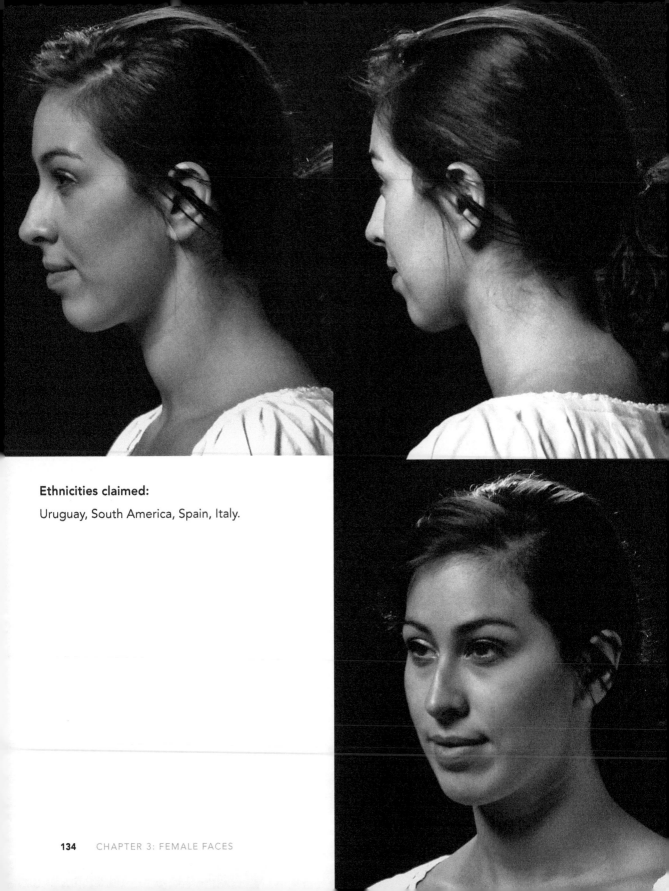

Ethnicities claimed:

Uruguay, South America, Spain, Italy.

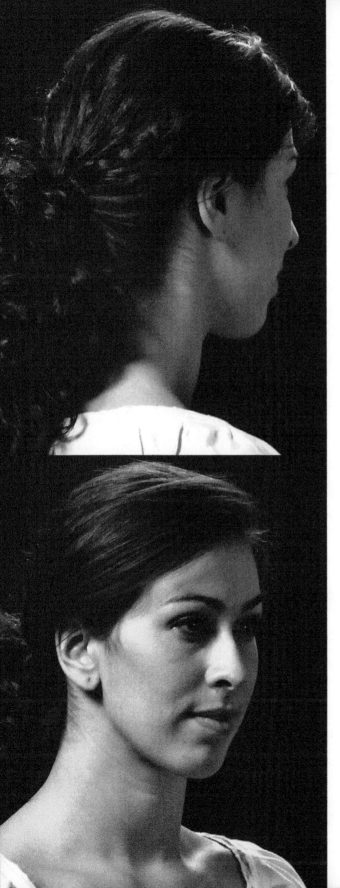

Head measurements (in):

A: 4 7/8
B: 4 3/4
C: 4 5/8
D: 4 3/4
E: 5 3/4
F: 3 5/8
G: 4 1/2
H: 5 1/8
I: 7 1/2
J: 5 1/4

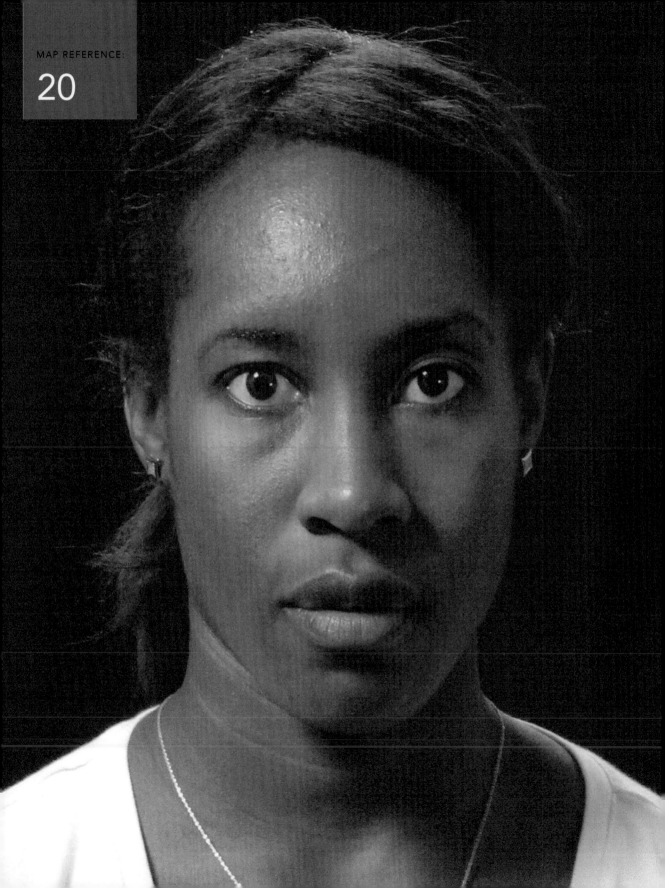

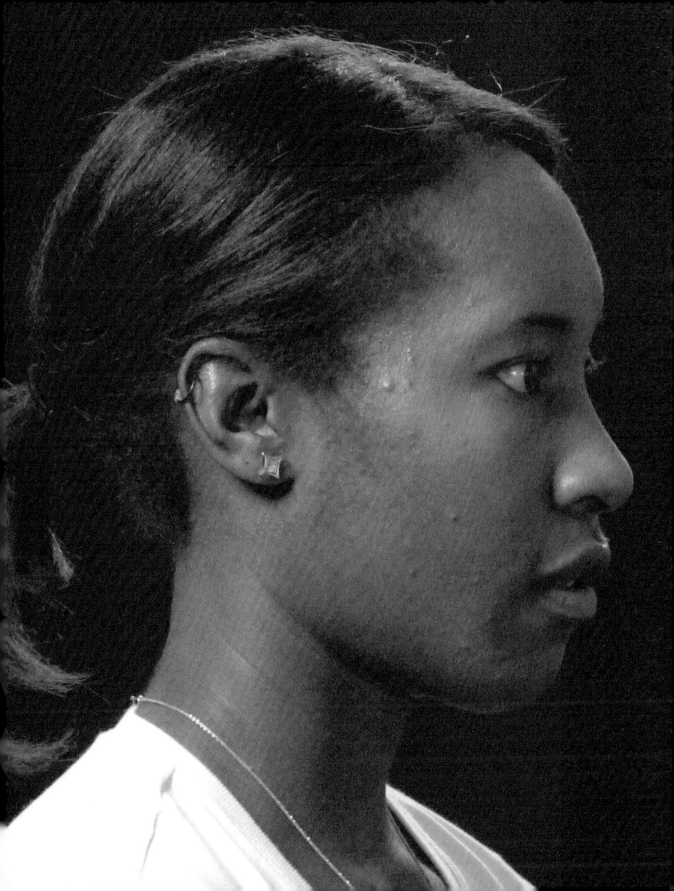

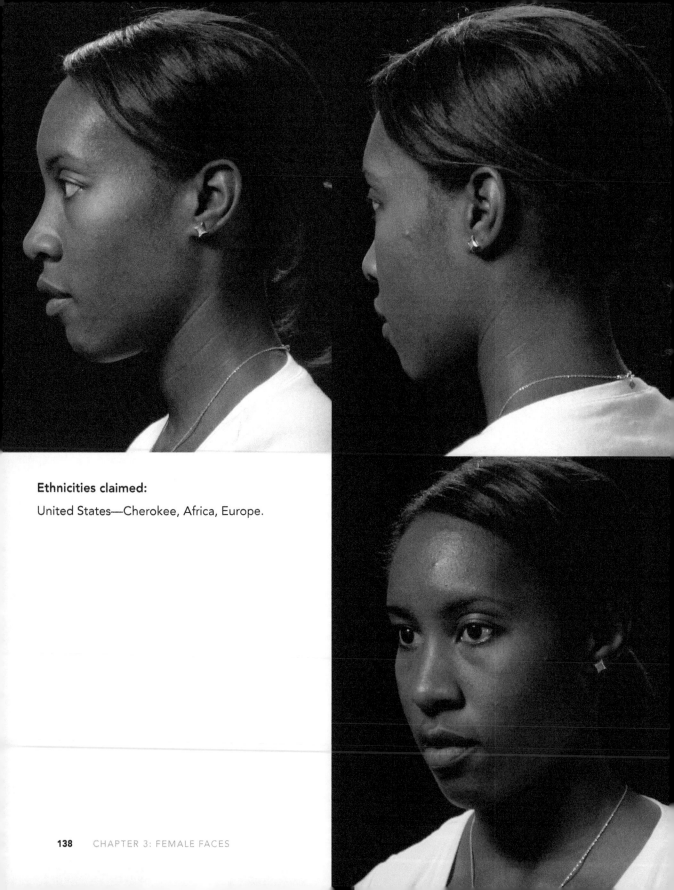

Ethnicities claimed:

United States—Cherokee, Africa, Europe.

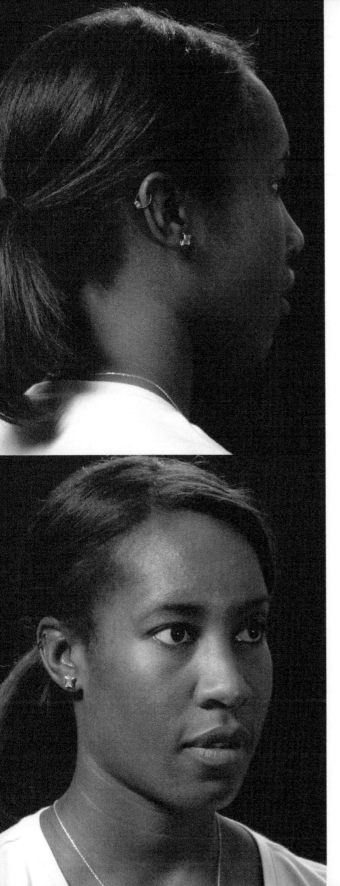

Head measurements (in):

A: 6
B: 5 1/4
C: 5 1/8
D: 5 5/8
E: 6 7/8
F: 4 1/4
G: 4 7/8
H: 6
I: 8 5/8
J: 5 1/2

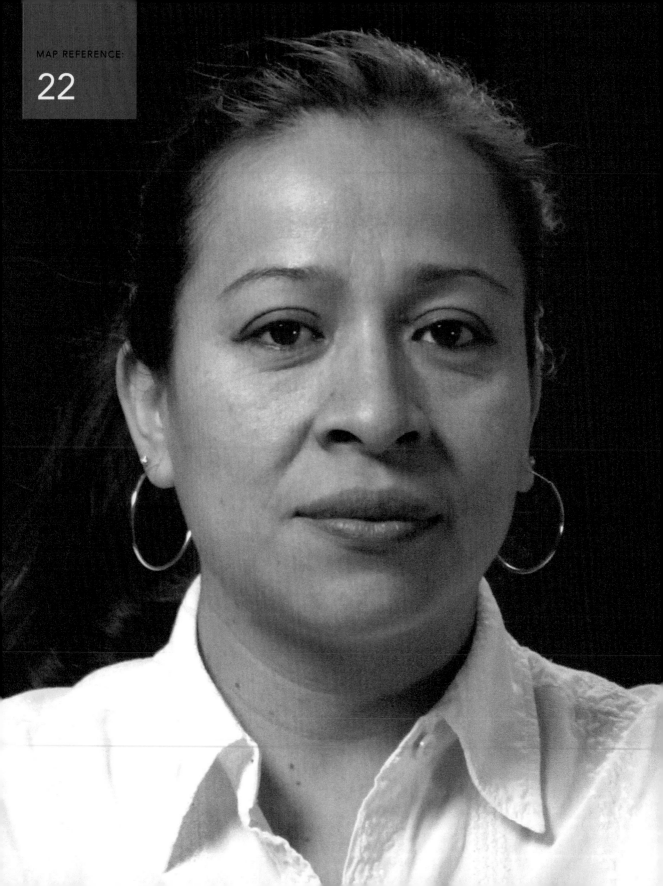

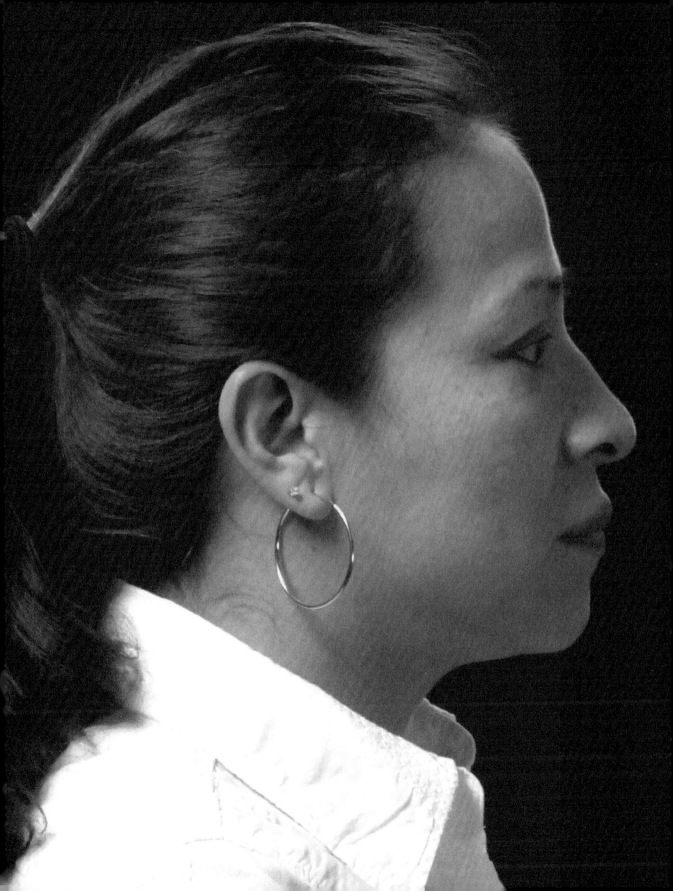

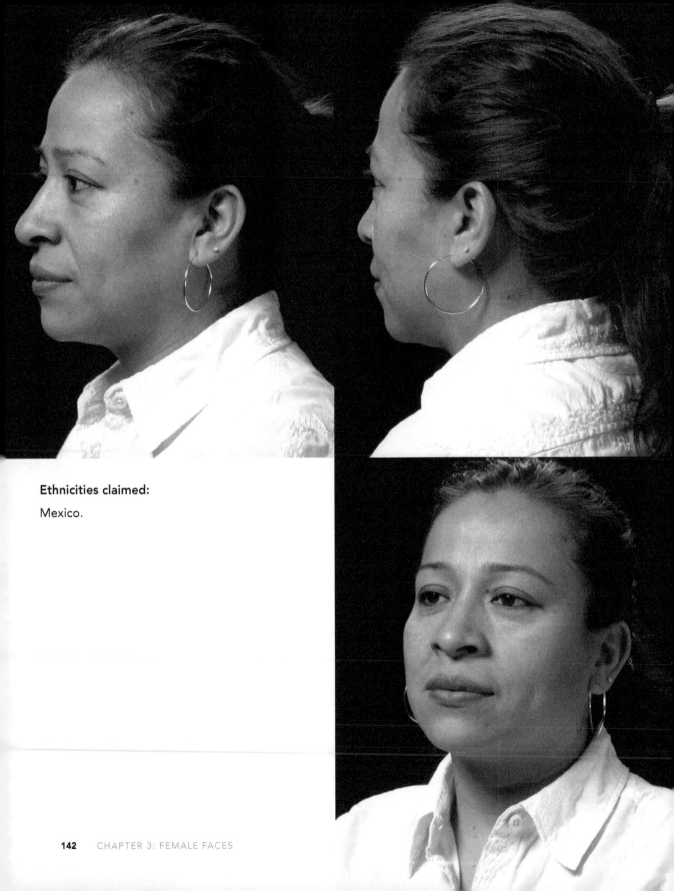

Ethnicities claimed:

Mexico.

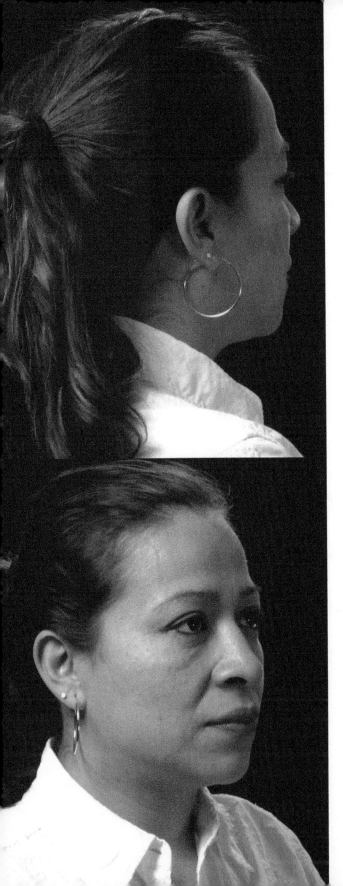

Head measurements (in):

A: 5 1/4

B: 5 1/8

C: 4 7/8

D: 5

E: 6 3/8

F: 3 3/8

G: 4 1/8

H: 5 3/8

I: 7 3/4

J: 5 3/4

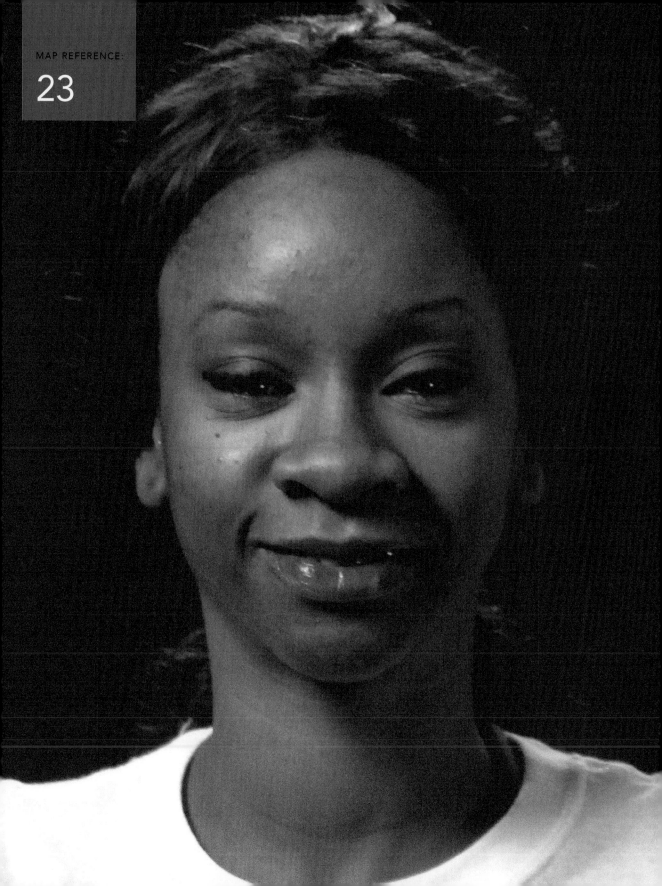

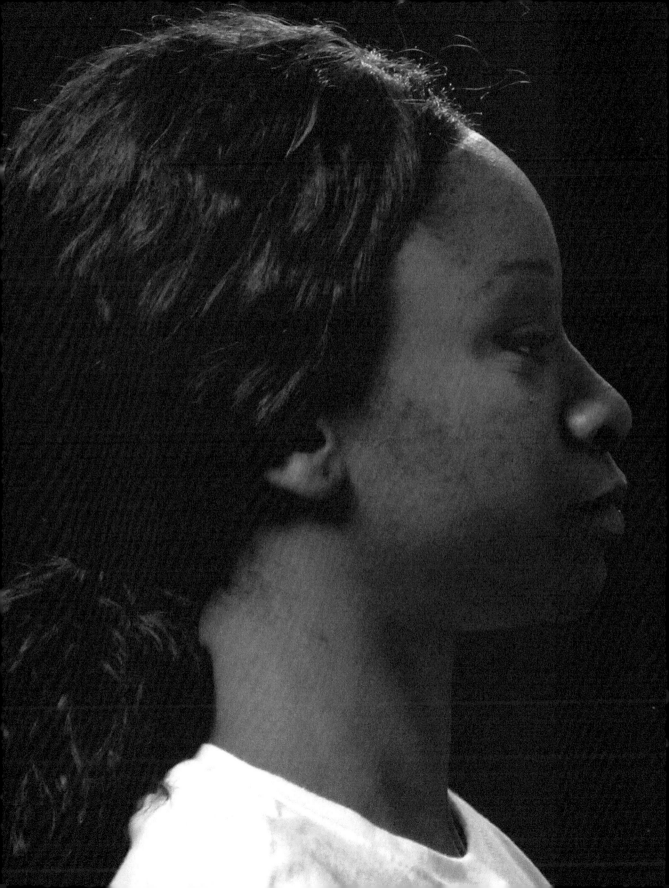

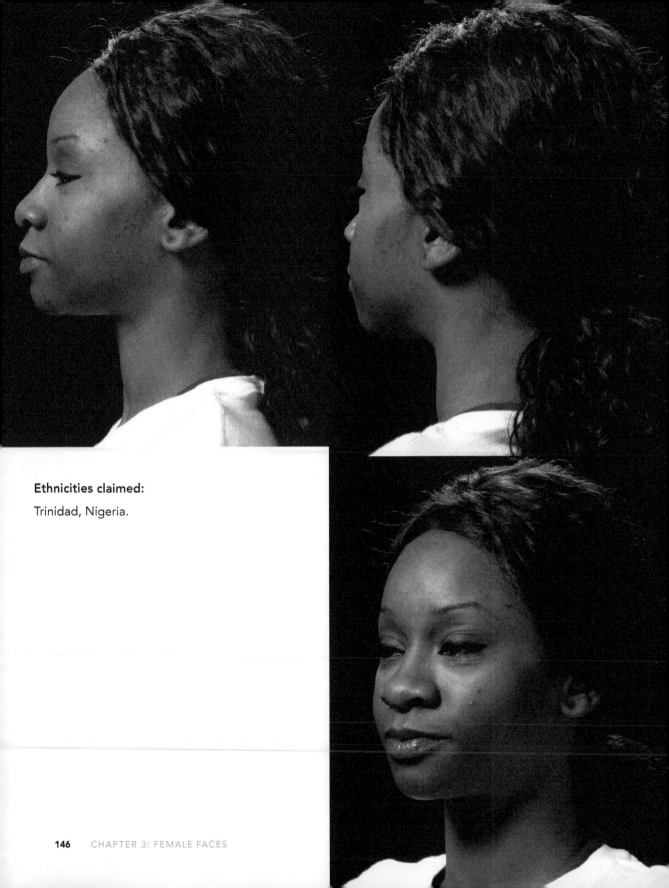

Ethnicities claimed:

Trinidad, Nigeria.

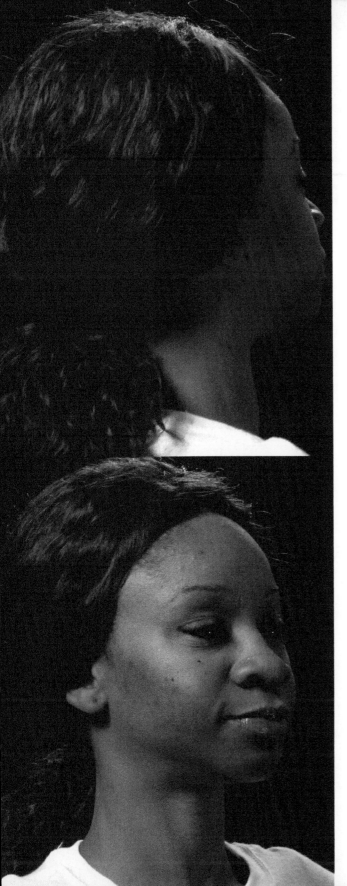

Head measurements (in):

A: 5 1/4

B: 5 1/4

C: 4 3/4

D: 5

E: 6 1/8

F: 3 1/2

G: 3 7/8

H: 5

I: 7 1/4

J: 5 3/8

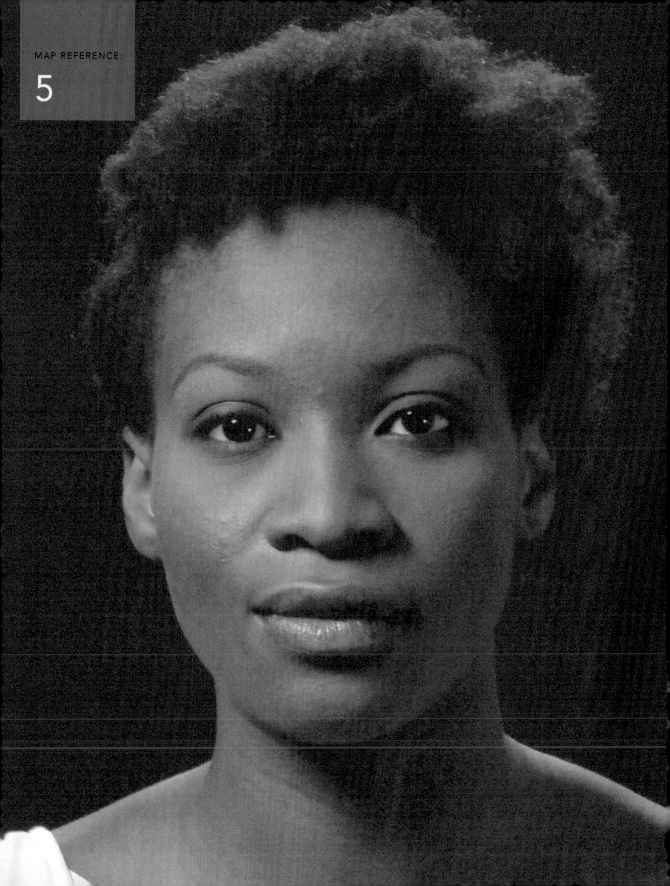

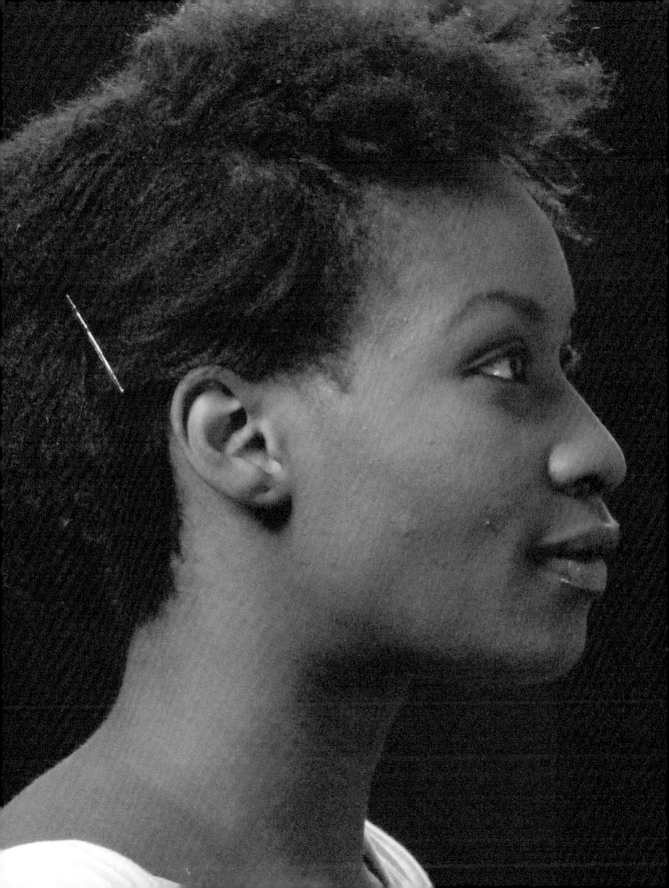

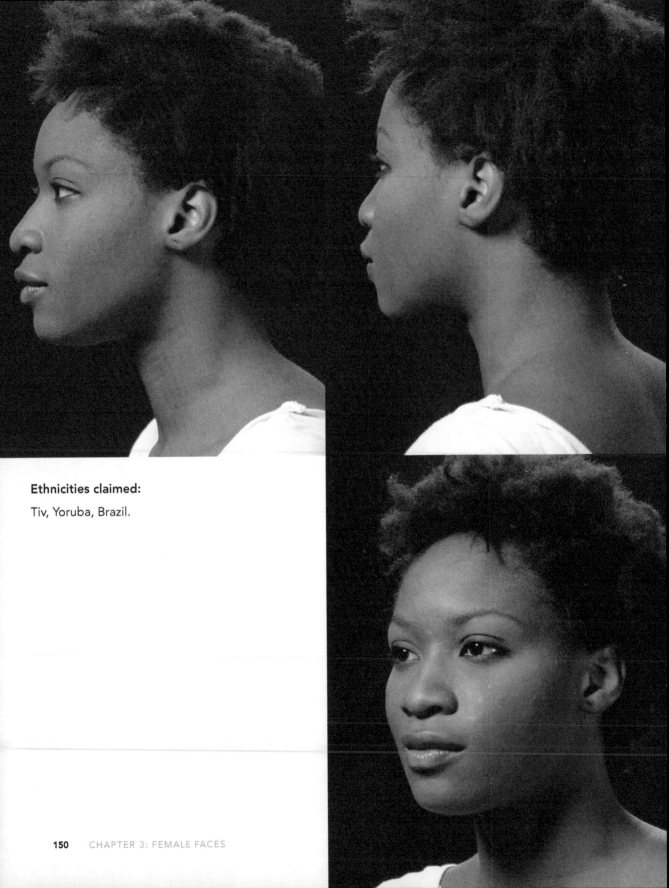

Ethnicities claimed:

Tiv, Yoruba, Brazil.

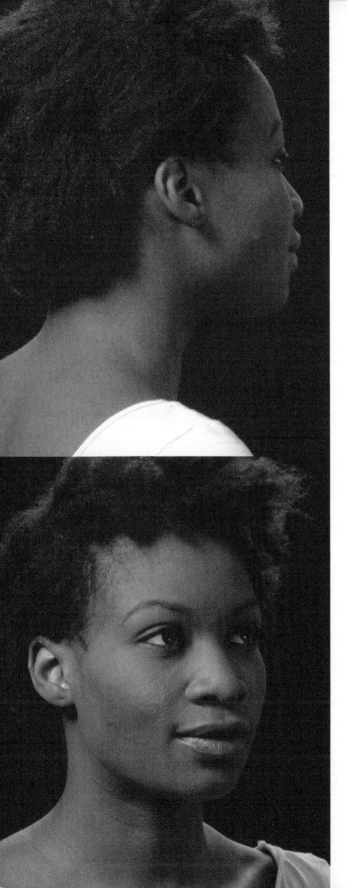

Head measurements (in):

A: 5 3/4
B: 4 5/8
C: 5
D: 4 7/8
E: 5 3/4
F: 3 1/2
G: 4 3/8
H: 5 3/8
I: 7 1/4
J: 5 5/8

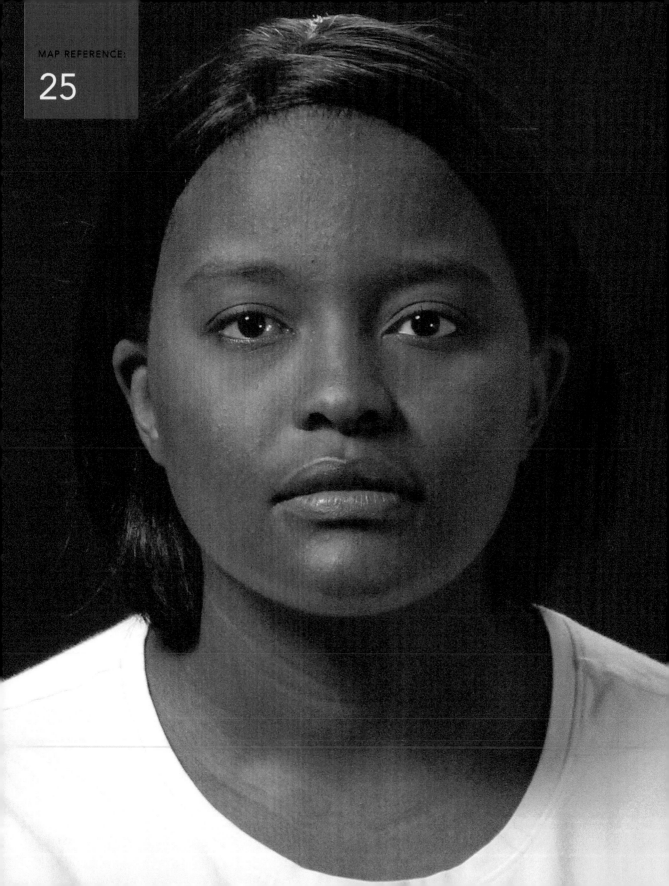

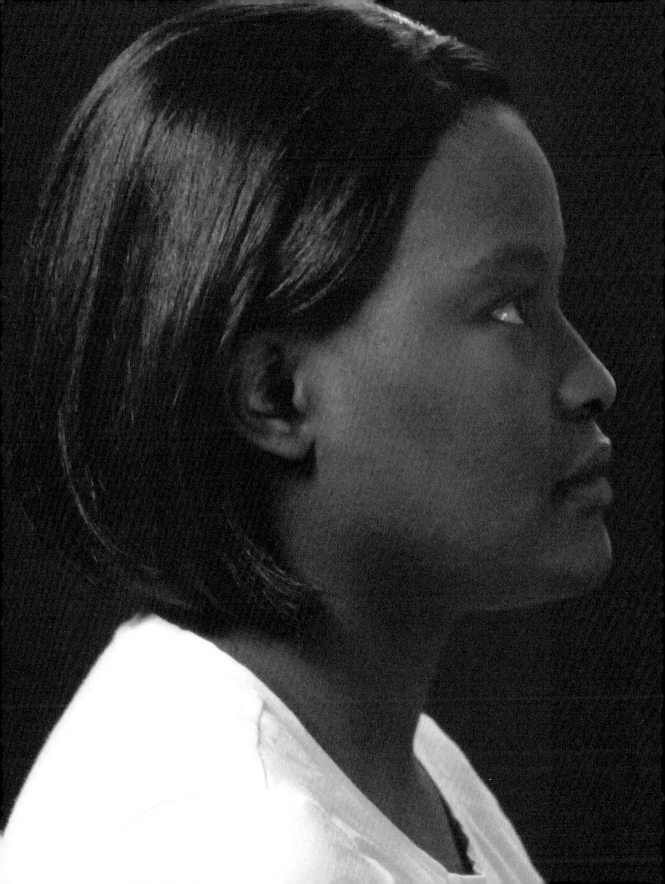

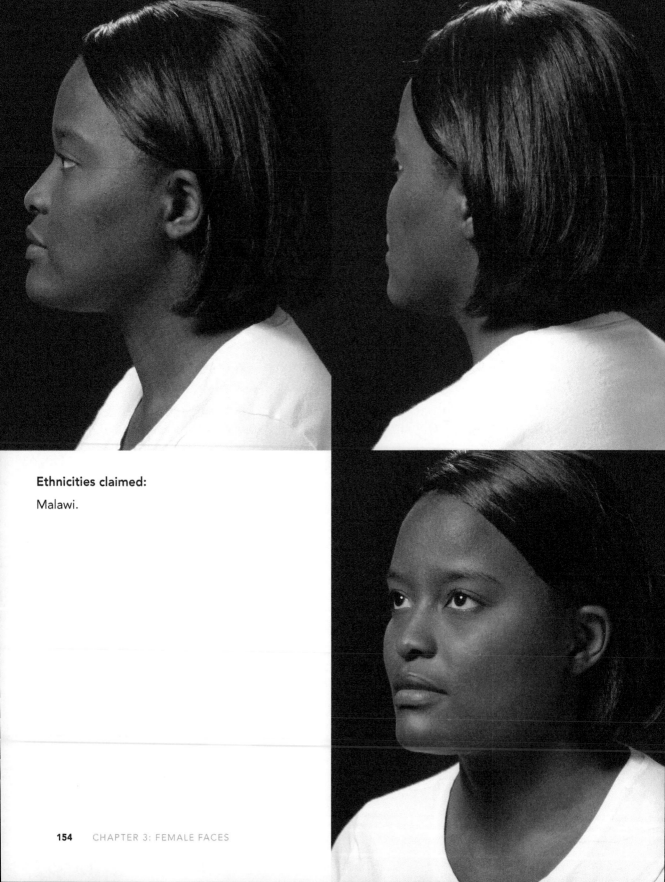

Ethnicities claimed:

Malawi.

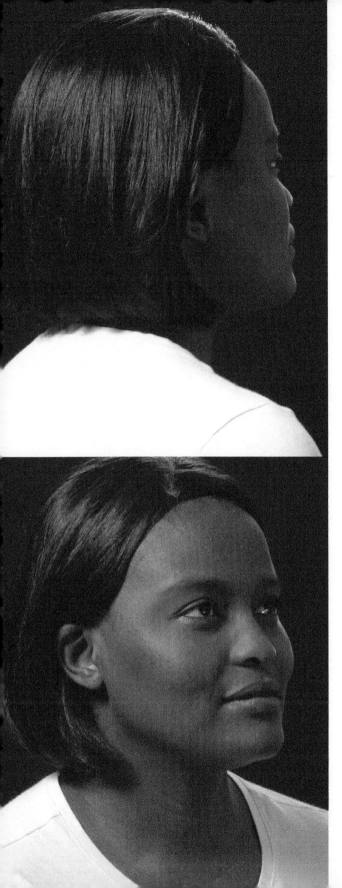

Head measurements (in):

A: 5 1/2
B: 5 1/2
C: 5
D: 5 1/2
E: 6 1/4
F: 3 3/8
G: 4 1/8
H: 5 1/8
I: 7 1/4
J: 5 3/4

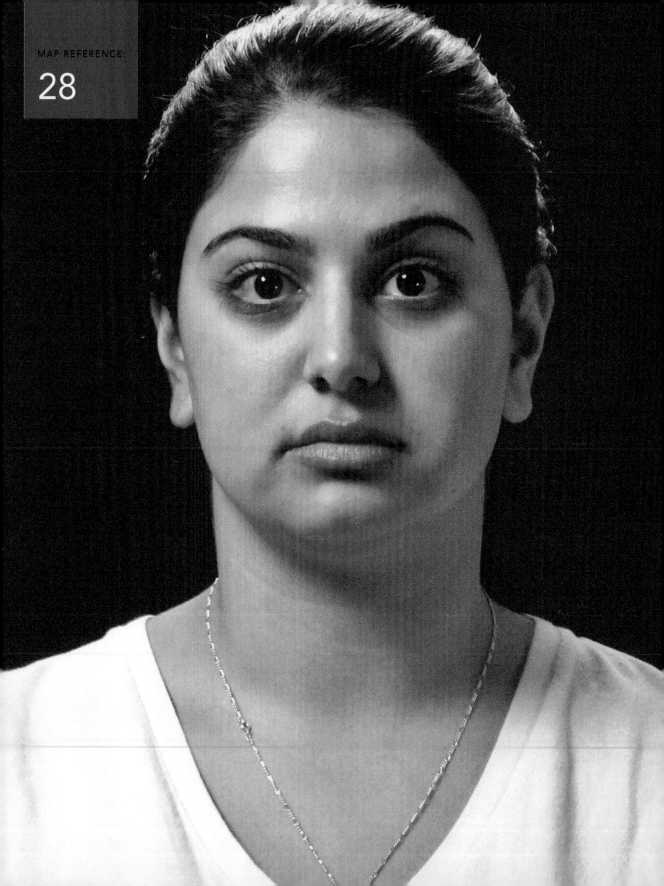

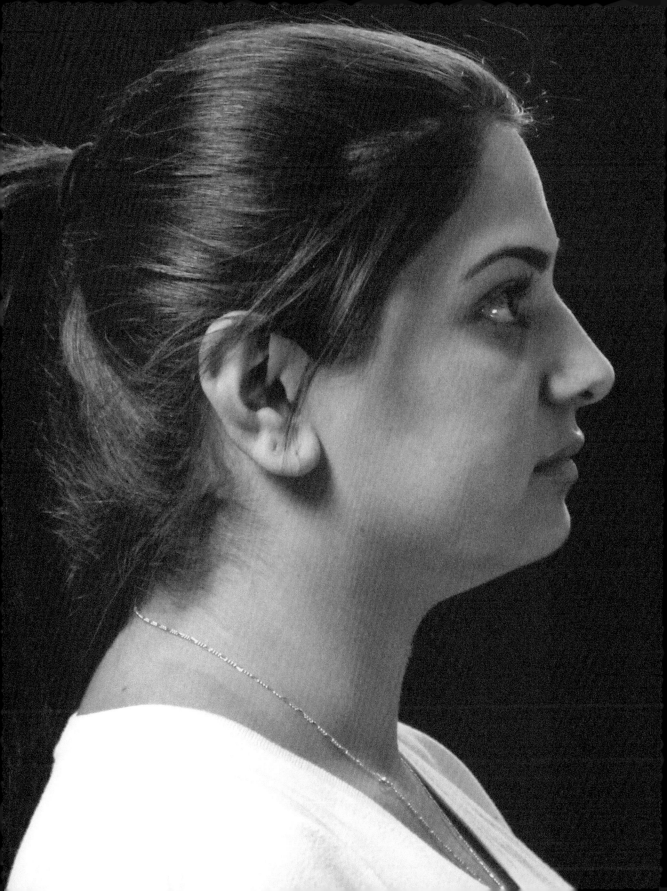

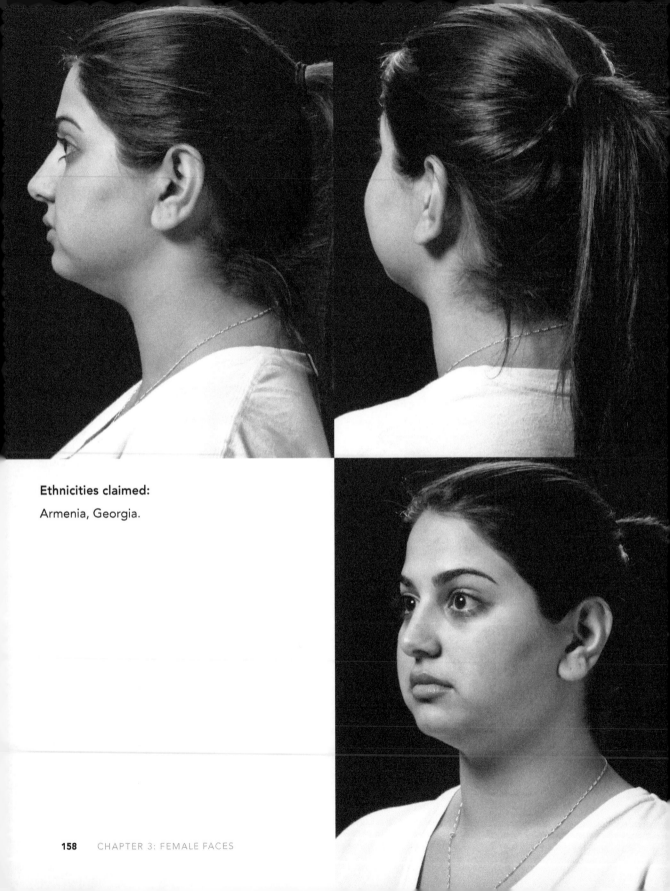

Ethnicities claimed:

Armenia, Georgia.

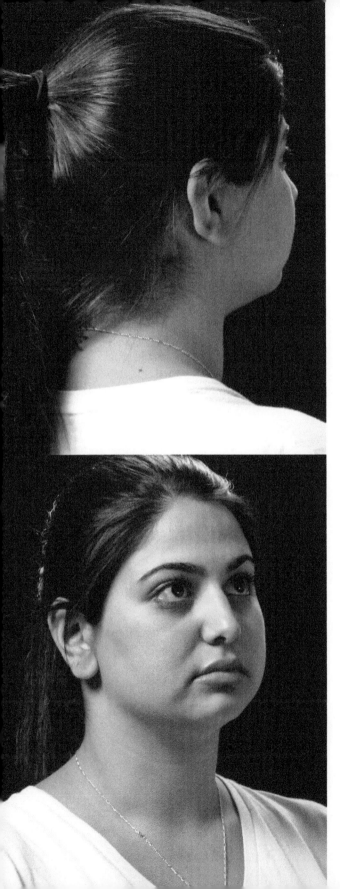

Head measurements (in):

A: 5
B: 5 1/2
C: 5
D: 5 1/4
E: 6 3/8
F: 3 1/8
G: 3 7/8
H: 4 7/8
I: 7 1/4
J: 5 1/2

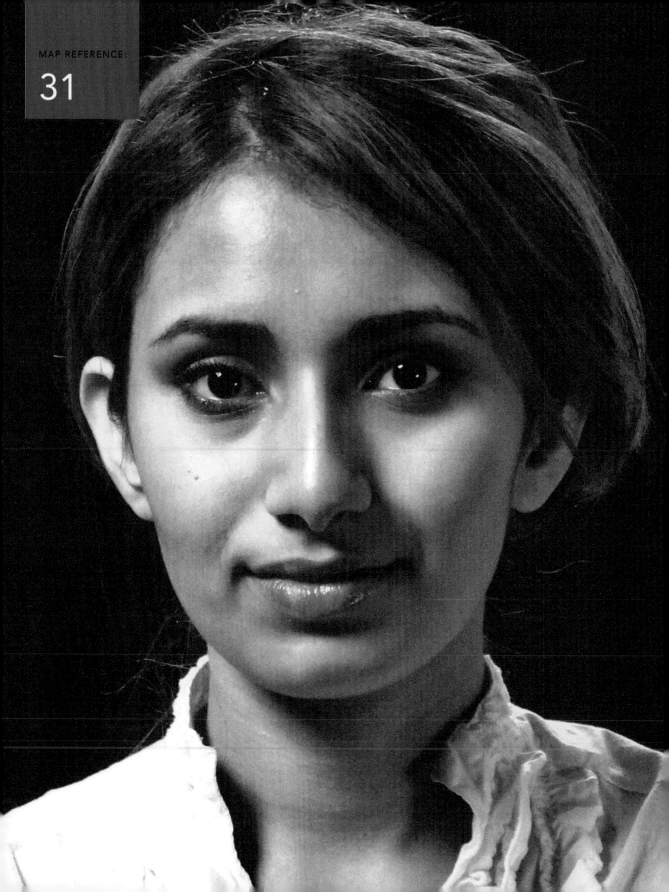

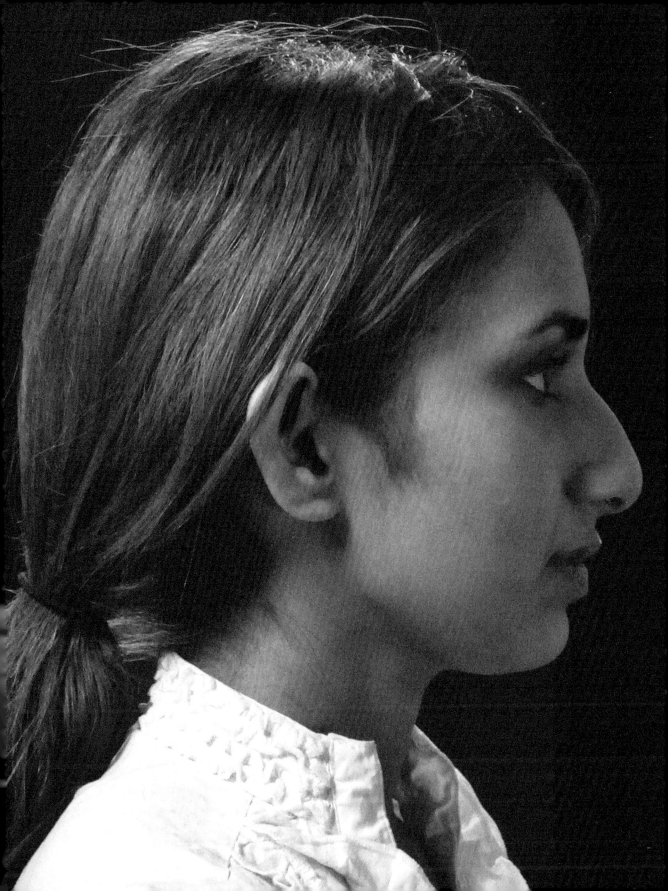

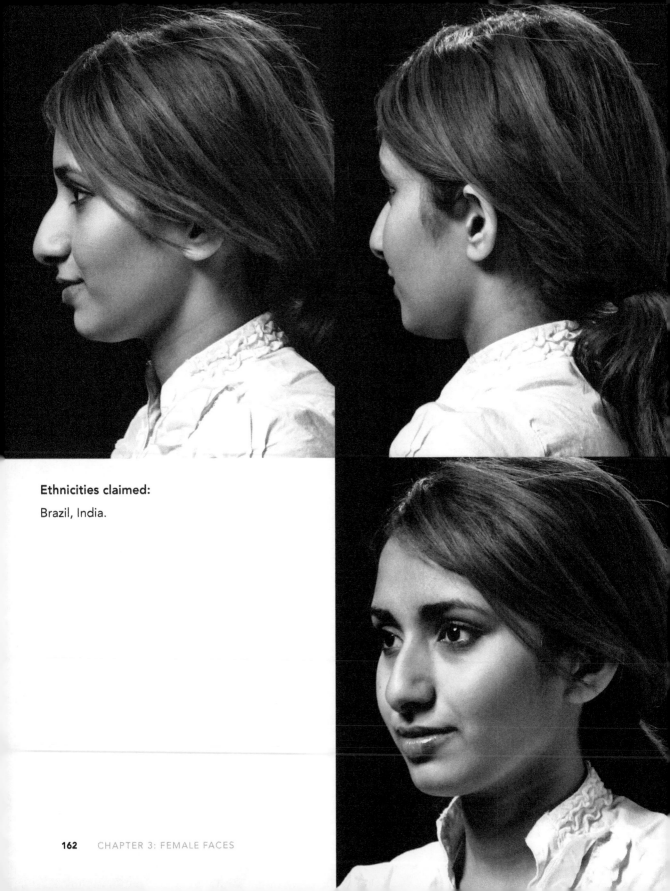

Ethnicities claimed:

Brazil, India.

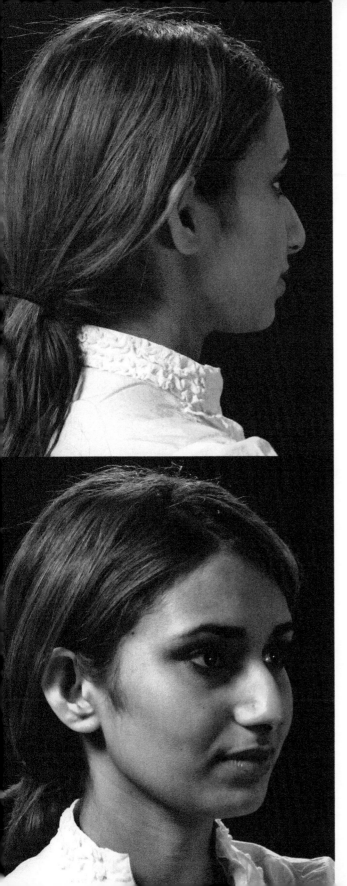

Head measurements (in):

A: 4 1/2
B: 4 3/4
C: 5
D: 5
E: 6
F: 3
G: 4 1/8
H: 5
I: 7 3/8
J: 5 1/2

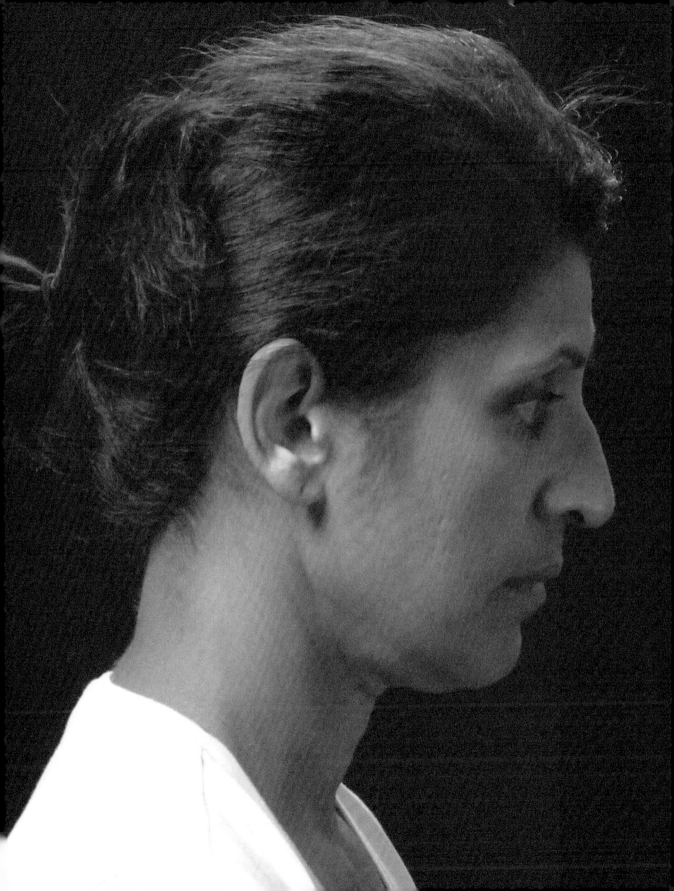

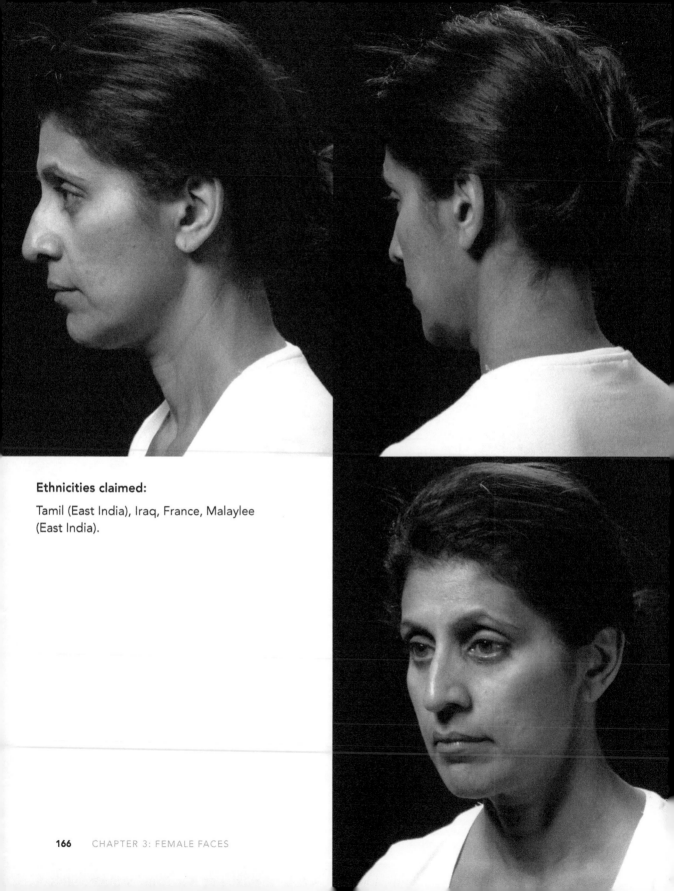

Ethnicities claimed:

Tamil (East India), Iraq, France, Malaylee (East India).

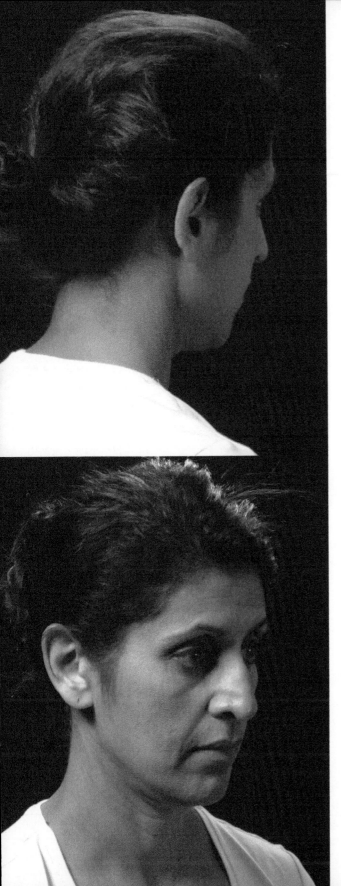

Head measurements (in):

A: 5 3/8
B: 5 1/2
C: 5 1/8
D: 5 1/4
E: 6 3/8
F: 3 5/8
G: 4 1/2
H: 5 5/8
I: 7 3/8
J: 5 5/8

Mother of 32

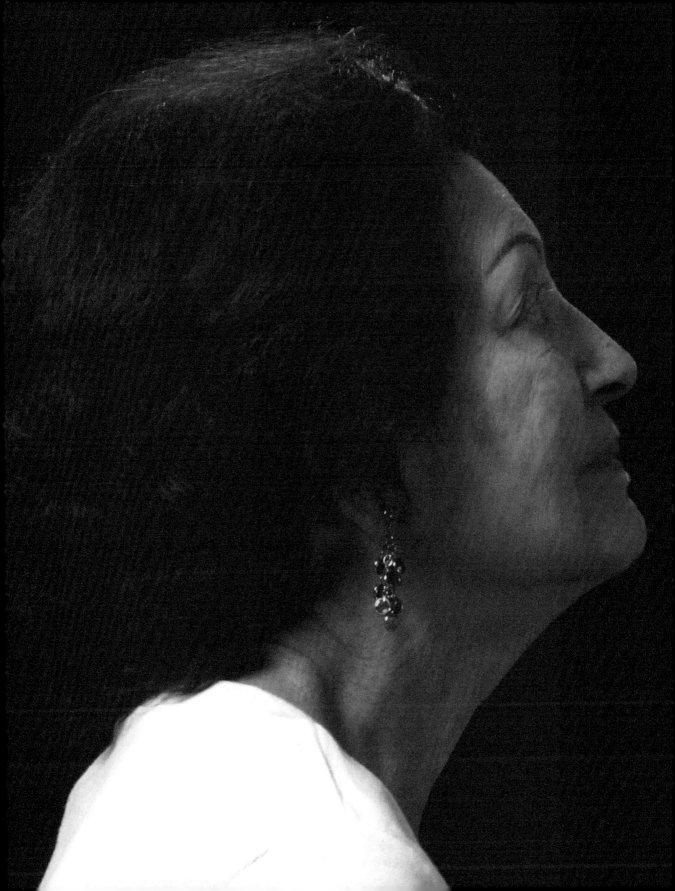

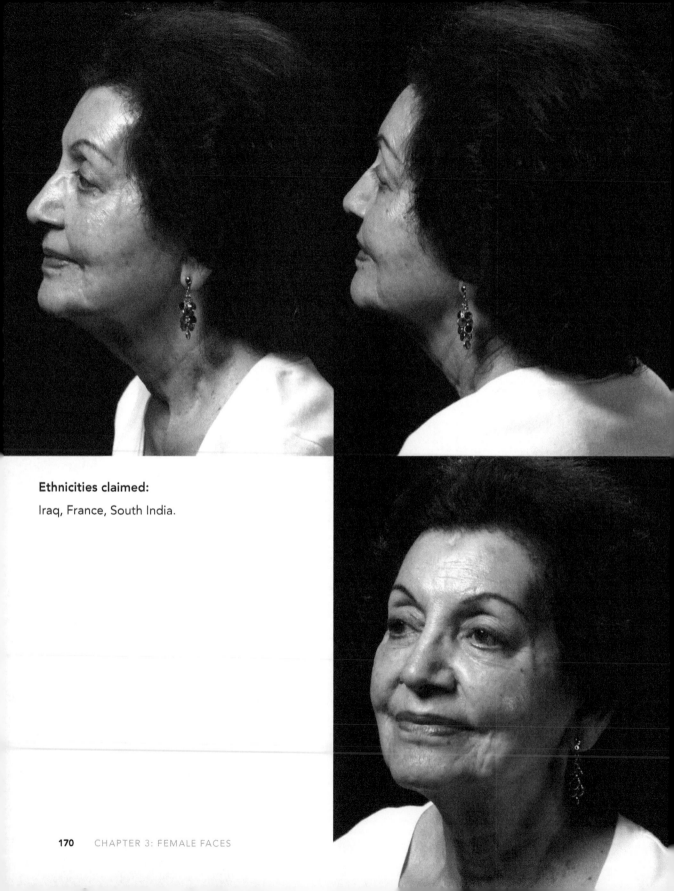

Ethnicities claimed:

Iraq, France, South India.

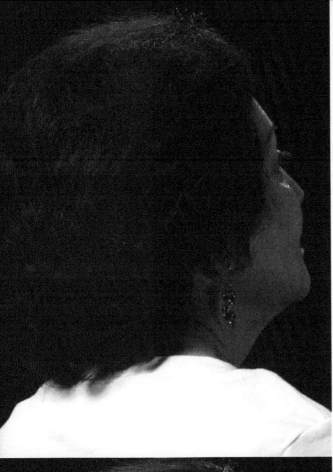

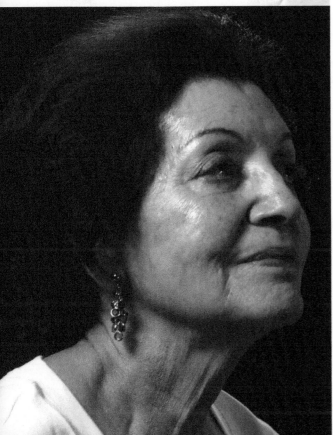

Head measurements (in):

A: 4 7/8

B: 5 1/8

C: 5

D: 5 1/8

E: 6 3/8

F: 3

G: 4

H: 5

I: 7 1/8

J: 5 7/8

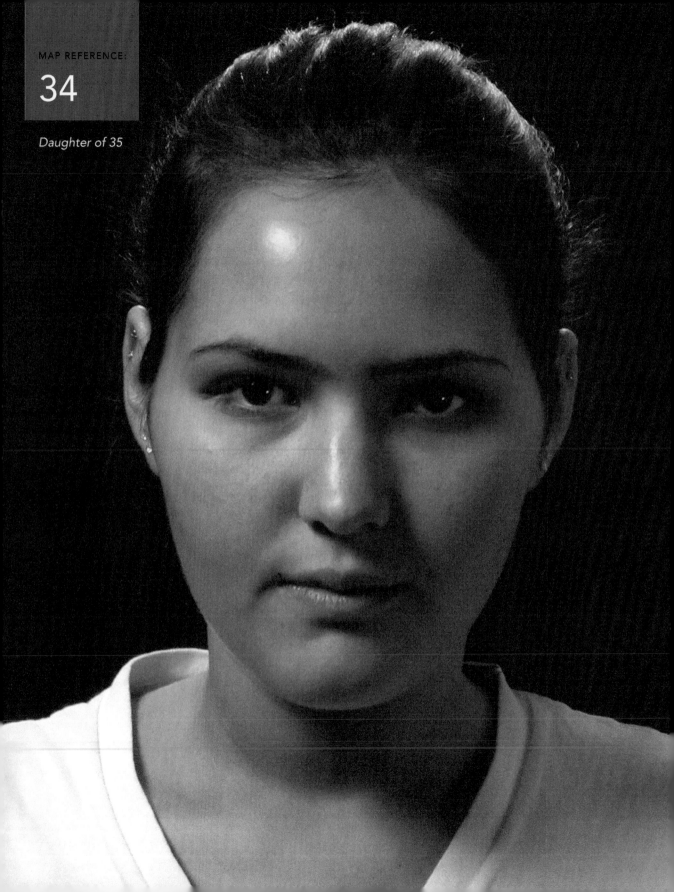

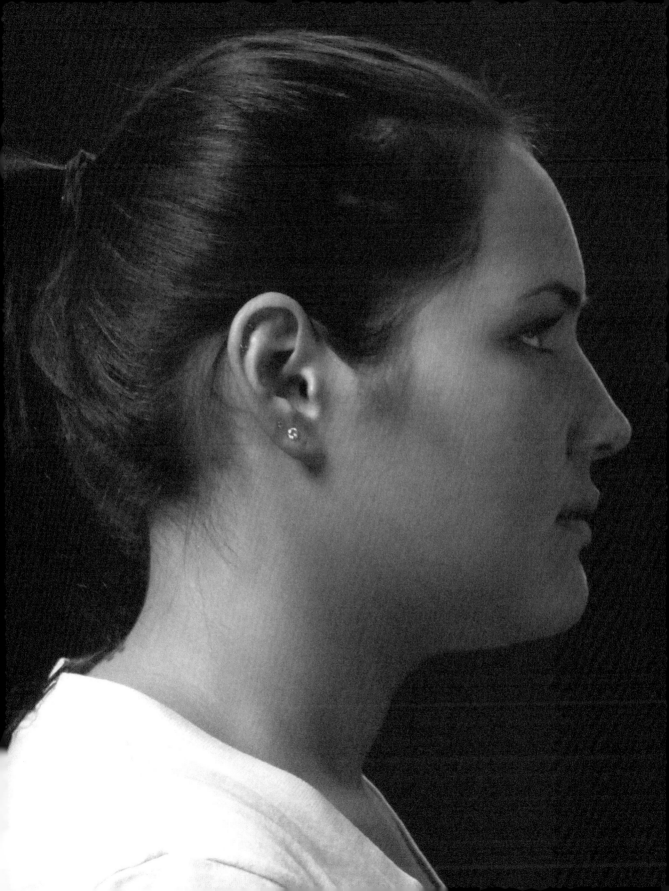

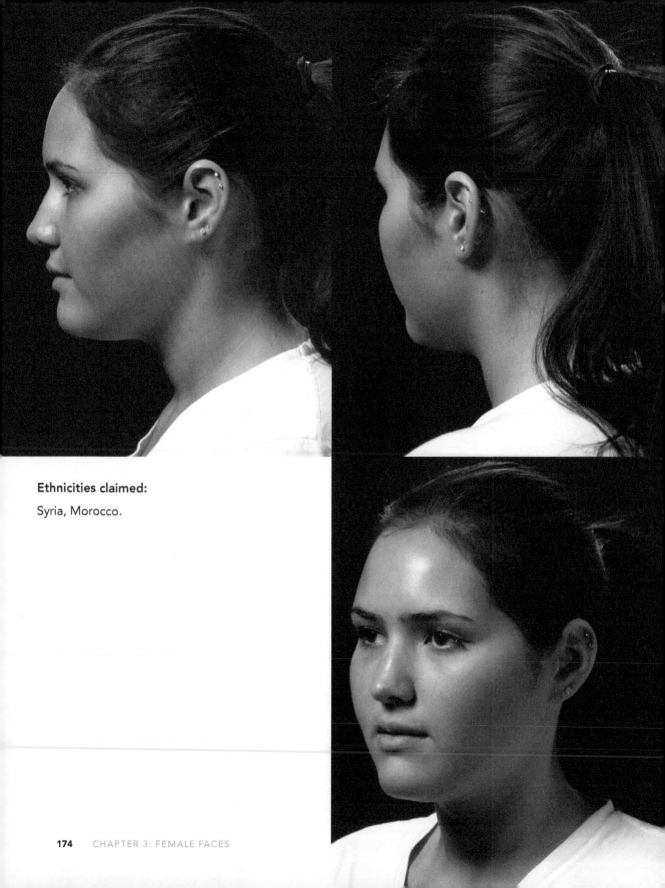

Ethnicities claimed:

Syria, Morocco.

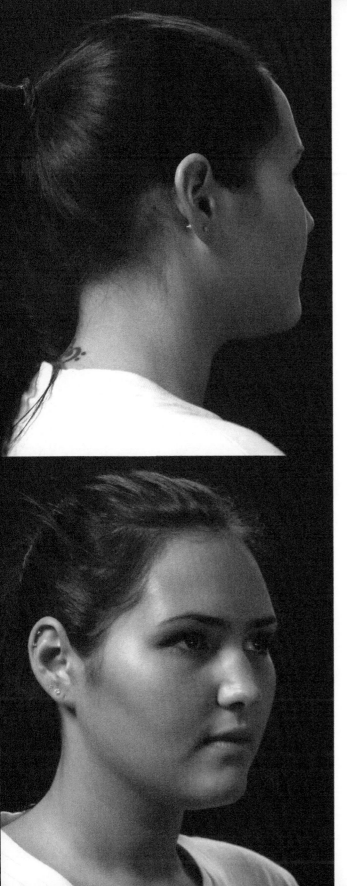

Head measurements (in):

A: 5 7/8

B: 5 5/8

C: 5 1/8

D: 5 3/4

E: 6 3/4

F: 3 1/2

G: 4 1/2

H: 5 1/8

I: 7 3/4

J: 5 3/8

Mother of 34

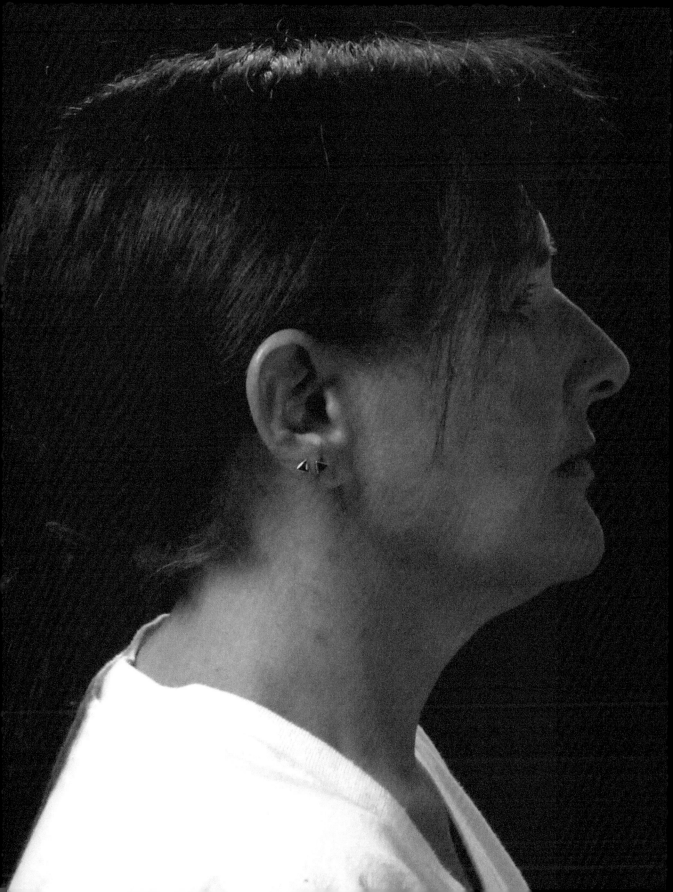

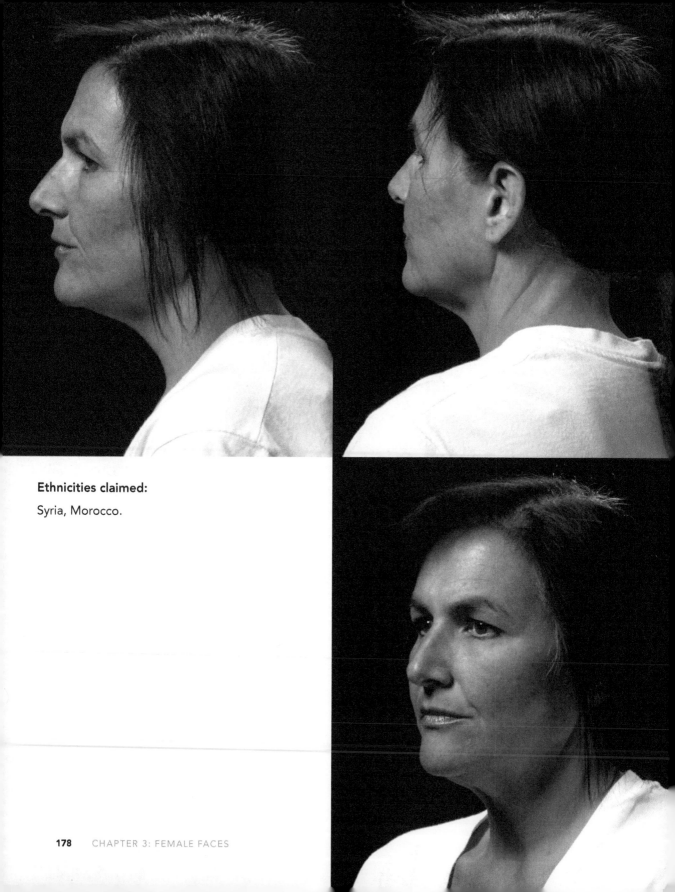

Ethnicities claimed:

Syria, Morocco.

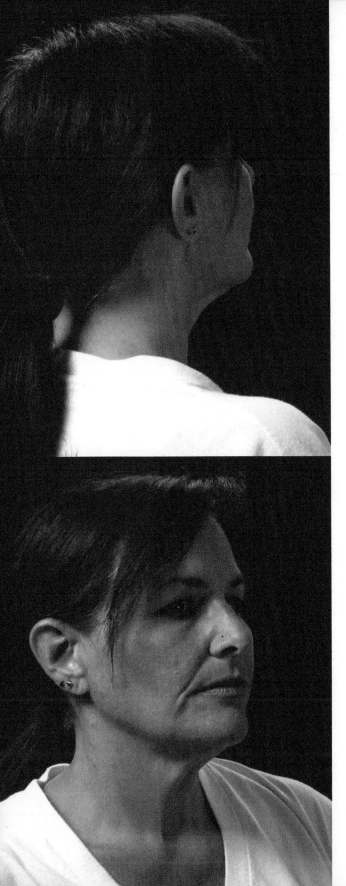

Head measurements (in):

A: 5 1/2

B: 4 3/4

C: 5 1/4

D: 5 1/2

E: 5 3/4

F: 3

G: 4 1/8

H: 5

I: 7

J: 6

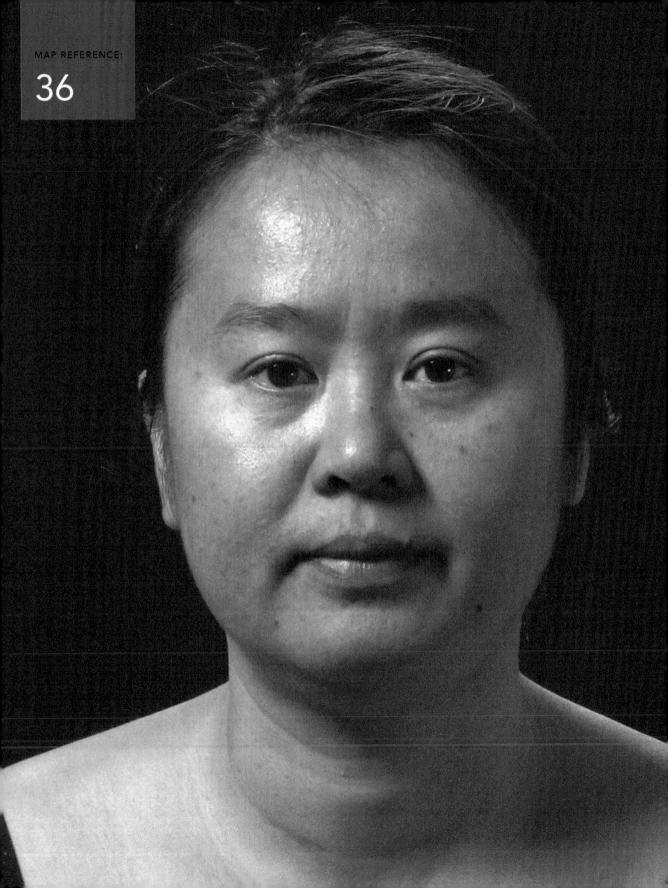

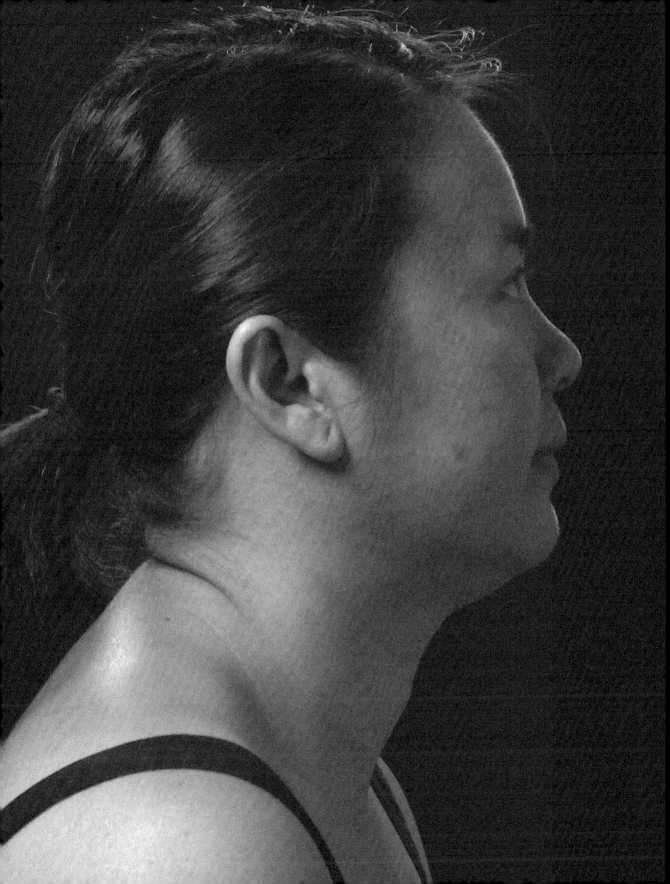

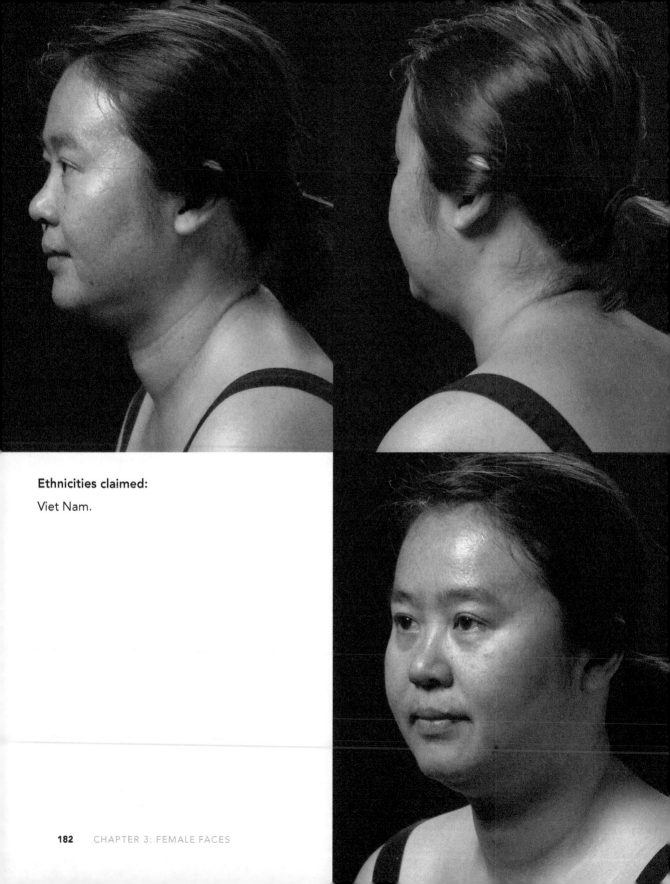

Ethnicities claimed:

Viet Nam.

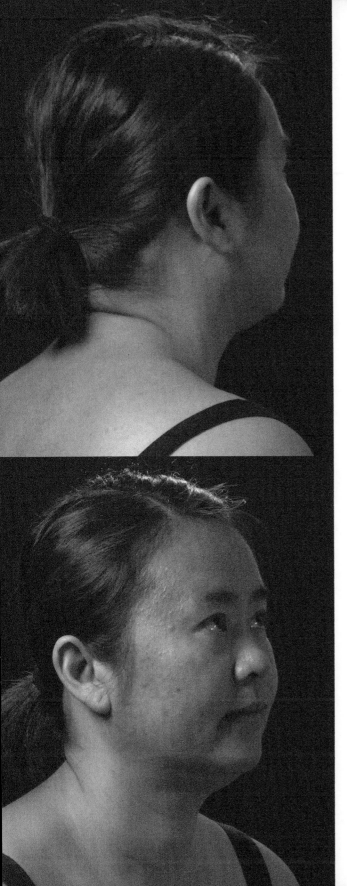

Head measurements (in):

A: 5 1/8

B: 5 1/8

C: 4 3/4

D: 5 1/8

E: 6 1/4

F: 3 3/8

G: 5

H: 5 1/4

I: 7 3/8

J: 5 3/4

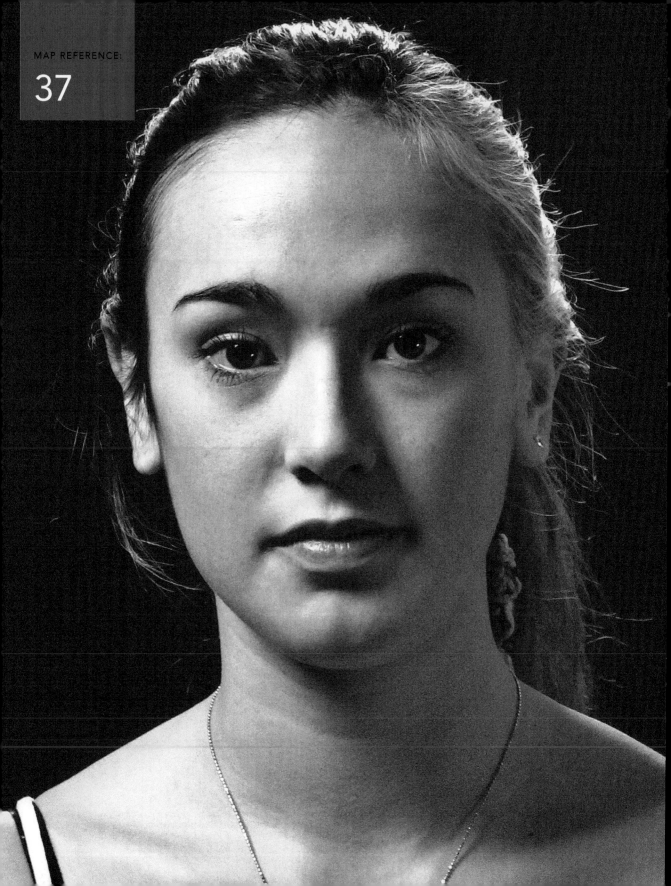

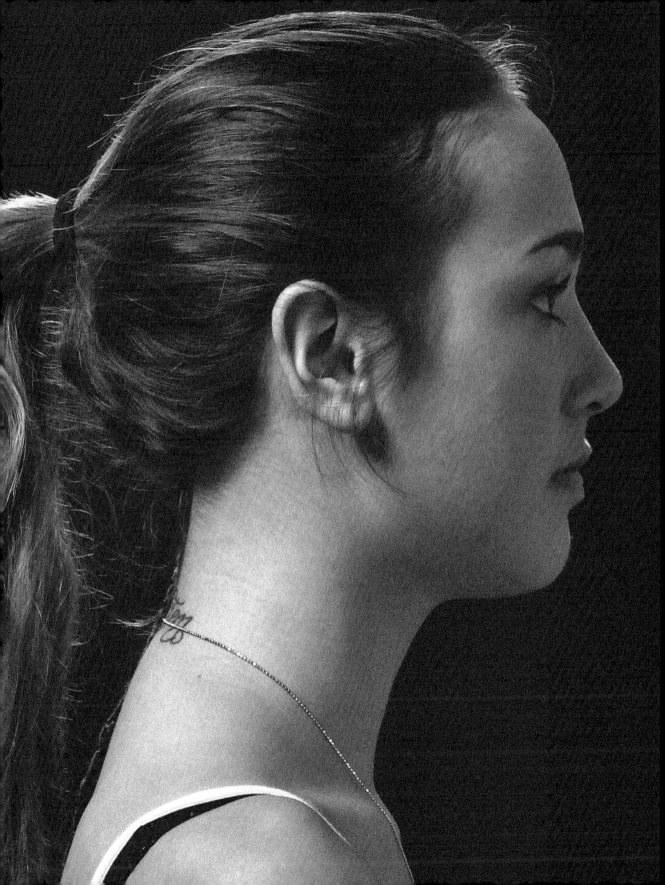

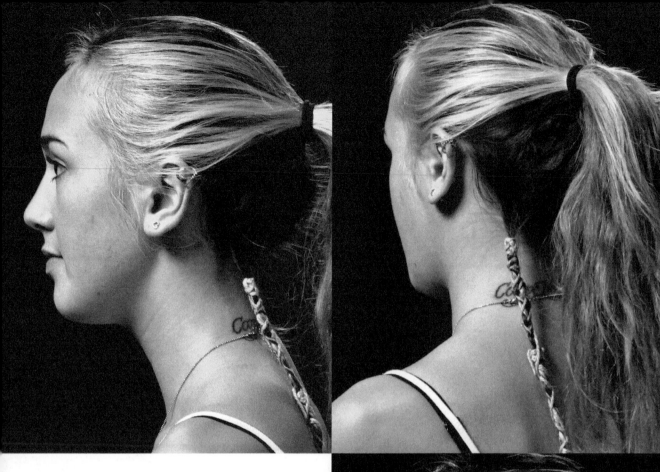

Ethnicities claimed:

England, Ireland, Scotland, Germany, China, Thailand.

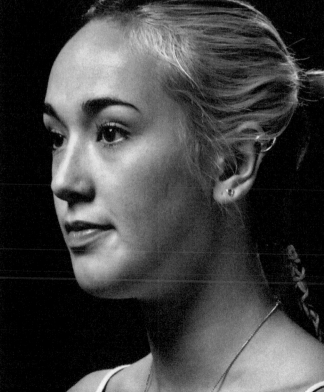

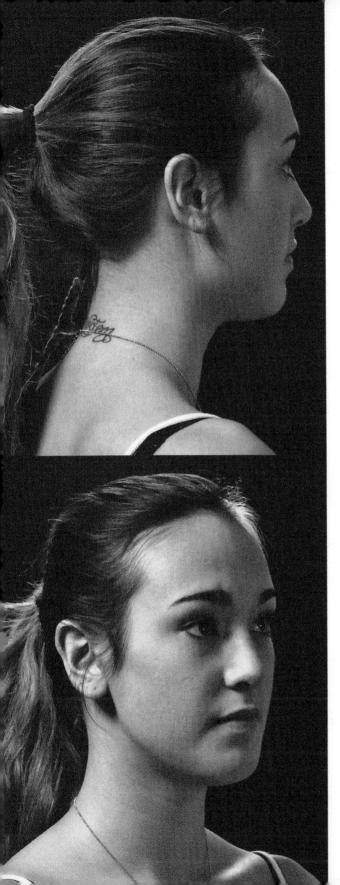

Head measurements (in):

A: 5
B: 4 7/8
C: 4 3/4
D: 5
E: 5 5/8
F: 3 5/8
G: 4 5/8
H: 5 3/8
I: 7 7/8
J: 5 5/8

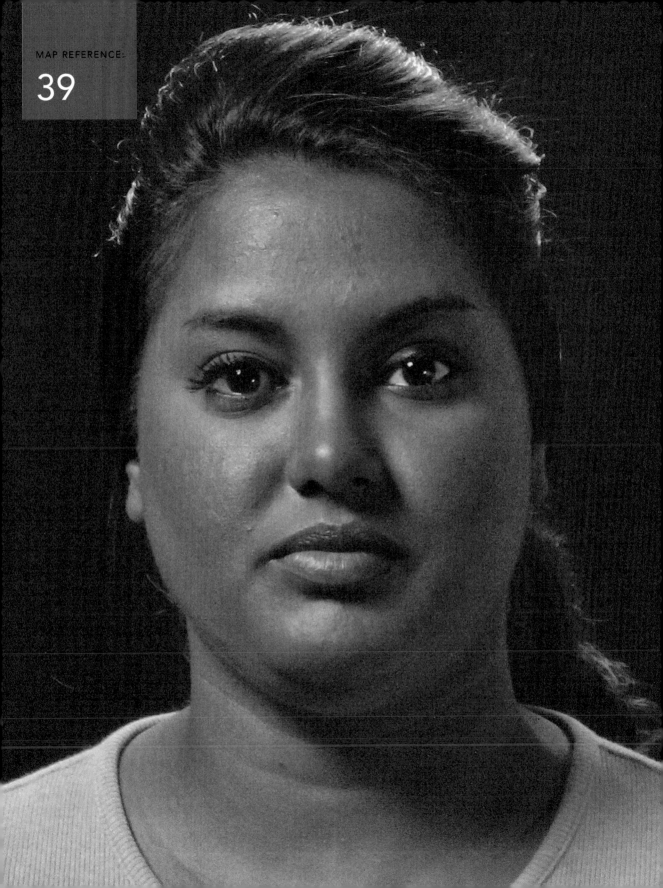

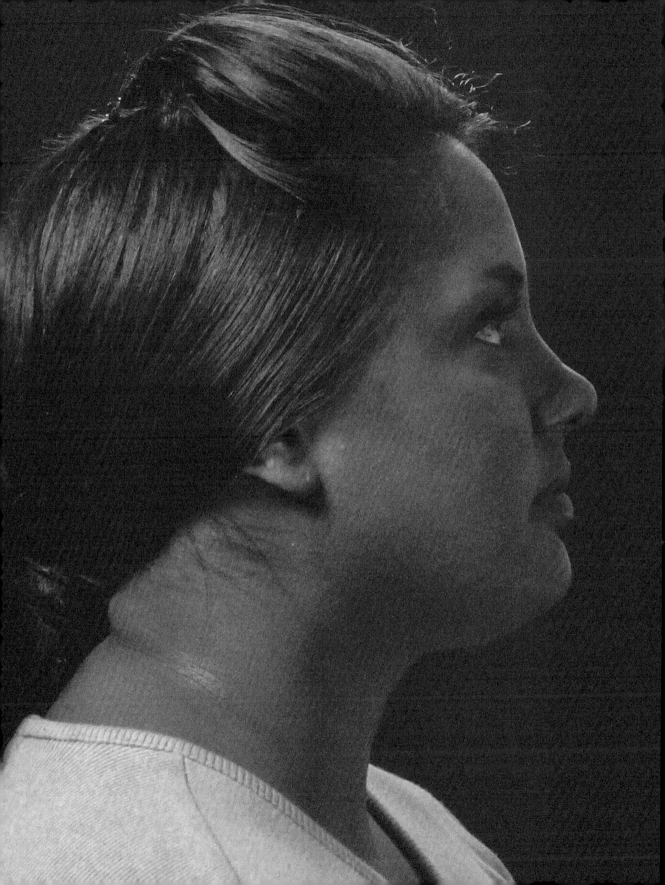

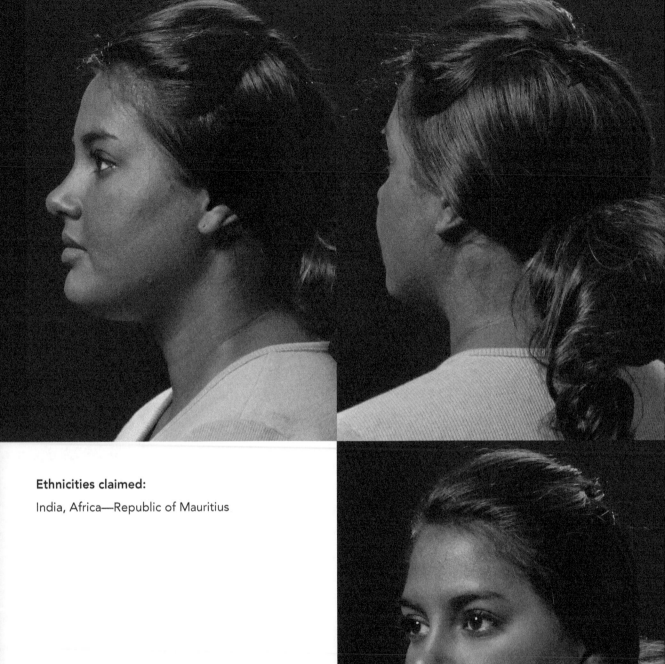

Ethnicities claimed:

India, Africa—Republic of Mauritius

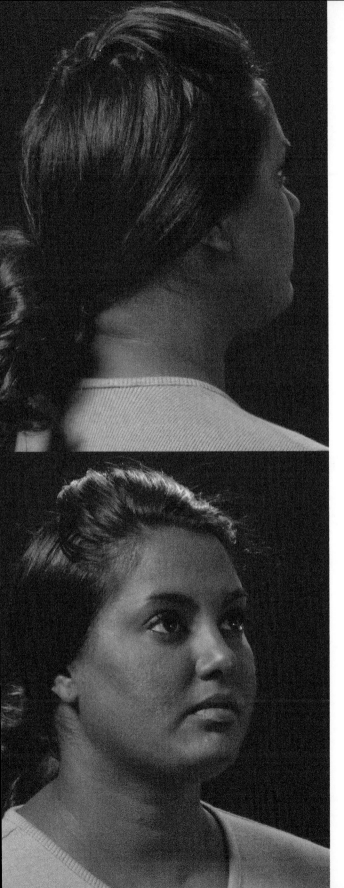

Head measurements (in):

A: 5 1/2

B: 4 7/8

C: 4 5/8

D: 4 7/8

E: 5 5/8

F: 3

G: 3 7/8

H: 4 5/8

I: 7

J: 5 5/8

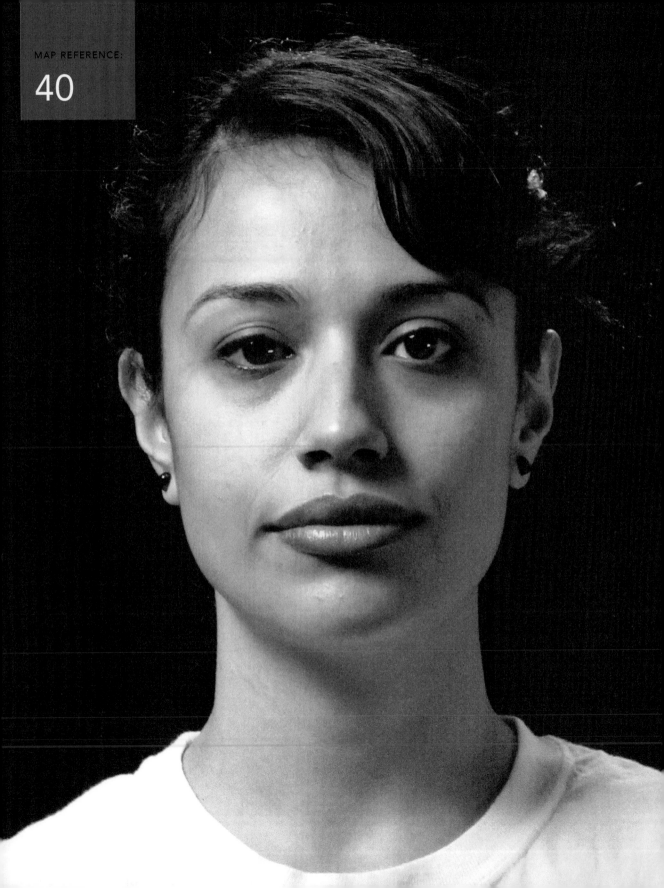

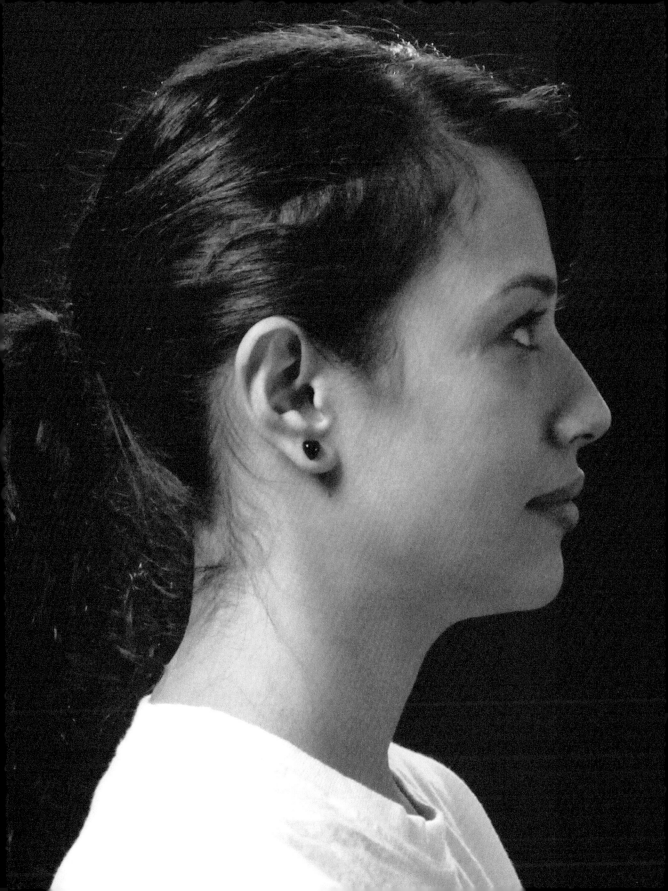

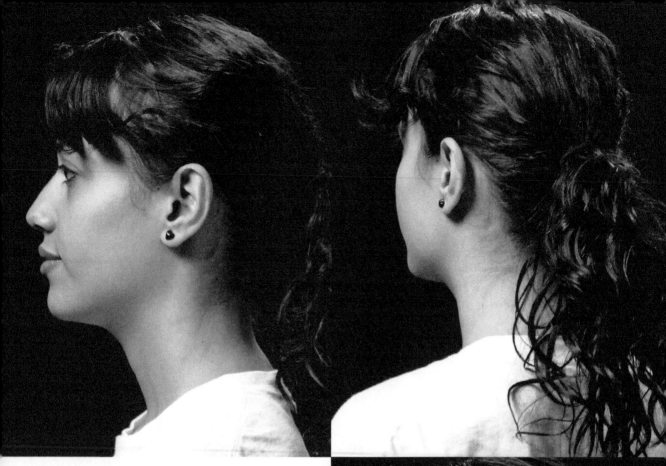

Ethnicities claimed:

Egypt, Mexico (Indian).

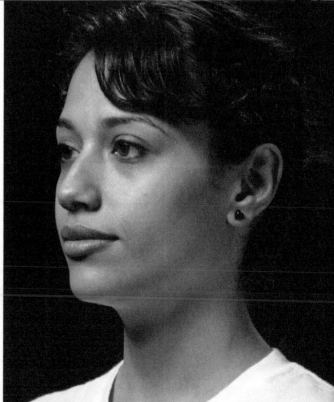

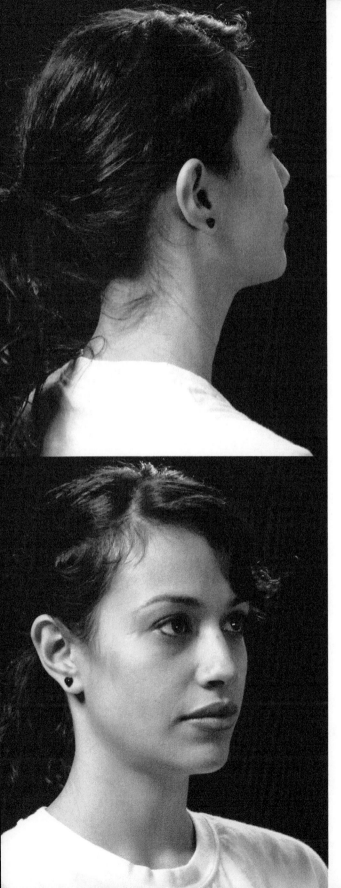

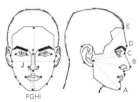

Head measurements (in):

A: 5 3/8
B: 4 7/8
C: 4 3/8
D: 5
E: 5 1/2
F: 3 1/4
G: 4 3/8
H: 4 7/8
I: 7 1/8
J: 5 5/8

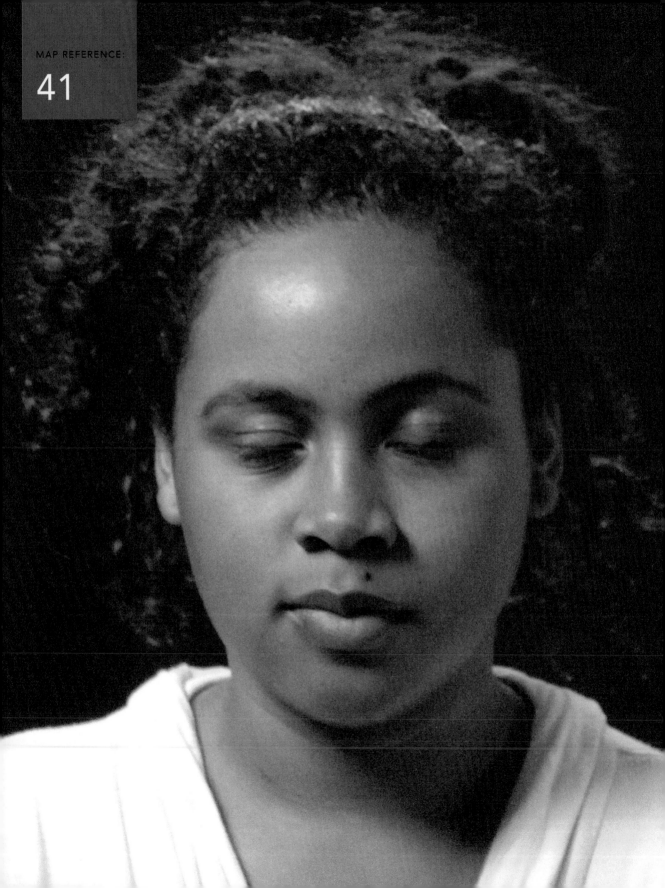

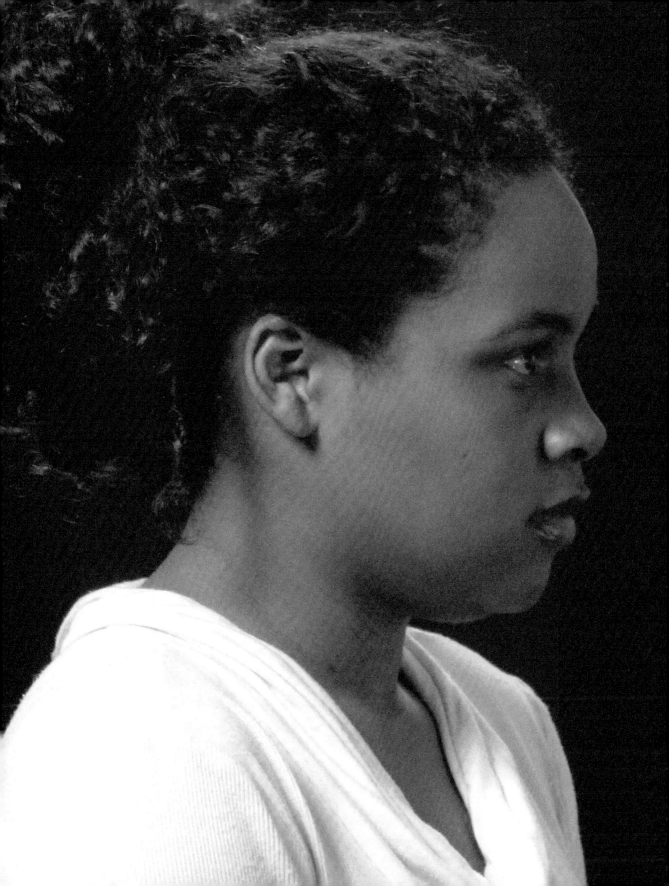

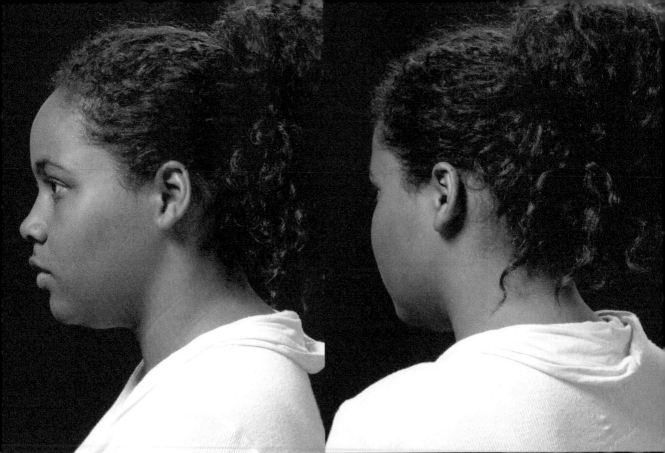

Ethnicities claimed:

Ethiopia, Mexico, Philippines, United States—
Native American.

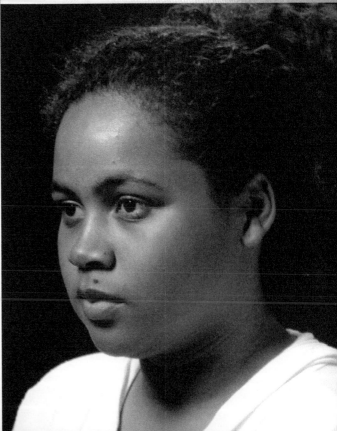

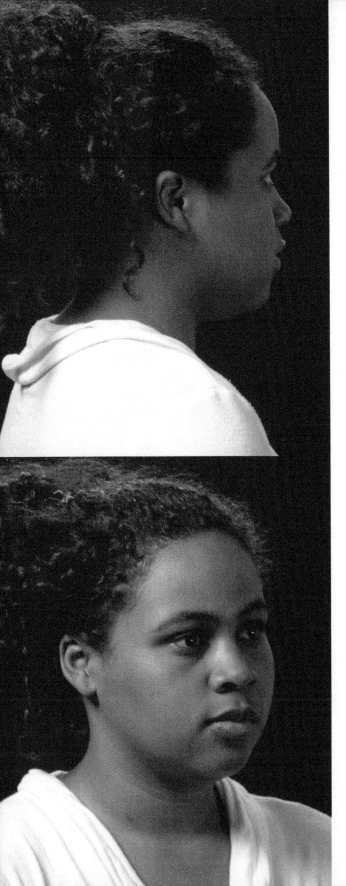

Head measurements (in):

A: 5 1/2
B: 5 1/2
C: 5
D: 5 3/8
E: 6 1/4
F: 3 3/8
G: 4 3/8
H: 5
I: 8
J: 5 7/8

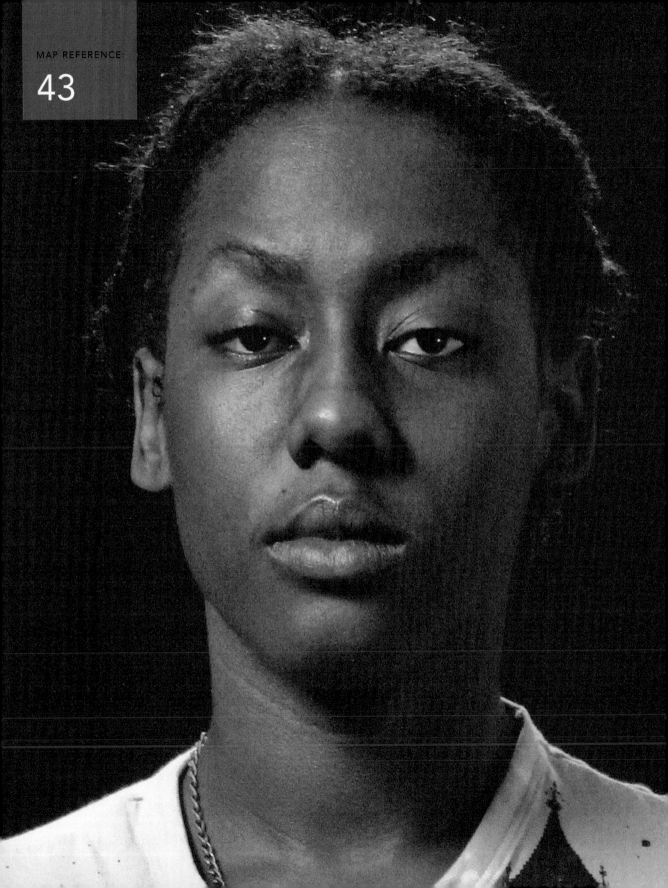

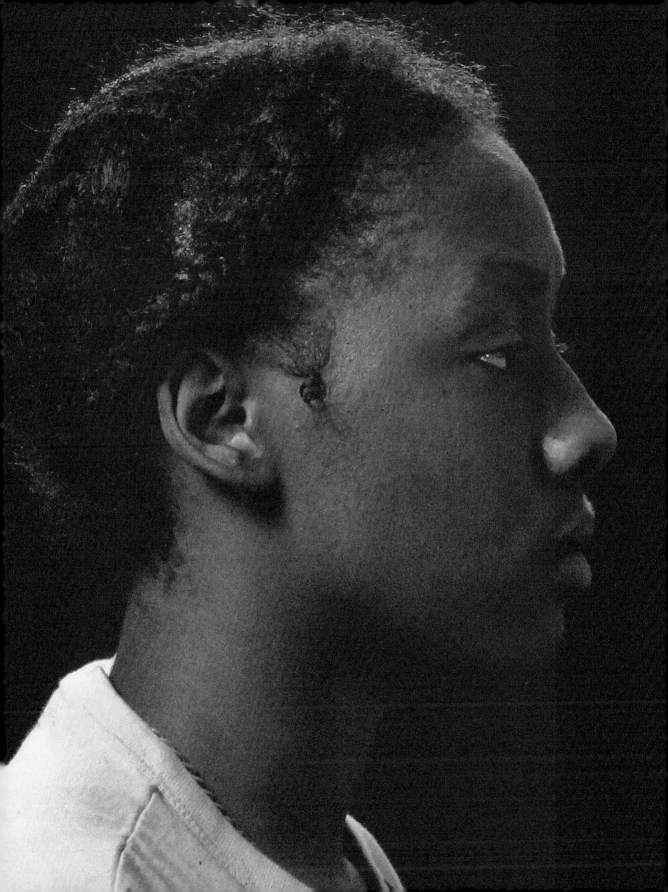

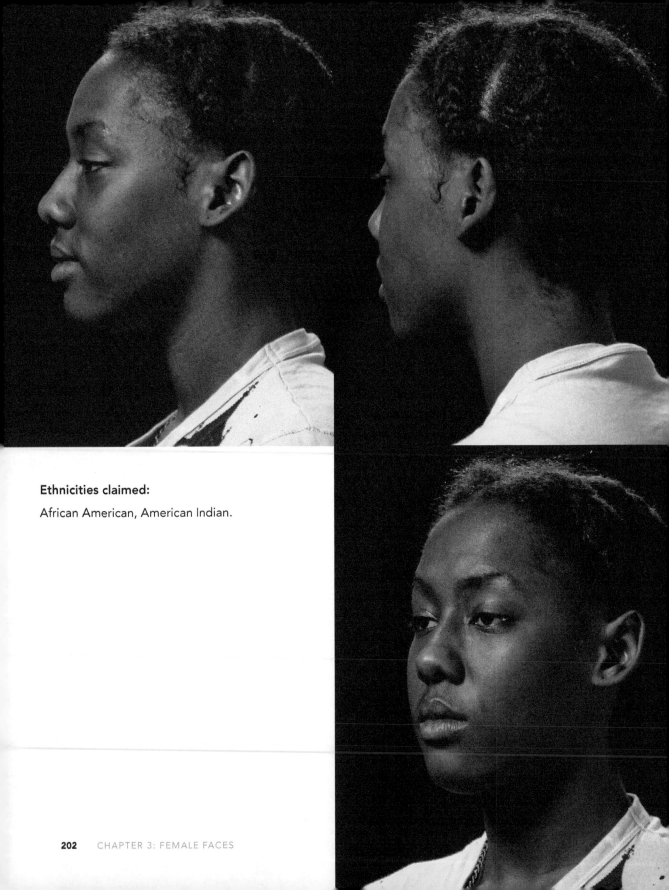

Ethnicities claimed:

African American, American Indian.

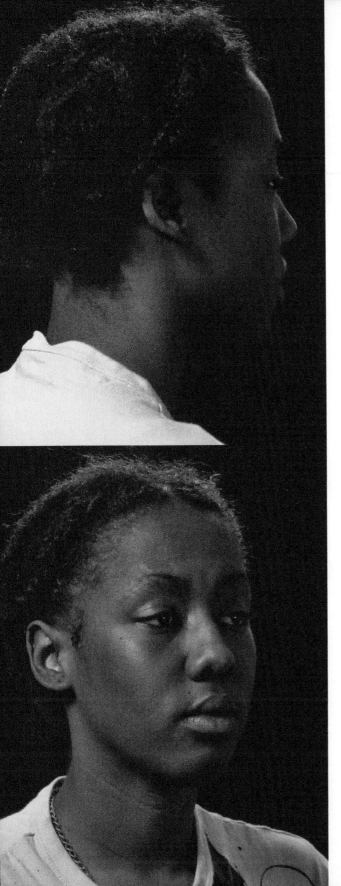

Head measurements (in):

A: 5 1/4
B: 5 1/8
C: 5
D: 5 1/4
E: 5 7/8
F: 3 1/8
G: 4 1/4
H: 5 1/4
I: 7 7/8
J: 5 7/8

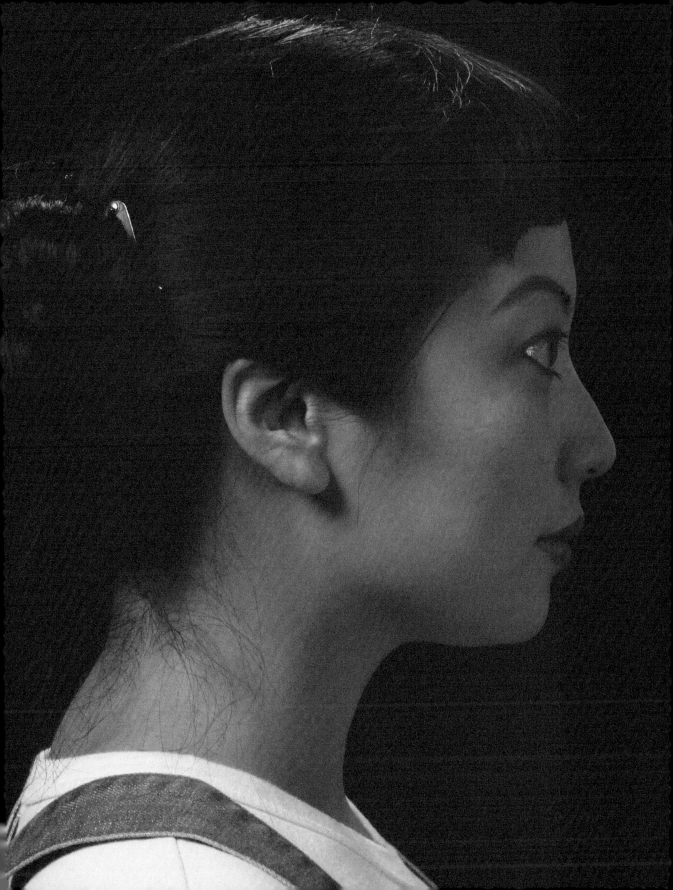

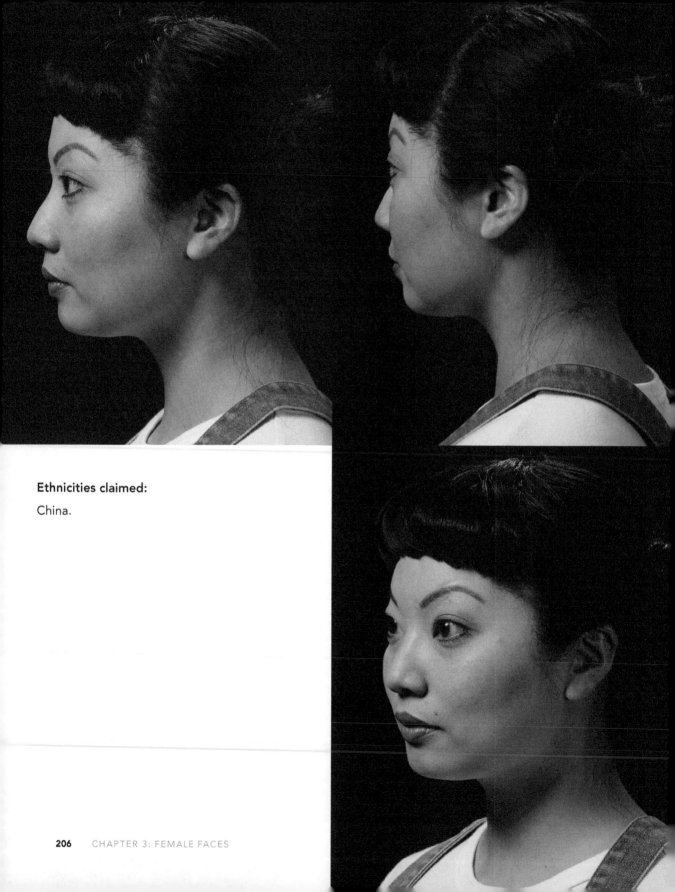

Ethnicities claimed:

China.

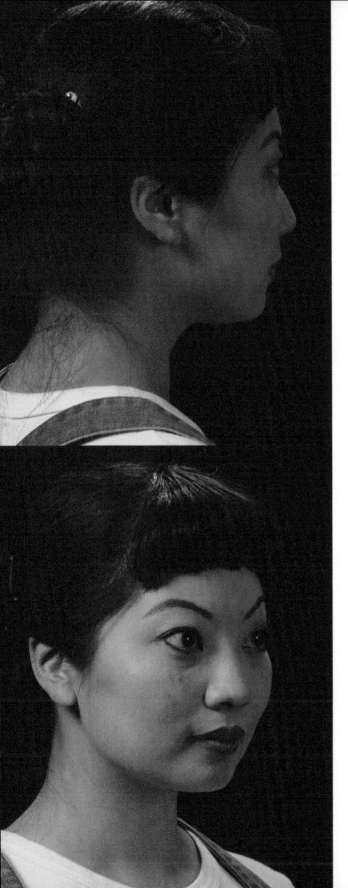

Head measurements (in):

A: 5 1/4
B: 5 1/2
C: 5 1/8
D: 5 3/8
E: 5 7/8
F: 3 1/4
G: 4 1/8
H: 4 7/8
I: 6 3/4
J: 6 1/8

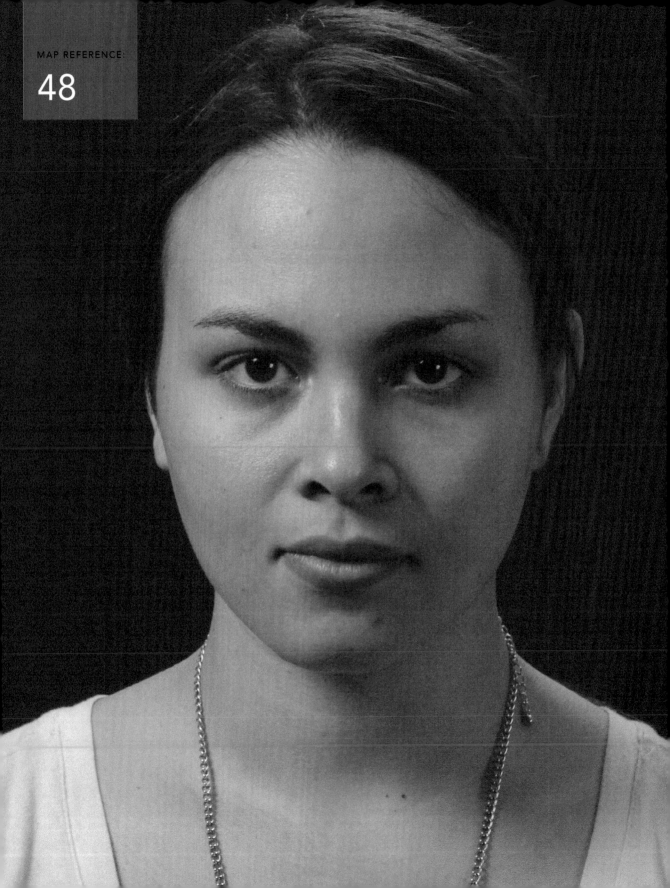

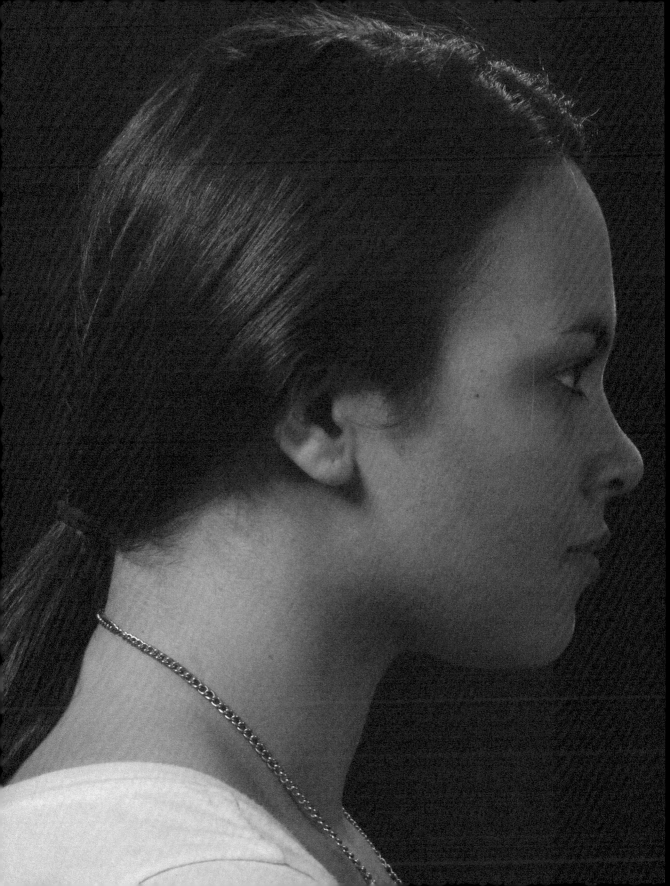

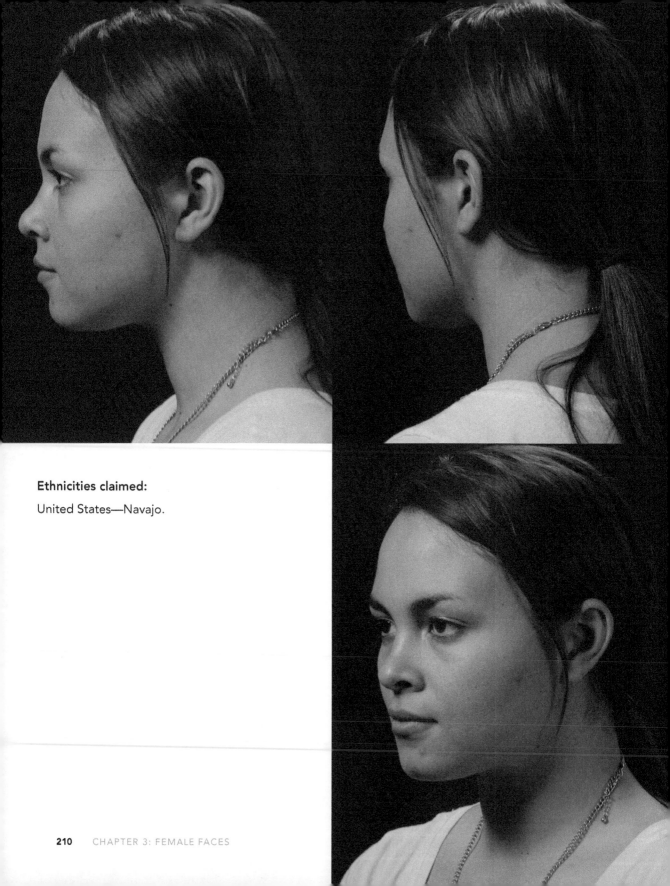

Ethnicities claimed:

United States—Navajo.

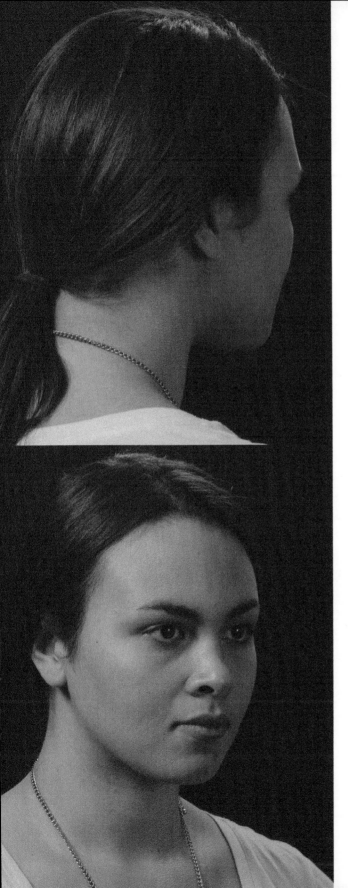

Head measurements (in):

A: 5 5/8
B: 5 1/2
C: 5 1/4
D: 5 3/4
E: 6 1/4
F: 3 1/2
G: 4 1/4
H: 4 7/8
I: 7 5/8
J: 5 7/8

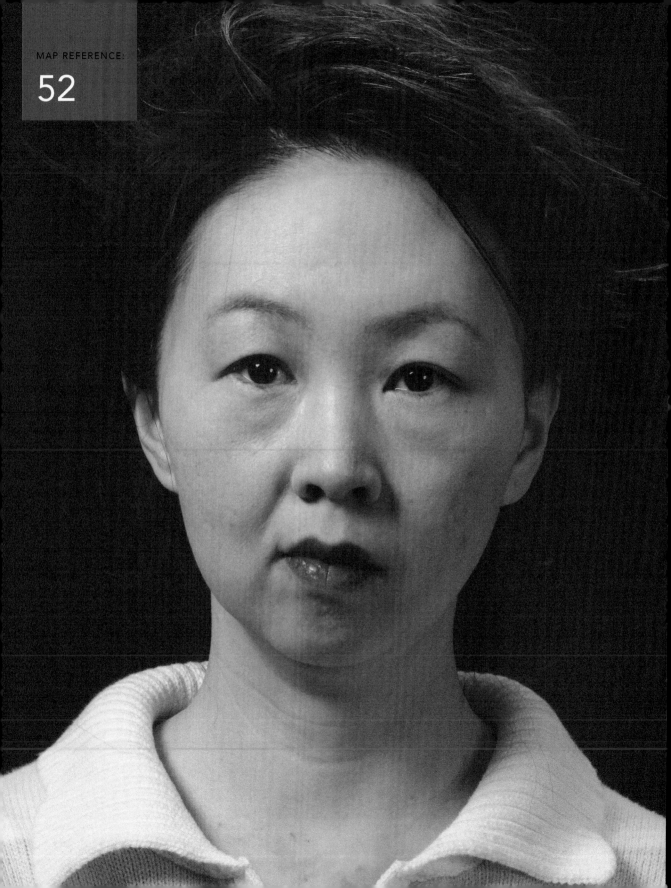

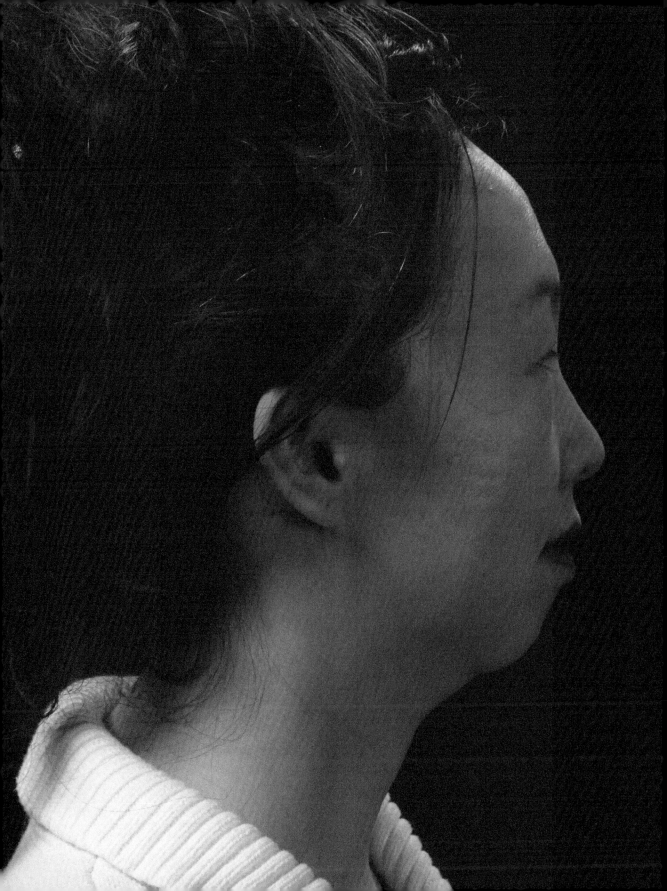

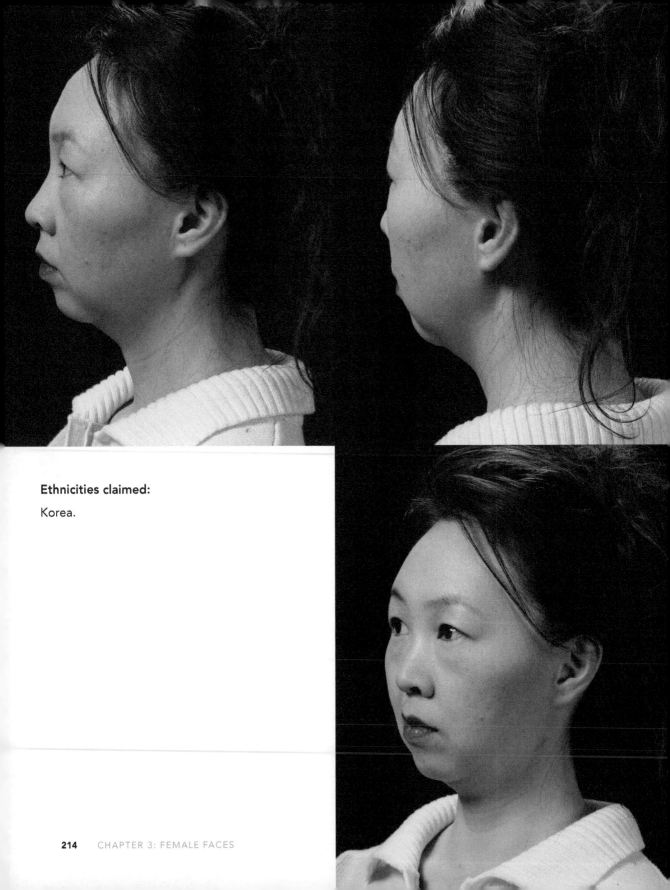

Ethnicities claimed:

Korea.

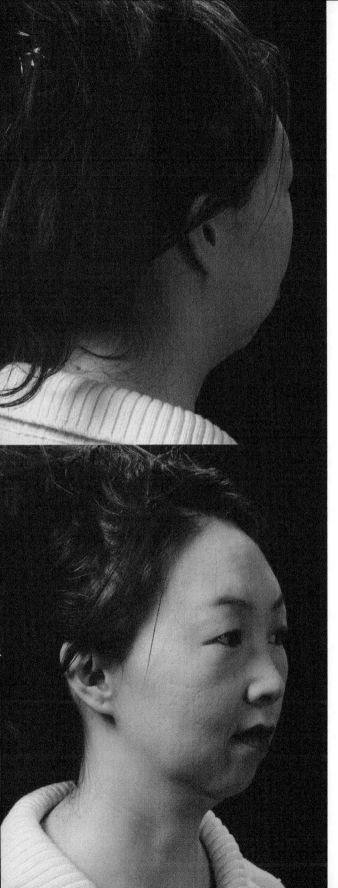

Head measurements (in):

A: 4 1/2
B: 4 1/4
C: 4 1/4
D: 4 5/8
E: 5 1/4
F: 3 1/4
G: 4 1/8
H: 4 5/8
I: 7
J: 5 3/8

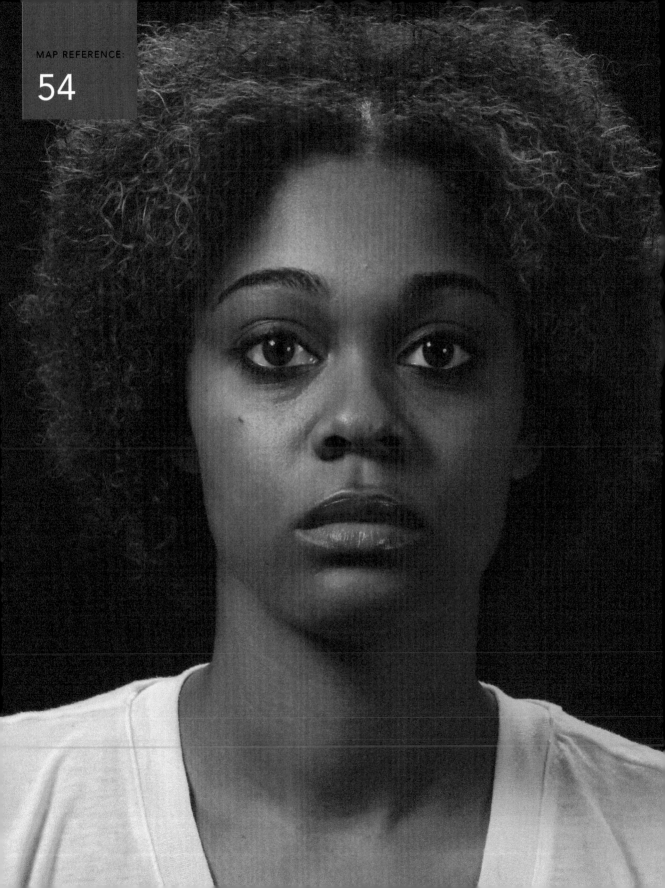

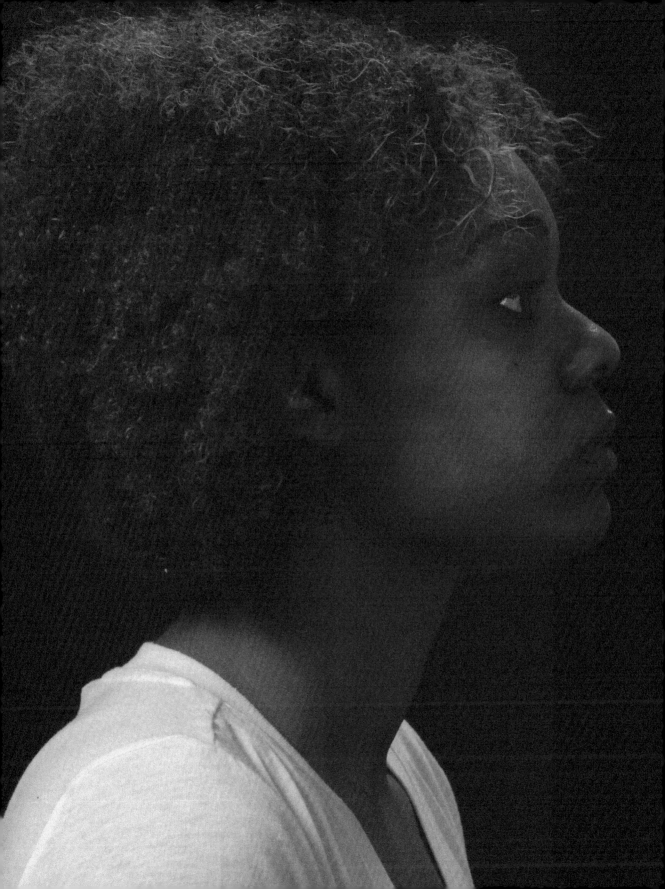

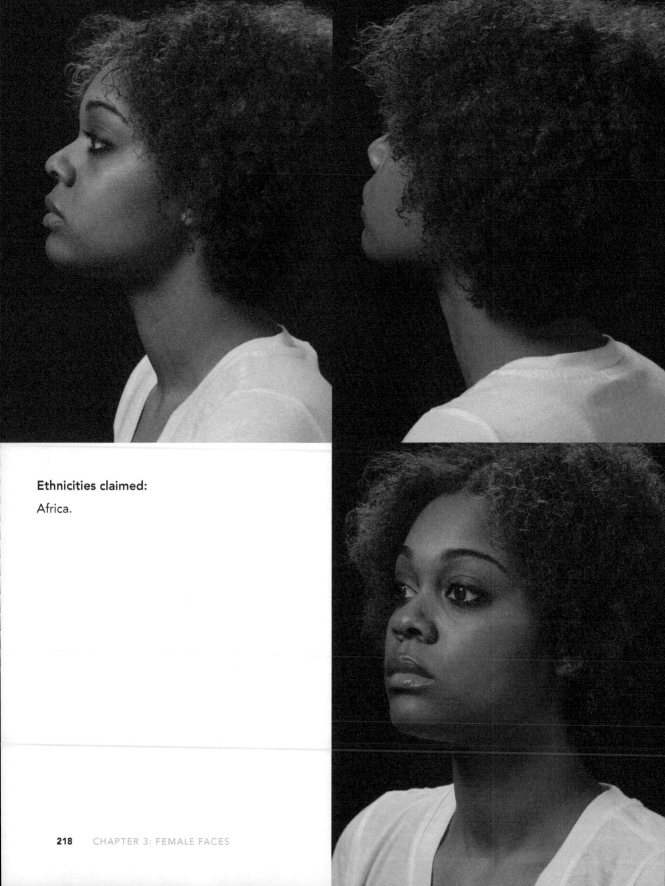

Ethnicities claimed:

Africa.

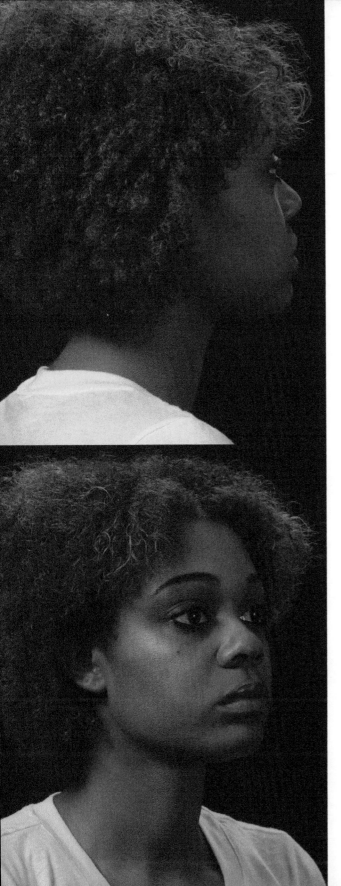

Head measurements (in):

A: 4 1/2
B: 4 5/8
C: 4 1/8
D: 4 3/4
E: 6
F: 3 5/8
G: 4 1/4
H: 4 7/8
I: 6 1/4
J: 4 7/8

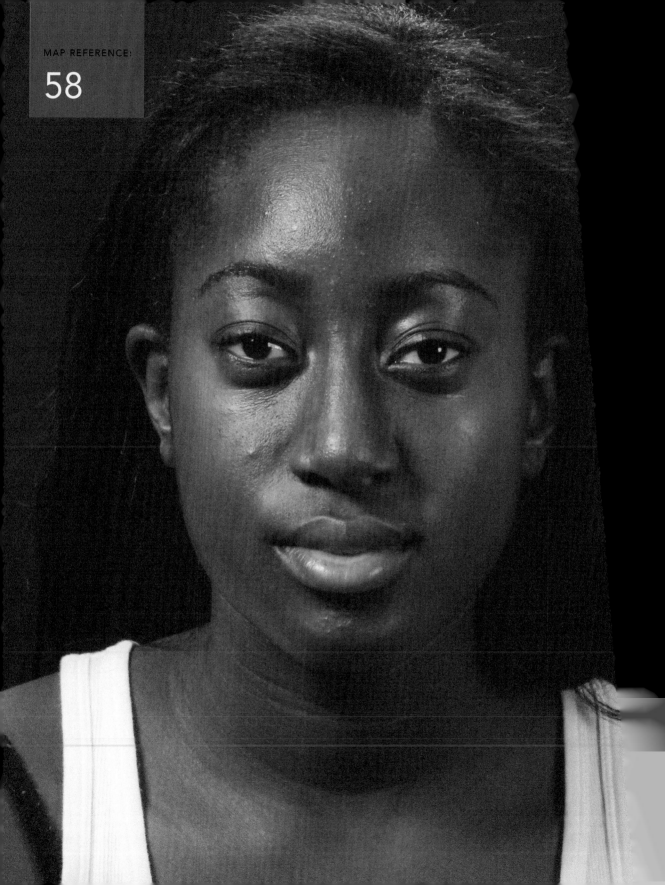

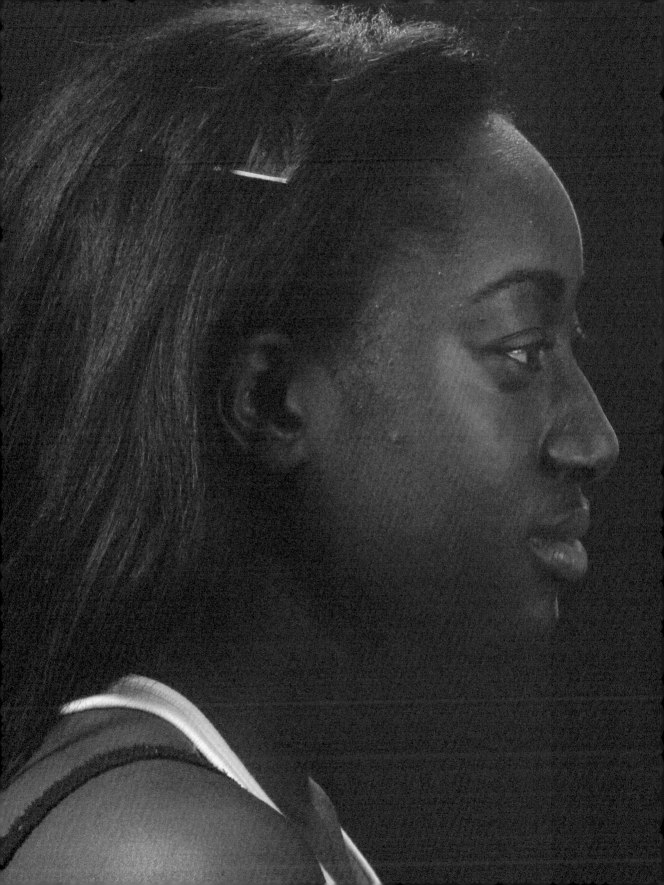

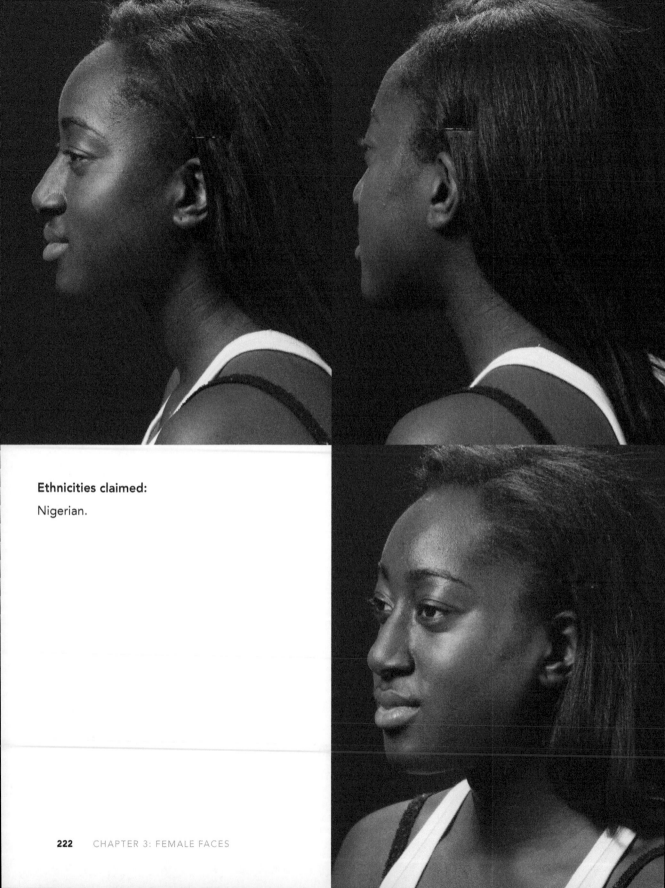

Ethnicities claimed:

Nigerian.

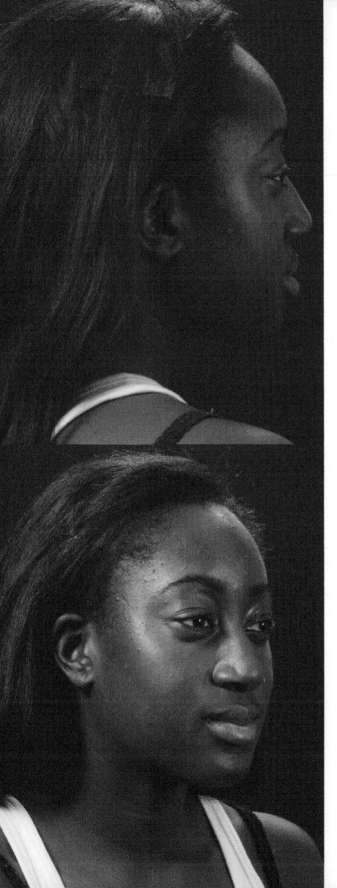

Head measurements (in):

A: 5 3/4

B: 4 3/4

C: 4 7/8

D: 4 15/16

E: 6

F: 3 1/2

G: 5

H: 5 5/8

I: 8 1/8

J: 5 3/8

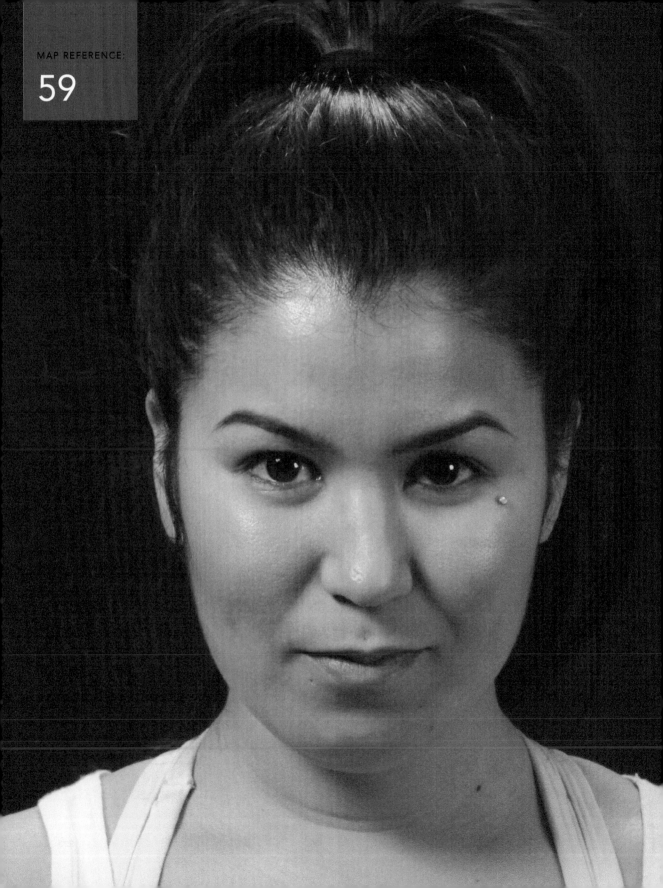

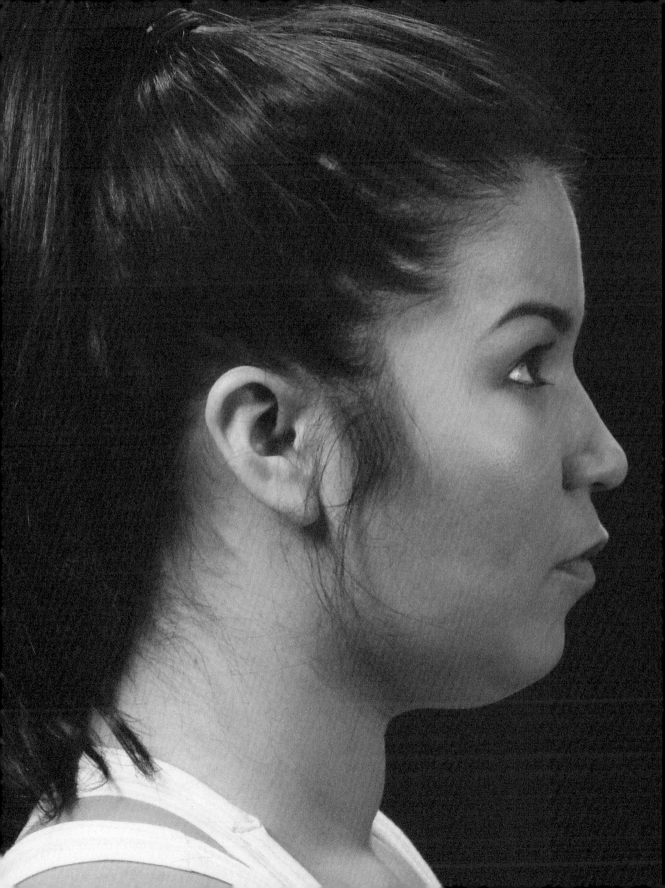

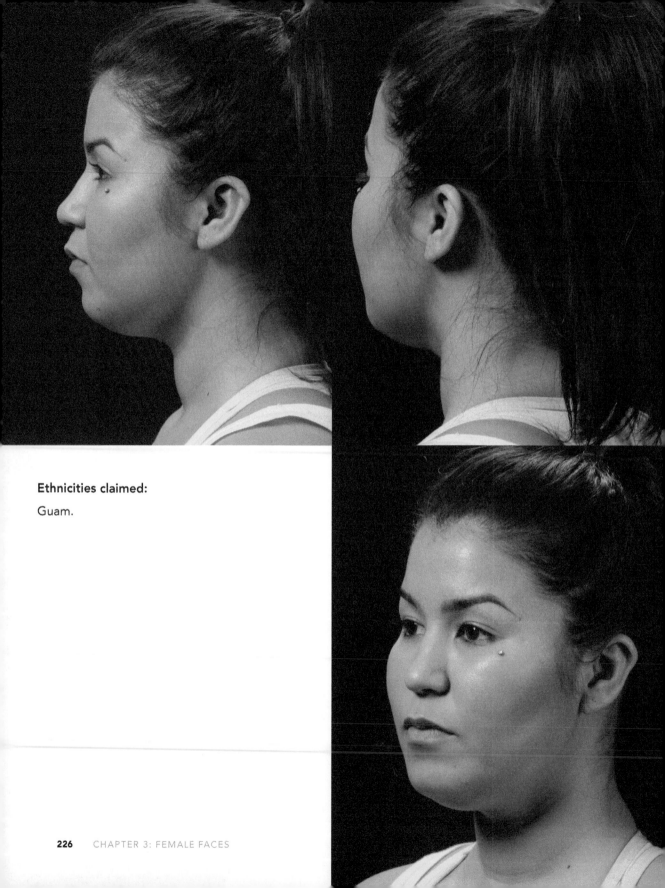

Ethnicities claimed:

Guam.

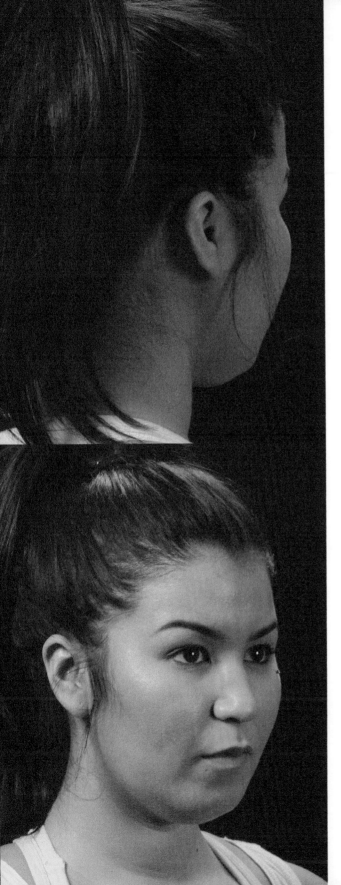

Head measurements (in):

A: 5

B: 4 1/2

C: 4 3/8

D: 4 3/4

E: 5 1/2

F: 3 5/8

G: 4 1/8

H: 4 3/4

I: 6 5/8

J: 4 1/2

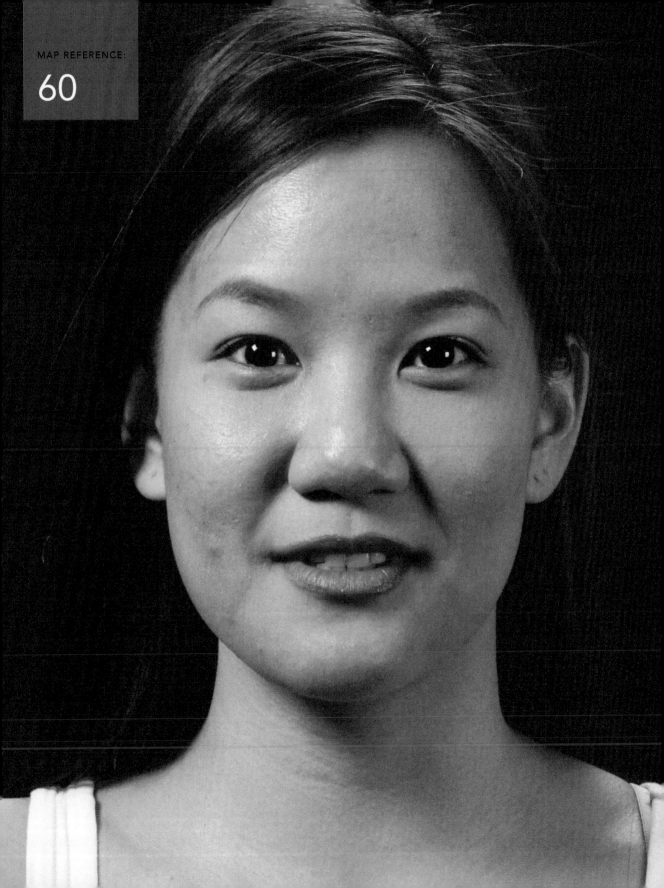

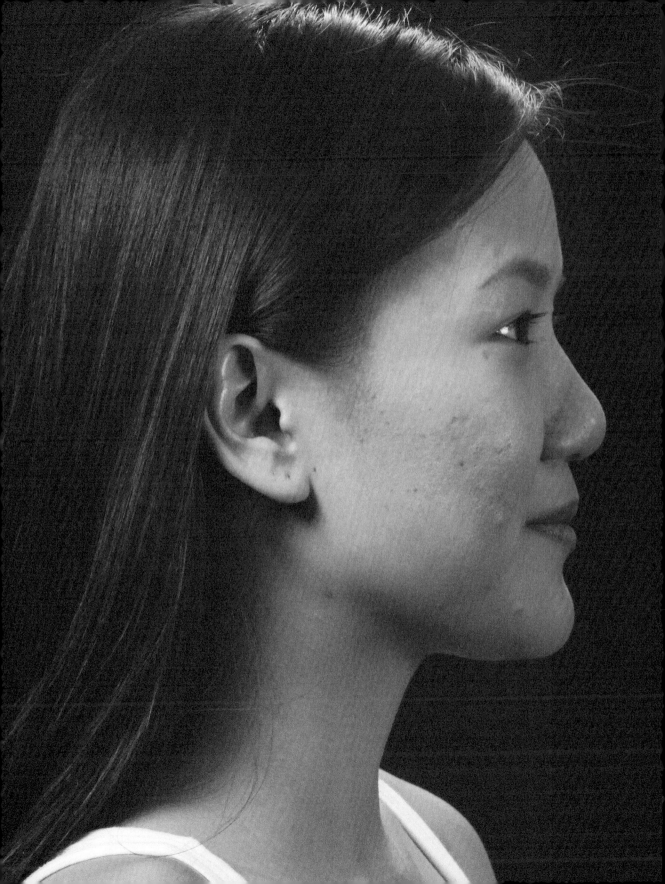

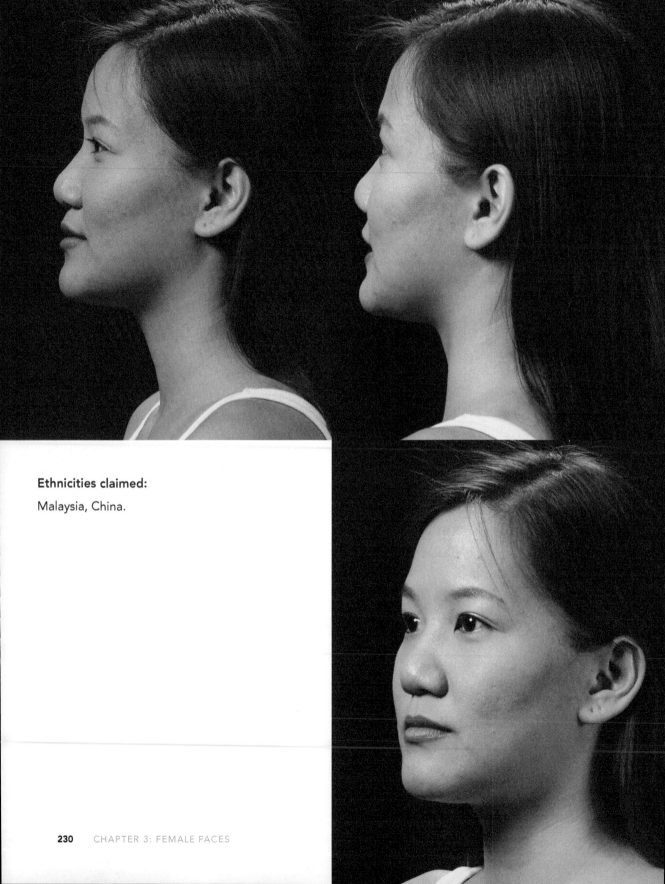

Ethnicities claimed:

Malaysia, China.

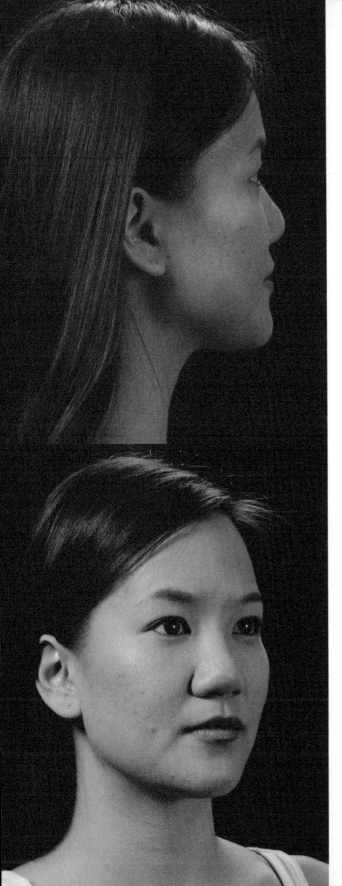

Head measurements (in):

A: 5 1/2

B: 5 1/8

C: 4 1/2

D: 5 1/8

E: 6 1/8

F: 3 1/4

G: 4 1/2

H: 5 1/4

I: 7 1/2

J: 5 3/8

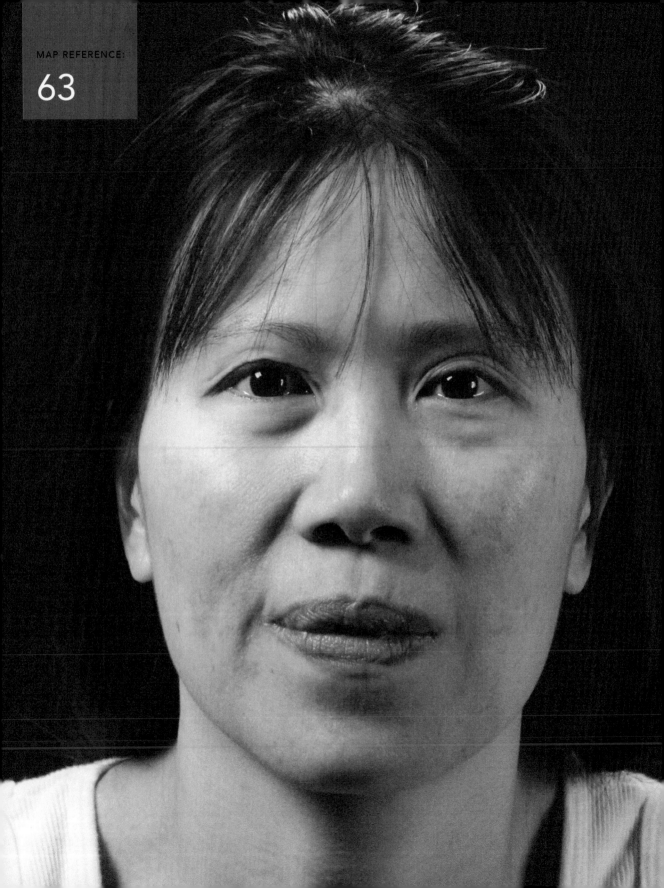

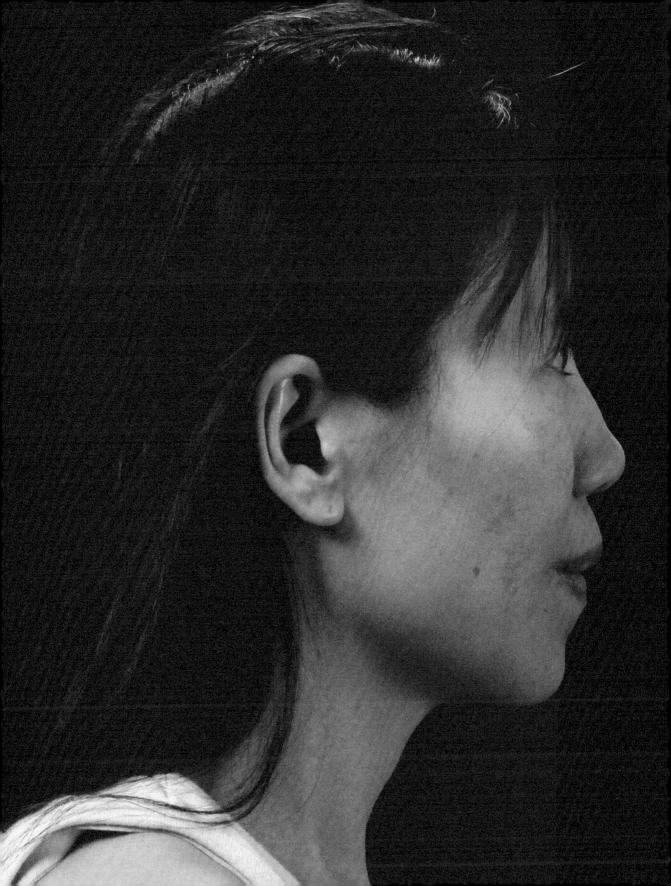

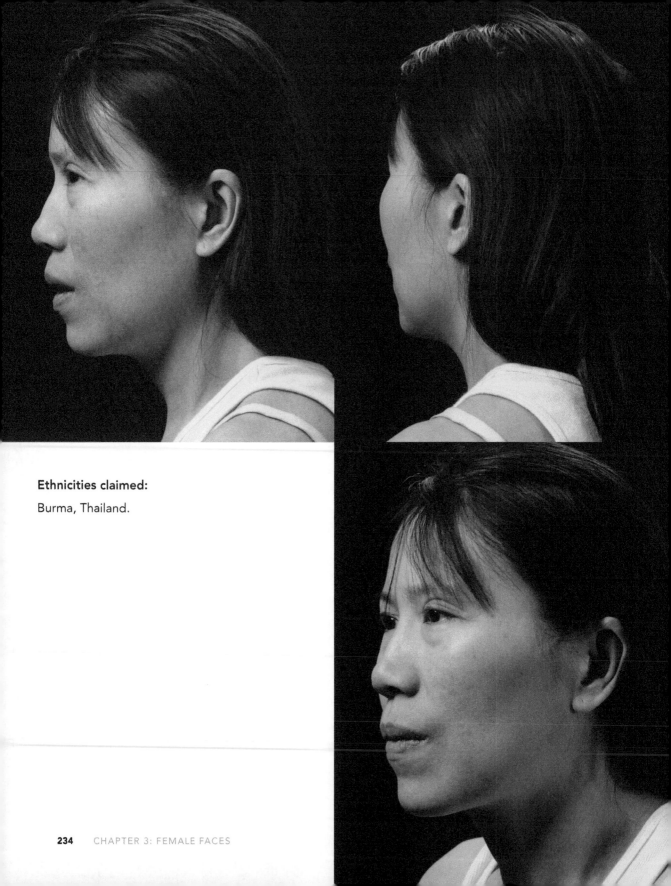

Ethnicities claimed:

Burma, Thailand.

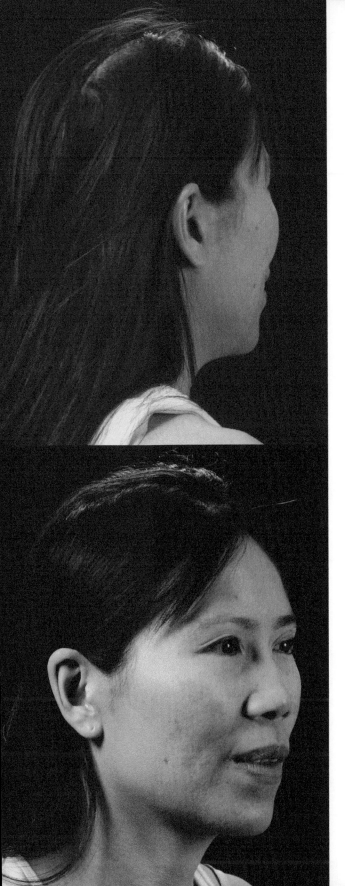

Head measurements (in):

A: 5 1/2
B: 4 3/4
C: 5
D: 5 3/8
E: 5 3/4
F: 3 5/8
G: 5 1/8
H: 5 3/8
I: 8
J: 5 1/2

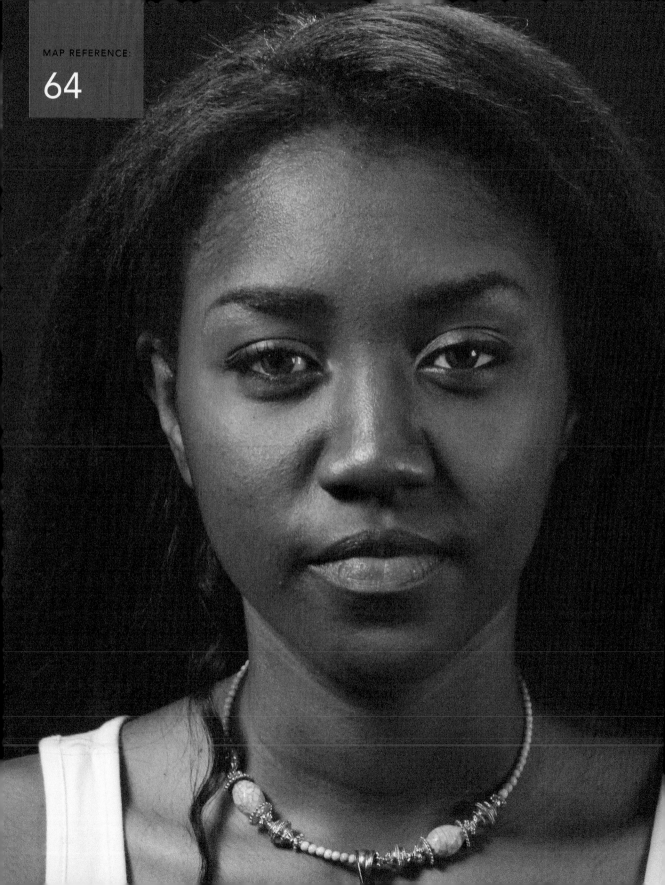

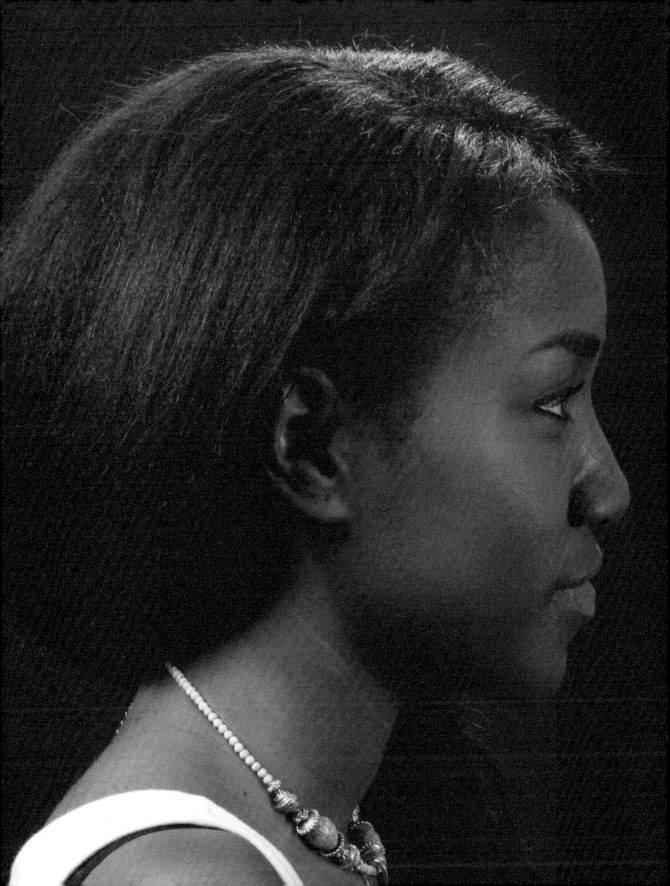

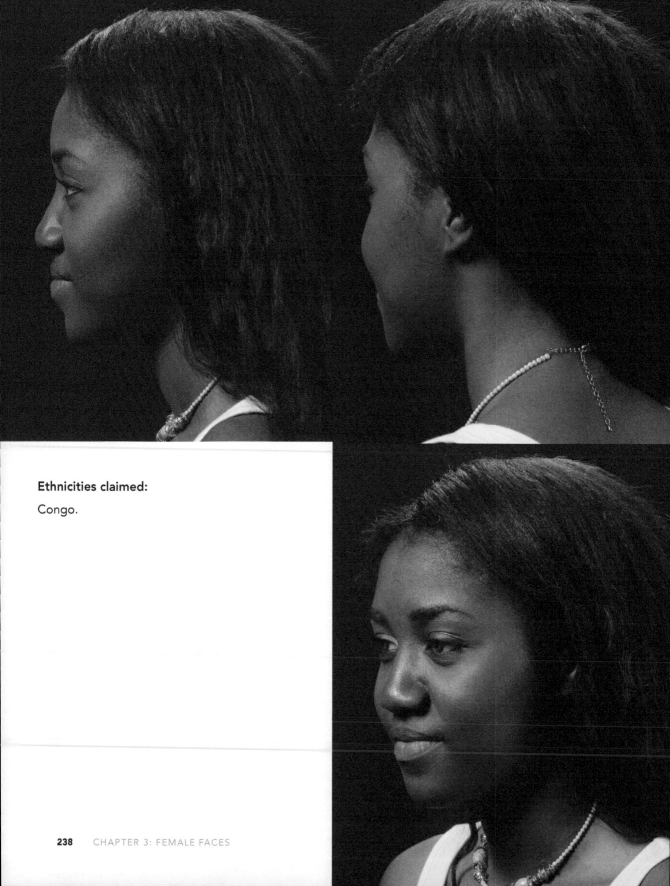

Ethnicities claimed:

Congo.

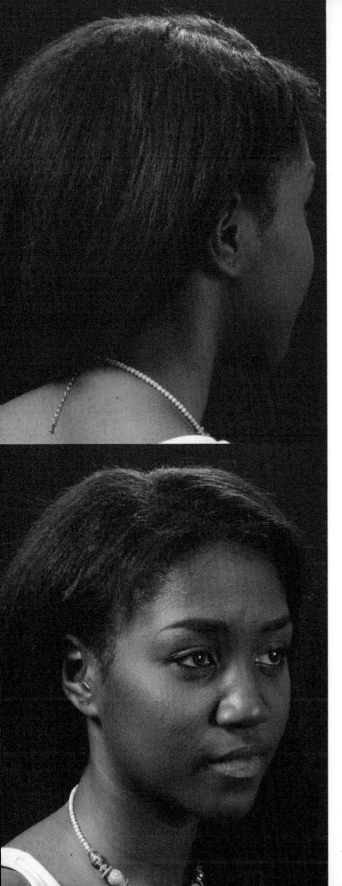

Head measurements (in):

A: 5 1/4
B: 5
C: 4 7/8
D: 5 1/8
E: 6
F: 3 3/8
G: 4 1/2
H: 5 3/8
I: 7 7/8
J: 5 1/8

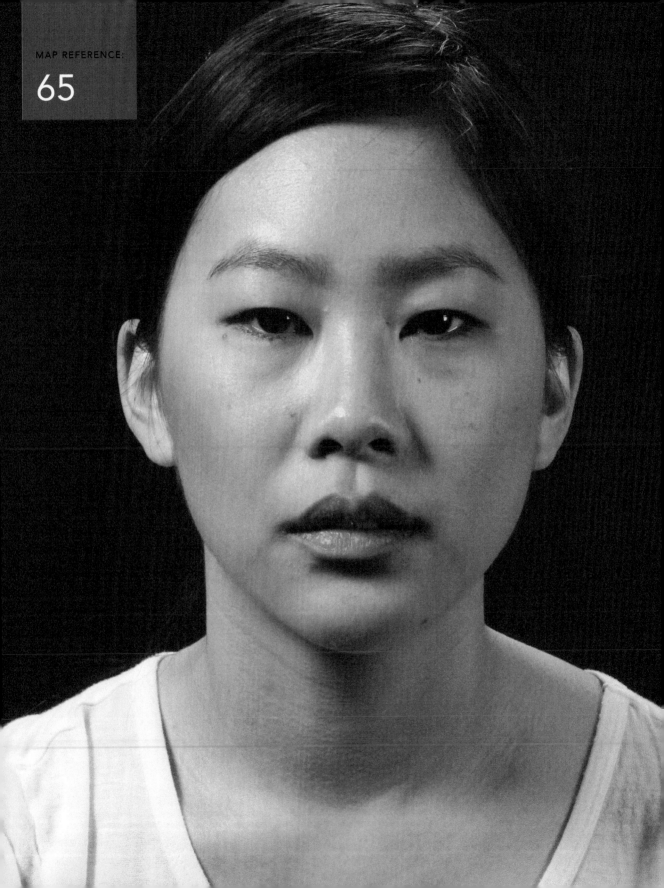

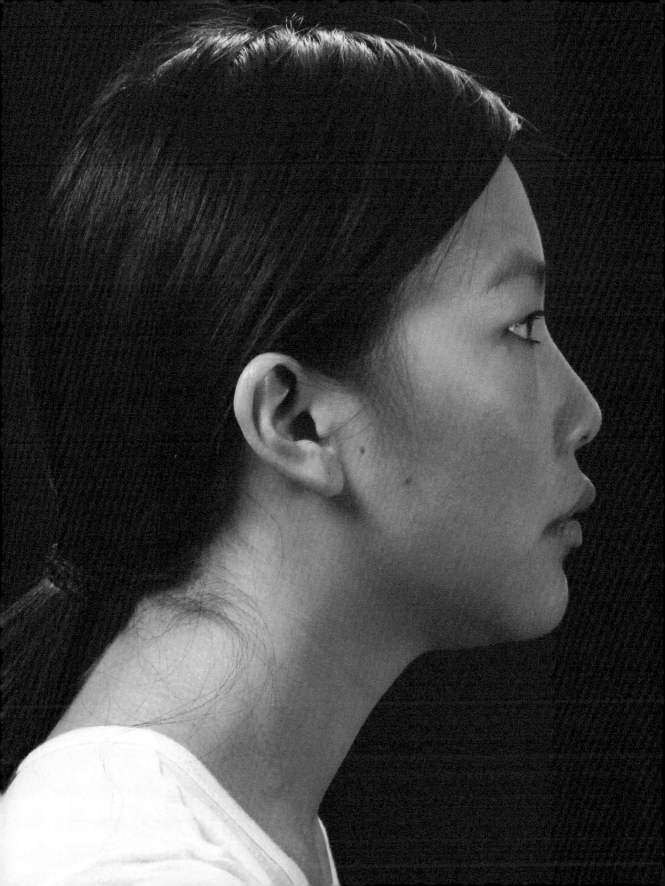

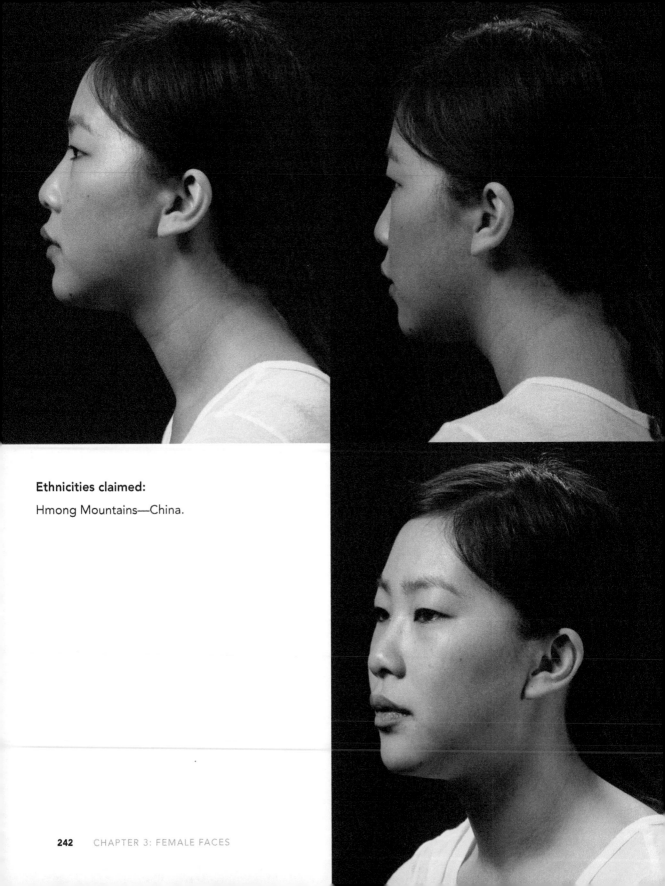

Ethnicities claimed:

Hmong Mountains—China.

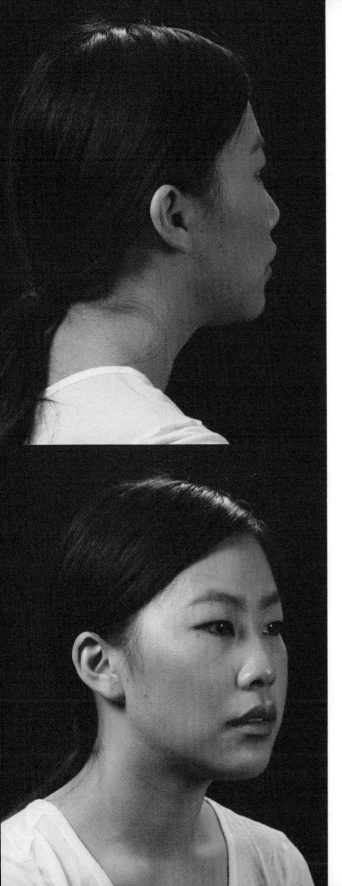

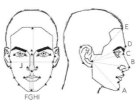

Head measurements (in):

A: 4 1/2
B: 4 3/8
C: 4 1/4
D: 4 5/8
E: 5 3/4
F: 3 1/4
G: 4 1/4
H: 4 7/8
I: 7 1/4
J: 5 1/2

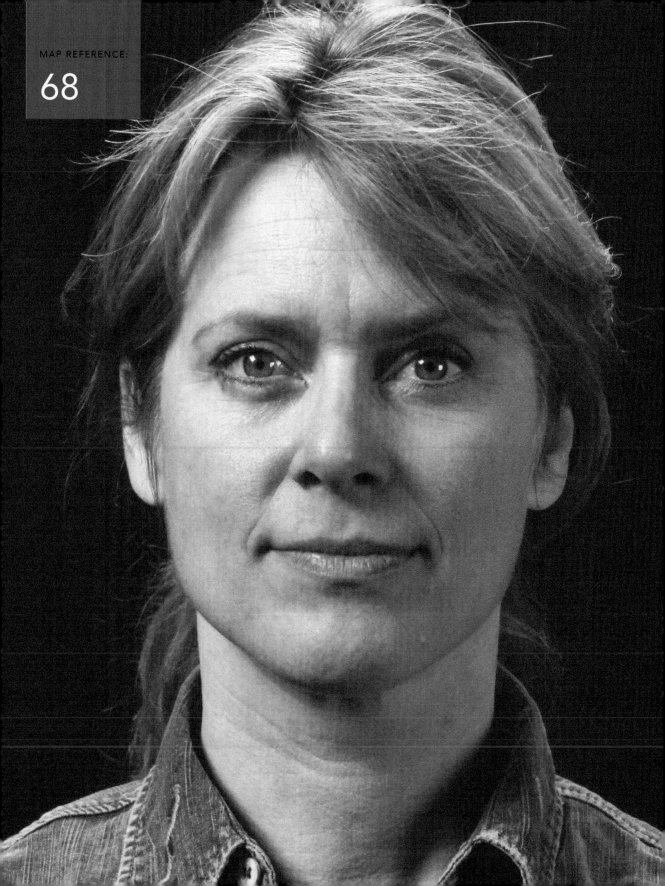

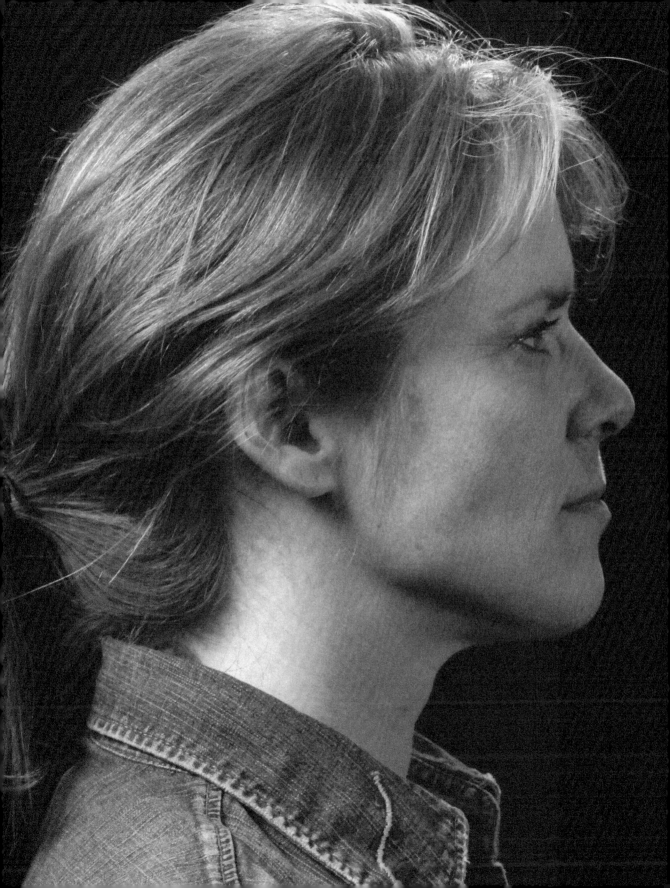

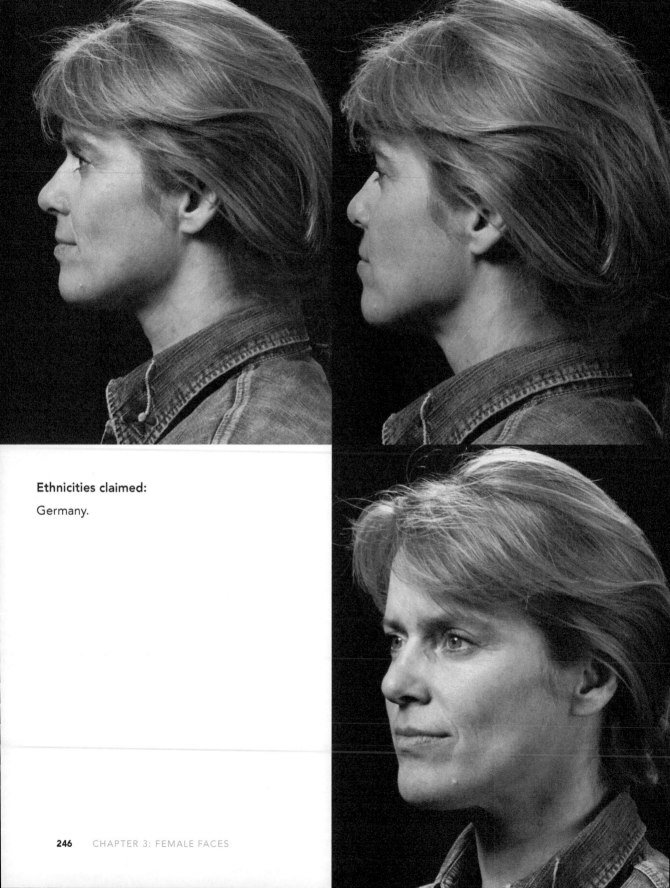

Ethnicities claimed:

Germany.

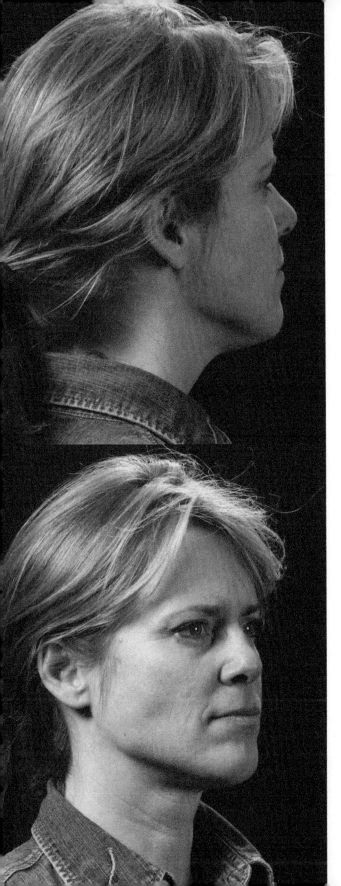

Head measurements (in):

A: 5 3/8
B: 5 3/16
C: 4 13/16
D: 5 3/16
E: 6 1/16
F: 3 1/16
G: 4 1/16
H: 4 7/8
I: 7
J: 5 1/4

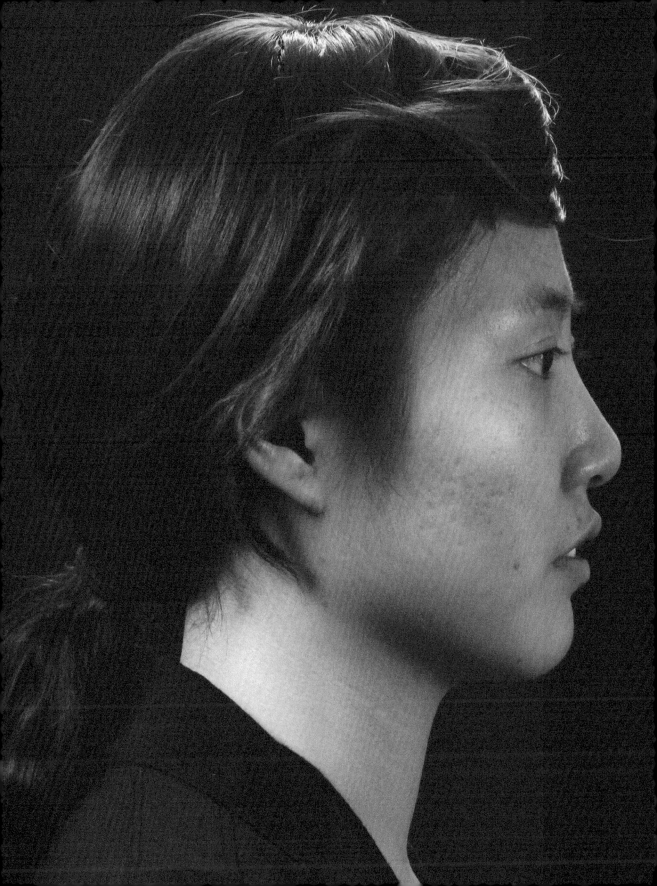

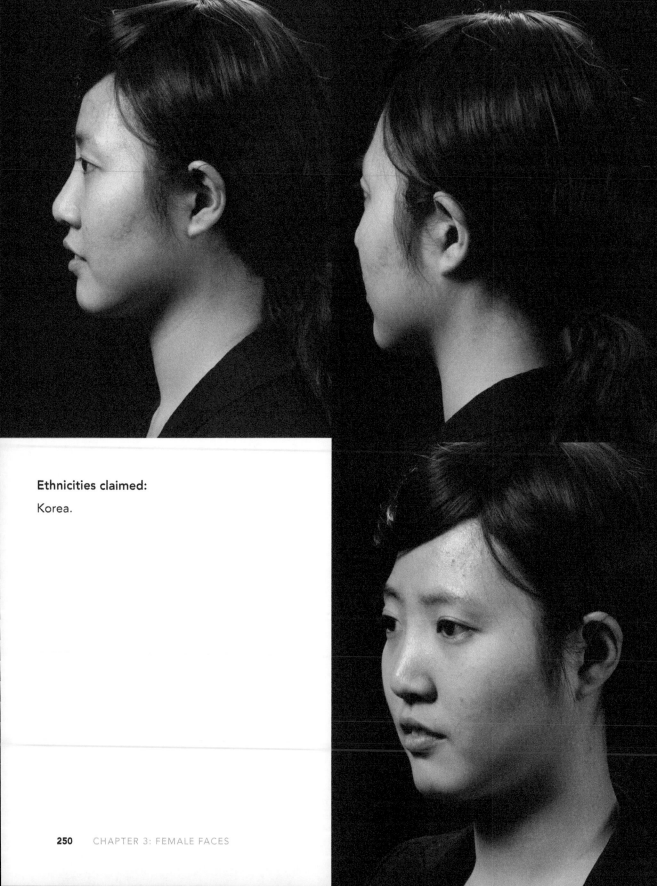

Ethnicities claimed:

Korea.

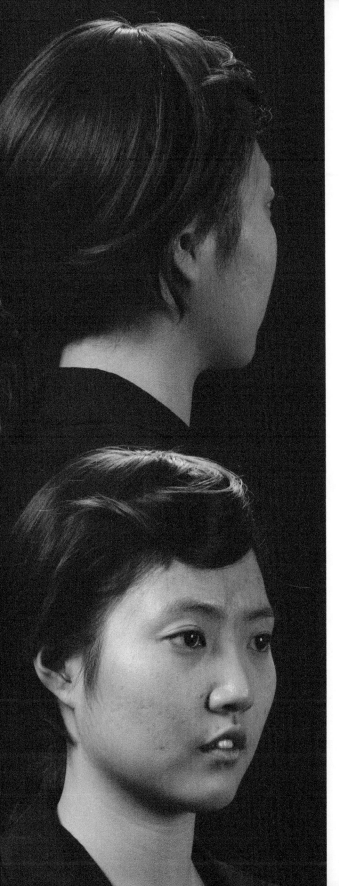

Head measurements (in):

A: 5 1/8

B: 5

C: 4 7/8

D: 5

E: 5 5/8

F: 3 1/8

G: 4 3/8

H: 5 1/4

I: 7 3/4

J: 5 1/2

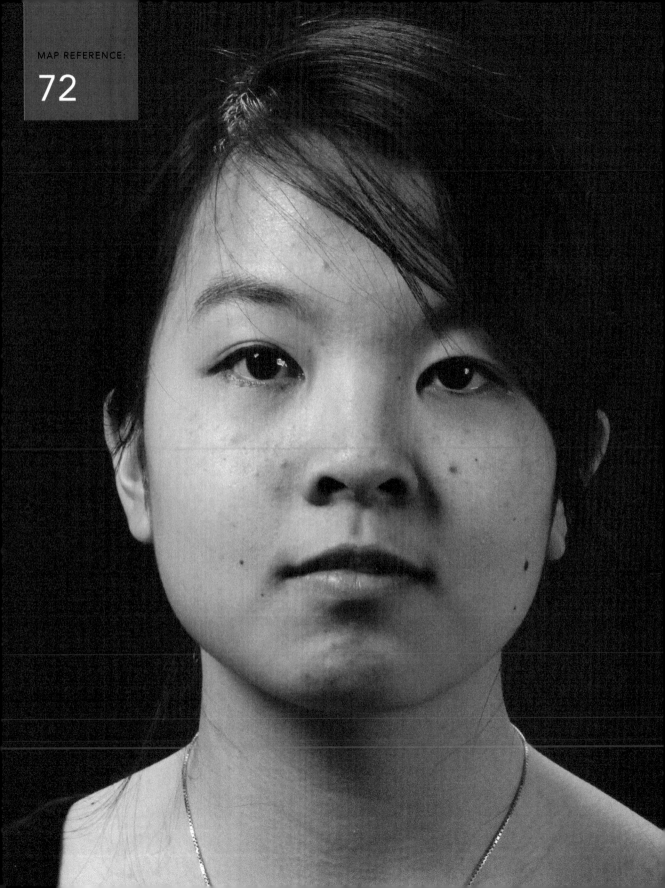

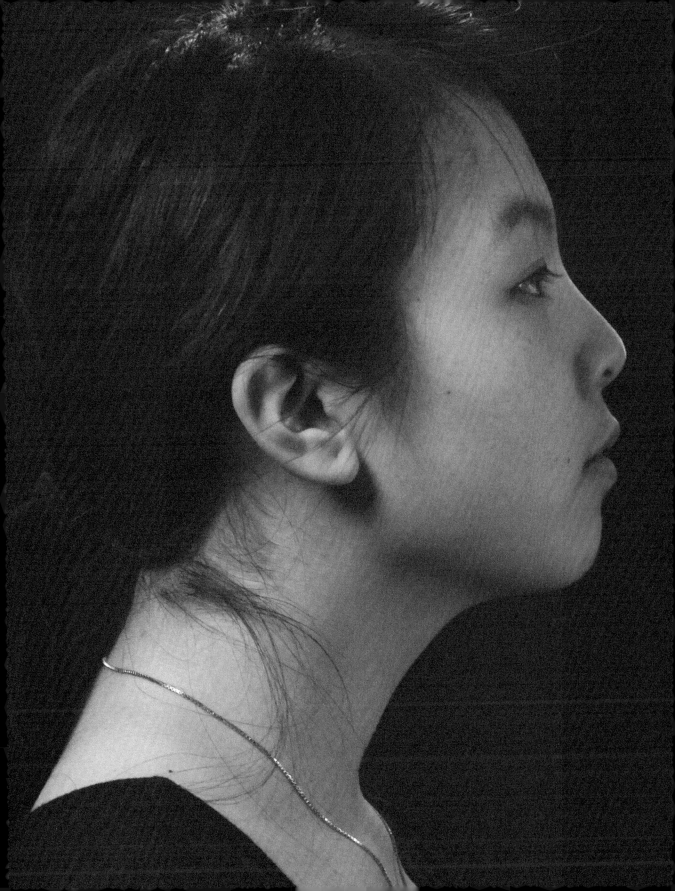

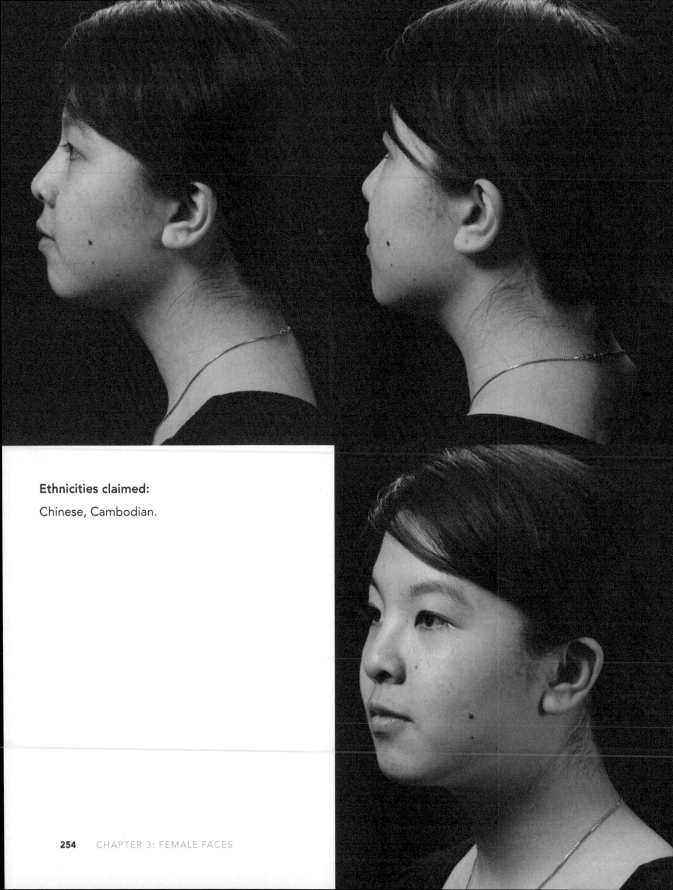

Ethnicities claimed:

Chinese, Cambodian.

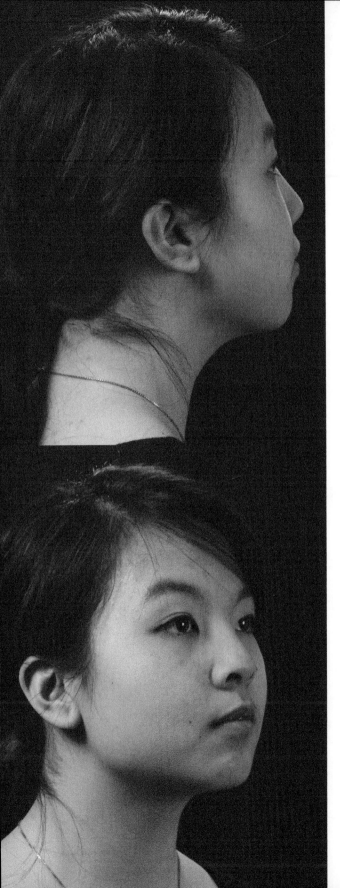

Head measurements (in):

A: 5 3/8

B: 5

C: 4 3/4

D: 4 5/8

E: 5 3/8

F: 3 1/8

G: 4 1/2

H: 5

I: 7 1/2

J: 5 1/4

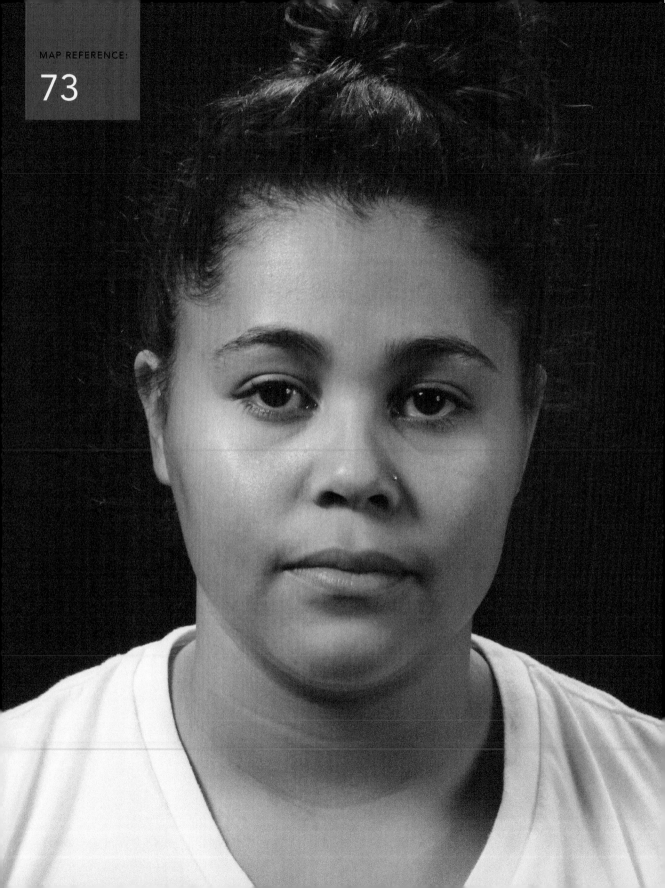

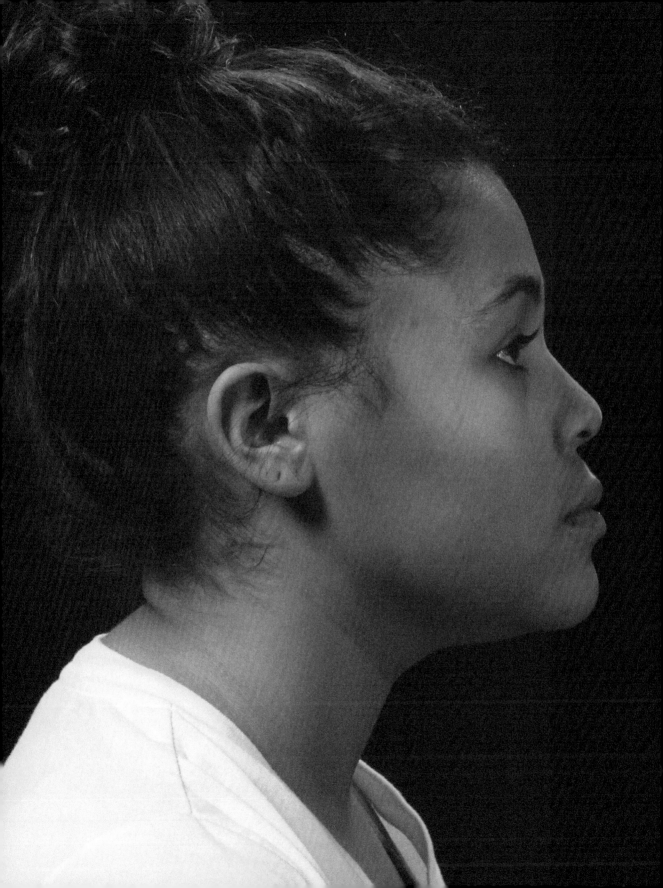

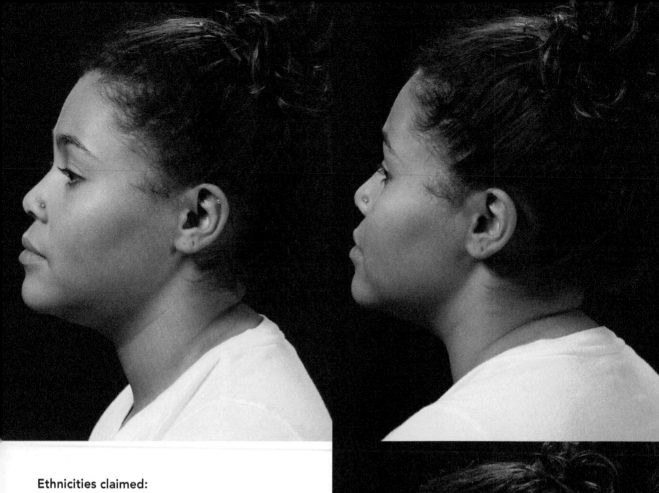

Ethnicities claimed:

Philippines, Mexico, United States—African American

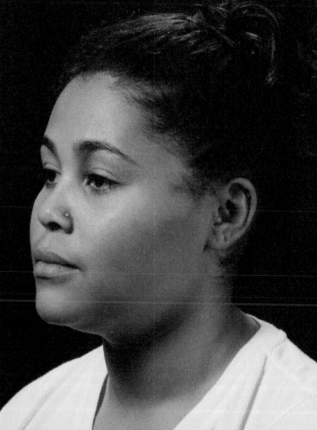

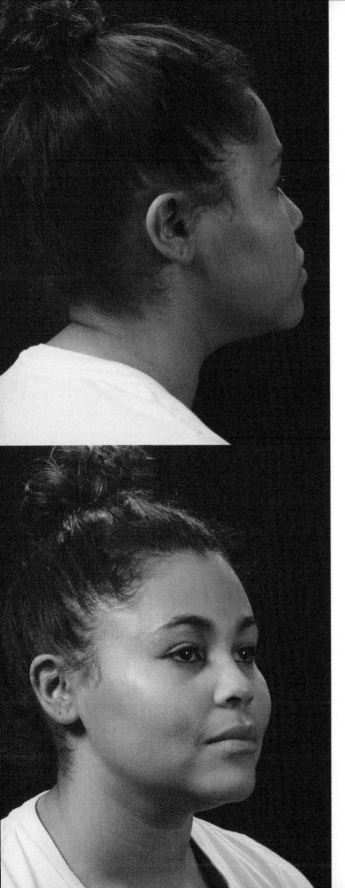

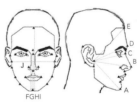

Head measurements (in):

A: 5 3/4
B: 5 1/4
C: 4 3/4
D: 5
E: 5 5/8
F: 3 1/8
G: 4 1/2
H: 4 7/8
I: 7 1/4
J: 5 1/4

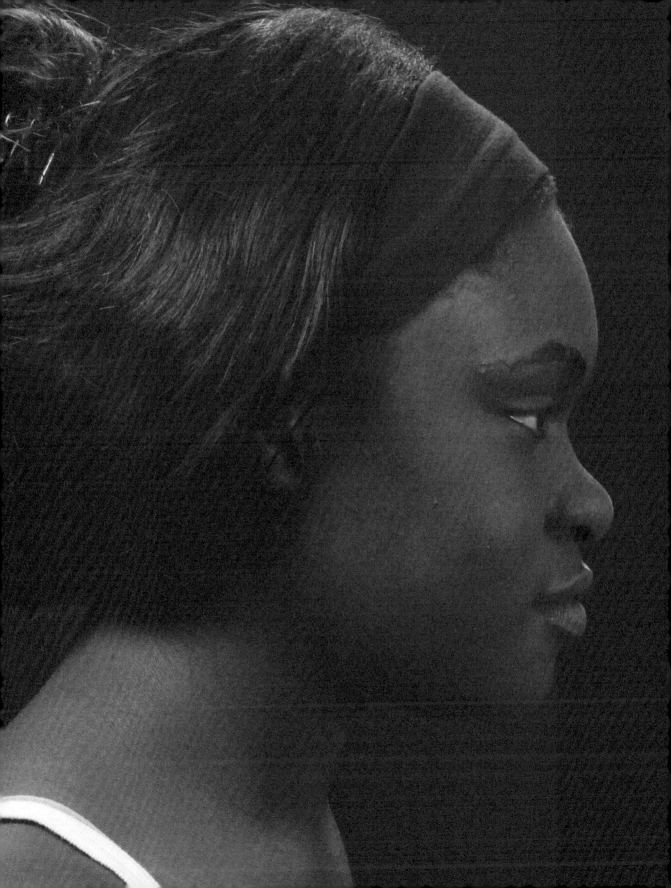

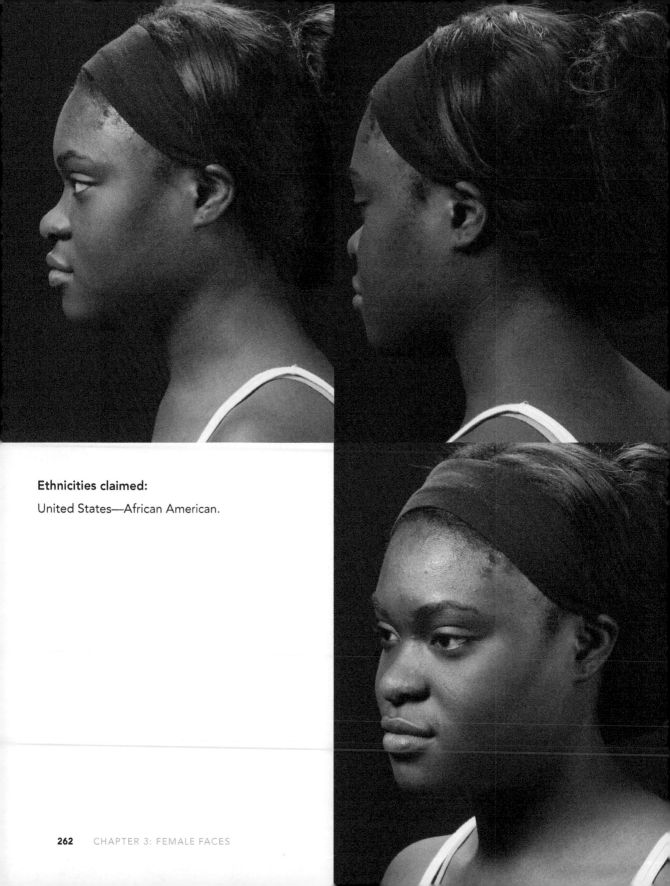

Ethnicities claimed:

United States—African American.

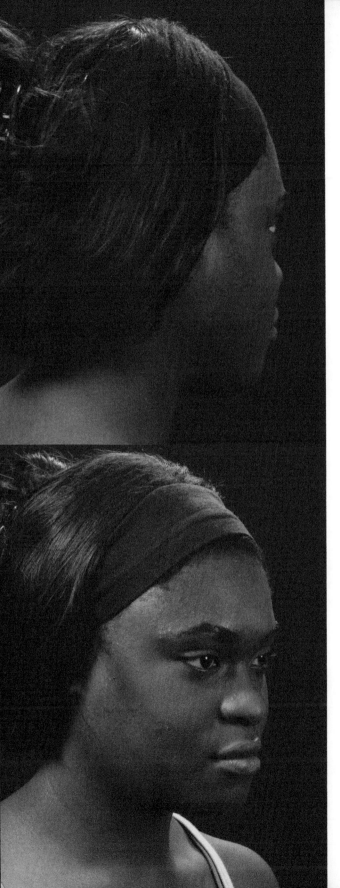

Head measurements (in):

A: 5 5/8
B: 5 1/2
C: 4 5/8
D: 5 1/4
E: 5 3/4
F: 3 3/8
G: 4 1/2
H: 4 7/8
I: 7 1/2
J: 5 5/8

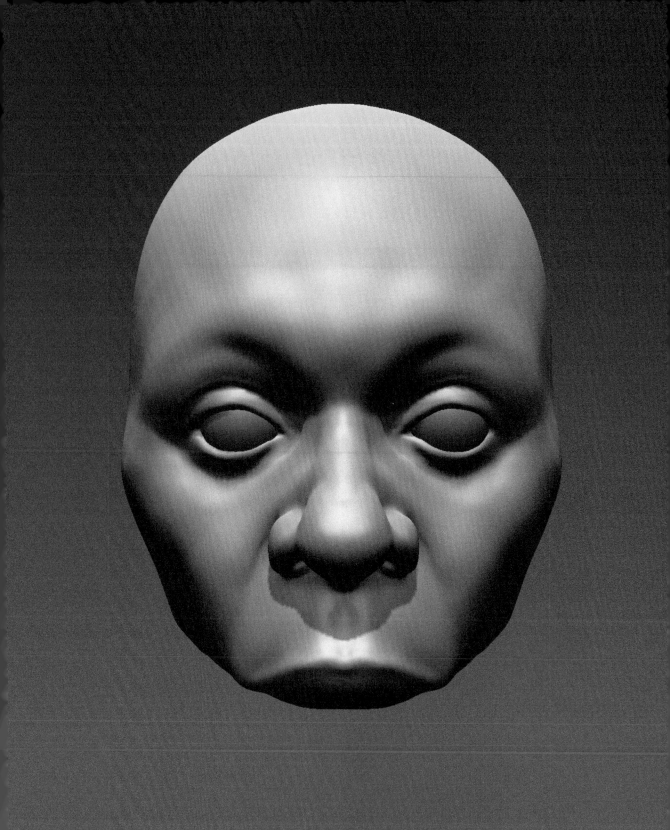

THE NOSE

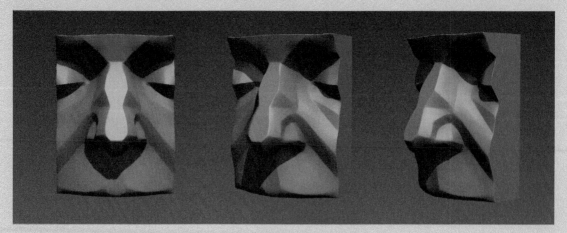

Basic planes of the nose.

Like all other aspects of anatomy, there are basic anatomical forms that make up all noses. What varies is the relative proportion and to a certain extent relative positions of those forms.

The figures below show the basic bone and cartilage anatomical elements that construct the shape of all human noses.

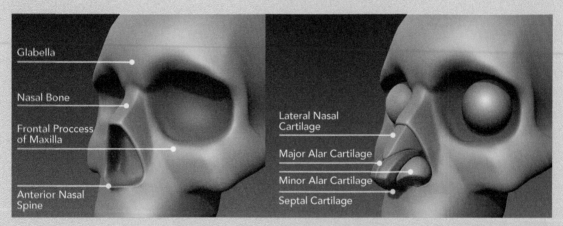

Glabella

Nasal Bone

Frontal Proccess of Maxilla

Anterior Nasal Spine

Lateral Nasal Cartilage

Major Alar Cartilage

Minor Alar Cartilage

Septal Cartilage

Basic anatomy of the nose.

In addition there are small muscles that will contribute to a smaller or greater extent to surface form depending on the individual and the facial expression. These muscles are the Nasalis, Procurus, Orbicularis Oculi, Corrugator, and Levator Labii Superioris Alaeque:

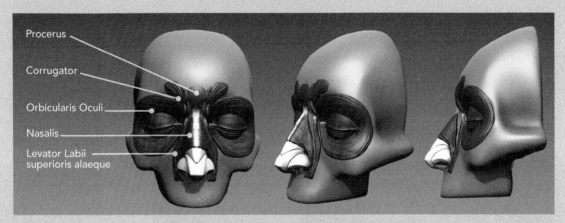

Basic muscles.

For the purposes of this tutorial, we are only concerned with how these muscles can affect surface form in a neutral facial pose. In the 'form relations' figure below you will see a simple example of how these forms translate into surface detail:

Form relations.

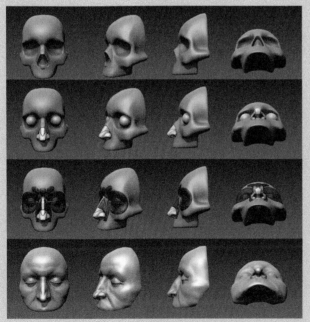

There are also intersecting forms surrounding the nose that you will need to consider. These will be shown in the tutorial below as well as in other tutorials in this book in more detail.

We will now walk through the construction of a basic nose using a basic version of our Bone Clones African American Female skull along with one of our female African American models.

The files can be found on the companion website.

\tutorials\tutorial2\african_american_female.jpg,
\tutorials\tutorial2\african_american_female_skull.jpg

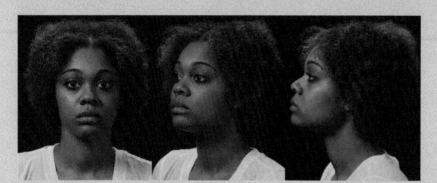

Model reference.

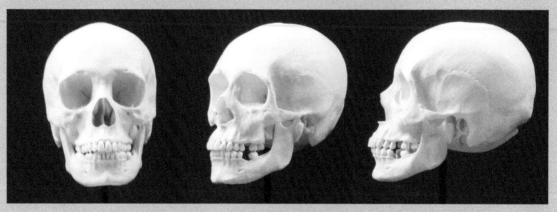

African American female skull.

TUTORIAL

Import \tutorials\tutorial2\female_african_nose_baseform.obj into your sculpting application. You may wish to assign a brightly colored material to the base form model so you can see it clearly where it penetrates your sculpt. Lock the base form model so you don't accidentally alter it.

Import **\tutorials\tutorial2\base_nose_skin.obj** model. You should see something like this:

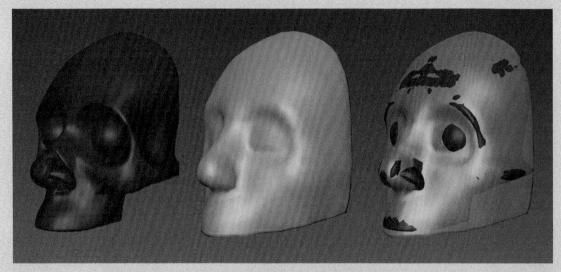

Starting point of tutorial. Transparency added to skin object to show alignment.

Skull measurements are provided (\tutorials\tutorial2\african_fem_skull_meas. txt) for traditional sculptors who want to block out the skull form in clay. You will need to approximate your own cartilage and eye forms using the photos provided.

While this tutorial may have a bit of a forensic reconstruction feel to it, what the goal really is to have you both thinking about the anatomical forms that rest directly below the skin surface and give you a tangible way to evaluate your work.

Subdivide the base skin model 1–2 times (less is better: keeping the poly count as low as possible as you build up form is the best practice and only increase subdivisions when you no longer have enough resolution to create the forms you need). Begin by making the images of the model available

to refer to either an image viewer onscreen, as image planes in your sculpture program or as printouts.

The first step will be to define the gabella, nasal bone, and the border of the orbital cavity. These landmarks will give you structure to begin seating the features of the face within. Keep in mind that while the skull is representative of a *typical* African American female skull, it will only loosely correspond to the model's features. So use her photos as a loose guide, but in this exercise focus on the base form of the provided geometry as a guide for positioning features.

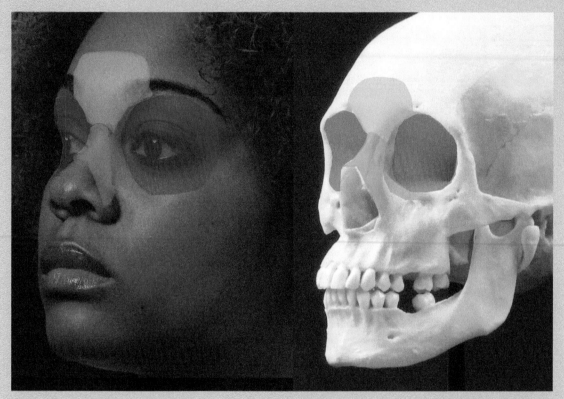

Areas to focus on the skull, and model photo.

You should make the overall shape of the skin geometry conform to the base form so that none of the skull is penetrating (with the exception of the nose cartilage forms for now). Once that is complete, focus your effort on roughing-in the bony areas mentioned above. When complete, your first step should look something like this:

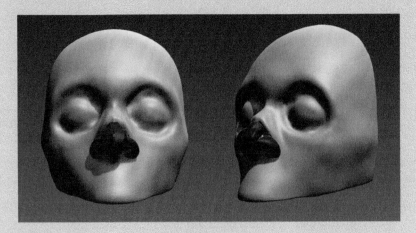

The next step will be to fill in the nose cartilage area, again using the base form as a template for the surface you are creating. Try adding one cartilage form at a time so that you get a feel for those forms and memorize them. Keep referring back to the model photos as reference for the surface forms that you are trying to create.

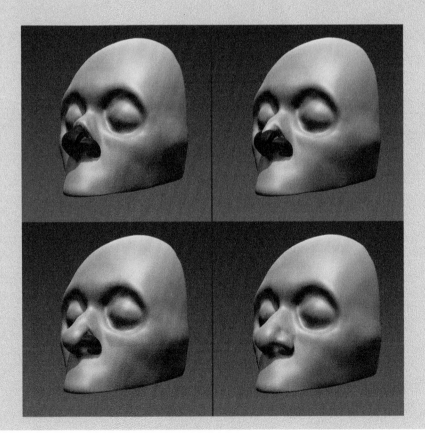

At this point you have blocked out the basic nose forms. Now we need to be concerned with the forms that surround the nose and how they interact. The first area we will address is the barrel of the mouth.

There is a decent amount of thickness to the flesh that covers the maxilla (upper jawbone/teeth) and there is a distinct barrel shape in most people of this form. The important thing to think about for now is the area where the nose and upper lip come together. The teardrop shaped cleft in the center that runs to the base of the nose is called the philtrum. The way the forms transition from the nostrils to the upper lip and the interconnection between the philtrum and the base of the nose are important things to observe carefully.

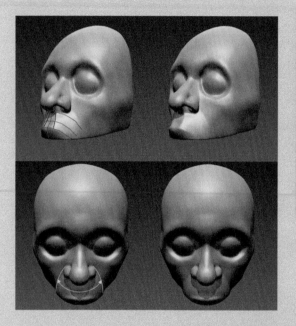
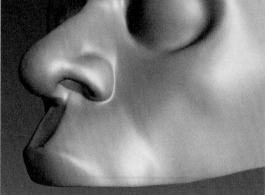

The final area we are going to look at is the nasal labial fold.

The nasal labial fold is the characteristic crease from the rear edge of the nostril to the region near the corners of the mouth. It includes a fat pad that covers the zygomatic muscles that travel from the cheek bone to the corner of the lips.

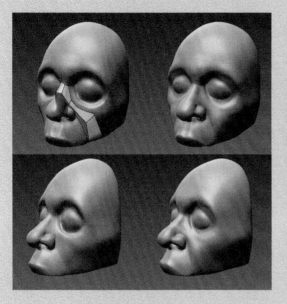
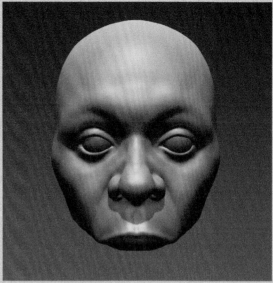

In the next tutorial we will cover the eye and we will revisit this project to finish the eye, brow cheek and temple areas.

Now that you have walked though one example, use the resources provided in the folder for this chapter's tutorial to complete three more nose studies of an Asian male and an African American male. The Caucasian male resources files used at the beginning of this tutorial are also provided.

> *\tutorials\tutorial2\male_asian_nose_baseform.obj*
> *\tutorials\tutorial2\male_african_american_nose_baseform.obj*
> *\tutorials\tutorial2\asian_male.jpg*
> *\tutorials\tutorial2\african_american_male.jpg*

Noses can appear very differently in different individuals, but if you keep in mind the basic anatomy that makes up all noses, you should have the tools for evaluating and constructing what you see in your subjects.

MALE FACES

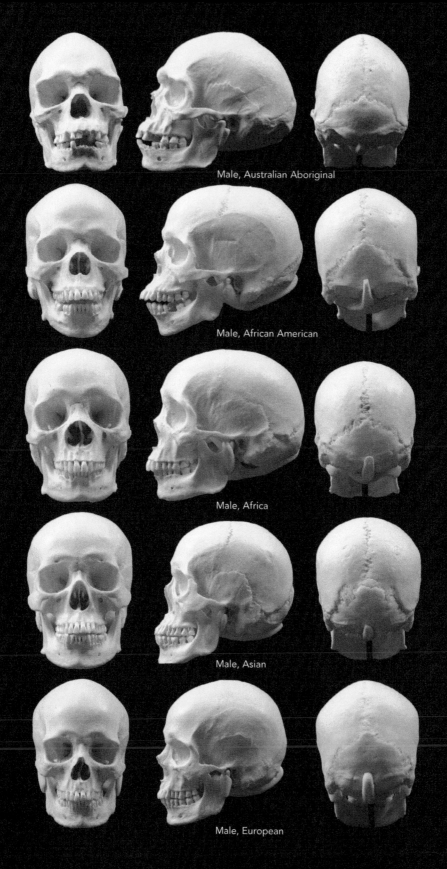

Male, Australian Aboriginal

Male, African American

Male, Africa

Male, Asian

Male, European

The male face is featured in this chapter. Each male will be featured in a turn-around. Each model's description will include measurements taken with calipers, and the country the person claims ancestry from.

You will notice when comparing the page of male skulls to the page of female skulls that the male skull is generally more angular than the female skull. Notice the forehead. The male forehead is more sloping. The ridge area is more pronounced too. The lower half of the face is larger on the male than on the female. This can be seen in the acute angle of the jaw, the square, pronounced chin, and the greater mass of muscle tissue. Notice, though, that this mass is more muscular. There is less fat in the male face.

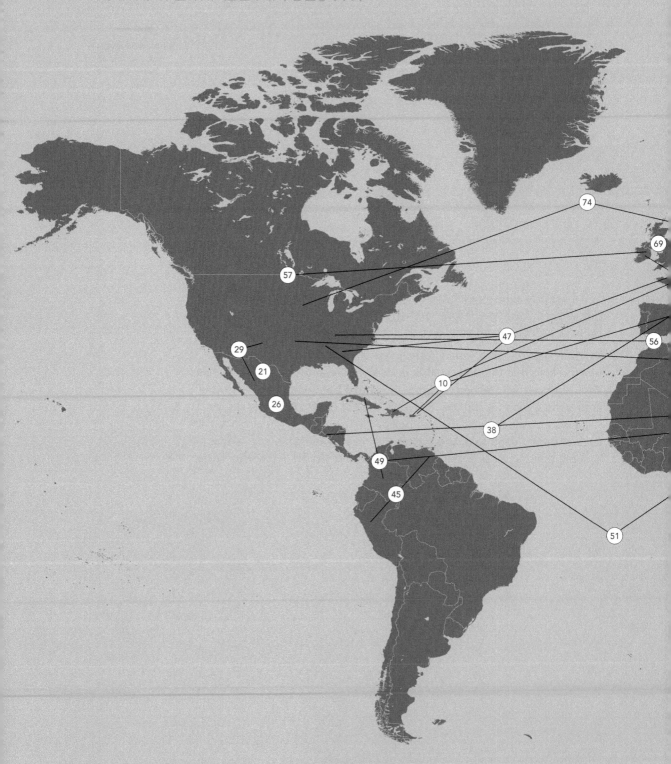

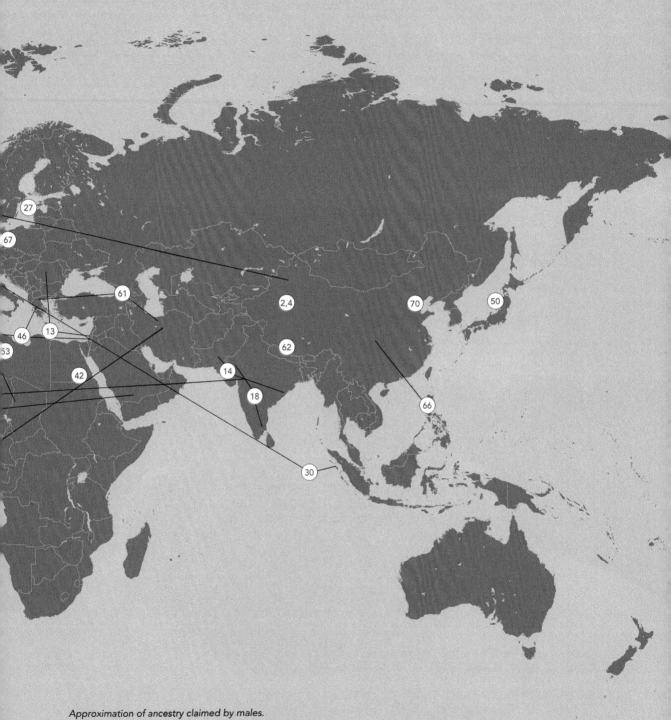

Approximation of ancestry claimed by males.

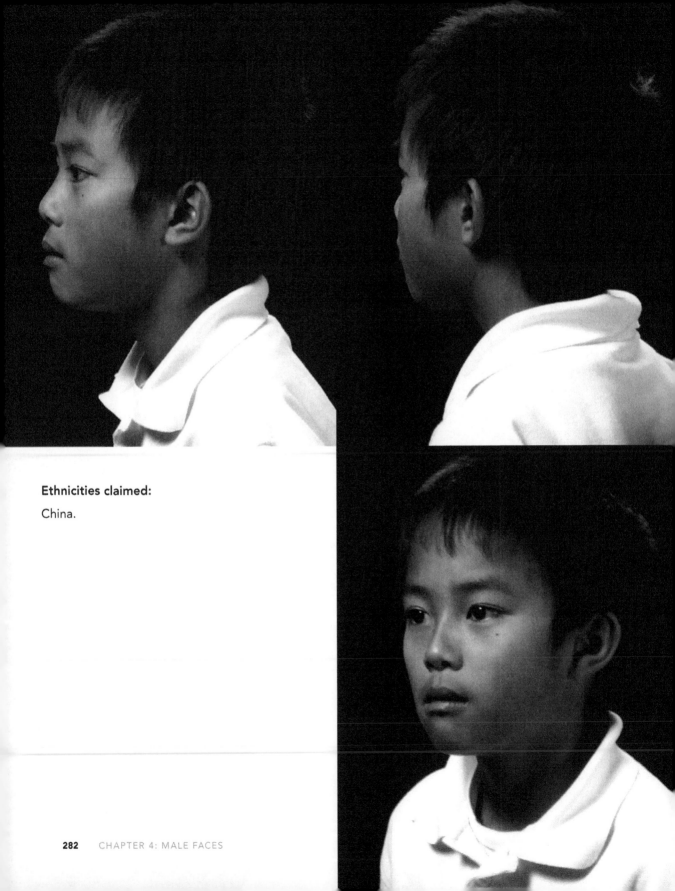

Ethnicities claimed:

China.

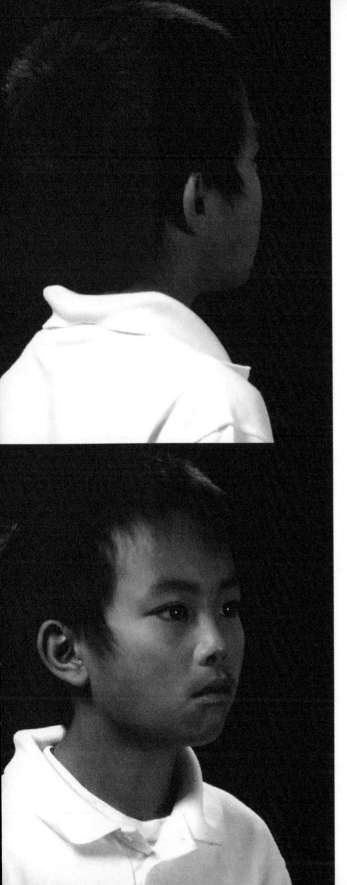

Head measurements (in):

A: 5
B: 4 3/8
C: 4 1/4
D: 4 3/8
E: 5 5/8
F: 3 1/2
G: 4
H: 4 7/8
I: 7 1/2
J: 5 3/8

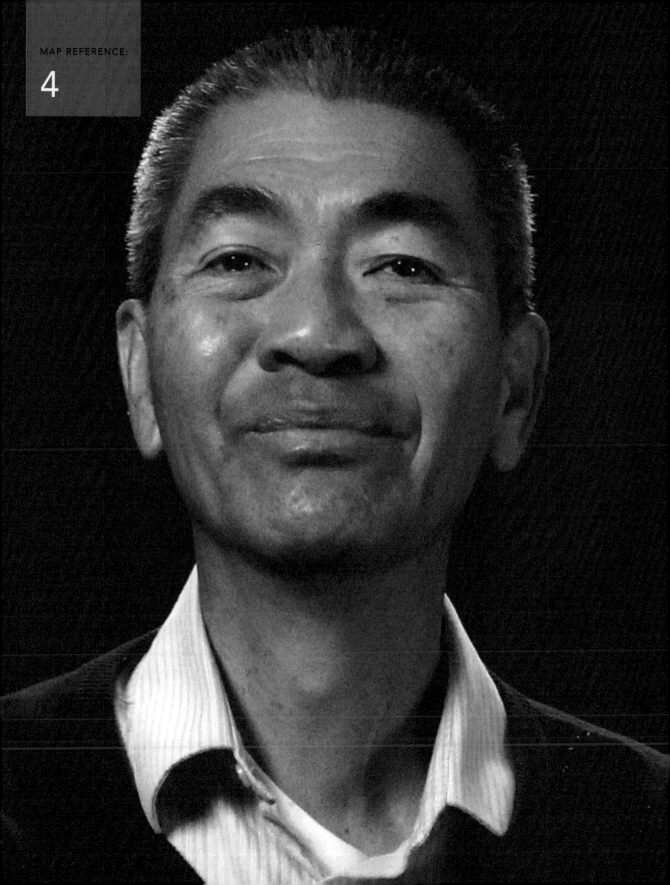

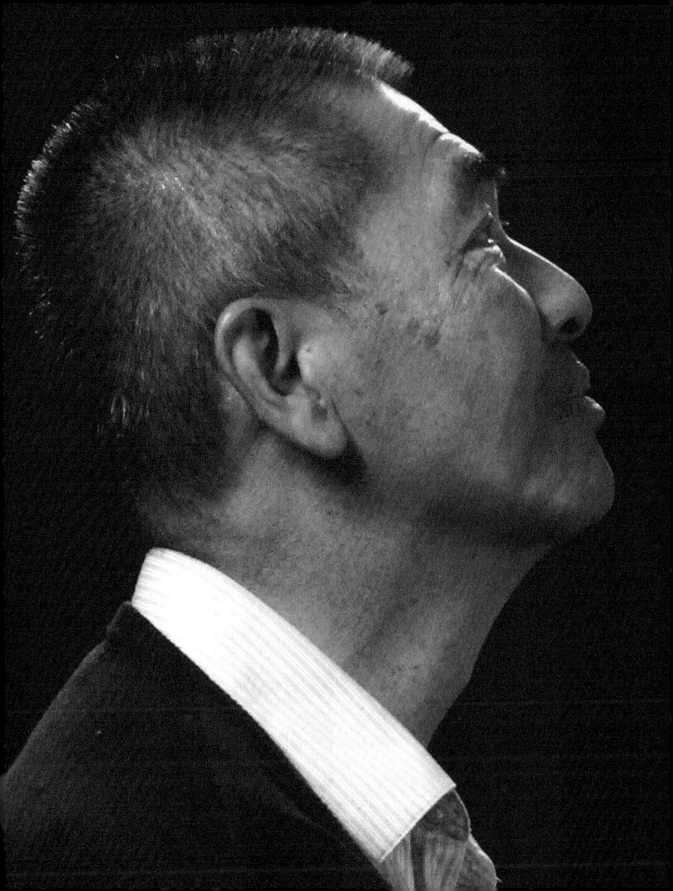

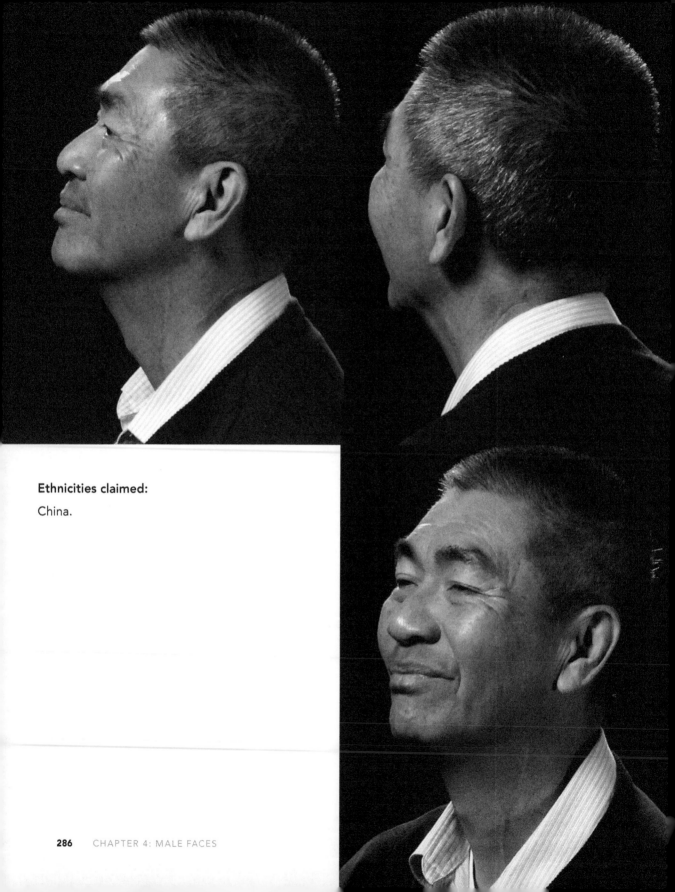

Ethnicities claimed:

China.

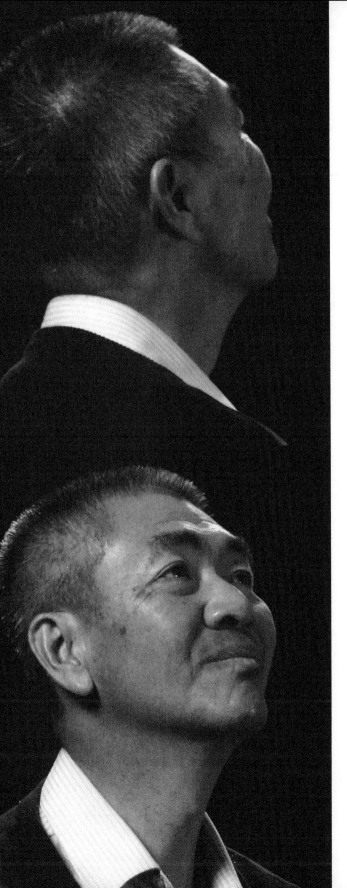

Head measurements (in):

A: 5 5/8

B: 5 1/2

C: 5 1/8

D: 5 1/2

E: 5 1/4

F: 3 1/4

G: 4 3/8

H: 5 3/4

I: 7 5/8

J: 6

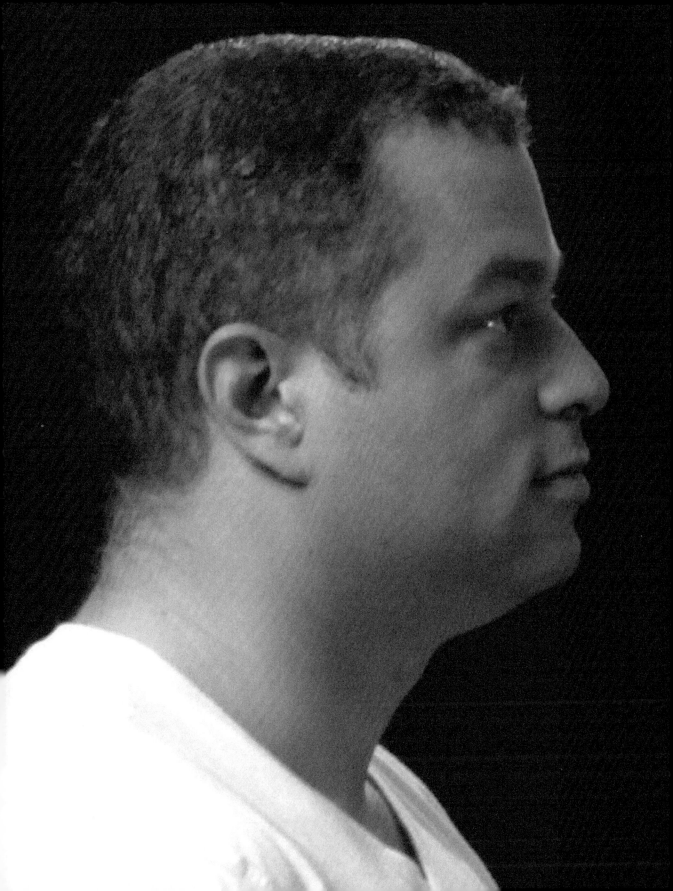

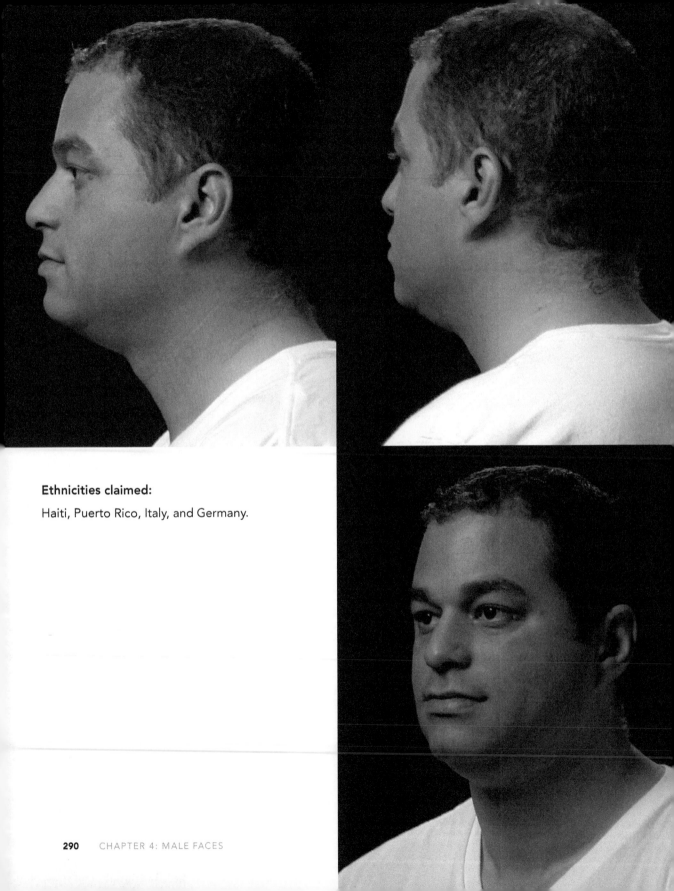

Ethnicities claimed:

Haiti, Puerto Rico, Italy, and Germany.

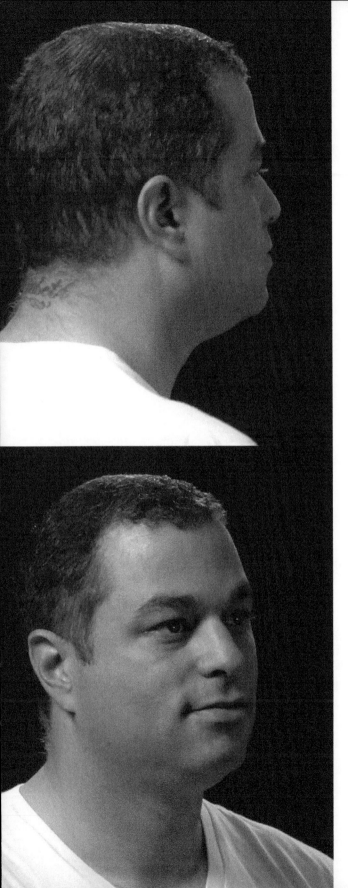

Head measurements (in):

A: 5 1/2

B: 5 5/8

C: 5

D: 5 1/2

E: 6 7/8

F: 3 3/8

G: 5 3/4

H: 5 3/8

I: 7 1/2

J: 6 1/4

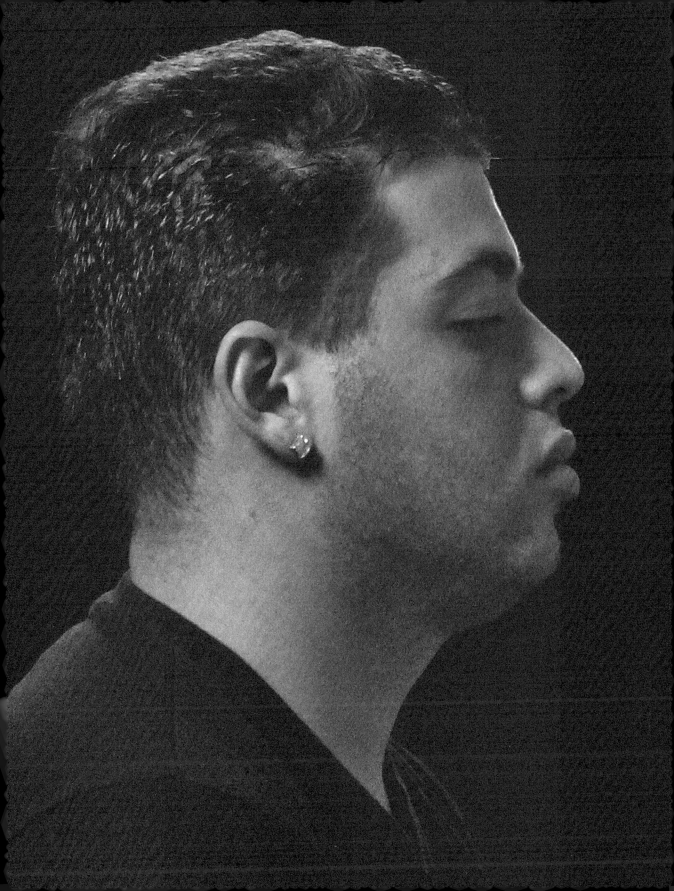

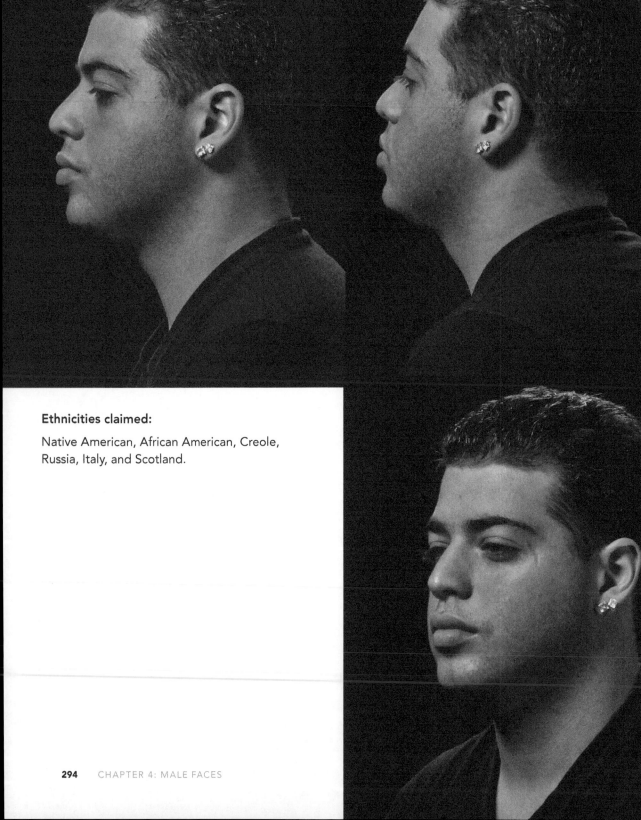

Ethnicities claimed:

Native American, African American, Creole, Russia, Italy, and Scotland.

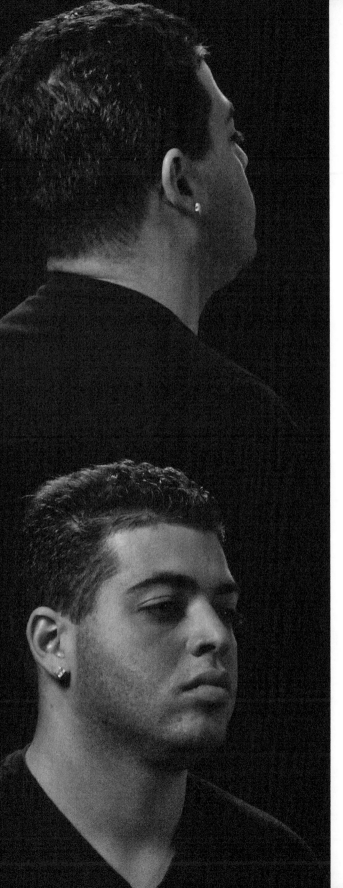

Head measurements (in):

A: 5 7/8

B: 5 3/8

C: 5 1/8

D: 5 1/8

E: 6 1/2

F: 3 5/8

G: 4 5/8

H: 5 1/4

I: 7 1/4

J: 6 1/4

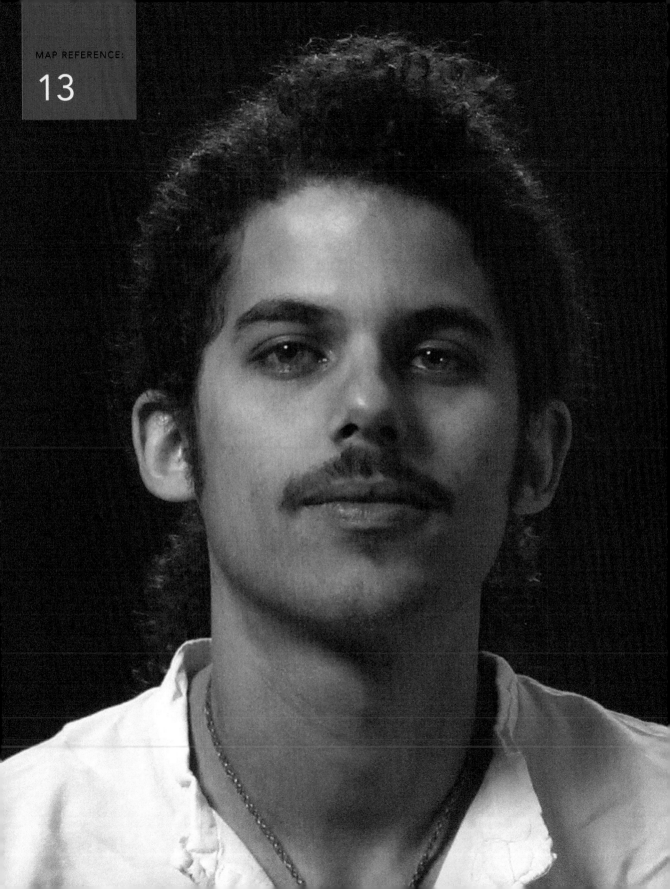

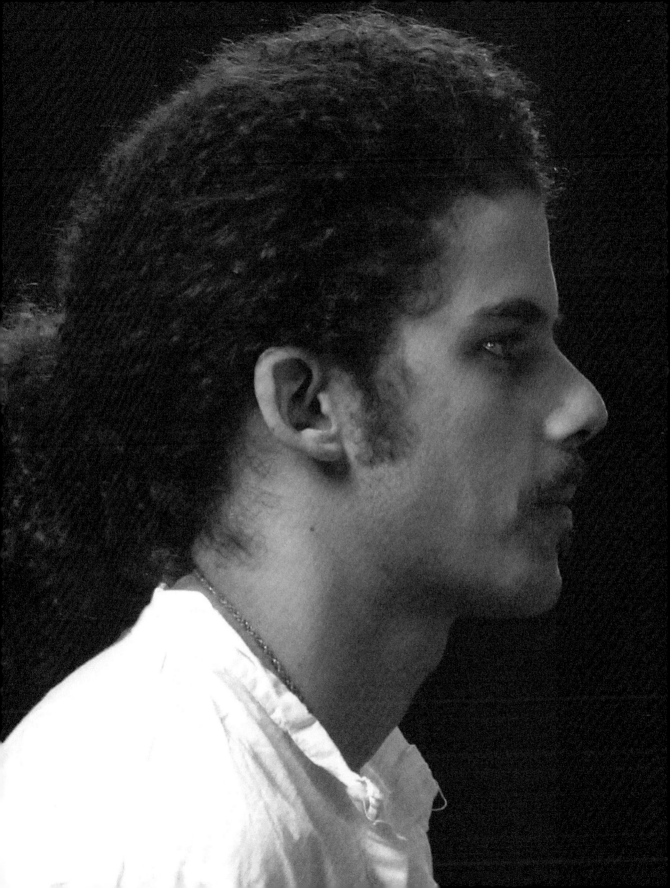

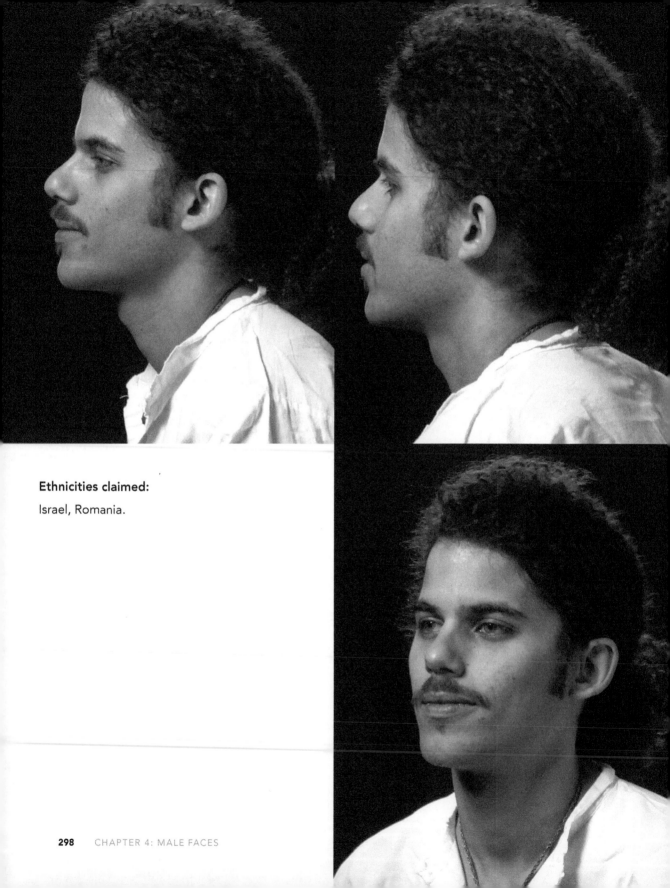

Ethnicities claimed:

Israel, Romania.

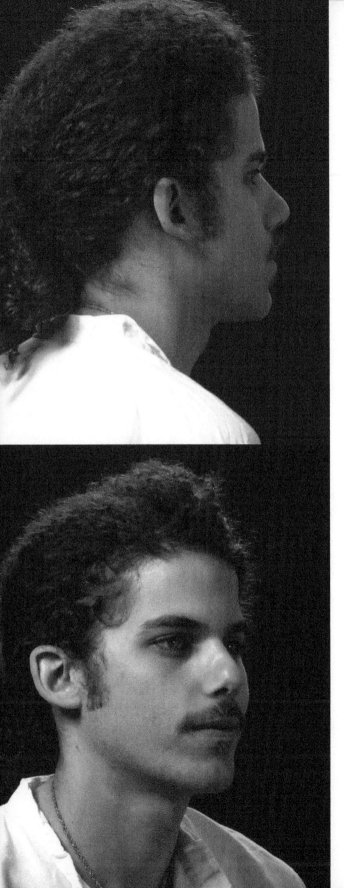

Head measurements (in):

A: 6
B: 5
C: 5 3/8
D: 5 3/8
E: 6 3/8
F: 4
G: 4 7/8
H: 5 3/8
I: 7 3/4
J: 5 3/4

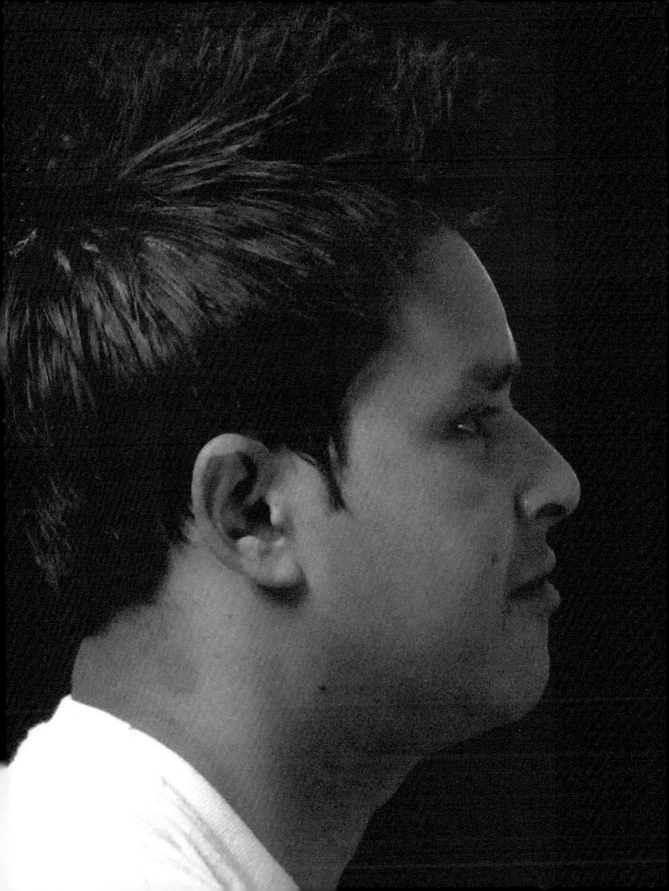

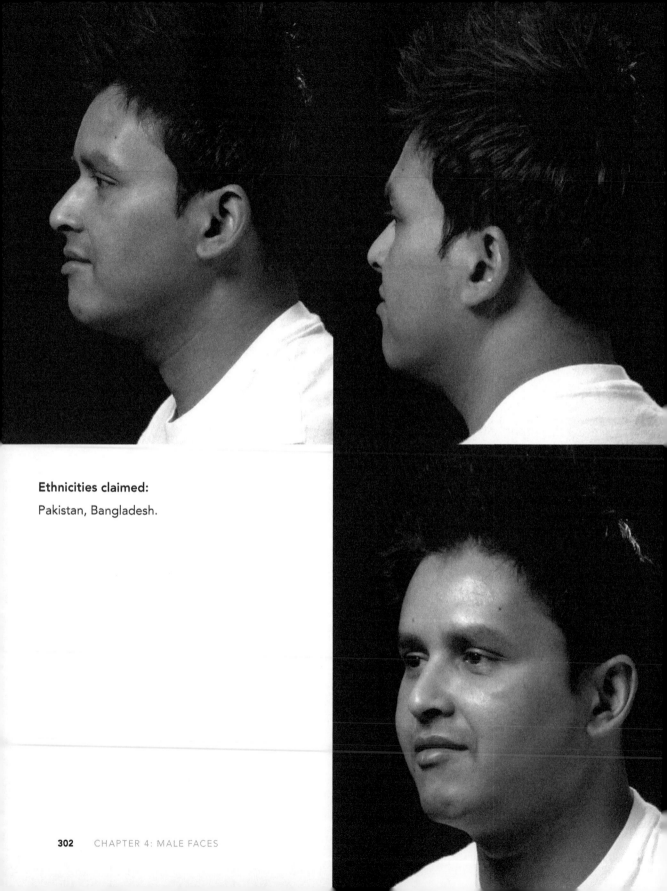

Ethnicities claimed:

Pakistan, Bangladesh.

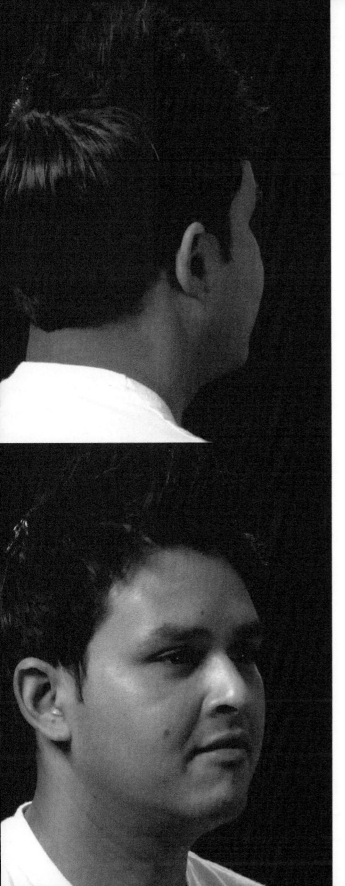

Head measurements (in):

A: 5

B: 5 1/4

C: 5 8

D: 5 1/4

E: 6 1/4

F: 3 7/8

G: 8 3/8

H: 5 3/8

I: 7 1/4

J: 6

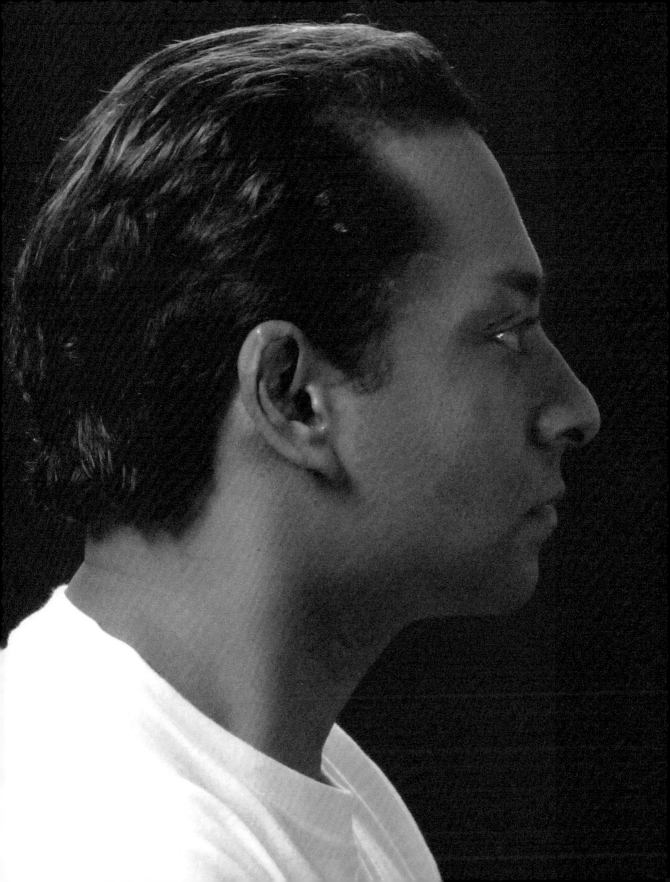

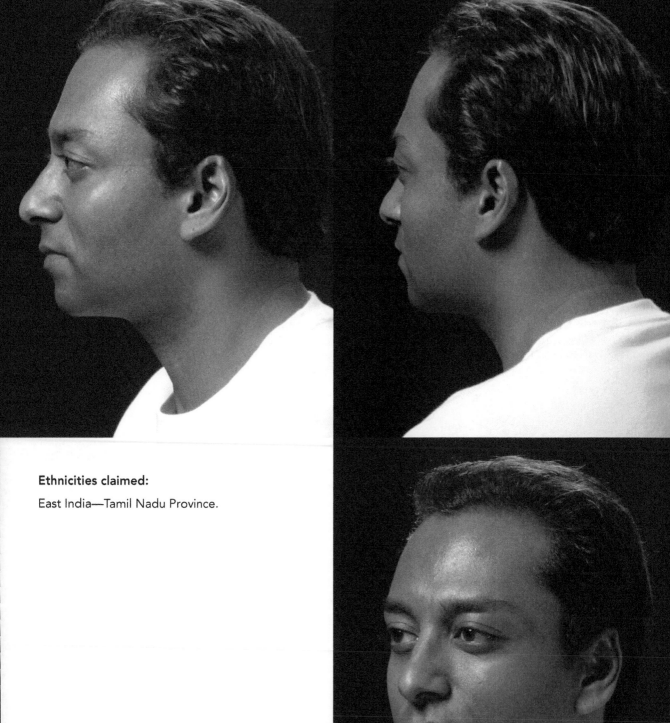

Ethnicities claimed:

East India—Tamil Nadu Province.

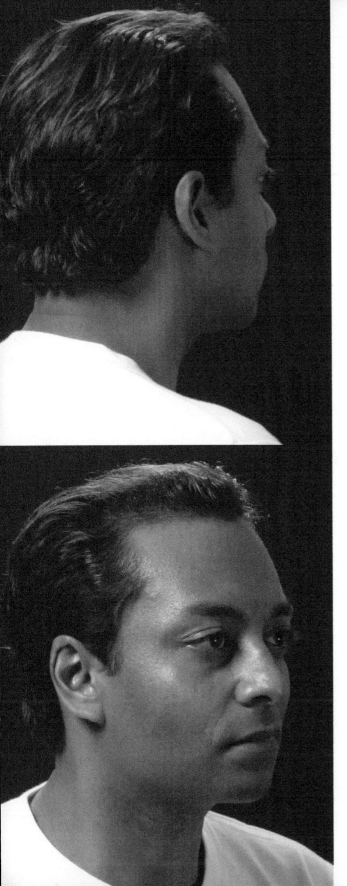

Head measurements (in):

A: 5 1/2

B: 5 1/4

C: 5 3/8

D: 5 3/4

E: 6 2/8

F: 3 3/8

G: 4 3/8

H: 5 1/4

I: 8

J: 5 3/4

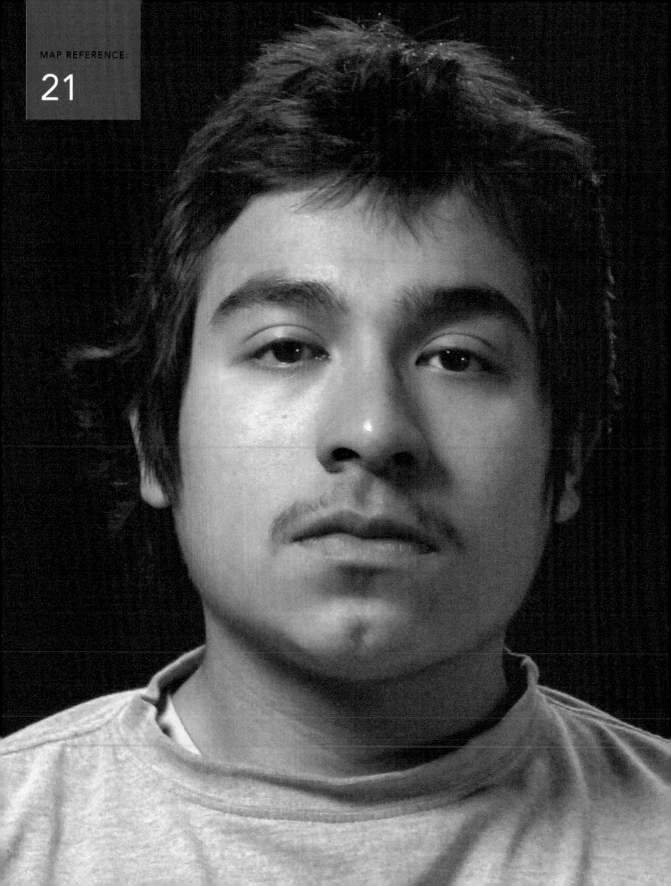

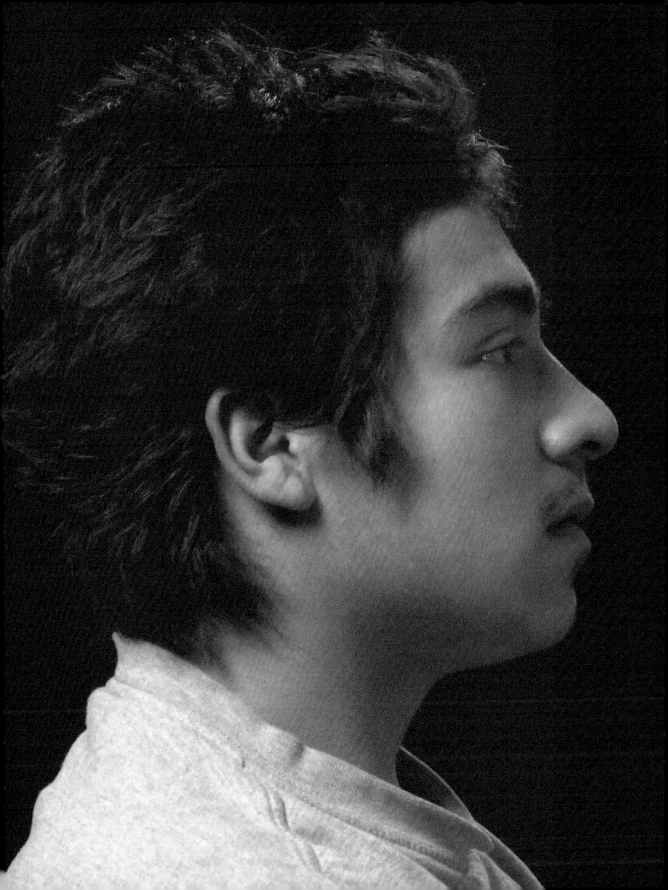

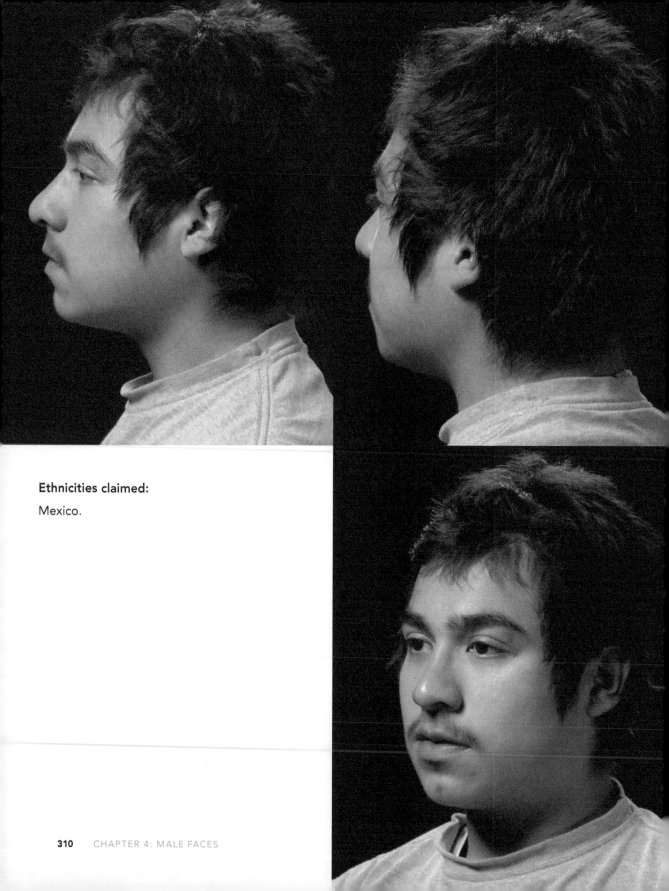

Ethnicities claimed:

Mexico.

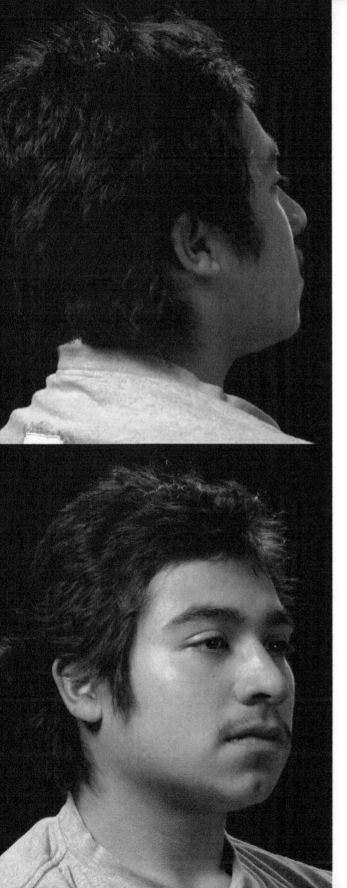

Head measurements (in):

A: 6 1/4
B: 6 1/8
C: 5 1/2
D: 5 7/8
E: 6 1/2
F: 3 5/8
G: 4 1/2
H: 5 1/2
I: 7 7/8
J: 6 1/2

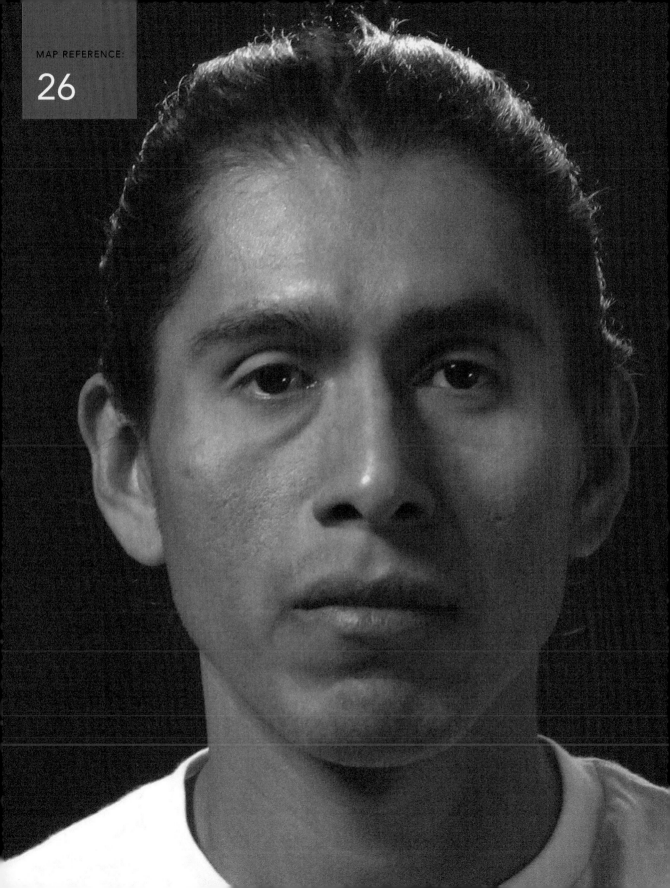

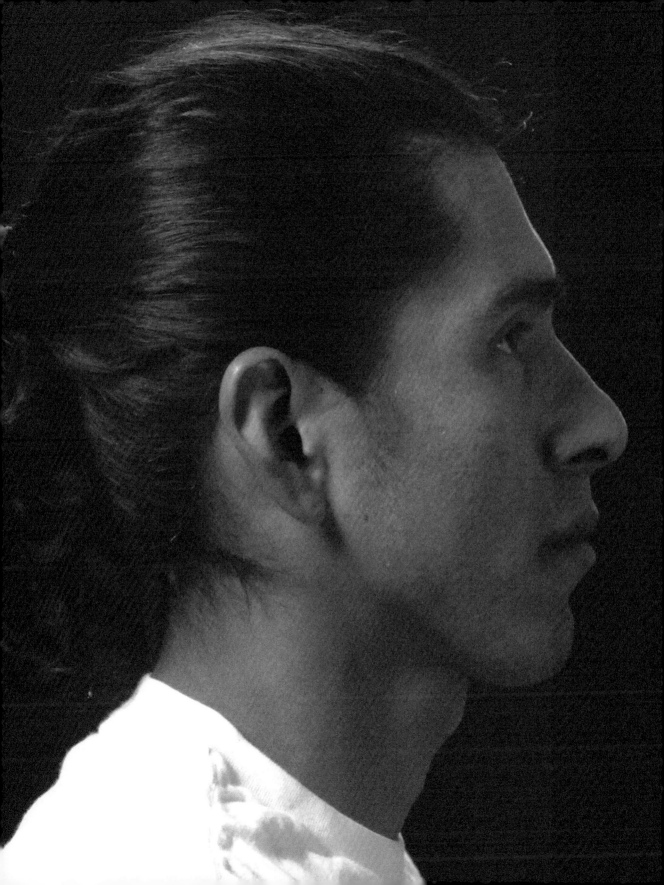

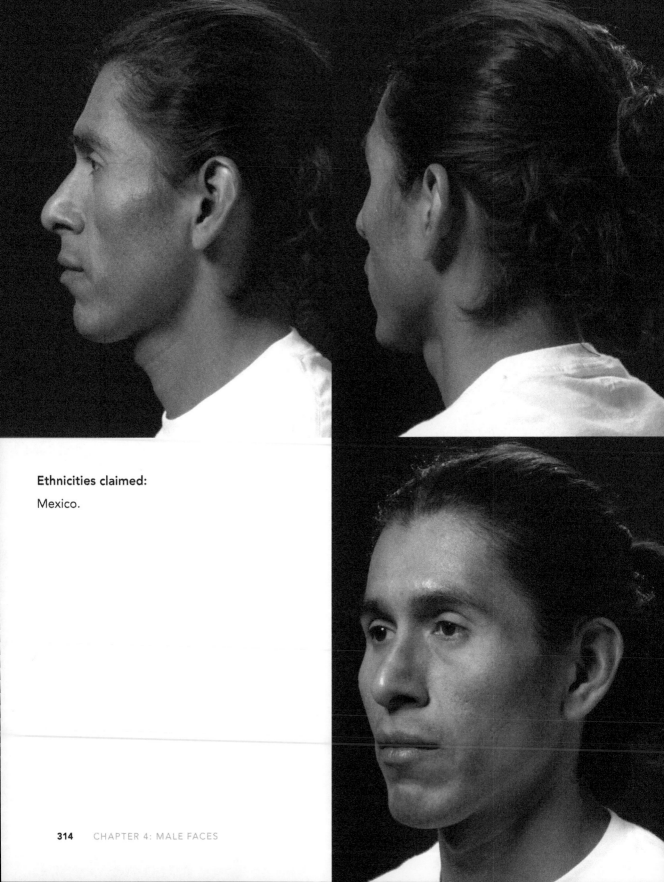

Ethnicities claimed:

Mexico.

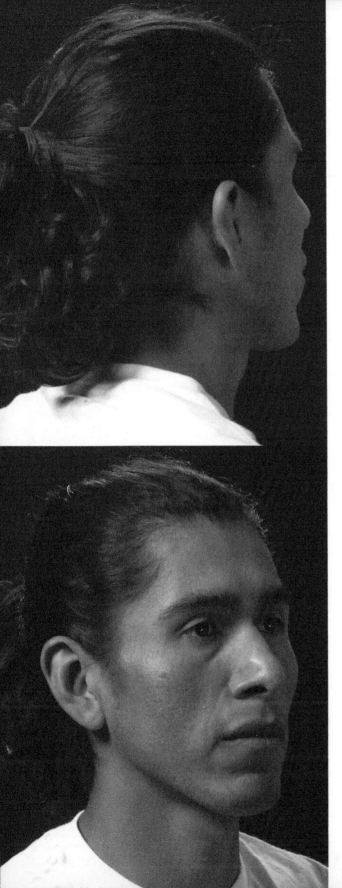

Head measurements (in):

A: 5 3/4

B: 4 3/4

C: 4 3/4

D: 5 3/8

E: 6 3/8

F: 3 3/4

G: 4 7/8

H: 5 5/8

I: 7 7/8

J: 6 1/8

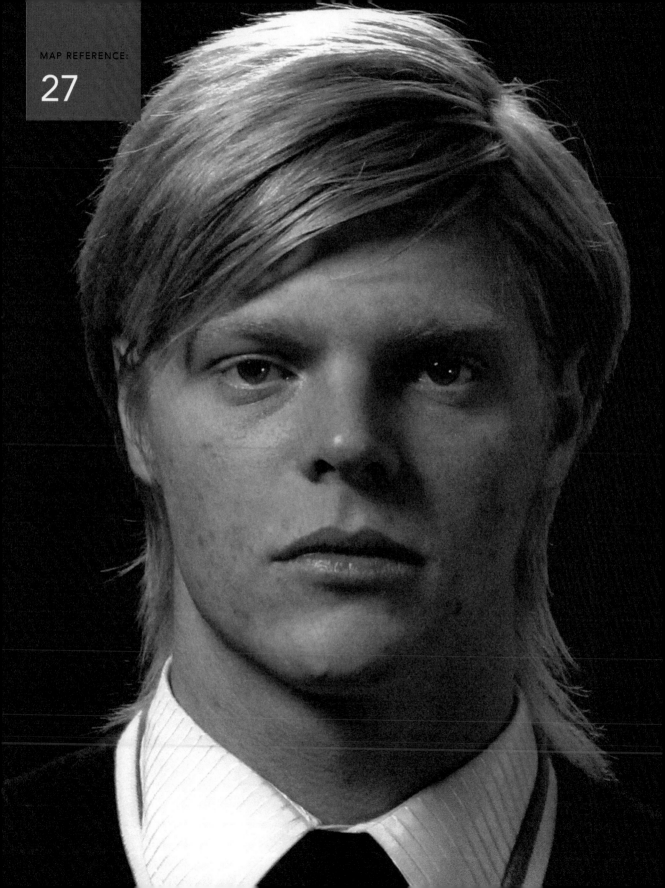

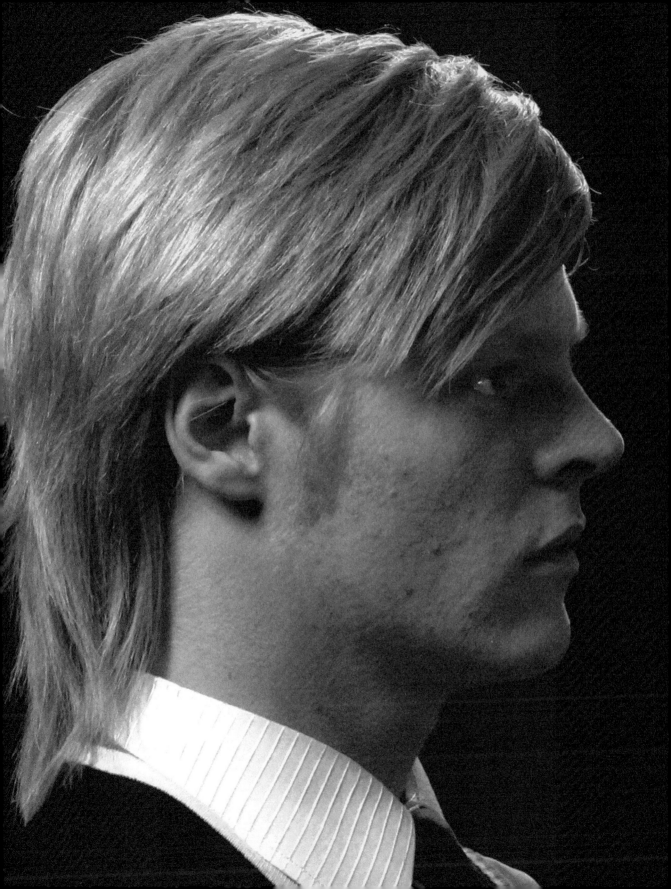

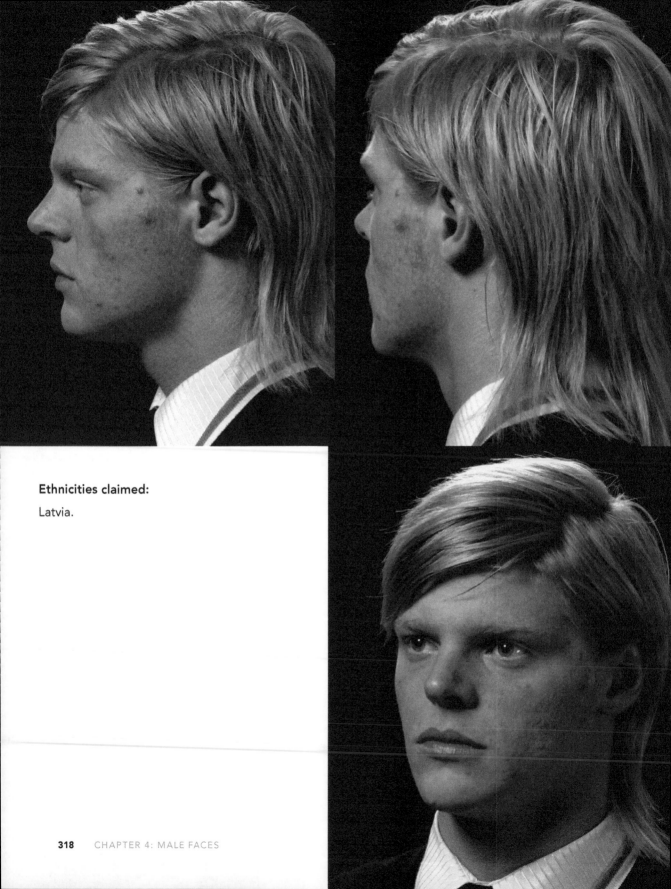

Ethnicities claimed:

Latvia.

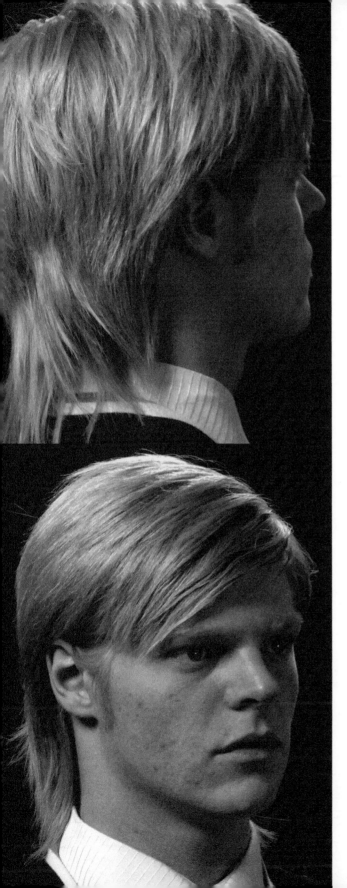

Head measurements (in):

A: 6 1/8
B: 5 3/4
C: 5 1/8
D: 5 3/4
E: 6 3/8
F: 3 7/8
G: 4 1/4
H: 5 1/8
I: 7 3/4
J: 6 1/8

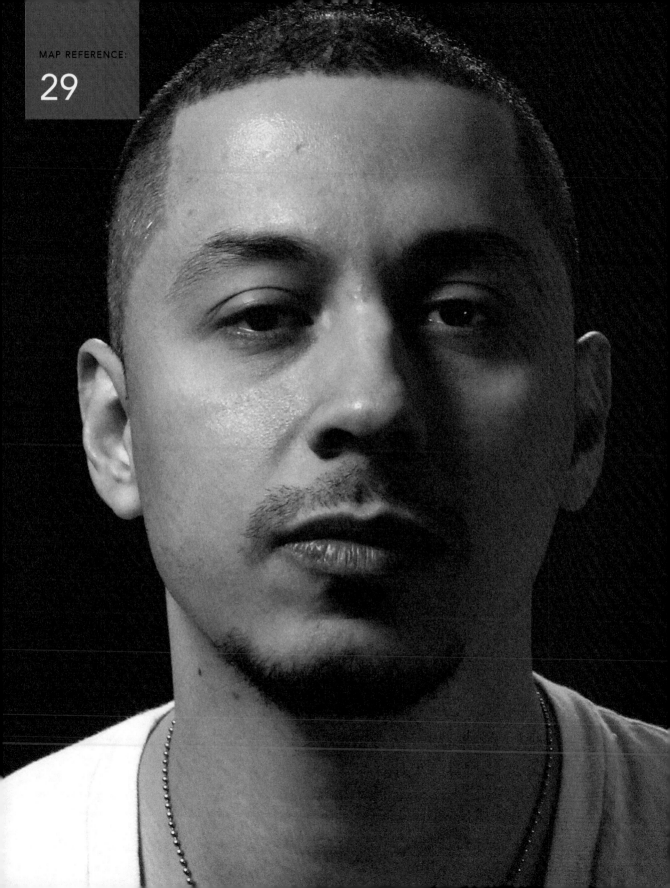

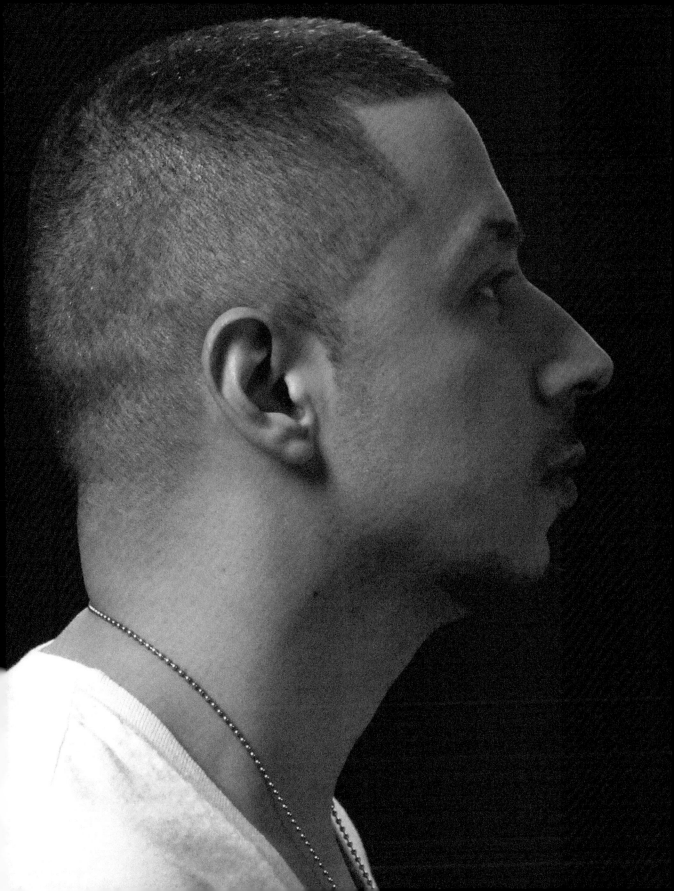

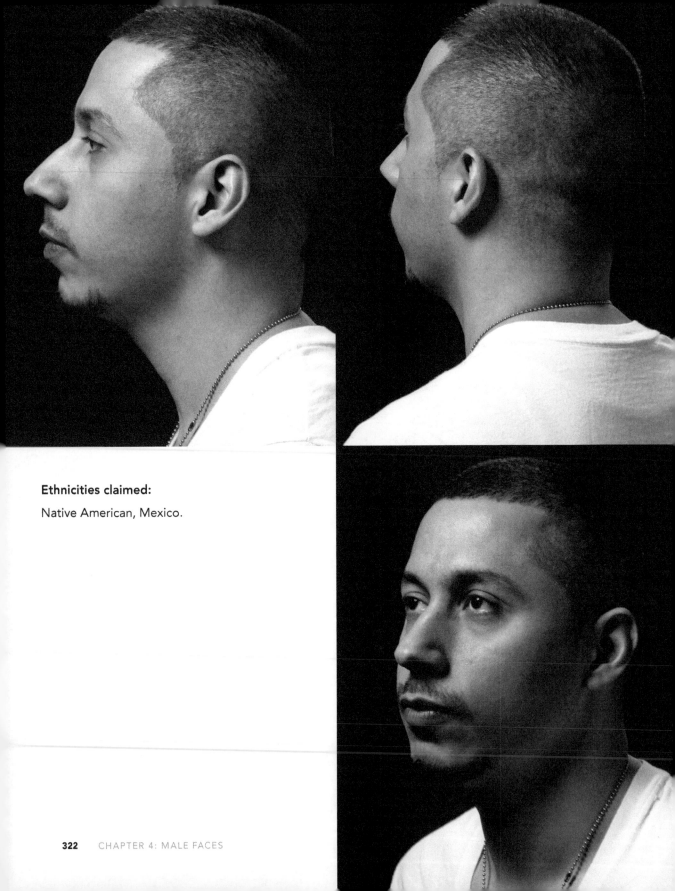

Ethnicities claimed:

Native American, Mexico.

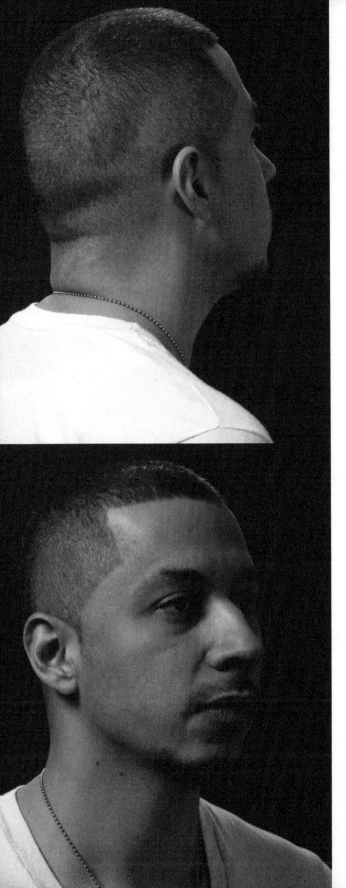

Head measurements (in):

A: 6 1/8
B: 5 3/4
C: 5 1/2
D: 5 5/8
E: 6 5/8
F: 3 7/8
G: 4 5/8
H: 5 5/8
I: 7 7/8
J: 6 1/8

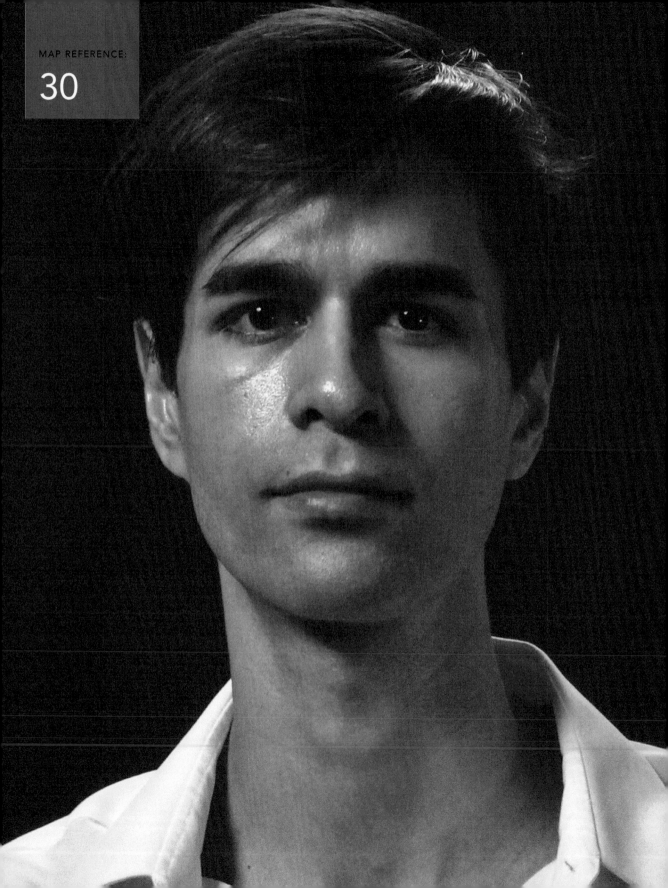

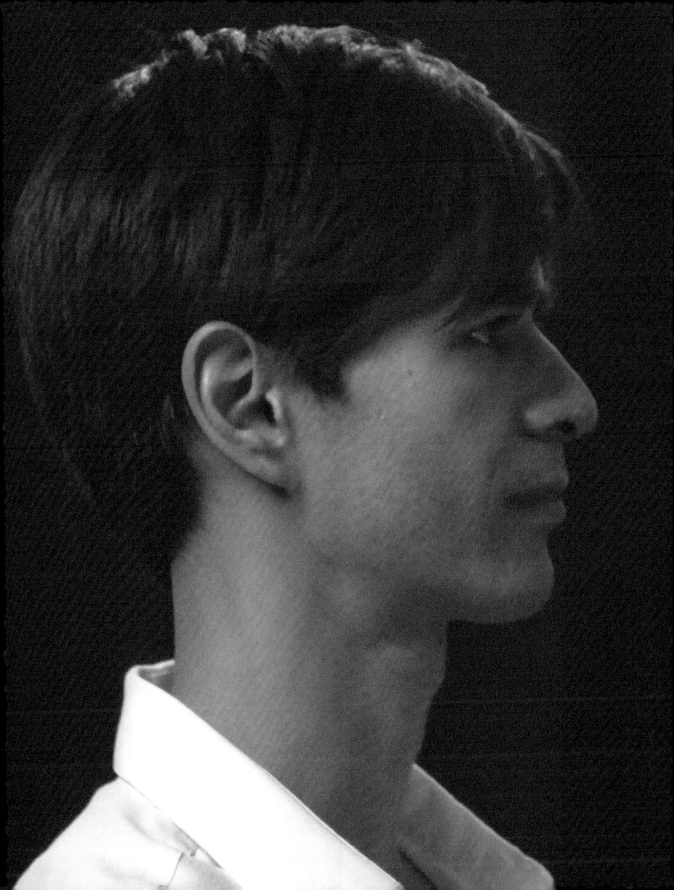

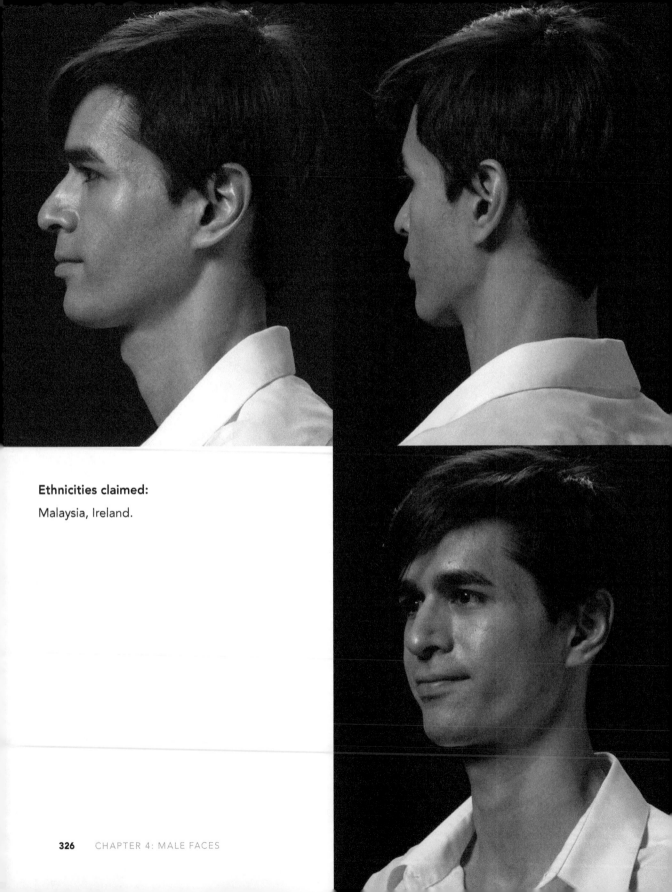

Ethnicities claimed:

Malaysia, Ireland.

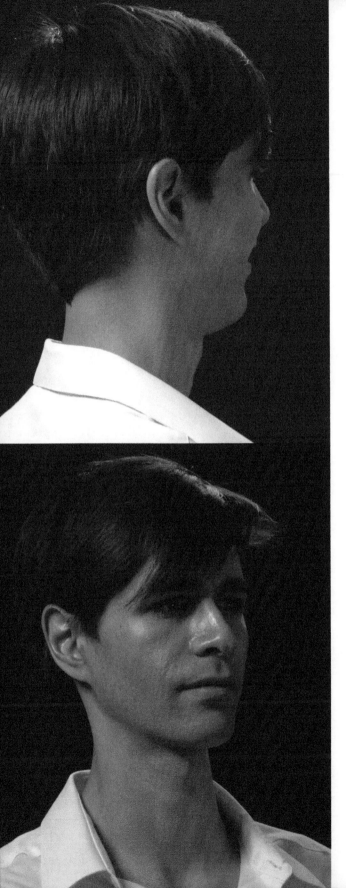

Head measurements (in):

A: 5 1/2

B: 6

C: 5 1/4

D: 5 1/2

E: 6 1/2

F: 3 3/8

G: 4 1/2

H: 5 1/4

I: 7 3/4

J: 5 3/4

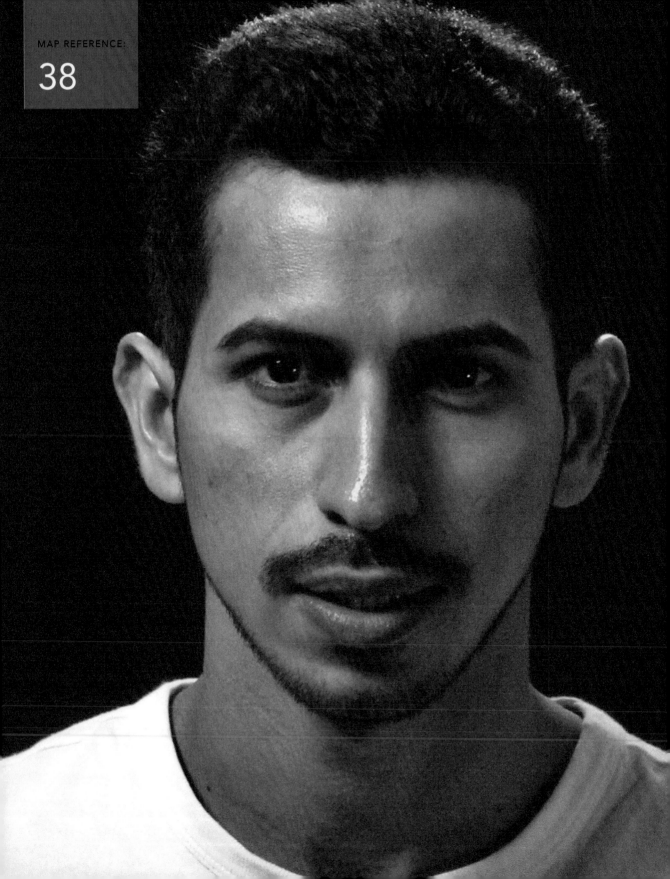

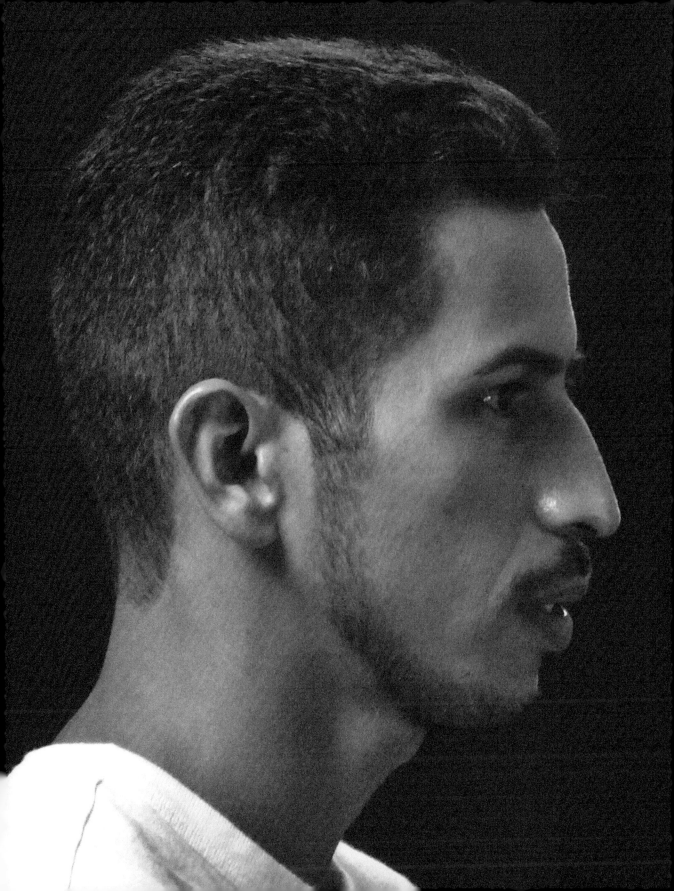

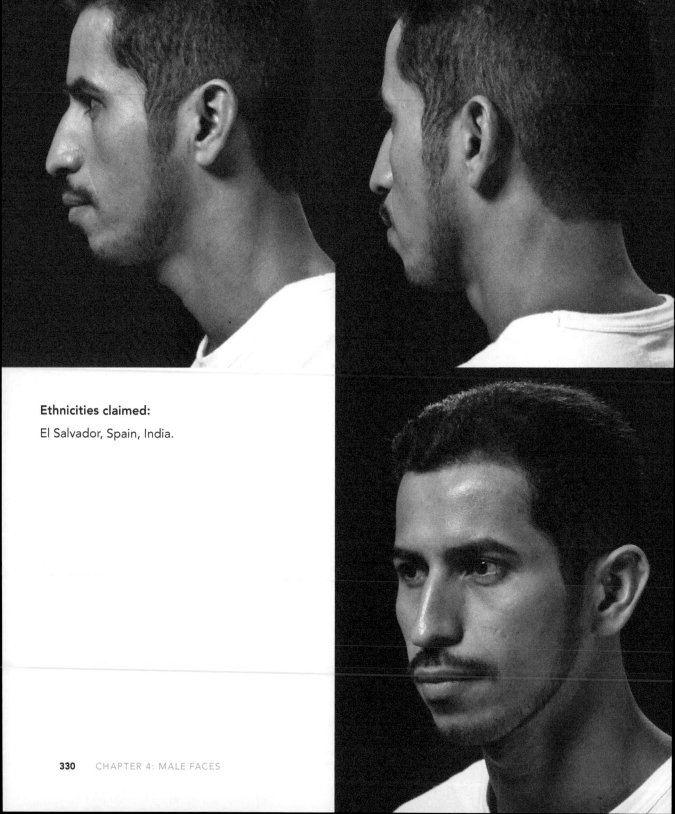

Ethnicities claimed:

El Salvador, Spain, India.

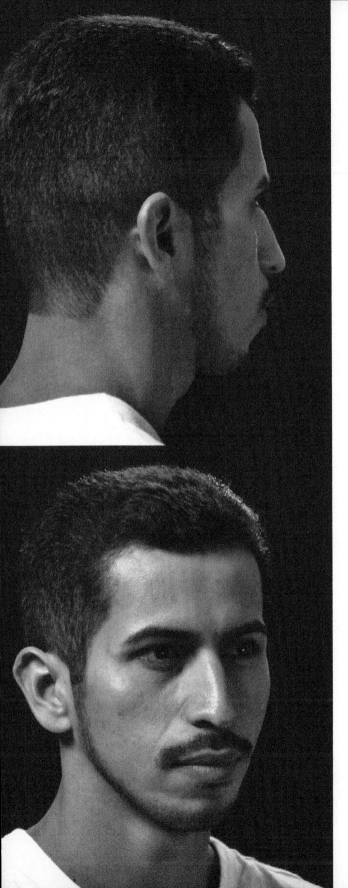

Head measurements (in):

A: 5 1/2

B: 5 1/4

C: 5 1/8

D: 5 1/8

E: 6 1/2

F: 3 3/8

G: 4 3/4

H: 5 5/8

I: 7 1/4

J: 5 3/8

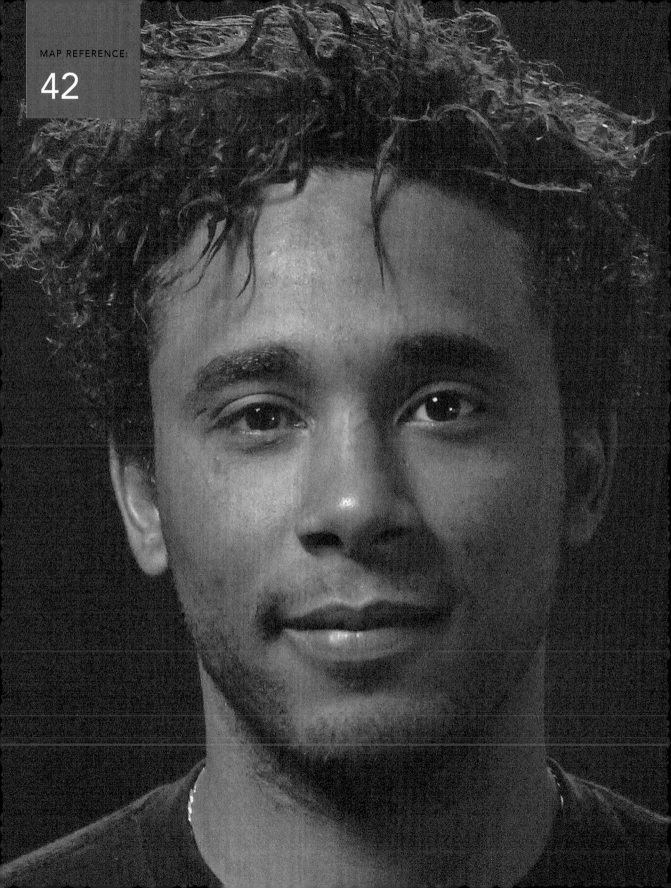

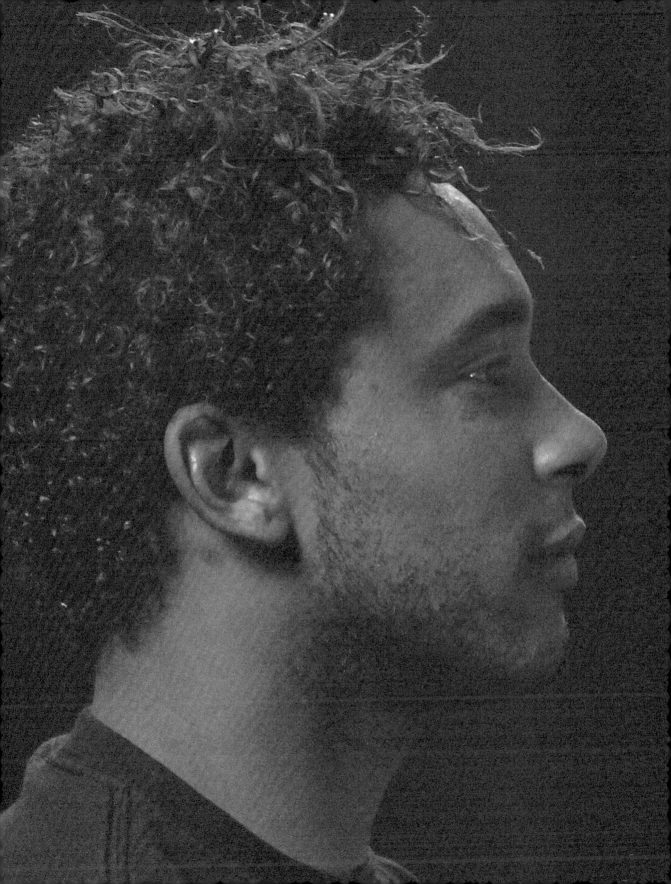

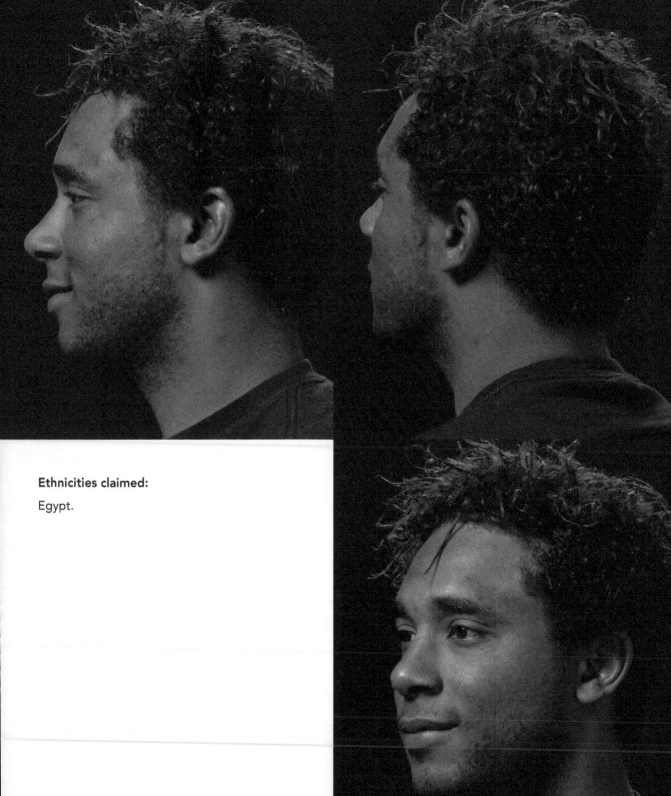

Ethnicities claimed:

Egypt.

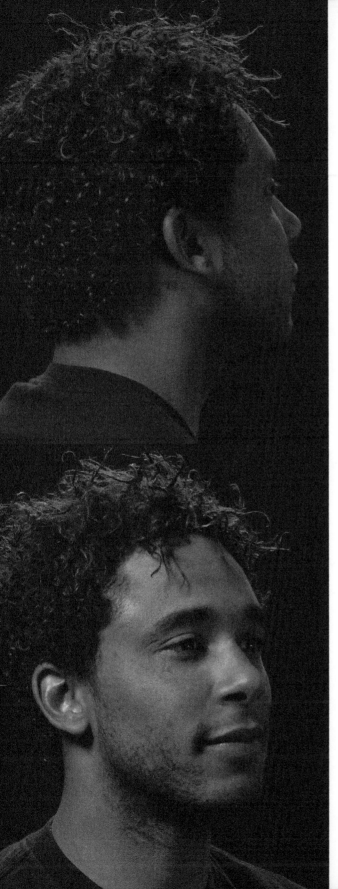

Head measurements (in):

A: 5 7/8
B: 5 5/8
C: 4 7/8
D: 5 5/8
E: 6 1/4
F: 4 3/8
G: 4 5/8
H: 5 5/8
I: 7 7/8
J: 5 7/8

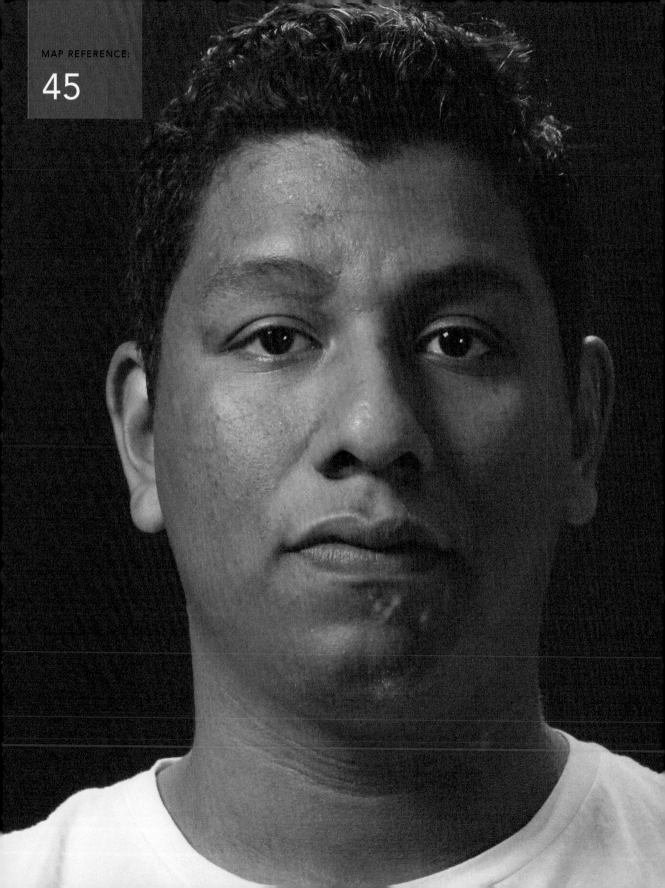

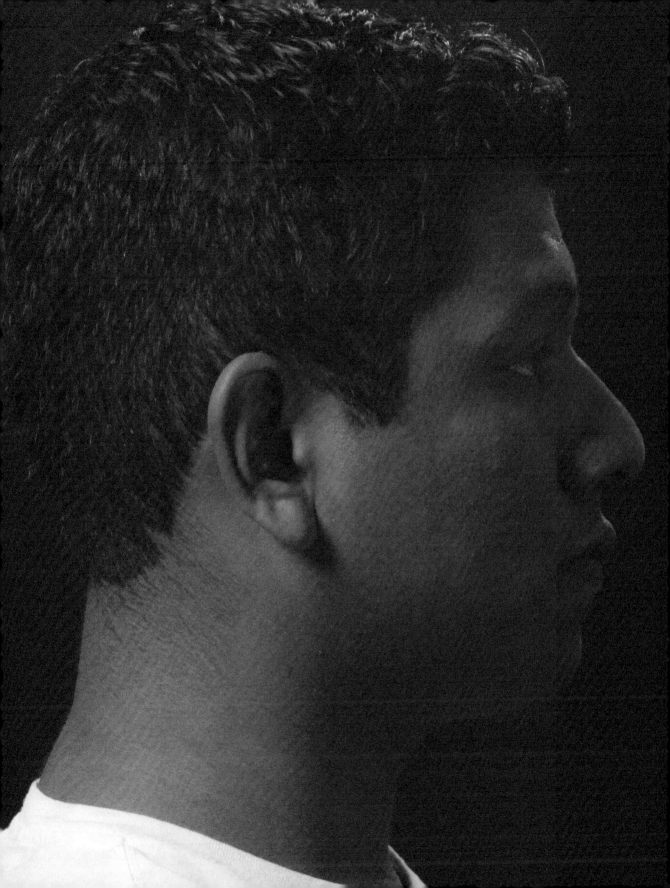

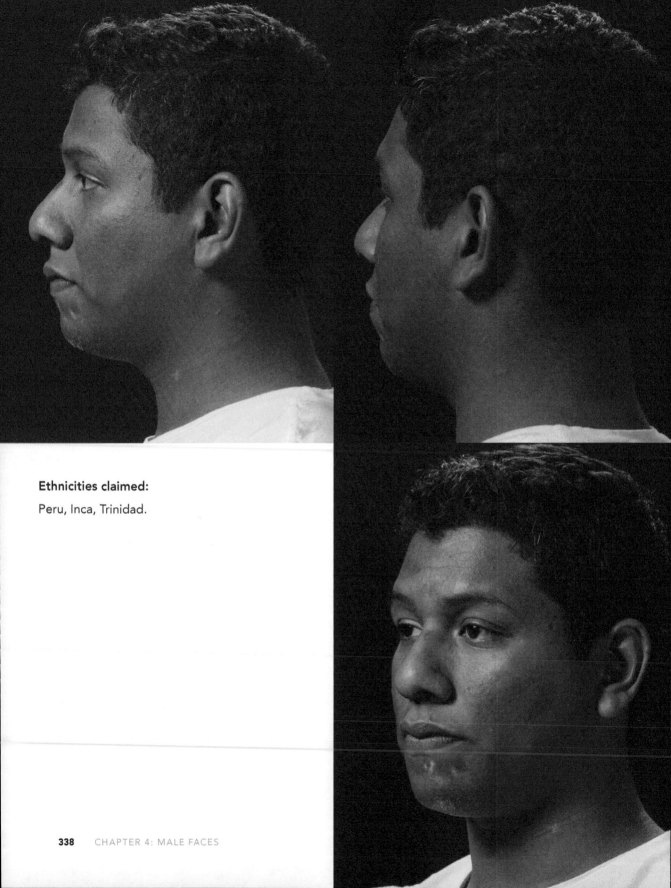

Ethnicities claimed:

Peru, Inca, Trinidad.

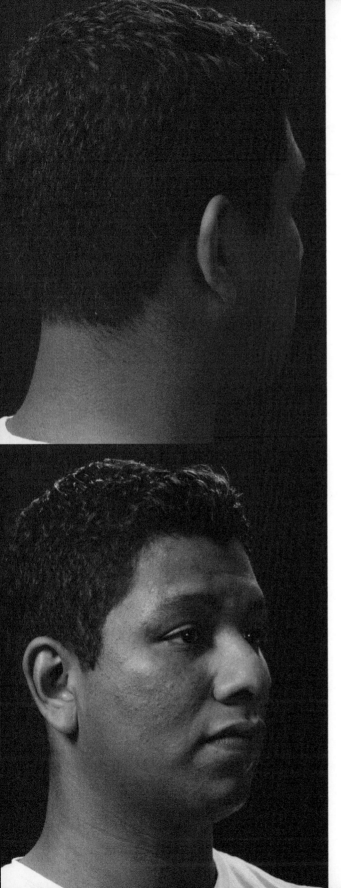

FGHI

Head measurements (in):

A: 6 5/8

B: 6 3/8

C: 5 7/8

D: 5 5/8

E: 6 1/2

F: 4

G: 4 1/2

H: 5 5/8

I: 7 3/4

J: 6 5/8

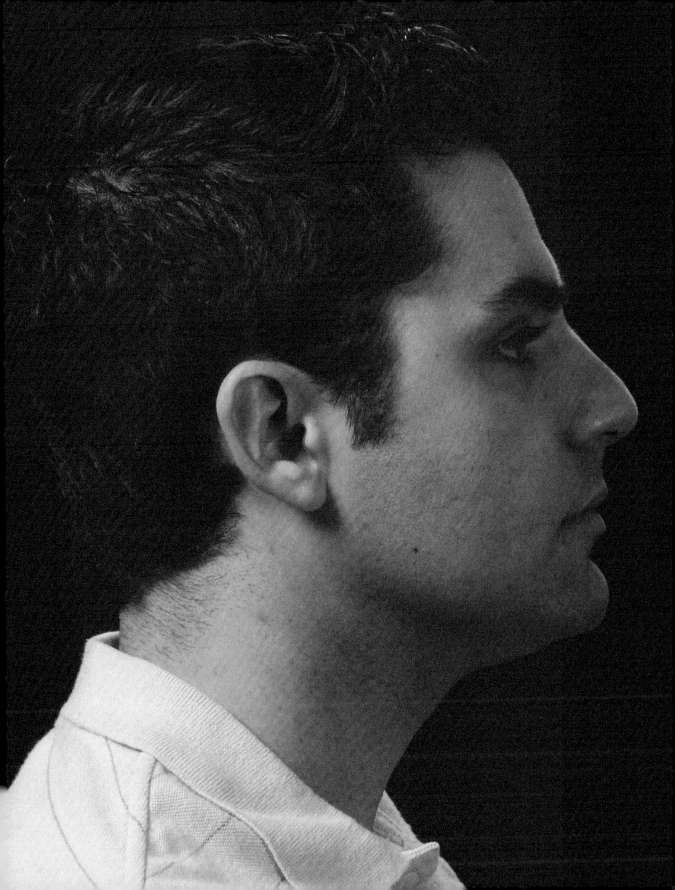

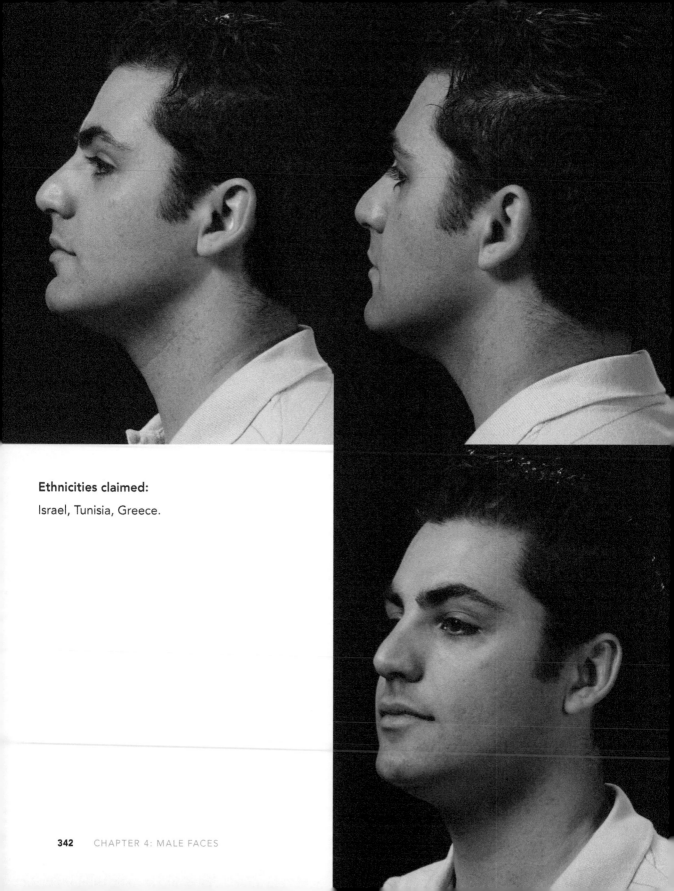

Ethnicities claimed:

Israel, Tunisia, Greece.

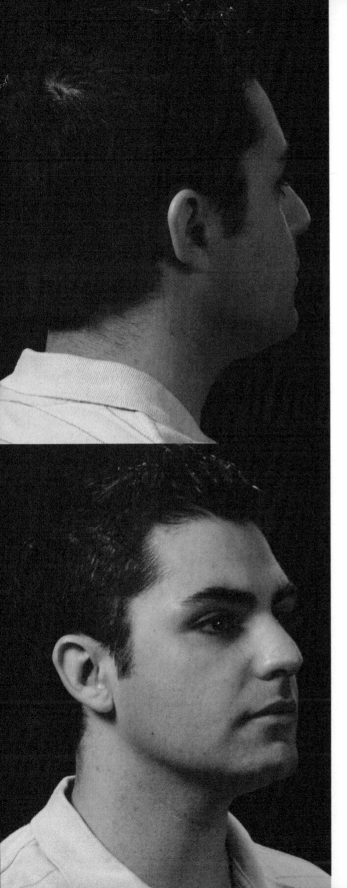

Head measurements (in):

A: 5 7/8
B: 5 5/8
C: 5 3/8
D: 5 1/2
E: 6 1/8
F: 3 3/8
G: 4 1/8
H: 5 1/4
I: 7 1/4
J: 5 7/8

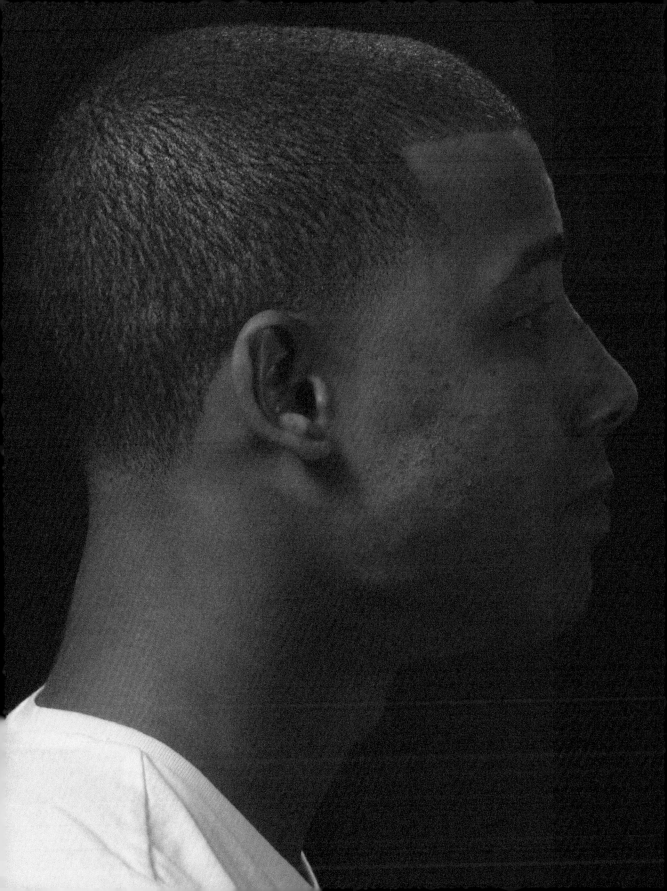

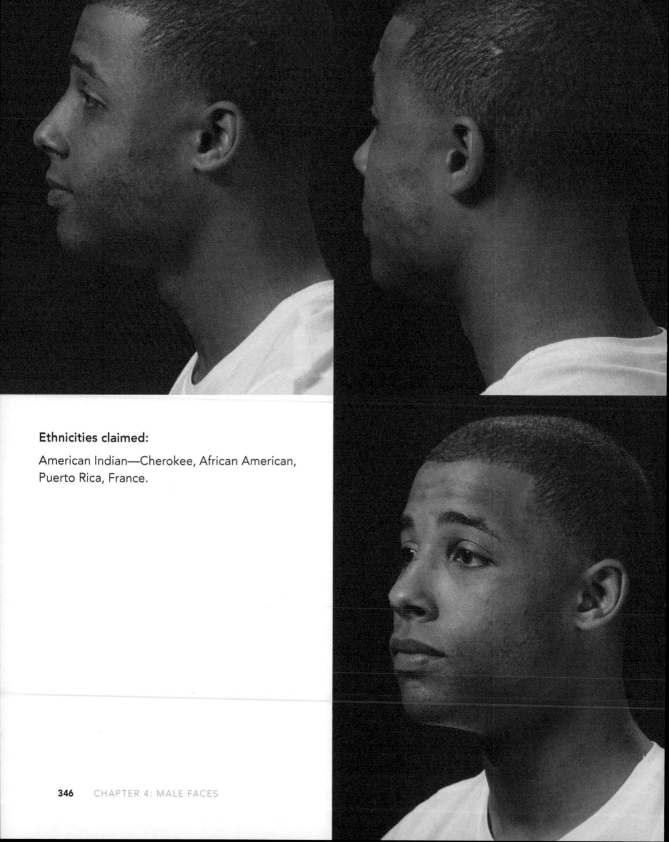

Ethnicities claimed:

American Indian—Cherokee, African American,
Puerto Rica, France.

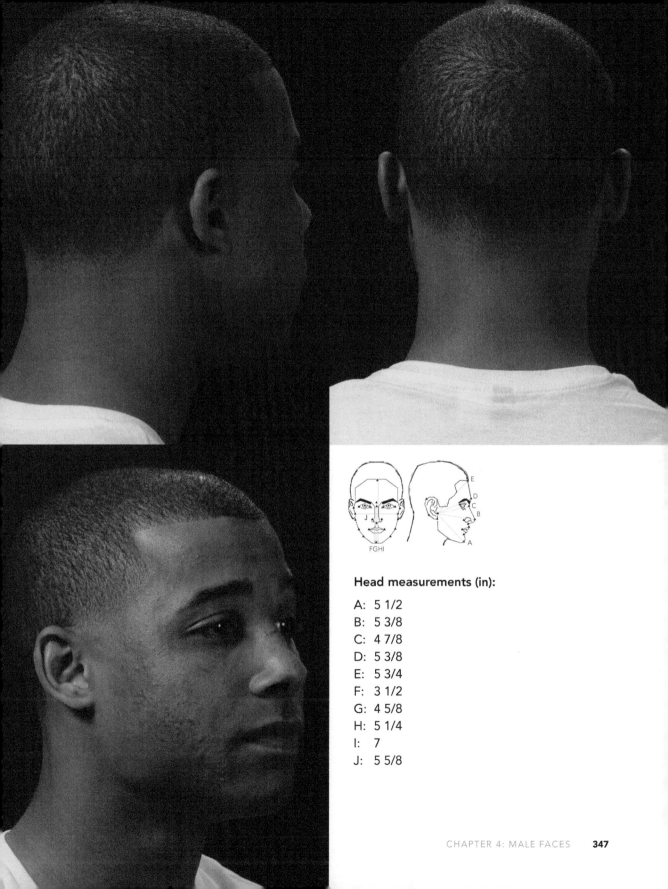

Head measurements (in):

A: 5 1/2

B: 5 3/8

C: 4 7/8

D: 5 3/8

E: 5 3/4

F: 3 1/2

G: 4 5/8

H: 5 1/4

I: 7

J: 5 5/8

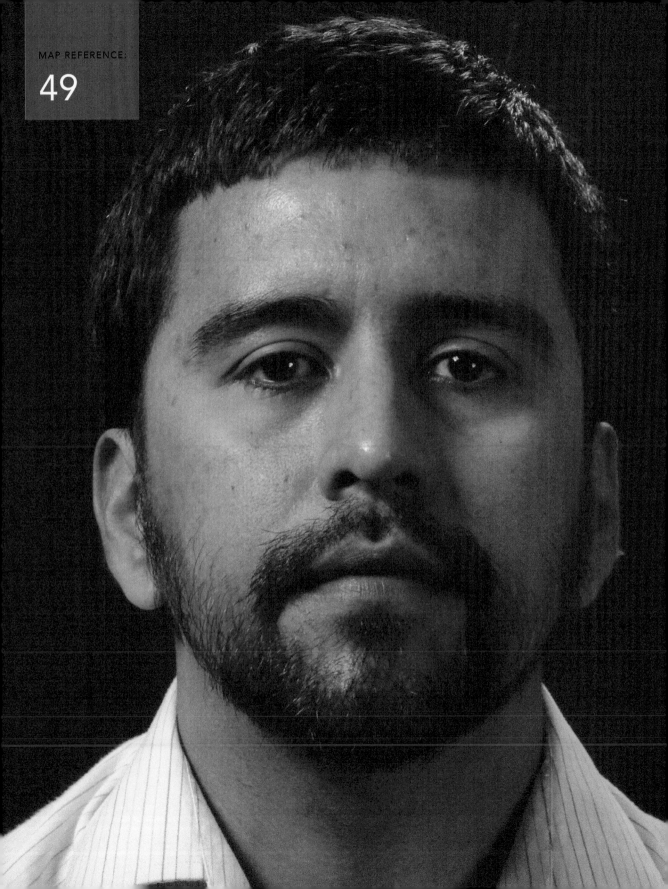

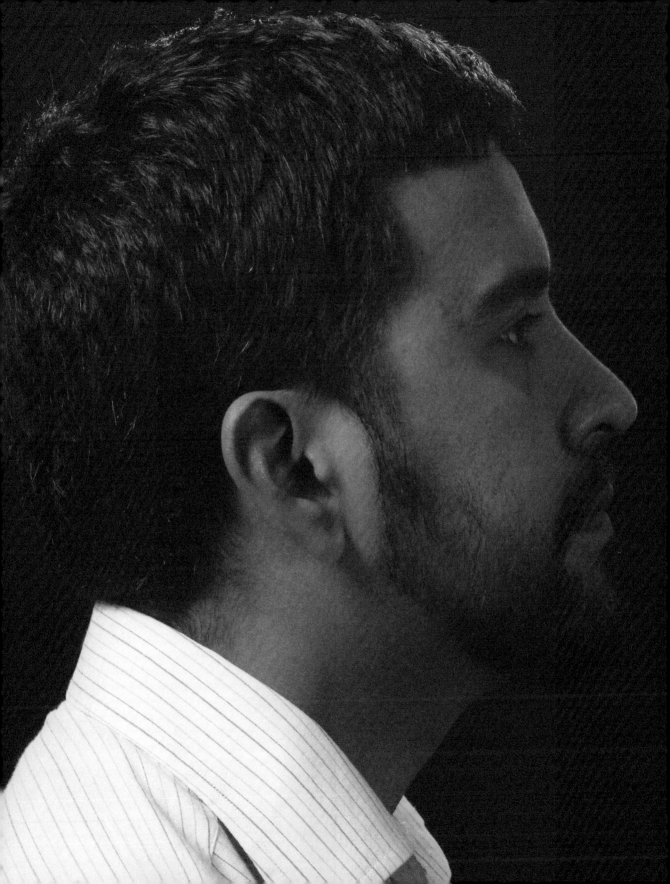

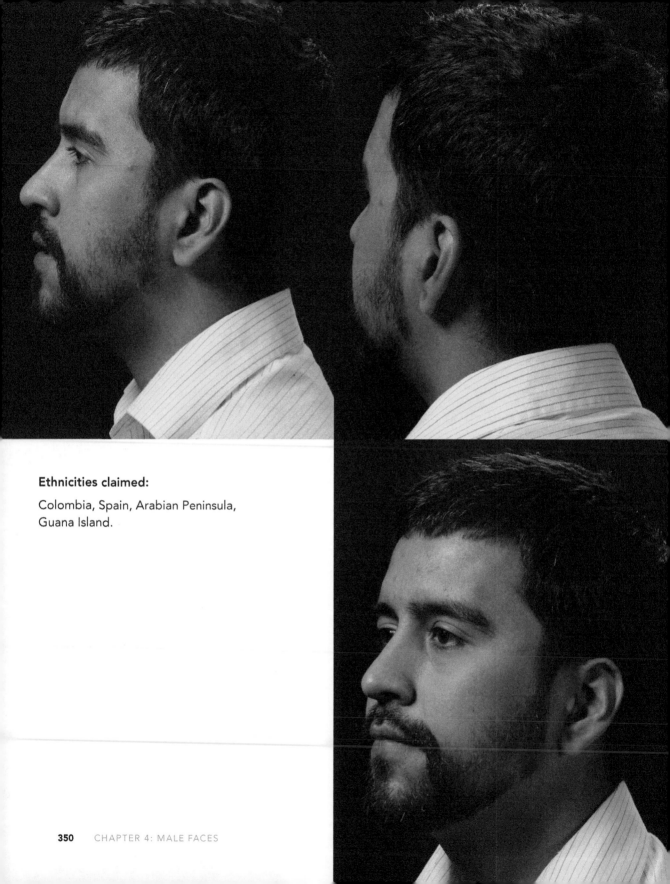

Ethnicities claimed:

Colombia, Spain, Arabian Peninsula,
Guana Island.

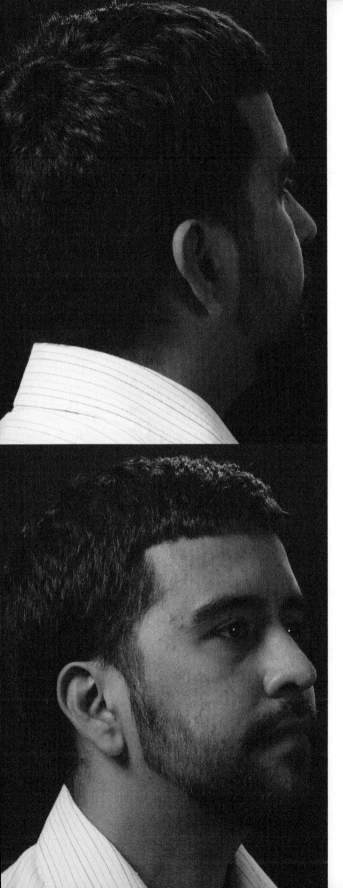

Head measurements (in):

A: 5 1/2
B: 5 1/2
C: 5 1/4
D: 5 3/4
E: 6 5/8
F: 4
G: 5
H: 5 3/4
I: 8 3/8
J: 5 5/8

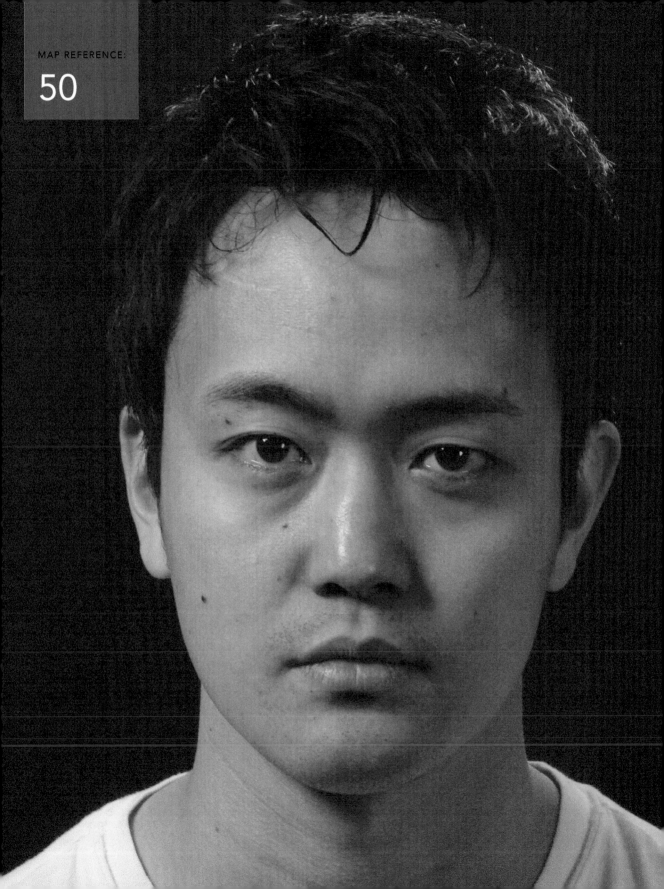

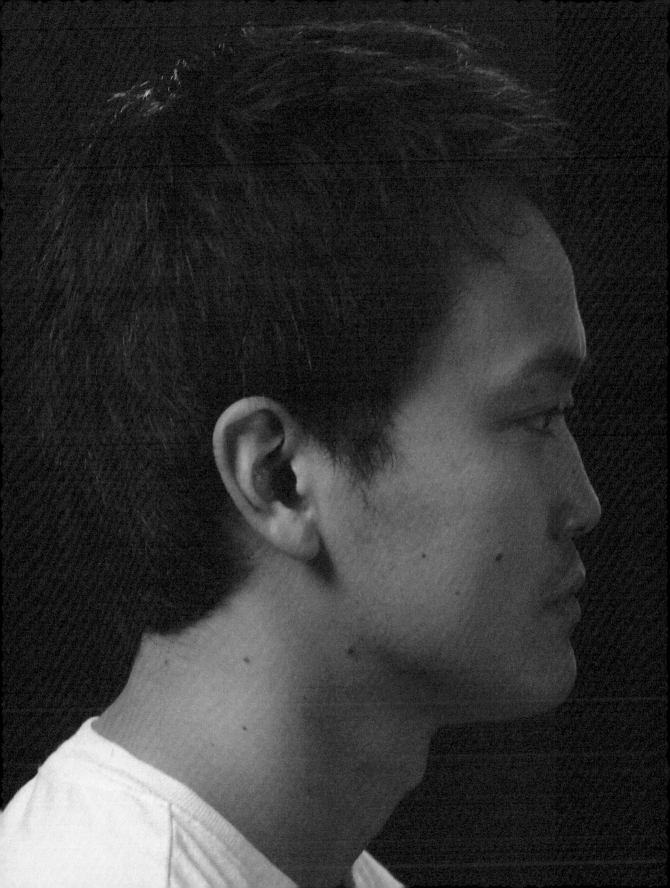

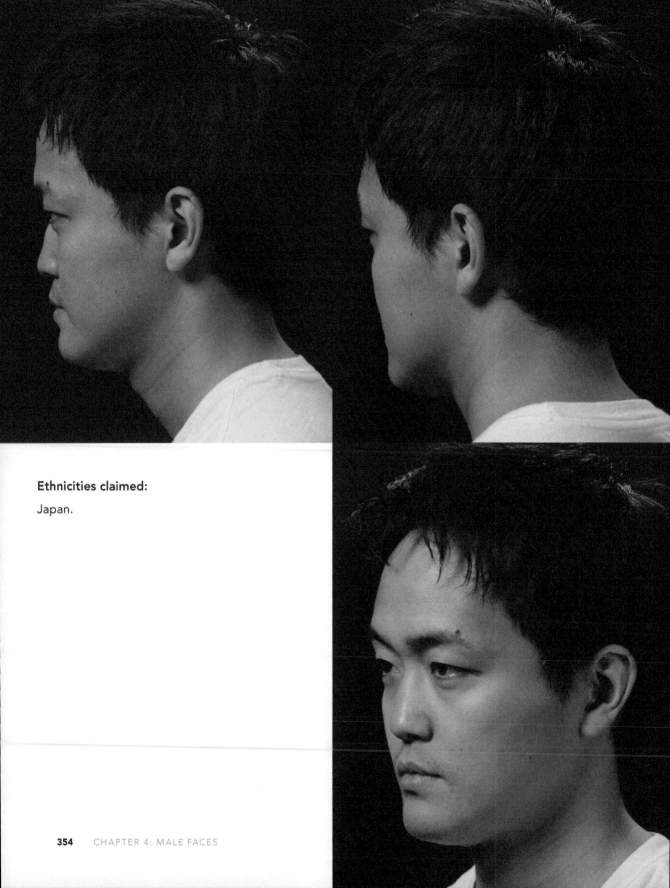

Ethnicities claimed:

Japan.

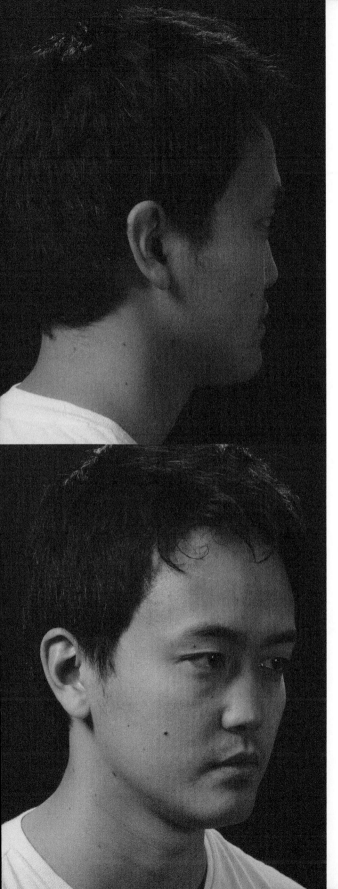

Head measurements (in):

A: 5 5/8

B: 5 1/2

C: 5 1/4

D: 5 5/8

E: 6 3/4

F: 3 3/8

G: 4 3/8

H: 5 1/8

I: 8 1/8

J: 6

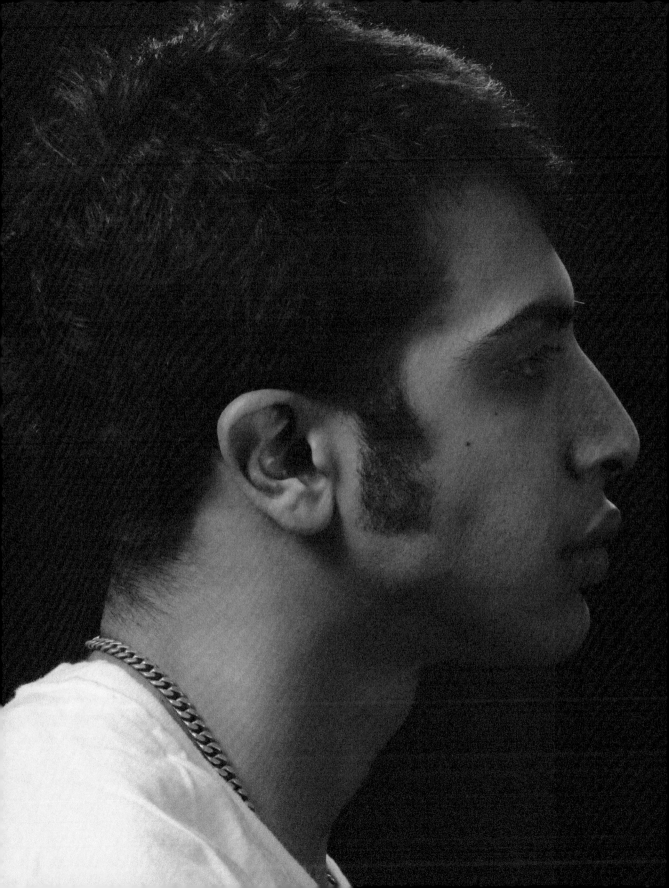

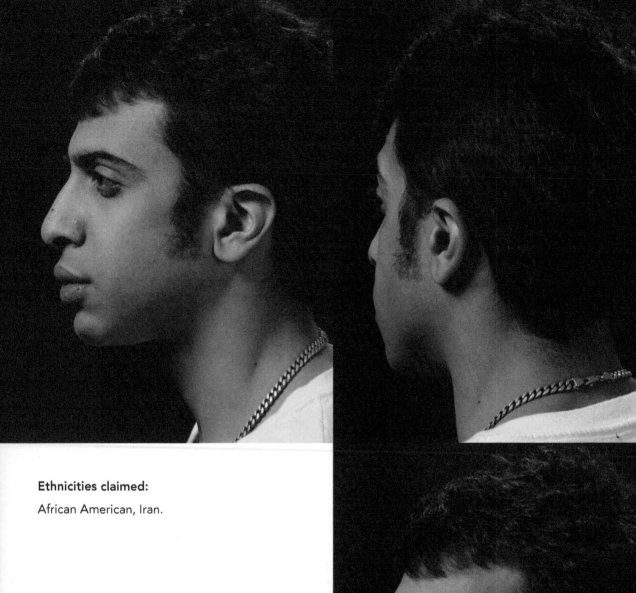

Ethnicities claimed:

African American, Iran.

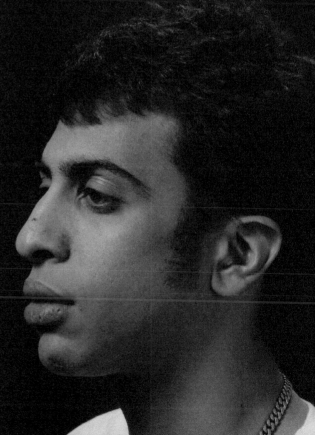

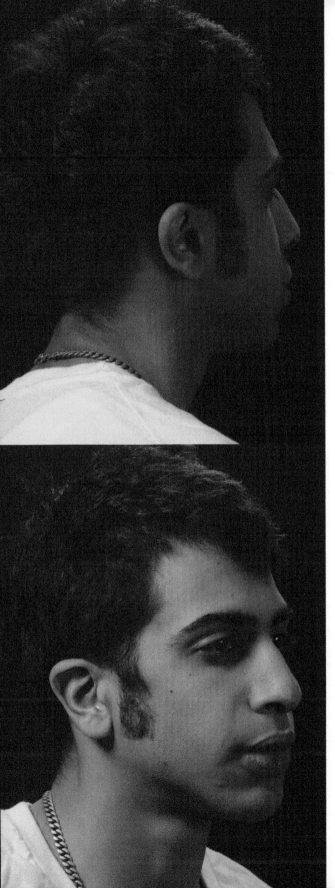

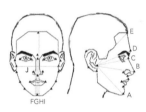

Head measurements (in):

A: 5 1/2
B: 5 5/8
C: 5
D: 5 3/4
E: 5 5/8
F: 3 5/8
G: 4 3/4
H: 5
I: 7 1/2
J: 5 1/8

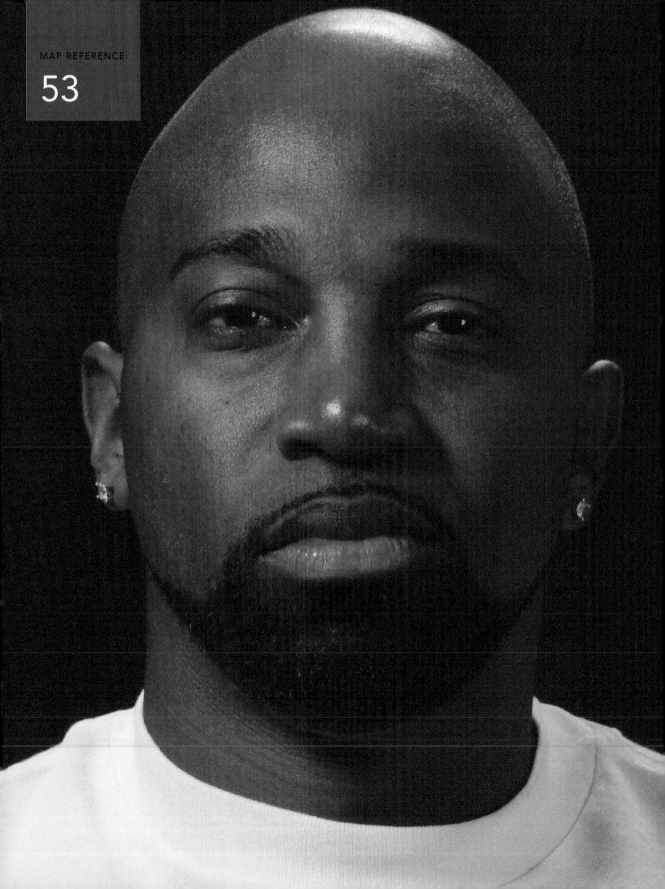

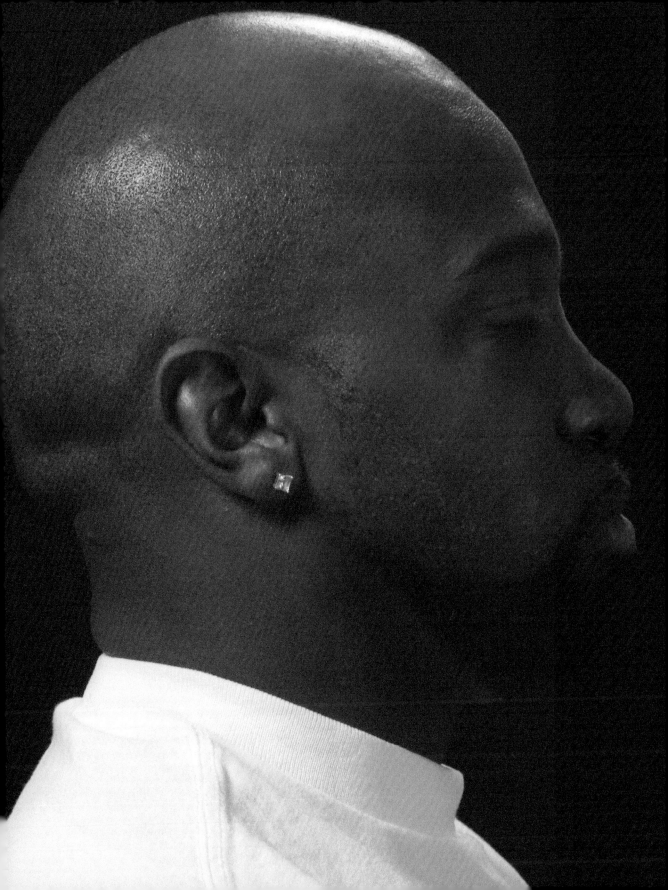

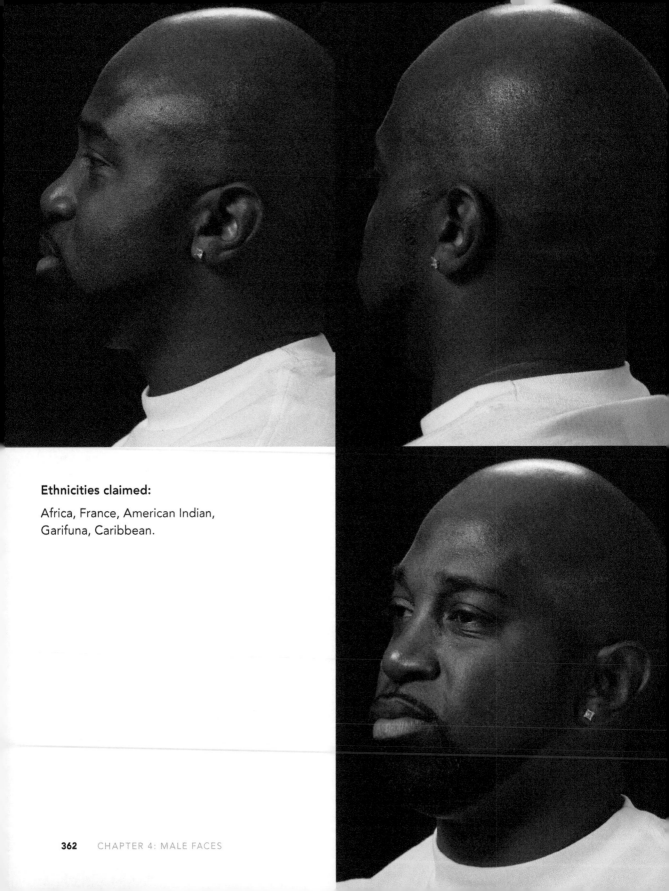

Ethnicities claimed:

Africa, France, American Indian,
Garifuna, Caribbean.

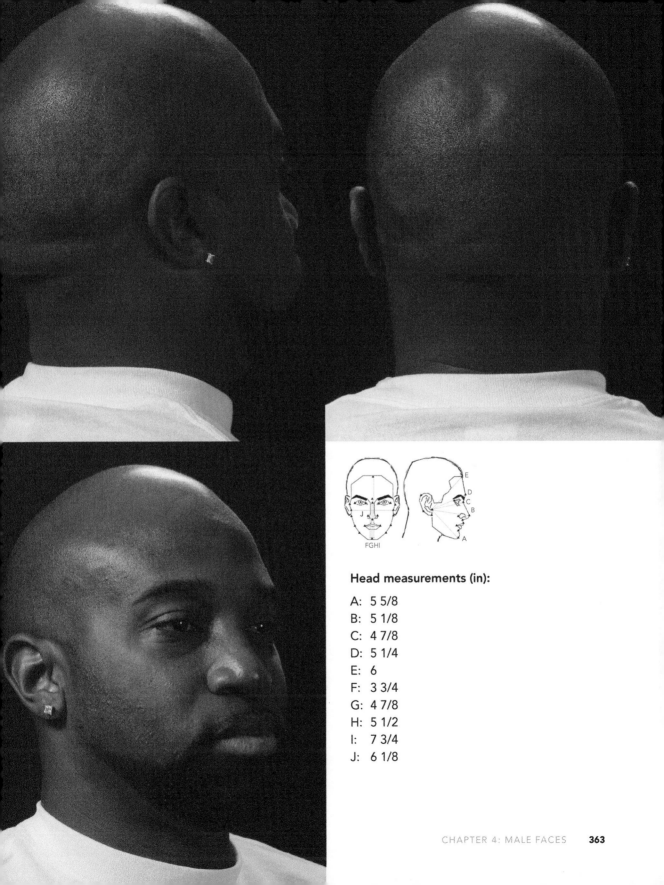

Head measurements (in):

A: 5 5/8
B: 5 1/8
C: 4 7/8
D: 5 1/4
E: 6
F: 3 3/4
G: 4 7/8
H: 5 1/2
I: 7 3/4
J: 6 1/8

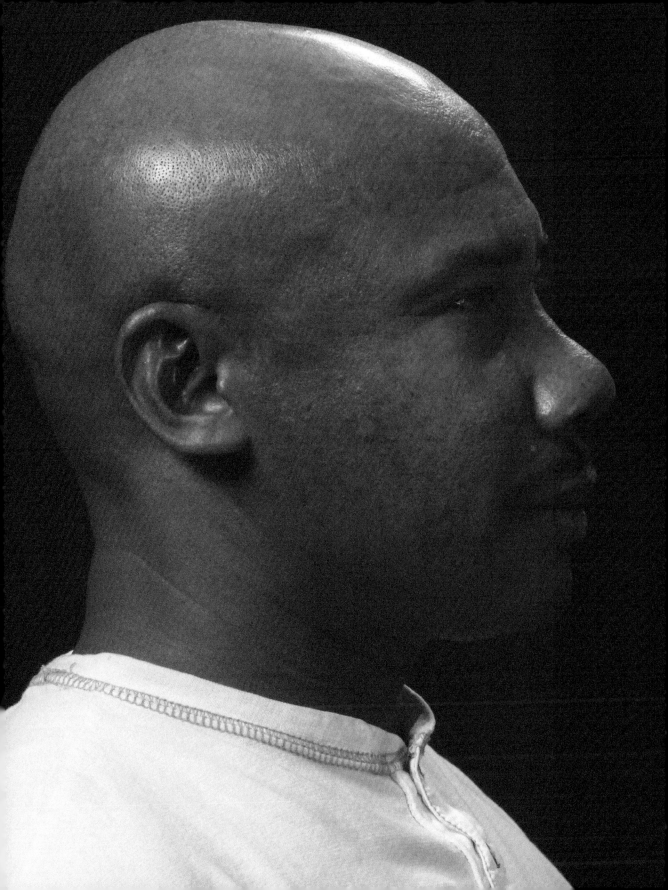

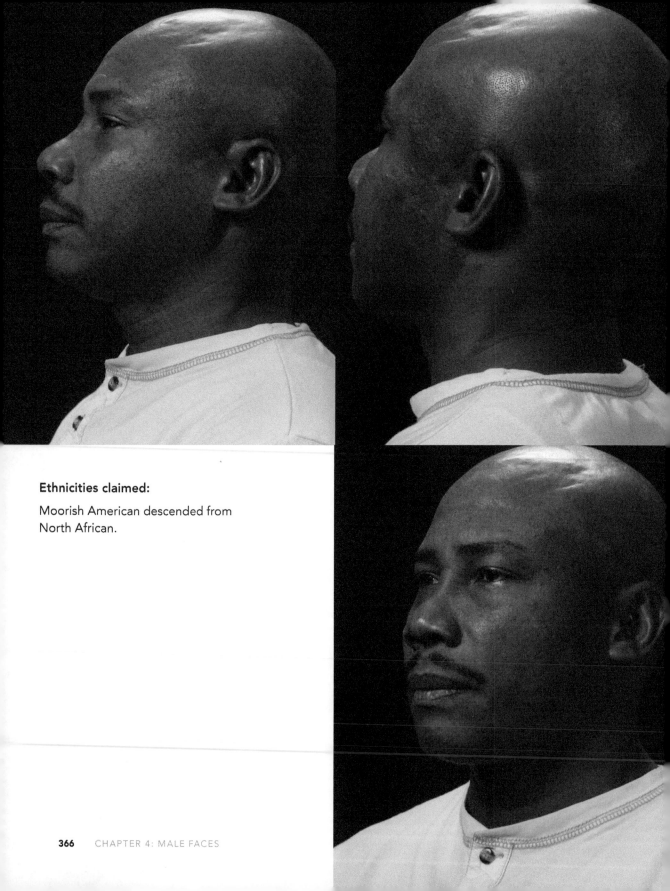

Ethnicities claimed:

Moorish American descended from
North African.

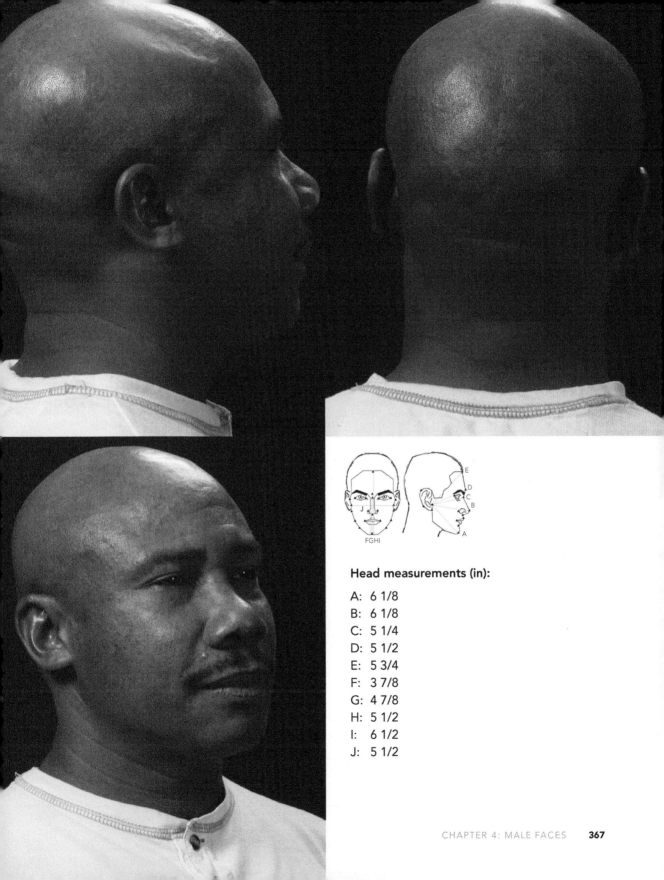

Head measurements (in):

A: 6 1/8

B: 6 1/8

C: 5 1/4

D: 5 1/2

E: 5 3/4

F: 3 7/8

G: 4 7/8

H: 5 1/2

I: 6 1/2

J: 5 1/2

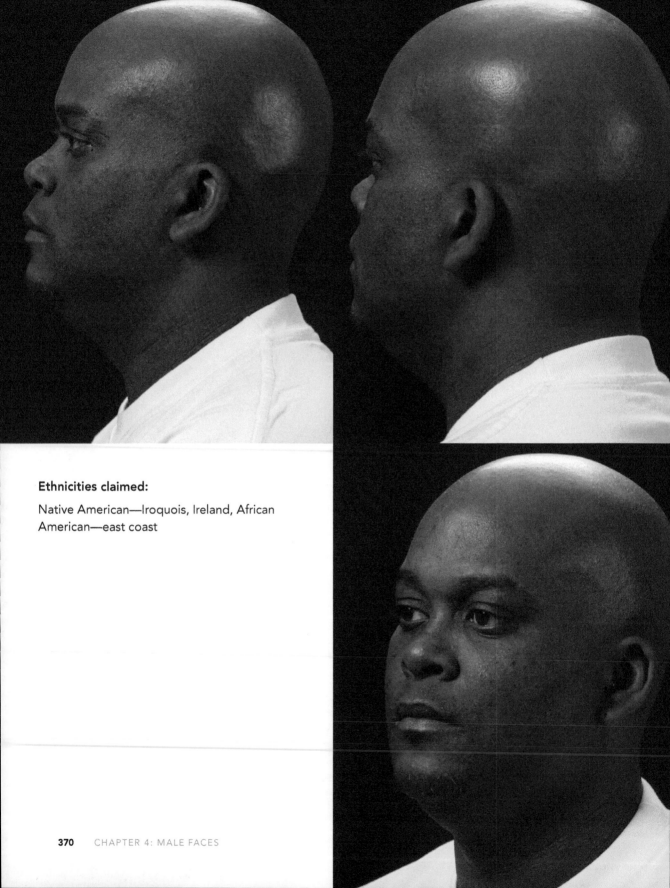

Ethnicities claimed:

Native American—Iroquois, Ireland, African American—east coast

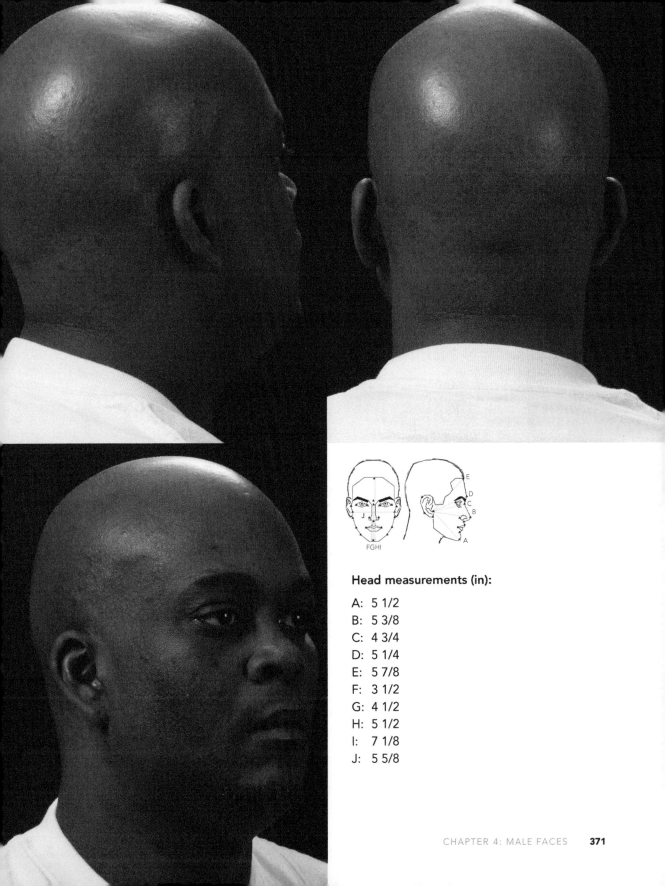

Head measurements (in):

A: 5 1/2
B: 5 3/8
C: 4 3/4
D: 5 1/4
E: 5 7/8
F: 3 1/2
G: 4 1/2
H: 5 1/2
I: 7 1/8
J: 5 5/8

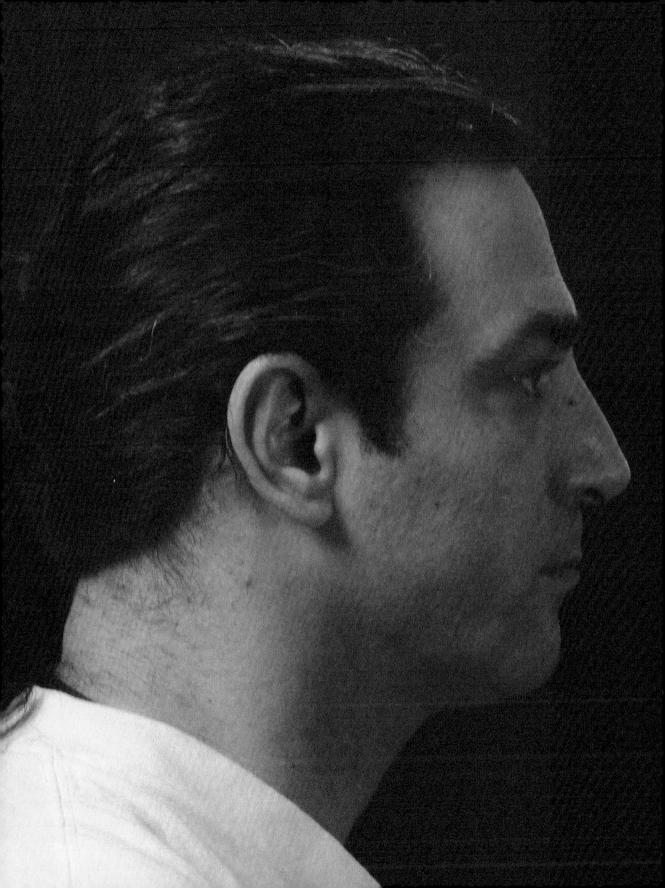

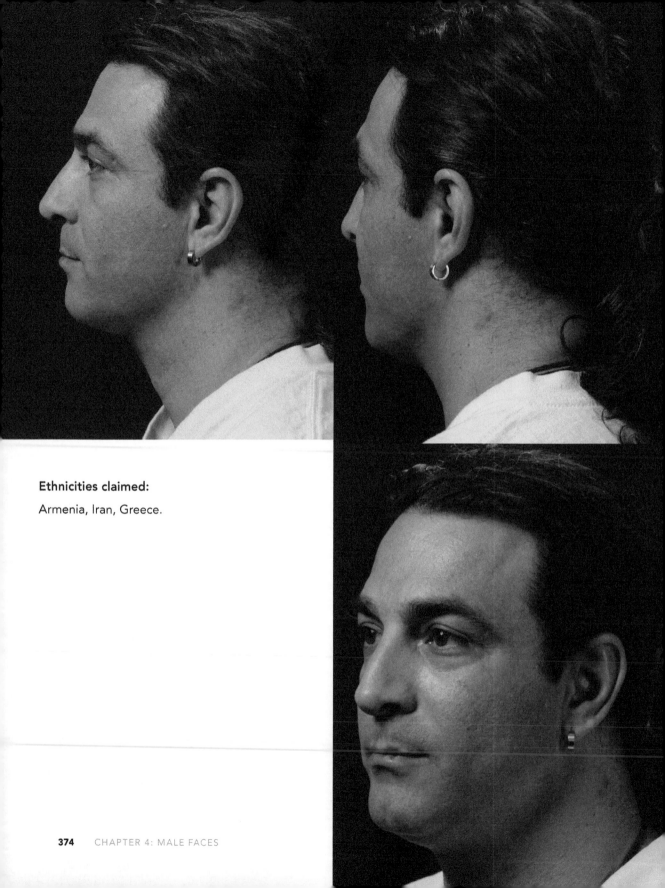

Ethnicities claimed:

Armenia, Iran, Greece.

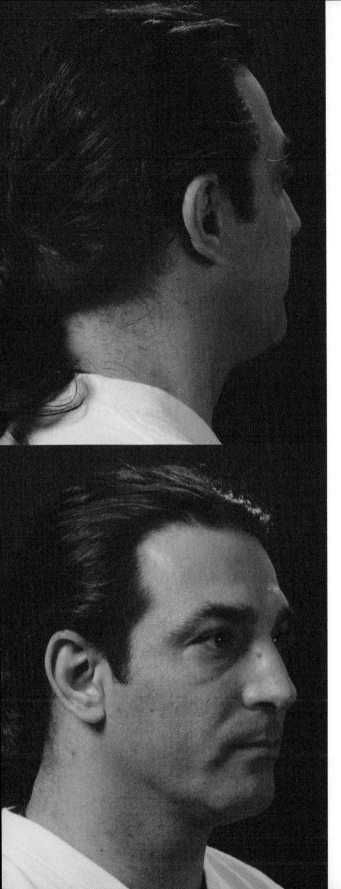

Head measurements (in):

A: 5 1/2
B: 5 1/2
C: 4 3/4
D: 5 1/8
E: 6
F: 3 7/8
G: 4 7/8
H: 5 3/8
I: 7 7/8
J: 5 1/8

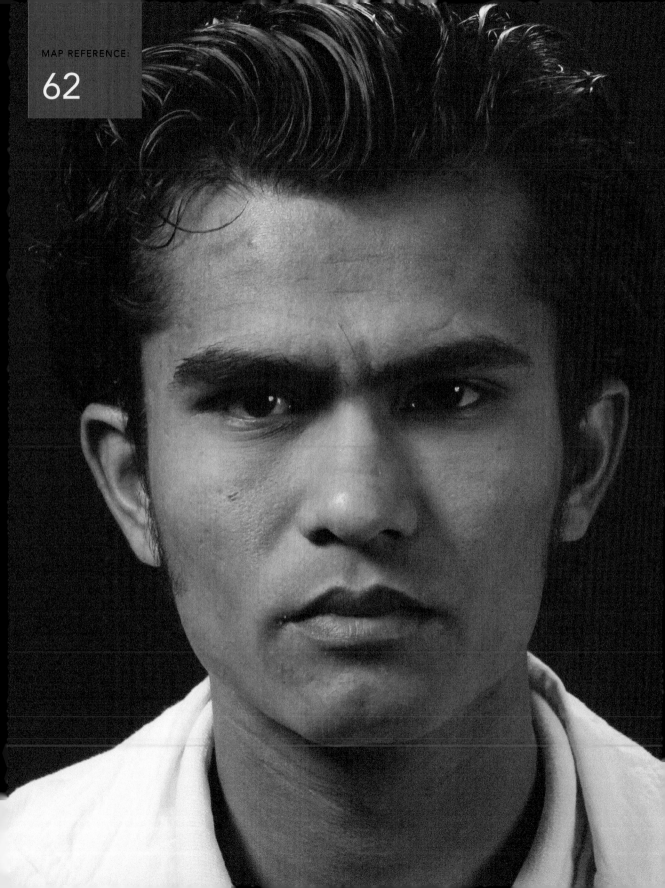

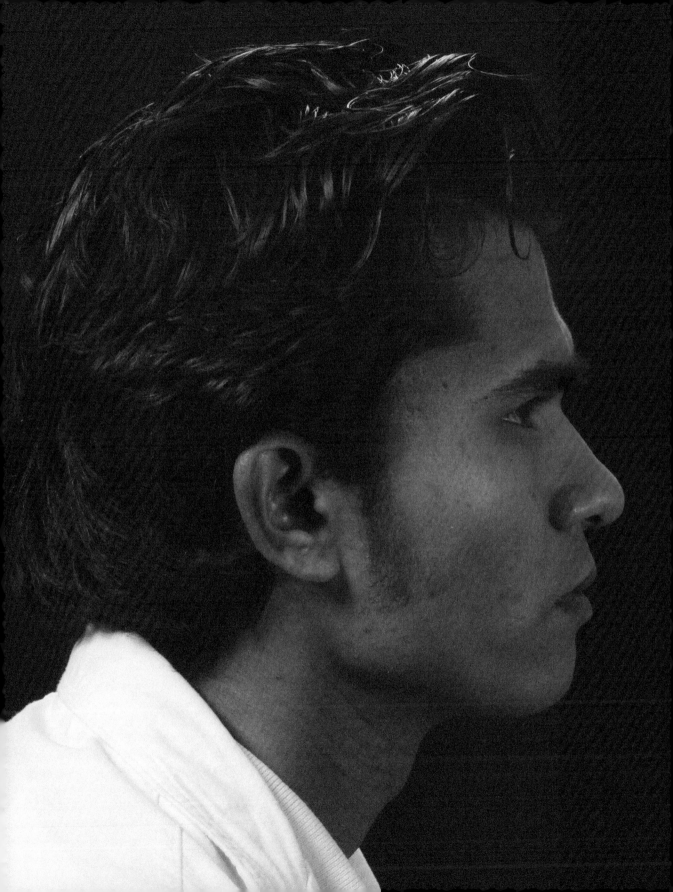

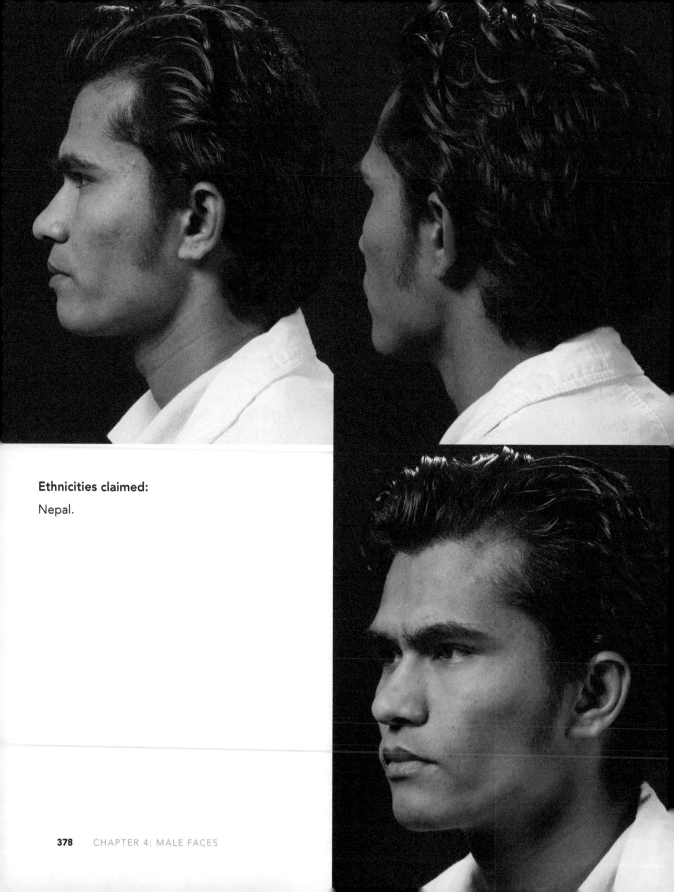

Ethnicities claimed:

Nepal.

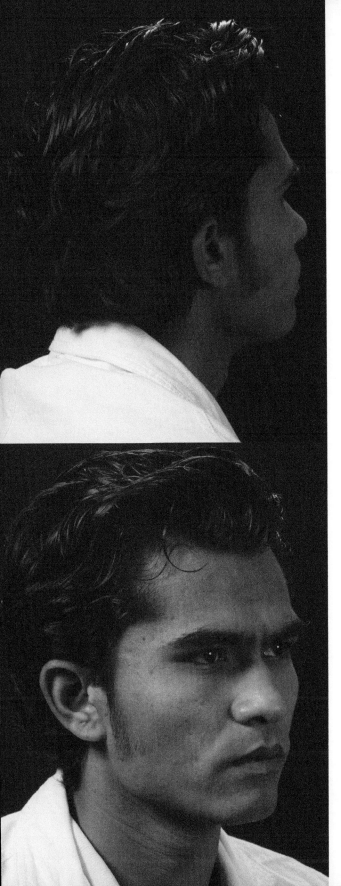

Head measurements (in):

A: 5 1/8
B: 5 1/8
C: 4 1/2
D: 4 5/8
E: 6
F: 3 3/8
G: 4 1/4
H: 4 7/8
I: 6 5/8
J: 5 1/2

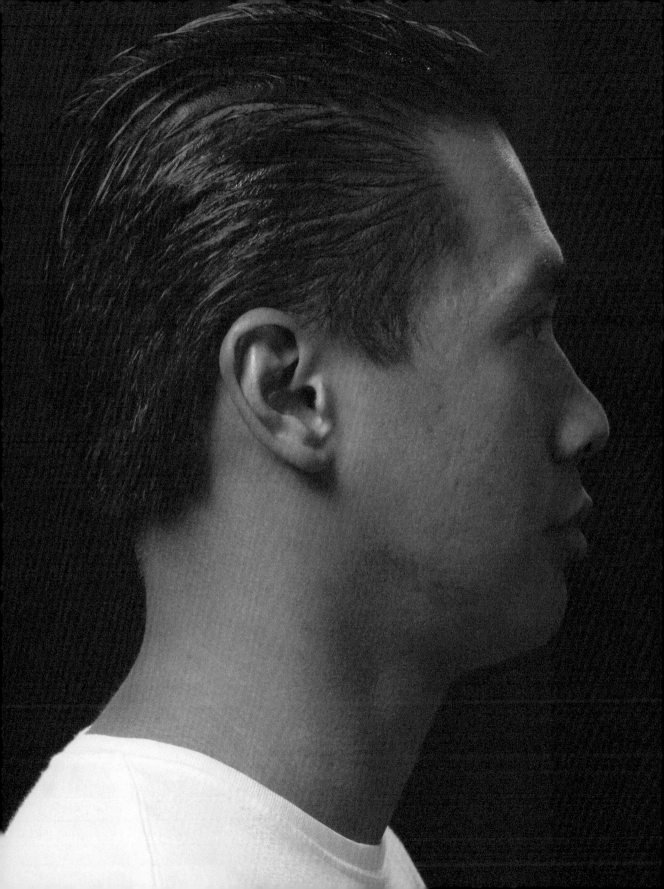

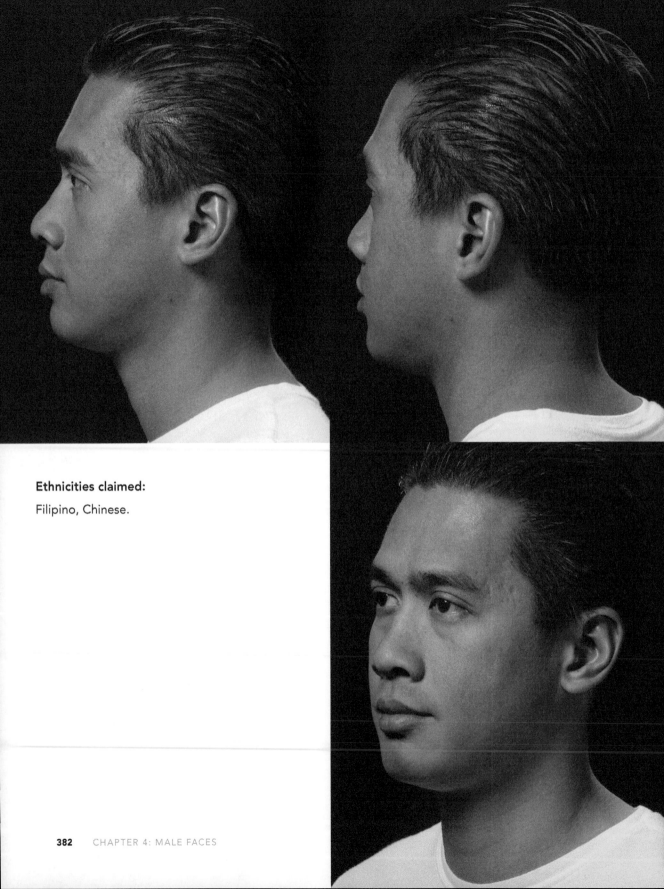

Ethnicities claimed:

Filipino, Chinese.

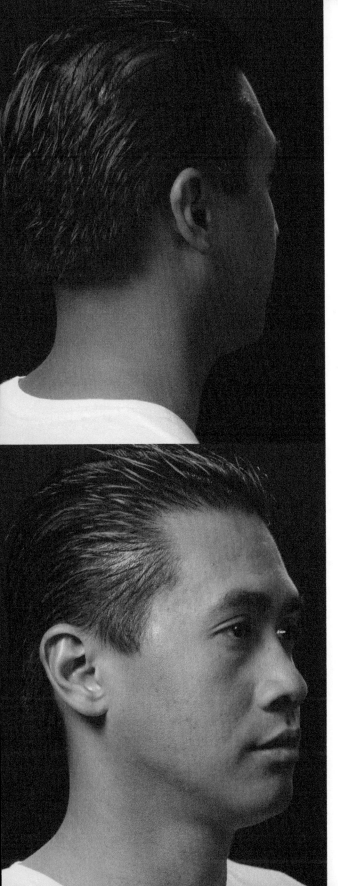

Head measurements (in):

A: 5 1/2
B: 5 1/2
C: 5 1/8
D: 5 3/8
E: 6 1/2
F: 3 1/4
G: 4 3/4
H: 5 1/8
I: 7 5/8
J: 6 1/8

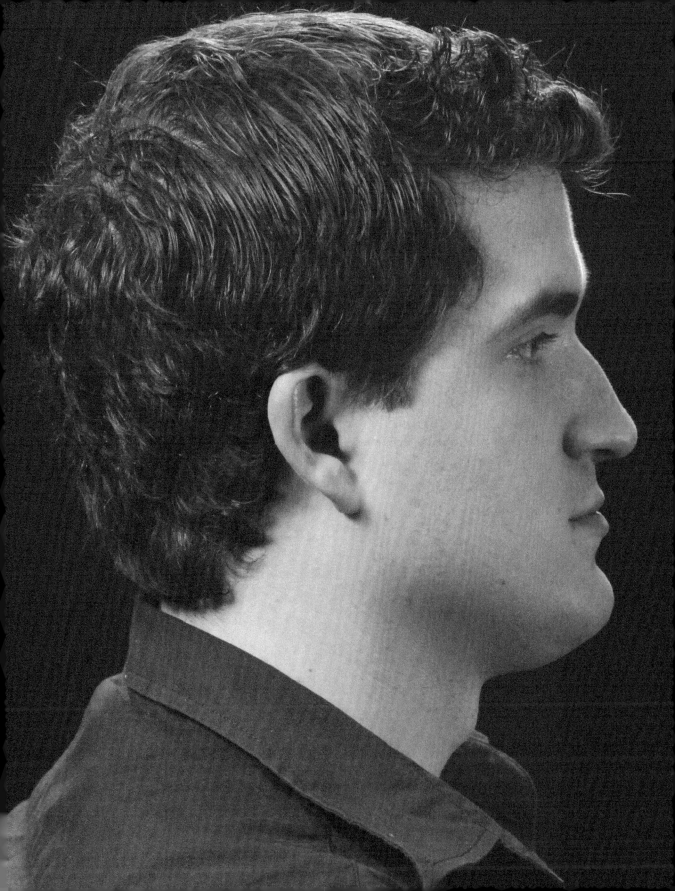

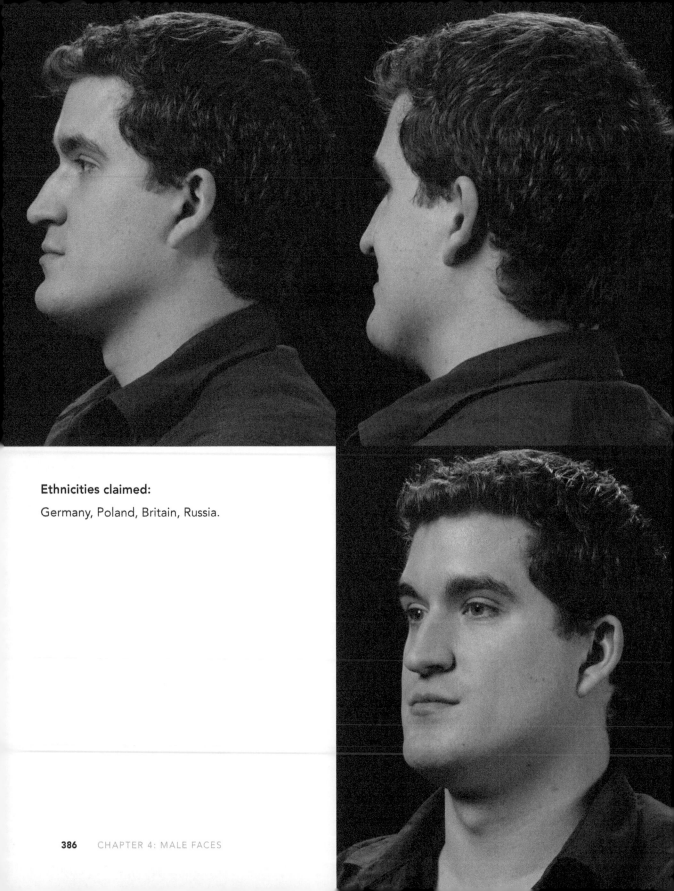

Ethnicities claimed:

Germany, Poland, Britain, Russia.

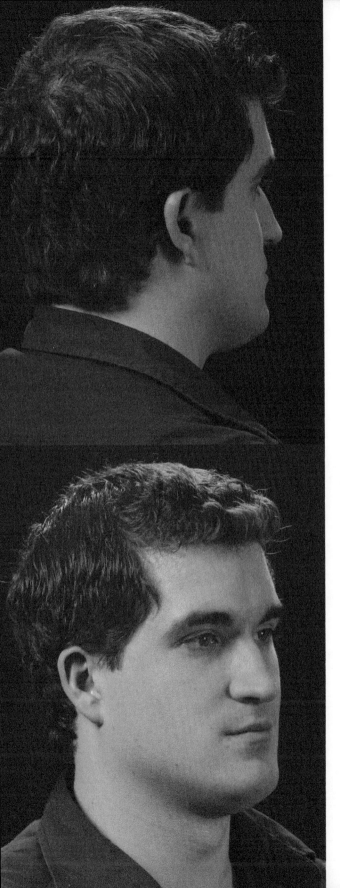

Head measurements (in):

A: 5 3/8
B: 5 3/8
C: 4 7/8
D: 5 1/4
E: 6
F: 3 5/8
G: 5 1/8
H: 5 3/4
I: 7 1/2
J: 6 1/8

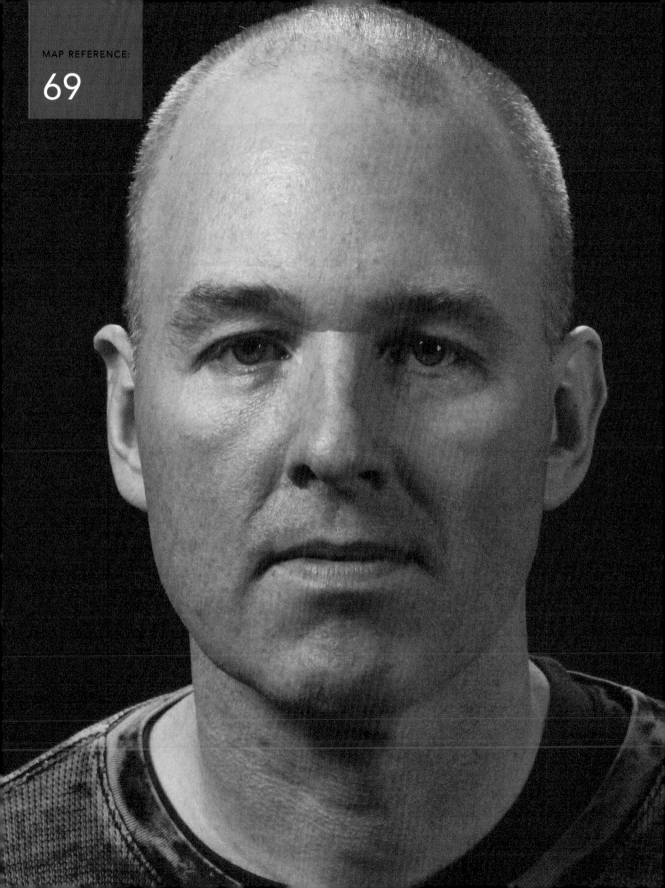

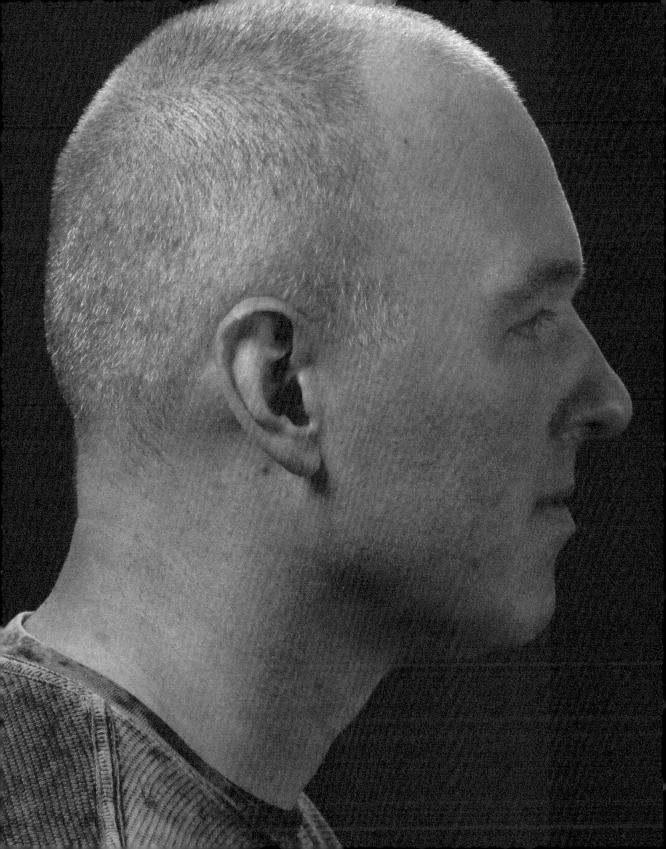

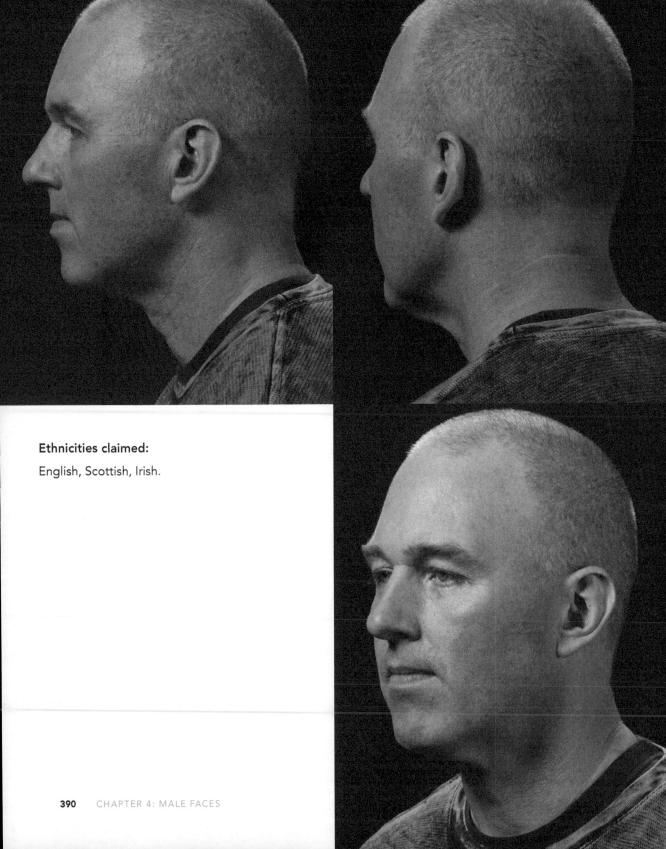

Ethnicities claimed:

English, Scottish, Irish.

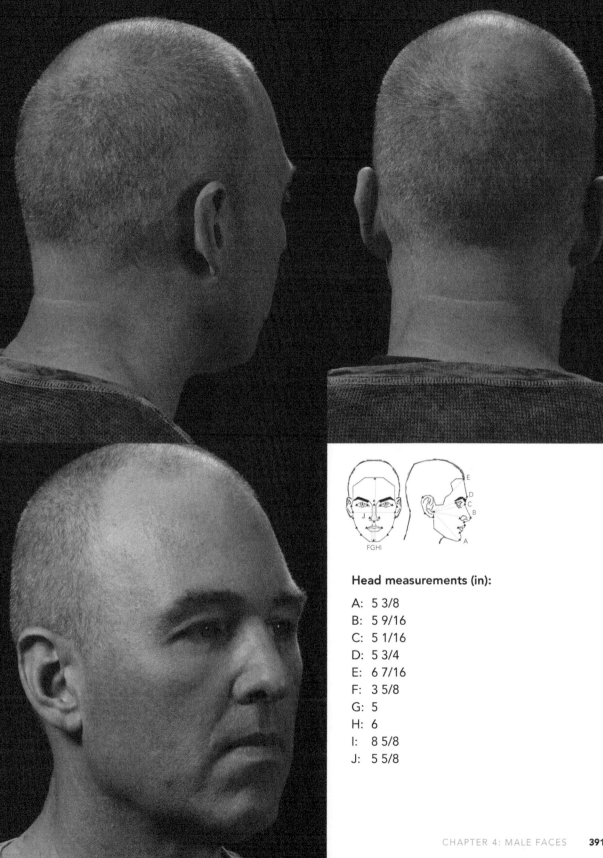

Head measurements (in):

A: 5 3/8
B: 5 9/16
C: 5 1/16
D: 5 3/4
E: 6 7/16
F: 3 5/8
G: 5
H: 6
I: 8 5/8
J: 5 5/8

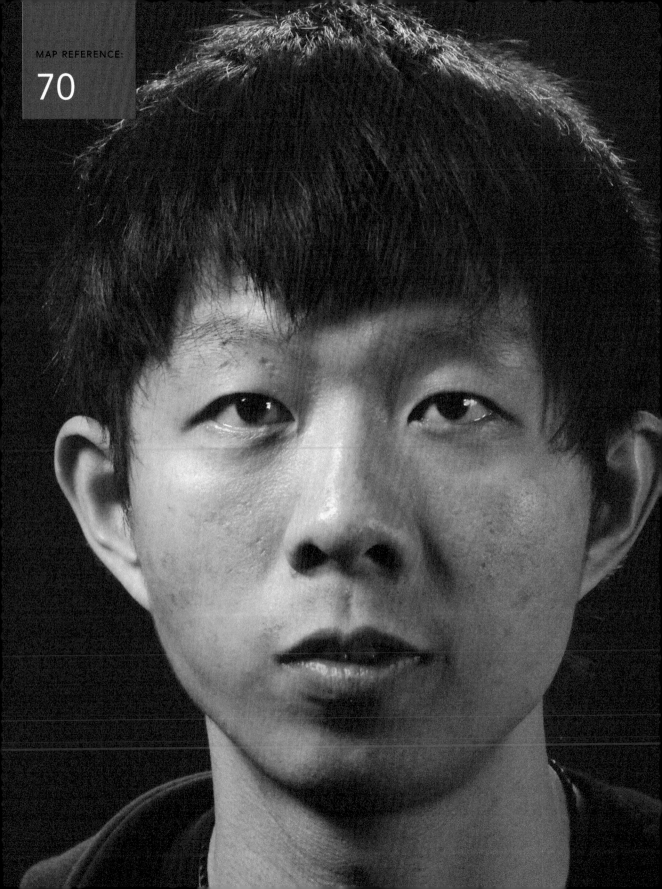

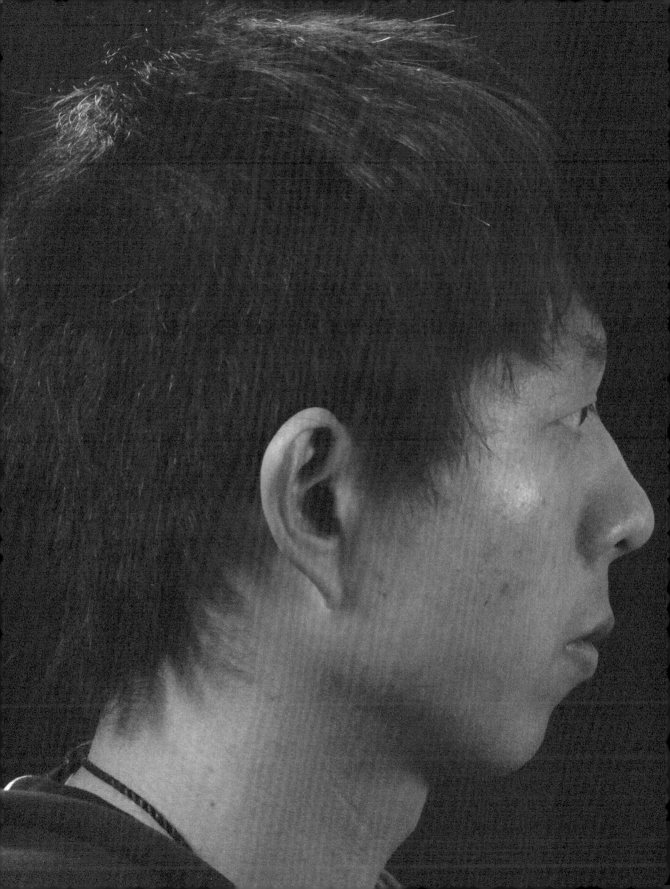

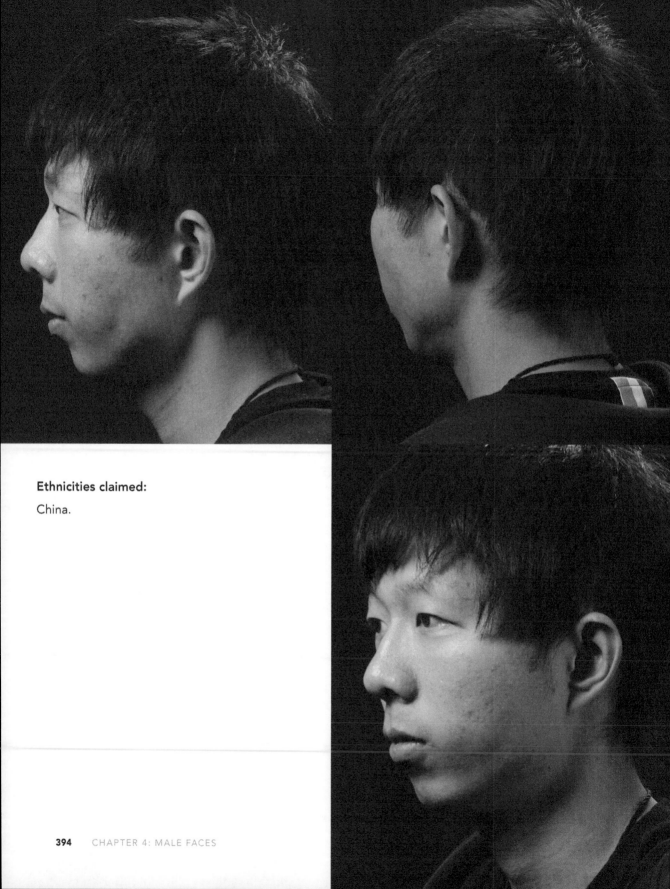

Ethnicities claimed:

China.

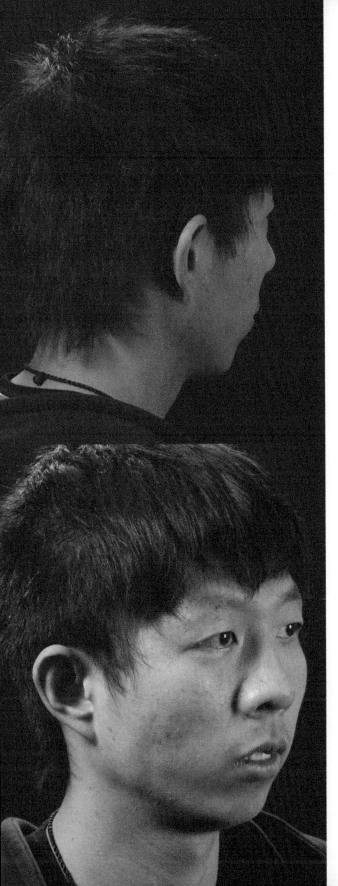

Head measurements (in):

A: 4 7/8
B: 4 3/4
C: 5
D: 5 3/8
E: 6 1/4
F: 3 5/8
G: 4 1/2
H: 5 3/4
I: 7 3/8
J: 5 5/8

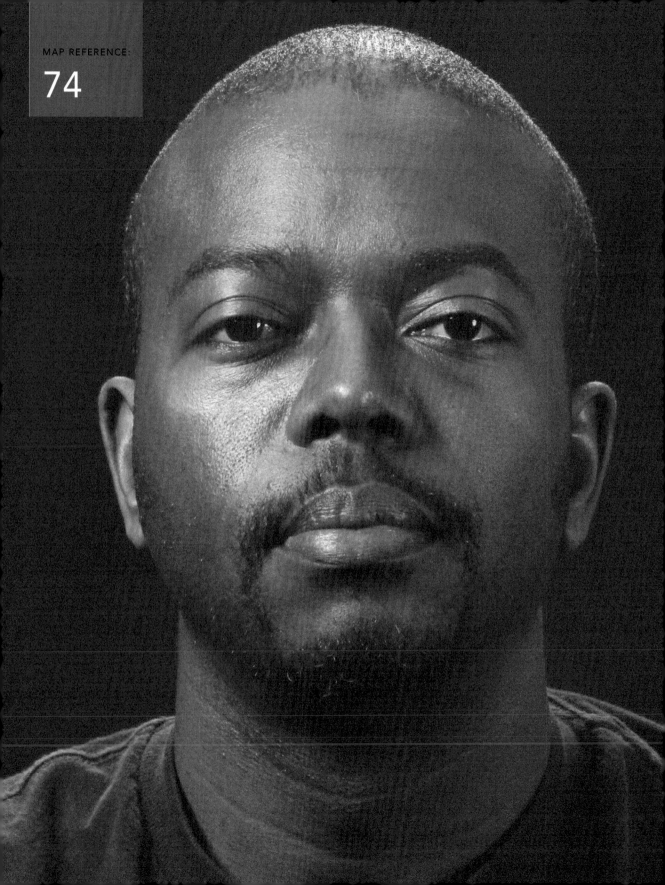

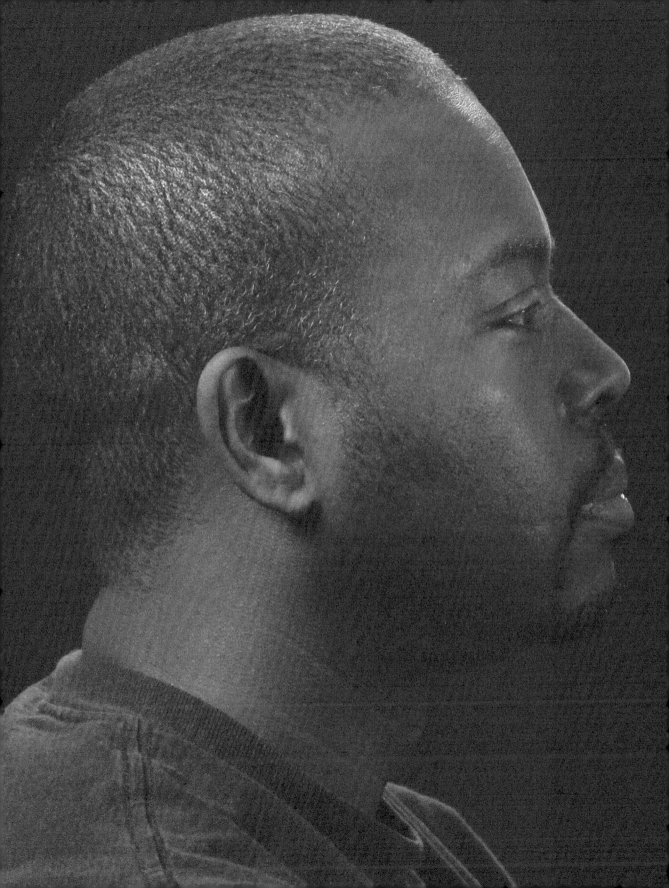

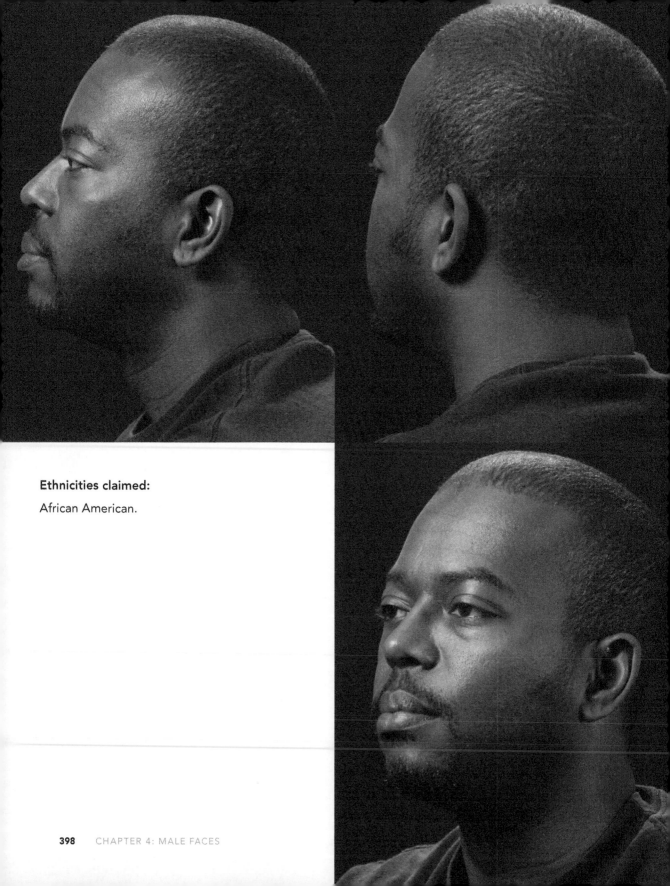

Ethnicities claimed:

African American.

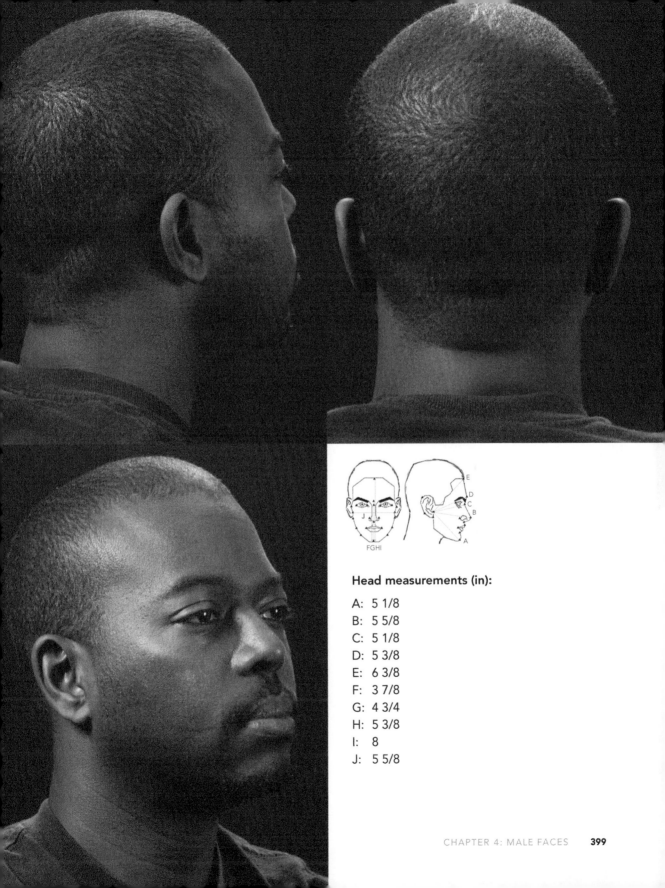

Head measurements (in):

A: 5 1/8
B: 5 5/8
C: 5 1/8
D: 5 3/8
E: 6 3/8
F: 3 7/8
G: 4 3/4
H: 5 3/8
I: 8
J: 5 5/8

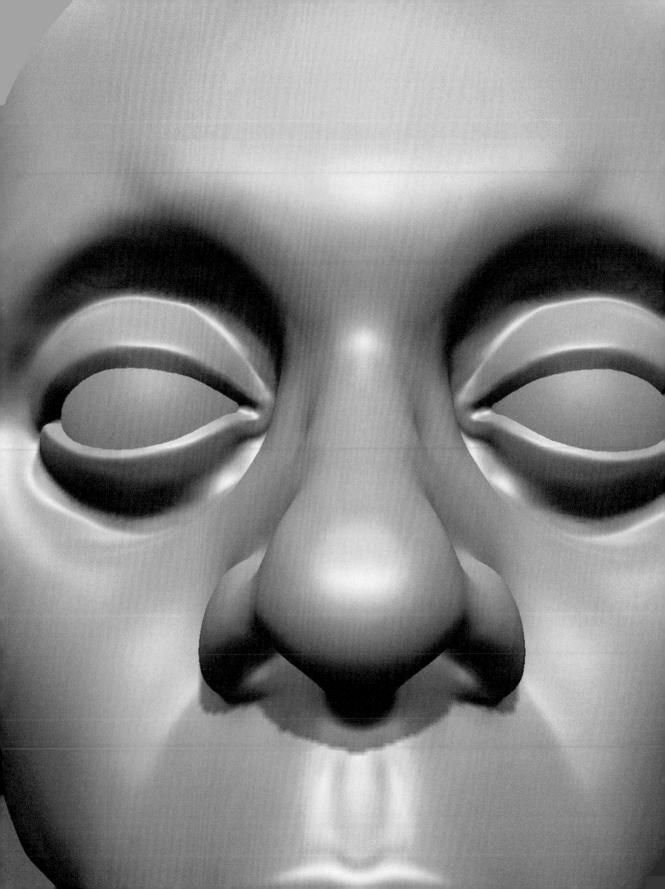

EYE TUTORIAL

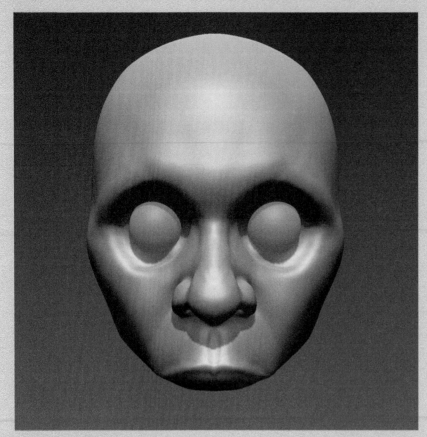

Load your model from the nose tutorial, or import from the companion website:

/tutorials/eye_tutorial/eye_starter.obj

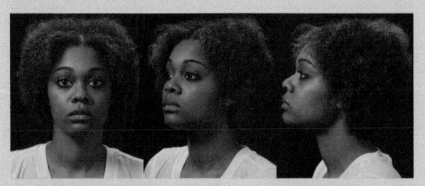

Female reference material.

Use the same reference images as in the nose tutorial:

/tutorials/tutorial2/african_american_female.jpg

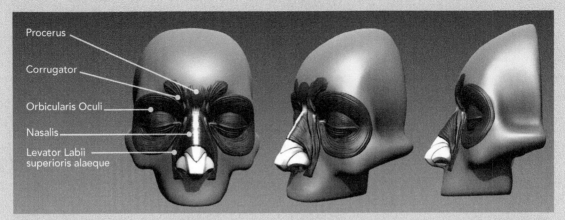

Procerus

Corrugator

Orbicularis Oculi

Nasalis

Levator Labii
superioris alaeque

Eye region anatomy.

Let's quickly review the anatomy of the eye region.

When creating an eye, a few landmarks you want to keep in mind:

- The boney border of the orbital cavity, particularly the prominence of the edge next to the nasal bone

- The fleshy bulge of the Orbicular muscle, again on the inside edge of the orbital cavity below the eye.

We'll start by blocking in the basic form of the upper eyelid. Focus on treating the lids very basically to start.

Blocking in the upper eyelid.

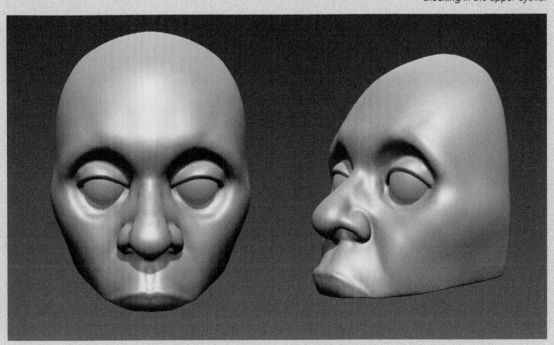

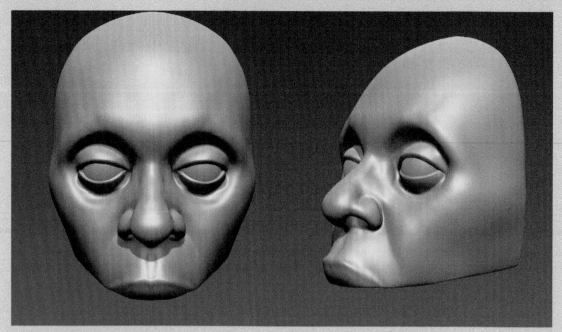

Next, add in the lower lid, again, very basically:

Blocking in the lower eyelid.

Now, referring to the model photos, rough in the tear duct as shown:

Model reference of tear duct.

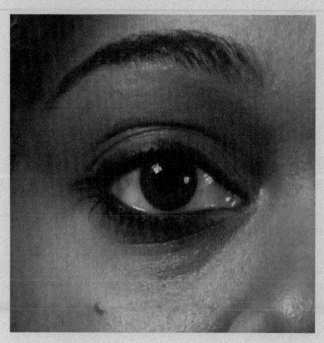

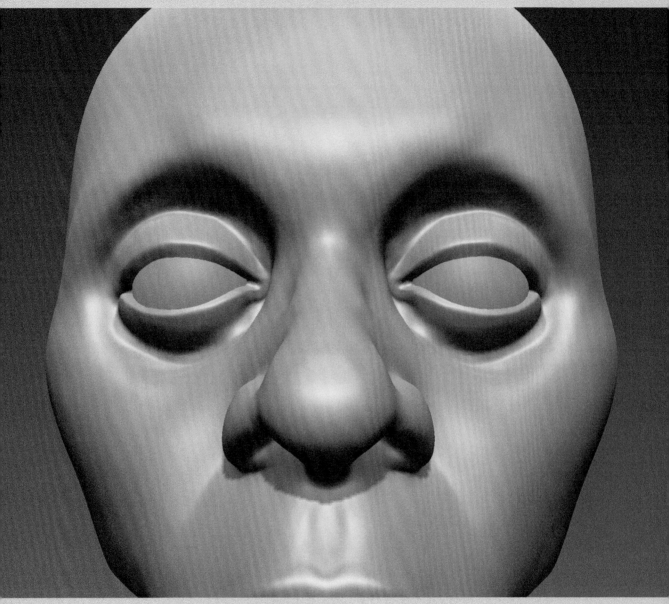

Progress of tear duct.

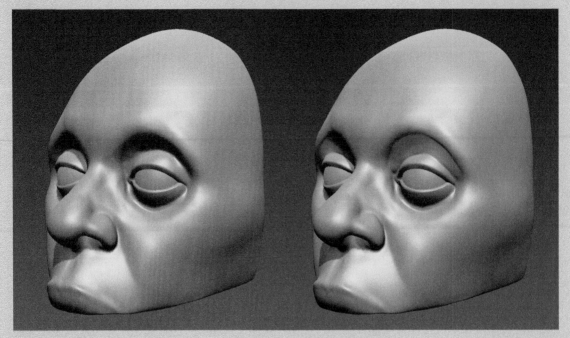

Cavity above eye.

Keep in mind we're roughing in form right now and there will be time to refine proportions and position once the surrounding area is blocked in. You want to focus on big shapes first.

Next, you are going to block in the area between the eye and the brow. The first step is to fill in the cavity above the eye as a flat plane:

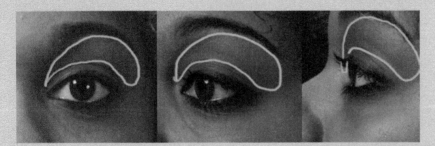

Model reference of flesh pockets.

Then create the flesh pocket that lies over the top of the eye, making the outer-upper corner the high point:

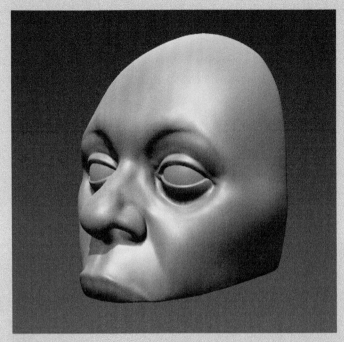

Next, you will address the cavity below the lower lid.

Start as in the last step by filling in the cavity with a flat plane as shown:

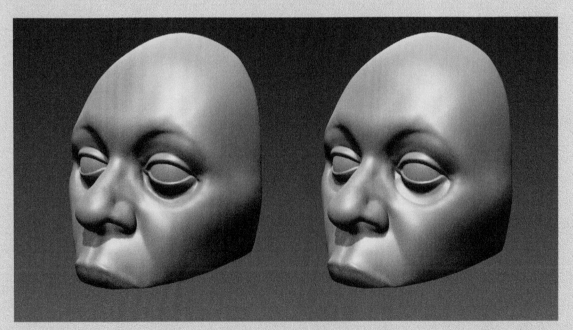

Filling in the cavity.

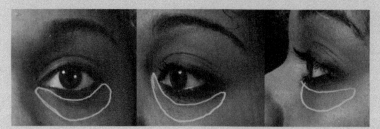

Model reference, fleshy pocket below eye.

Next, create the fleshy pocket between the lower eyelid and the edge of the orbital cavity. Pay particular attention to how it bulges on the side closest to the nose. Also, make sure you keep the inner edge of the orbital cavity clearly defined as it is an important structural landmark:

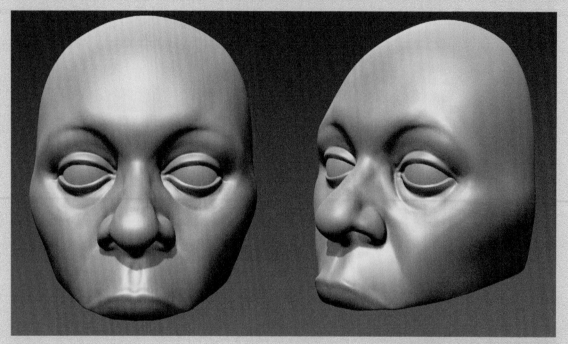

Evaluate progress. *Model reference.*

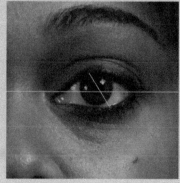

Before finishing up, look closely at the photo reference. You want to be sure to position the tear duct vertically, properly in relation to the outer corner of the eye. You also will notice that the high point of the upper lid and the low point of the lower lid are slightly offset:

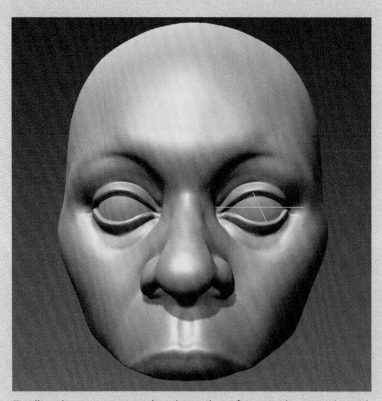

Evaluate tear duct.

Finally, take some time and evaluate the reference photographs and add or correct any forms you think are required. Pay attention to impacting forms, such as the subtle bulge of the fleshy area above the eye impacting the upper eyelid. These types of details help in the realism of the final sculpt.

In the end, you should wind up with something that looks similar to the images below.



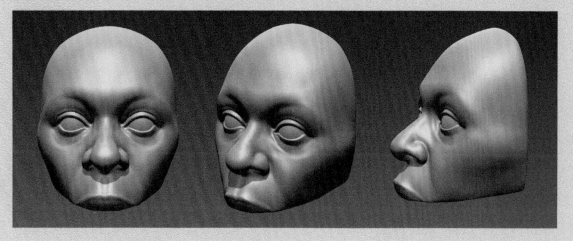

EXPRESSIONS

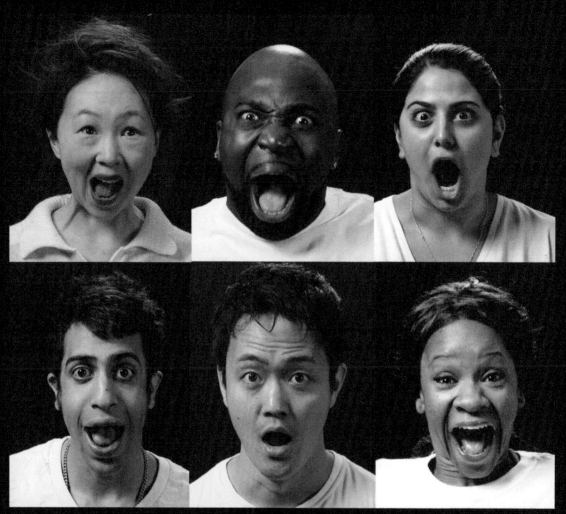

And now for something completely different...

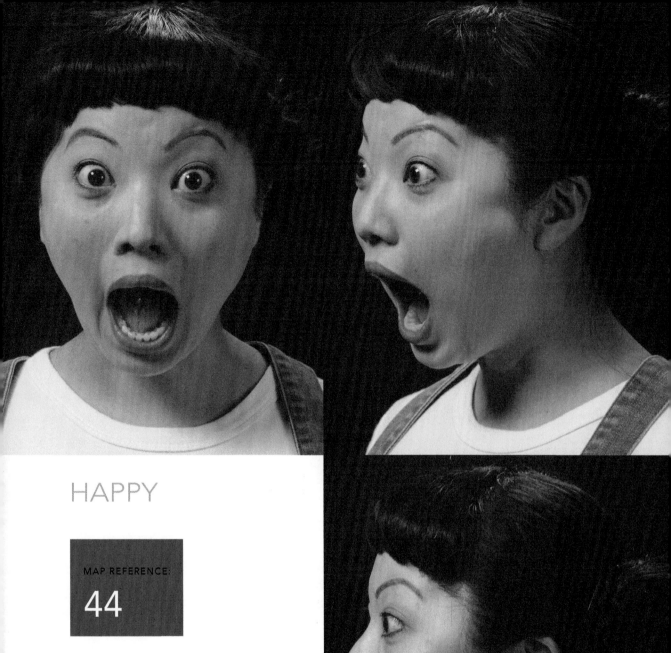

HAPPY

MAP REFERENCE:

44

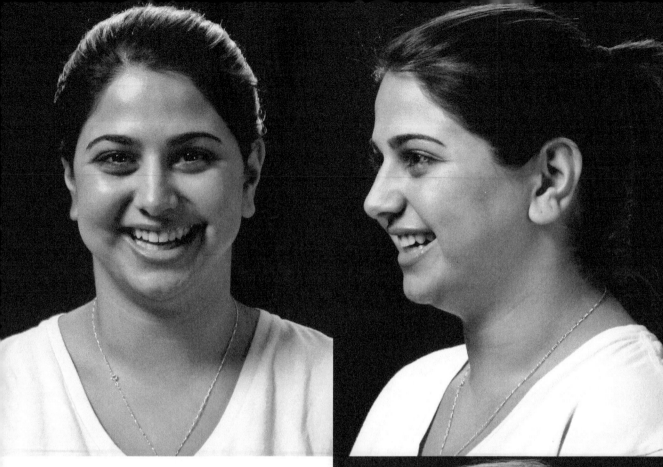

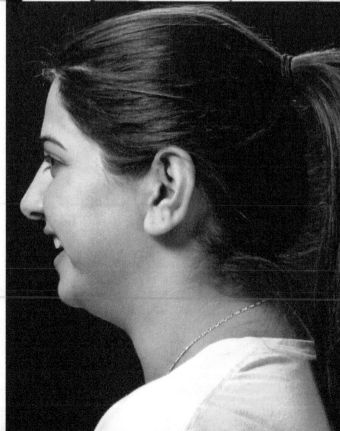

HAPPY

MAP REFERENCE:

28

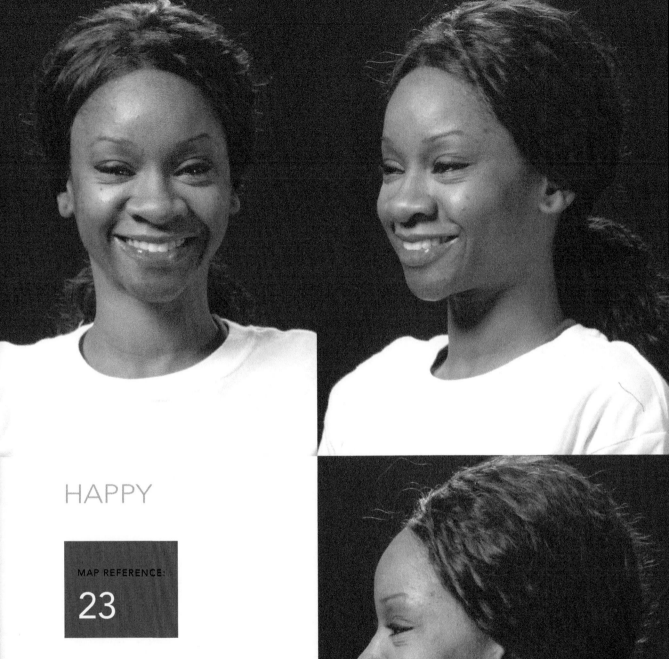

HAPPY

MAP REFERENCE:
23

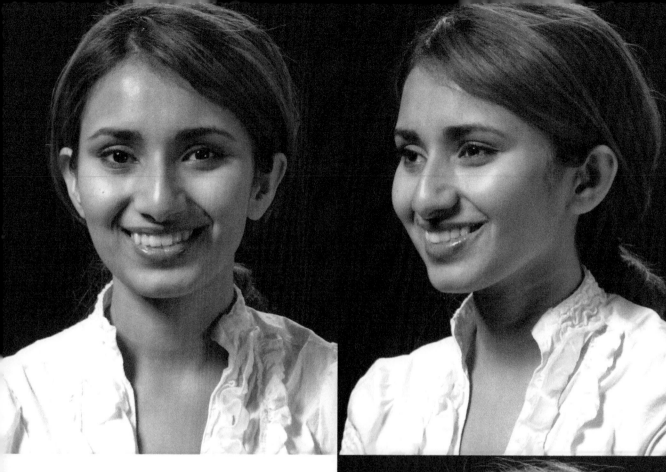
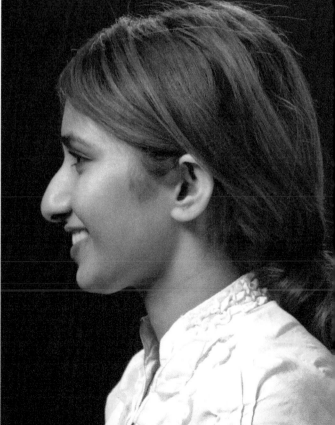

HAPPY

MAP REFERENCE:

31

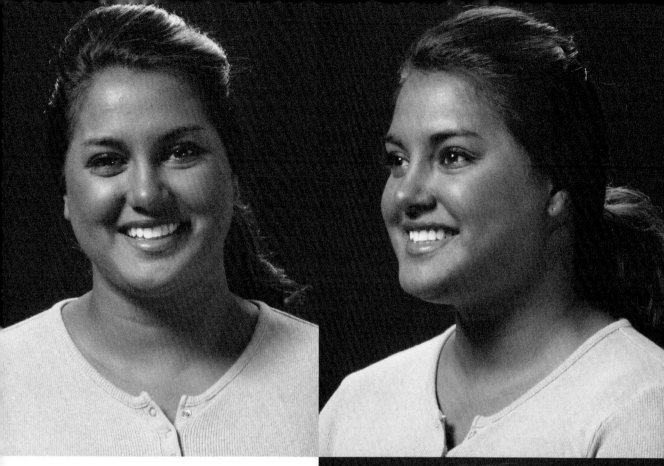

HAPPY

MAP REFERENCE:

39

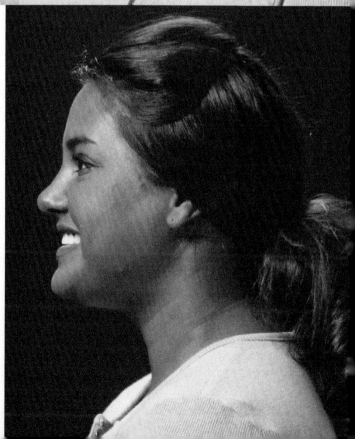

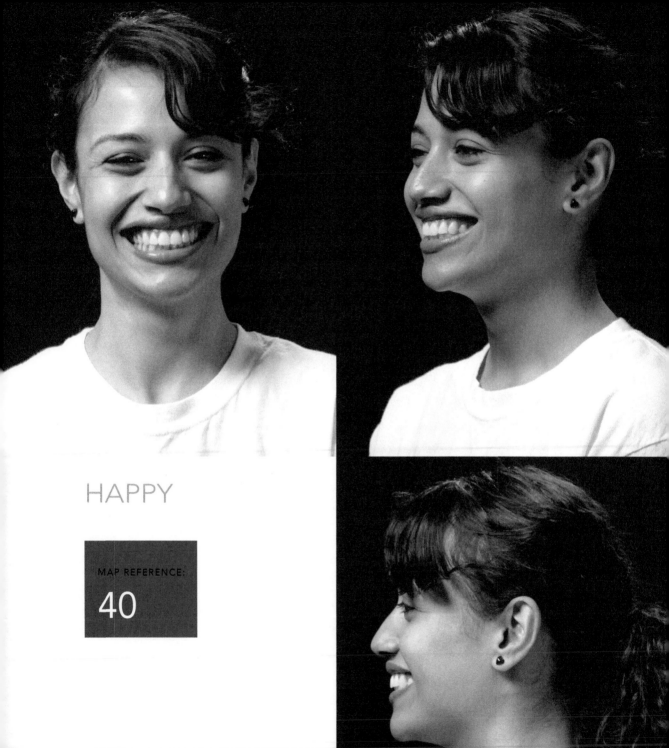

HAPPY

MAP REFERENCE:

40

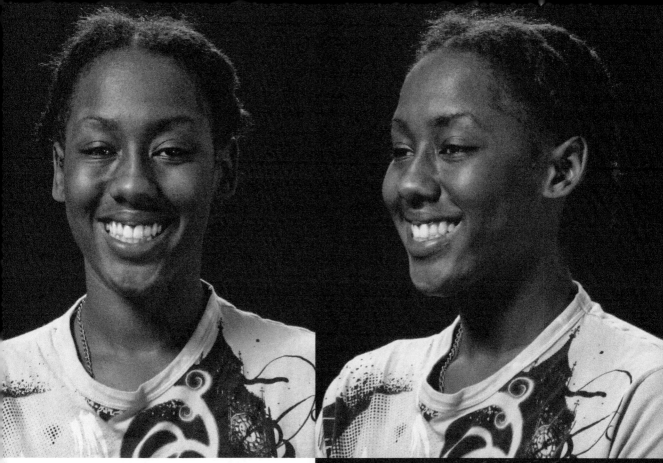

HAPPY

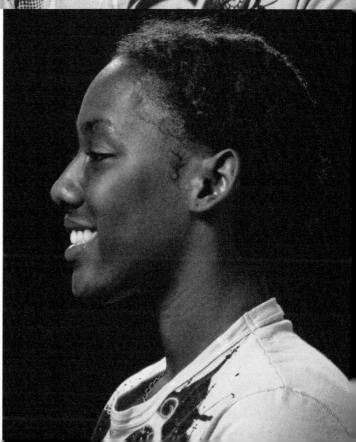

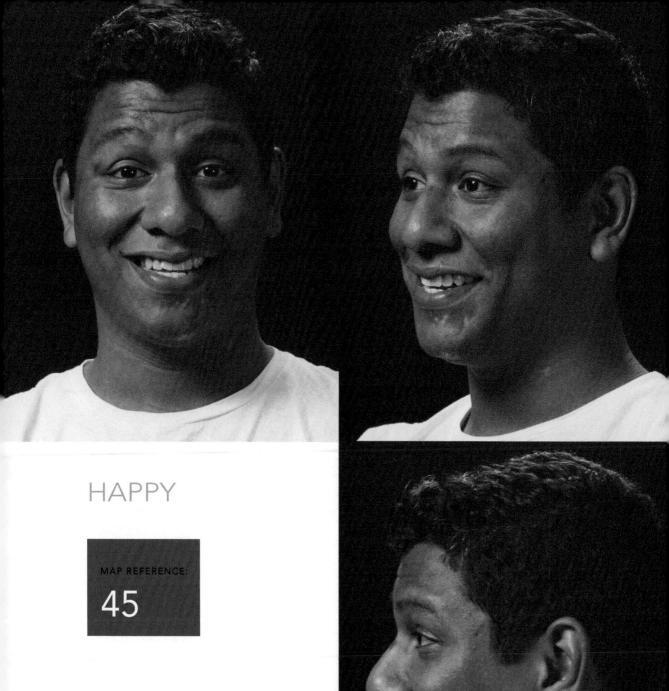

HAPPY

MAP REFERENCE:

45

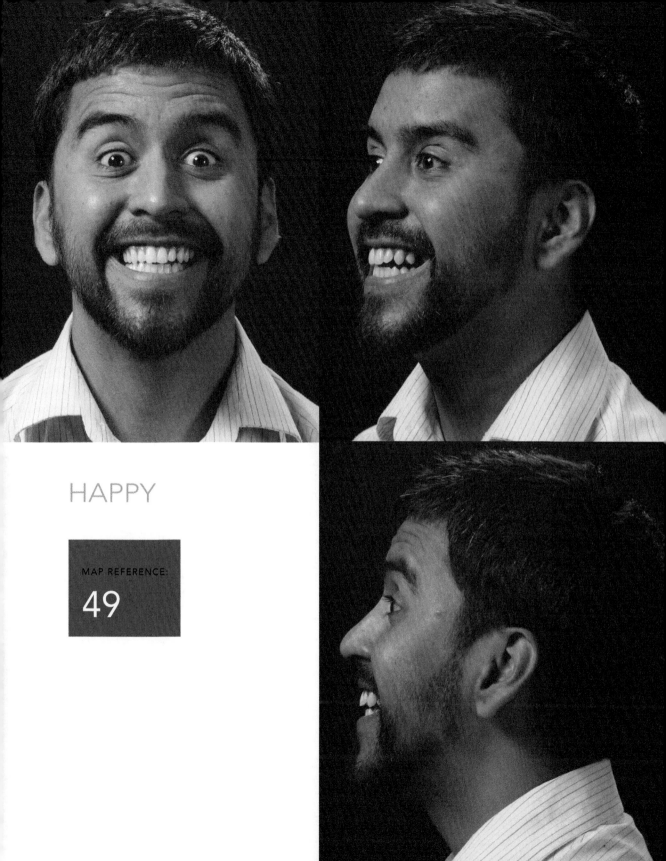

HAPPY

MAP REFERENCE:

49

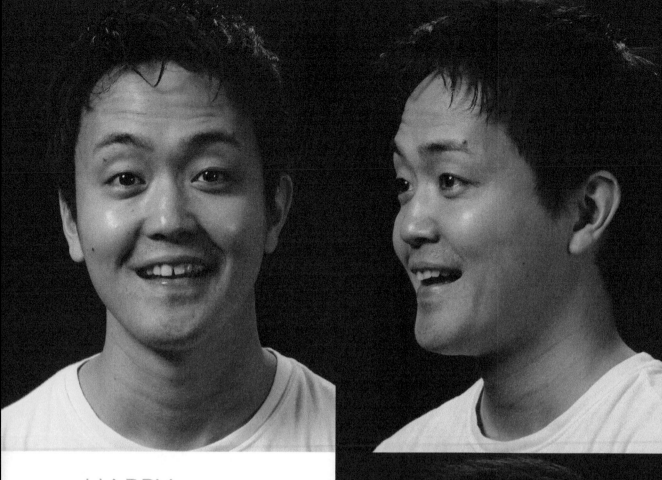

HAPPY

MAP REFERENCE:

50

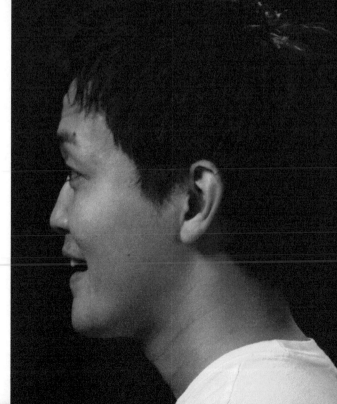

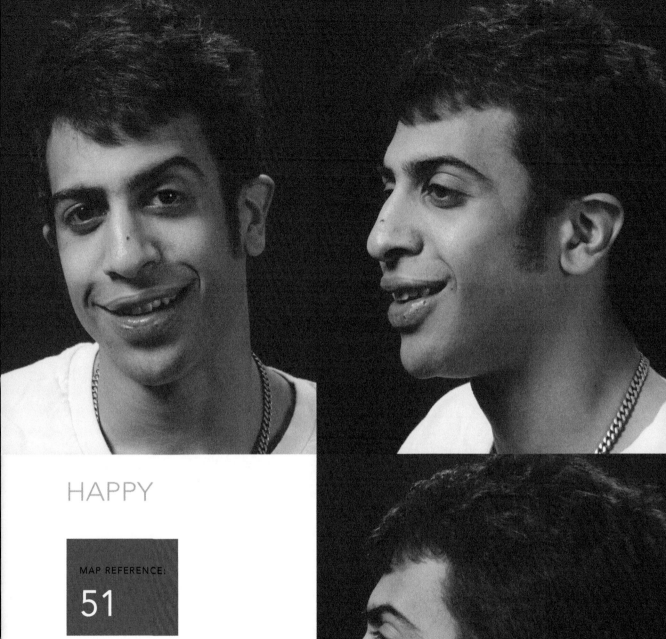

HAPPY

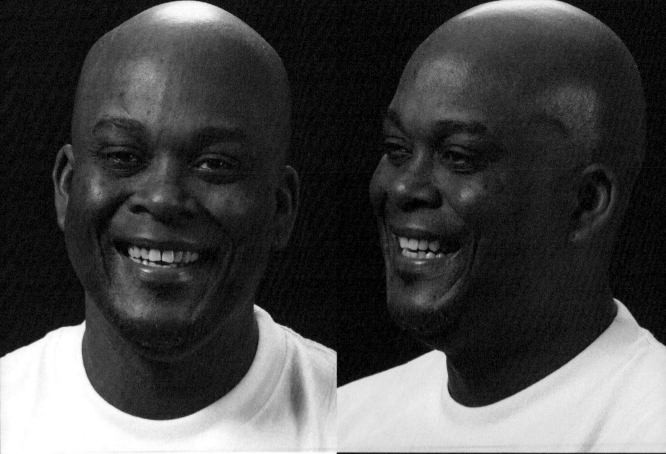

HAPPY

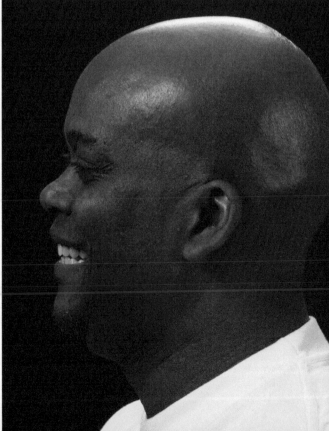

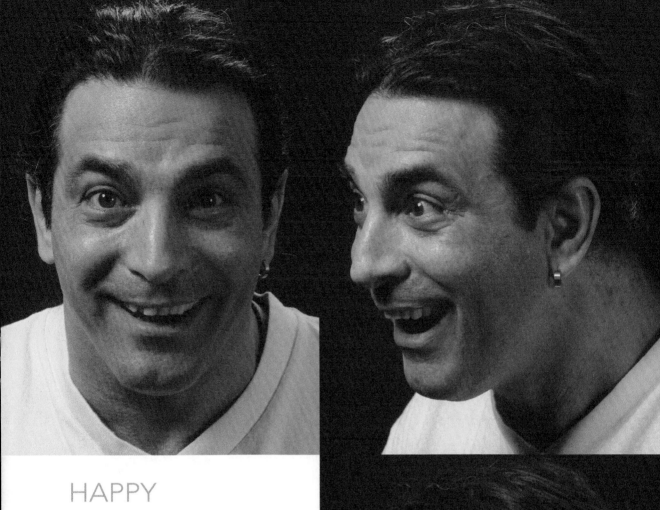

HAPPY

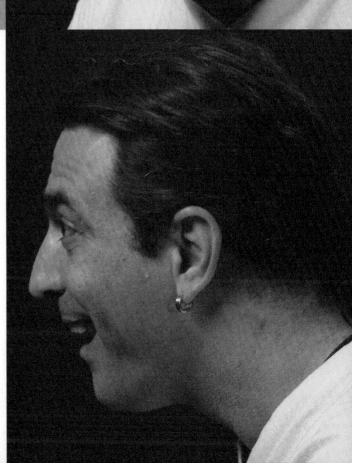

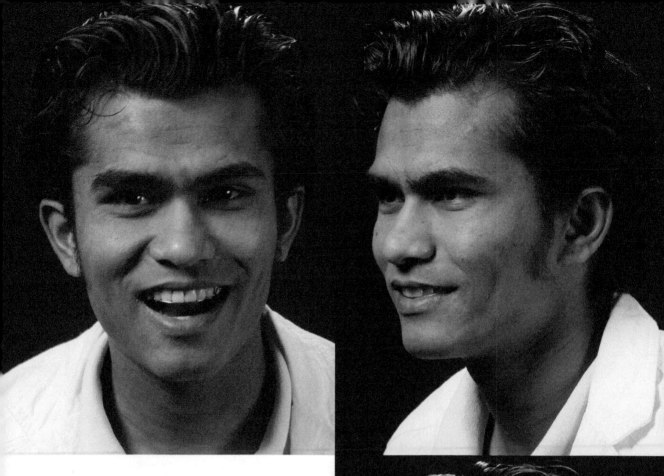

HAPPY

MAP REFERENCE:

62

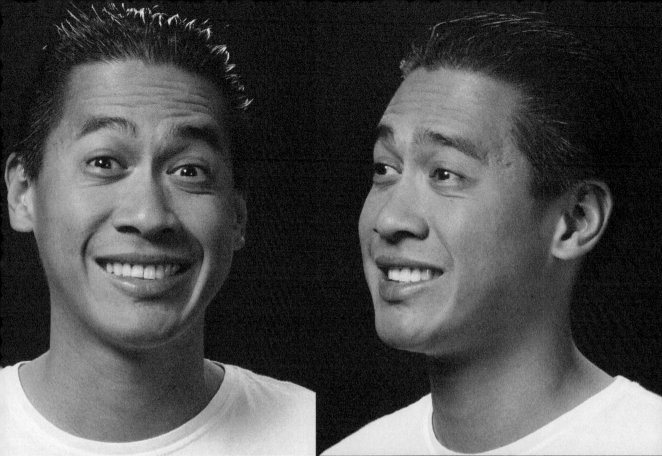

HAPPY

MAP REFERENCE:

66

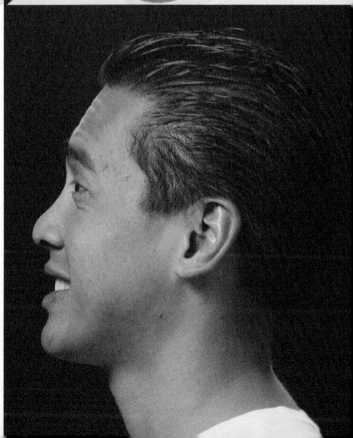

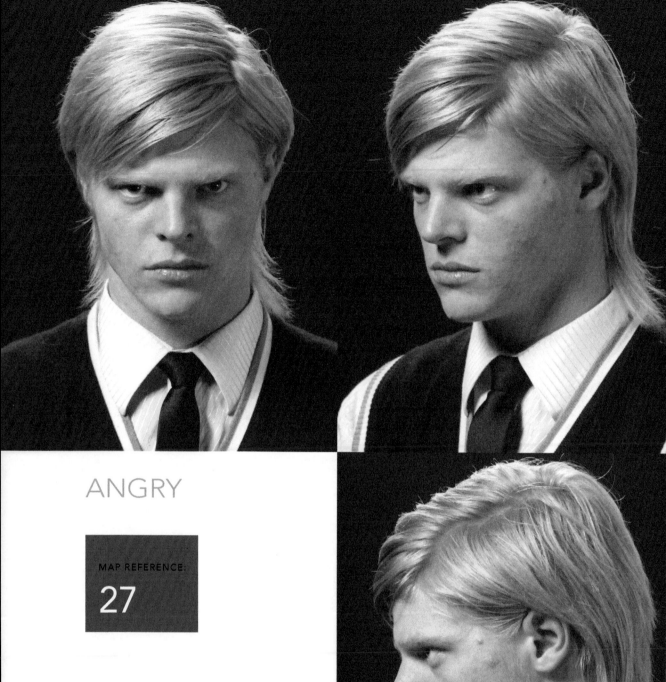

ANGRY

MAP REFERENCE:

27

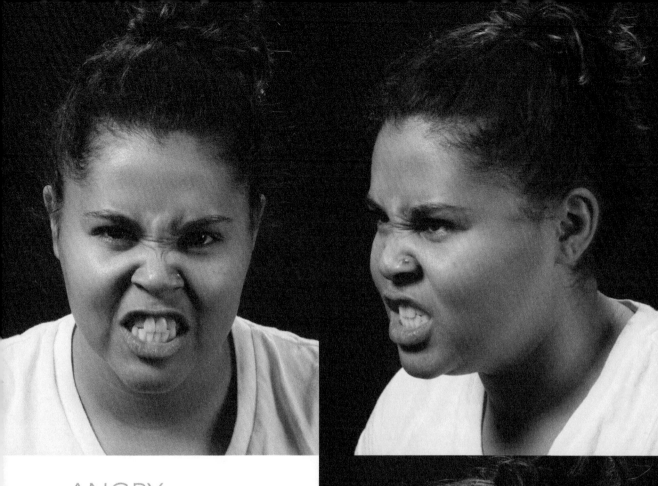

ANGRY

MAP REFERENCE:

73

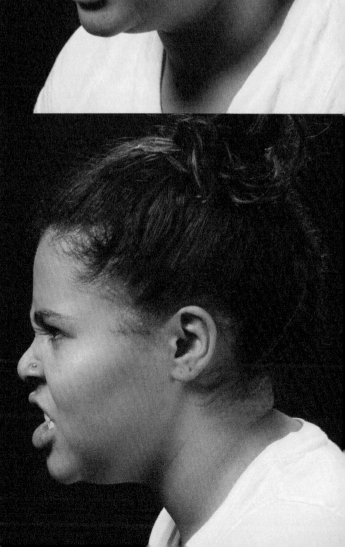

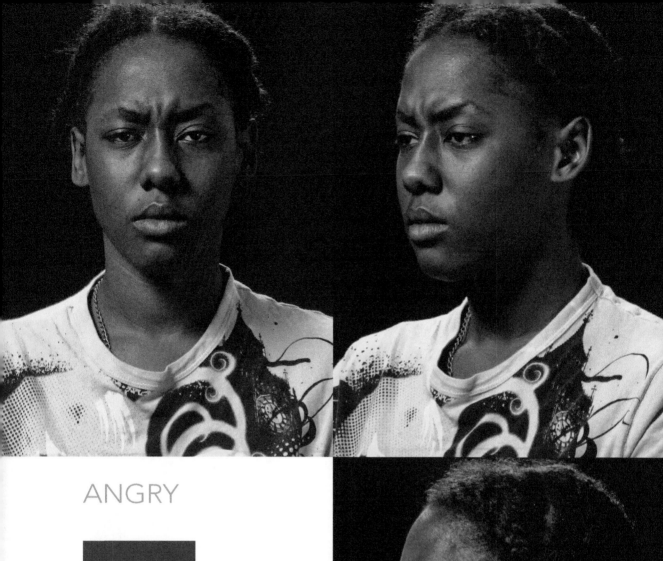

ANGRY

MAP REFERENCE:

43

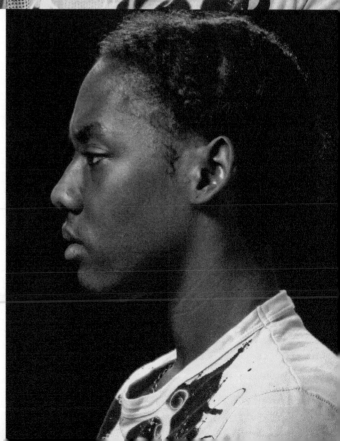

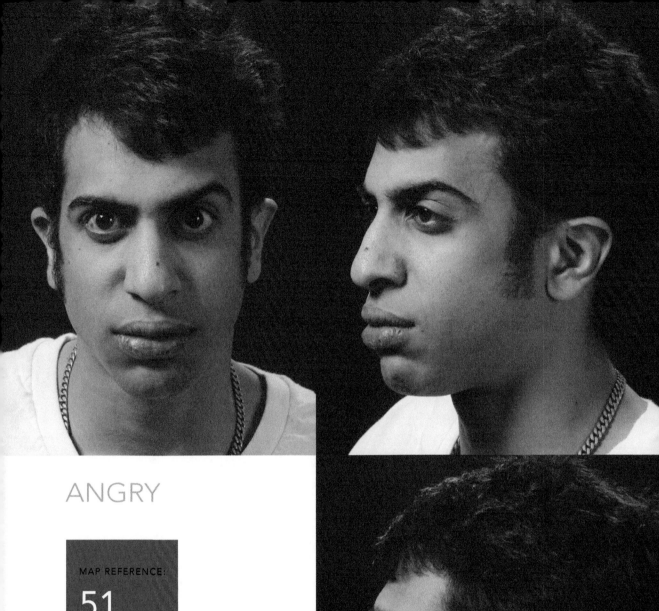

ANGRY

MAP REFERENCE:

51

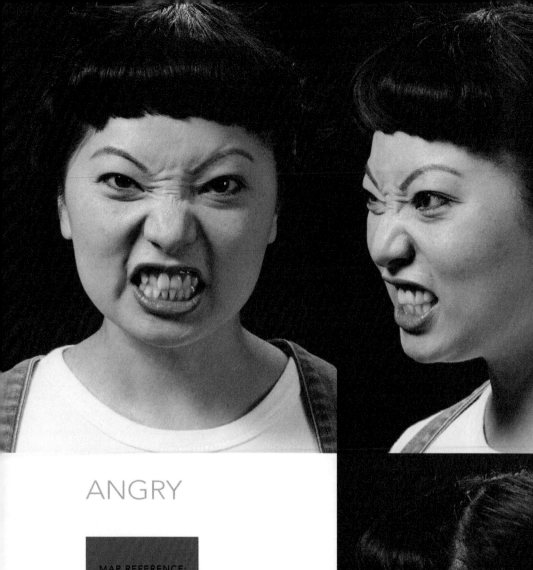

ANGRY

MAP REFERENCE:

44

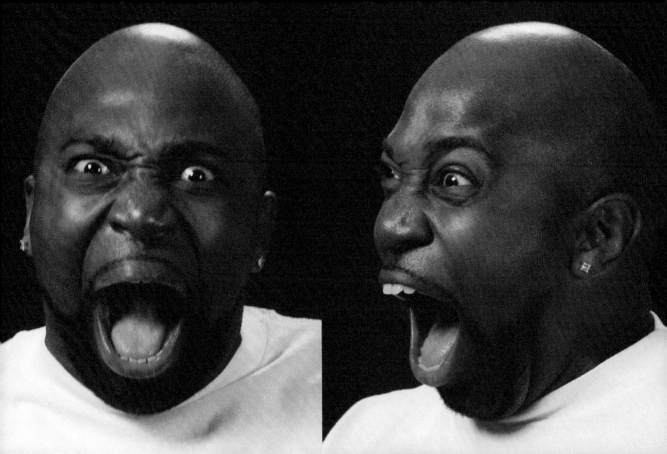

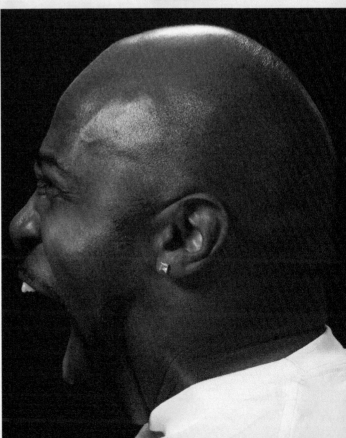

ANGRY

MAP REFERENCE:

53

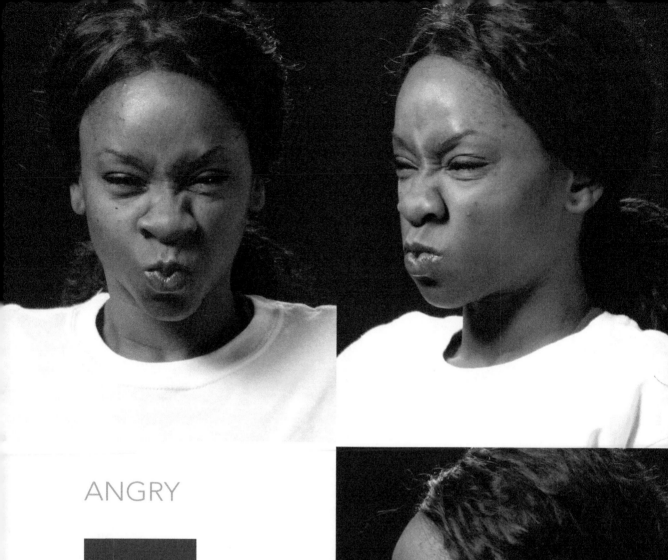

ANGRY

MAP REFERENCE:
23

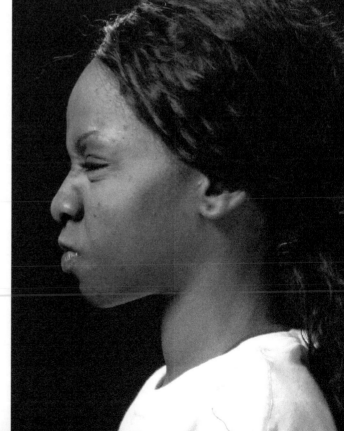

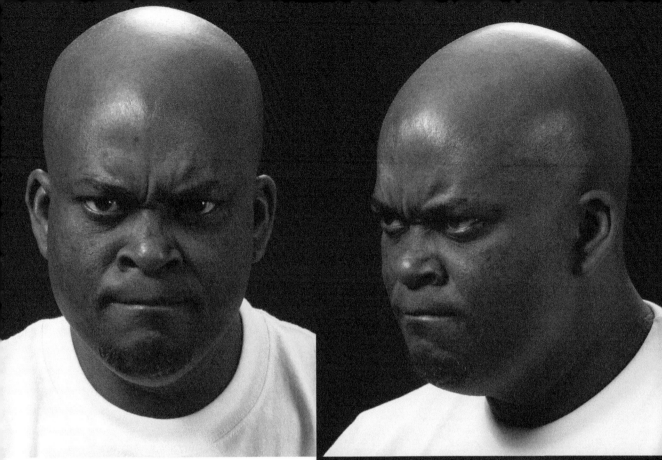

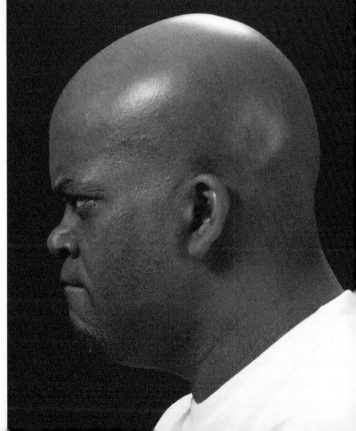

ANGRY

MAP REFERENCE:

57

ANGRY

MAP REFERENCE:
47

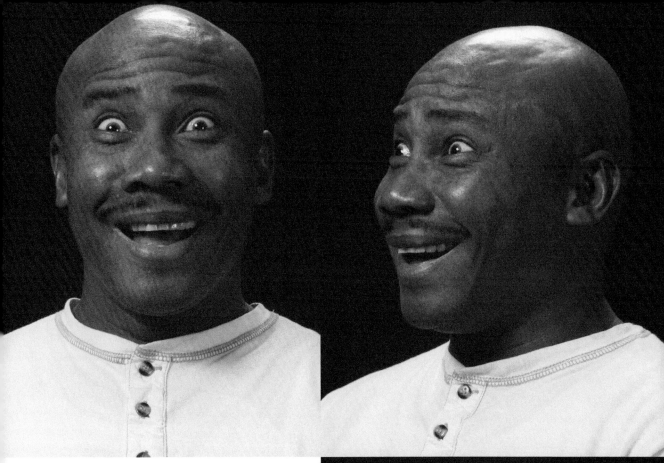

SURPRISE

MAP REFERENCE:

56

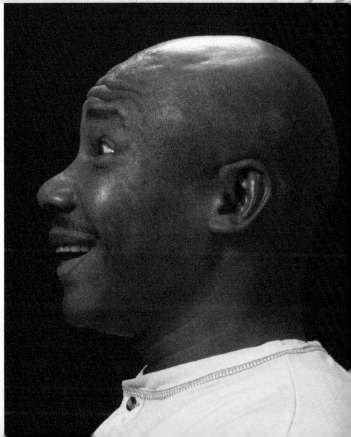

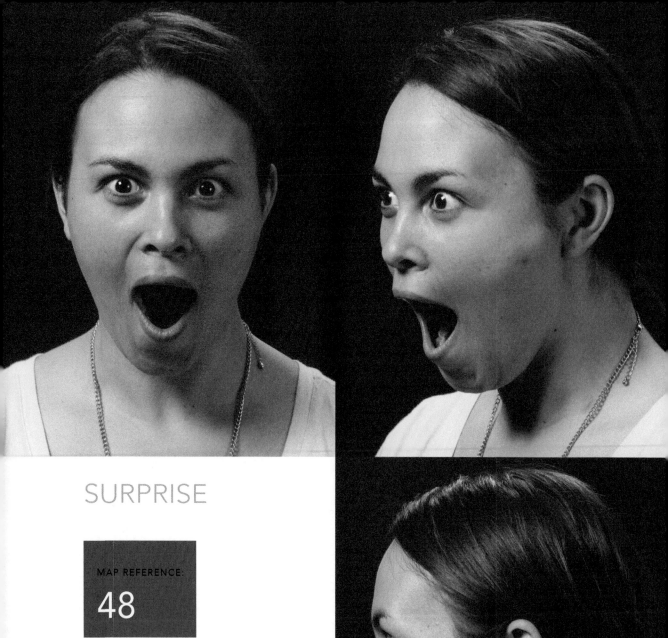

SURPRISE

MAP REFERENCE:

48

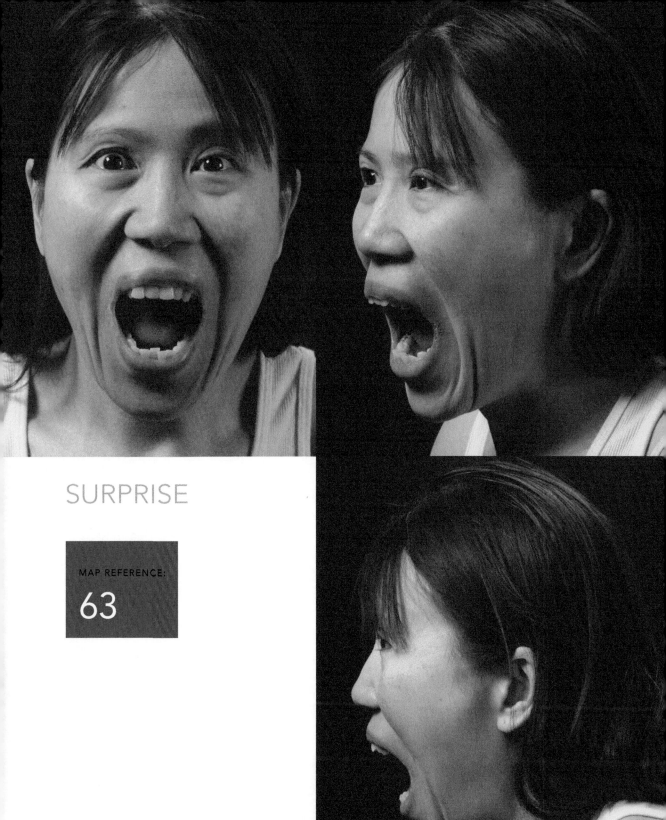

SURPRISE

MAP REFERENCE:

63

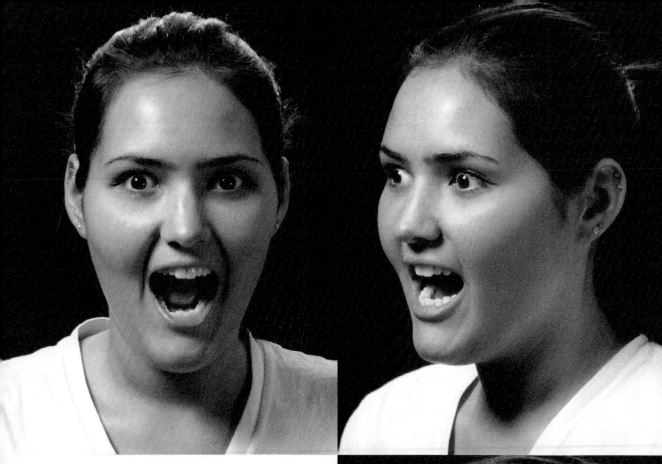

SURPRISE

MAP REFERENCE:

34

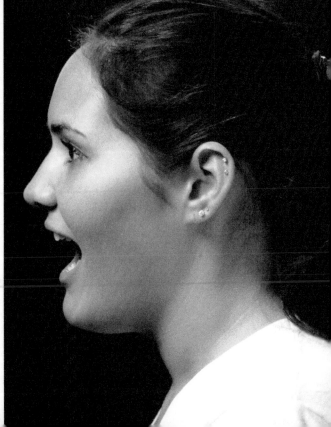

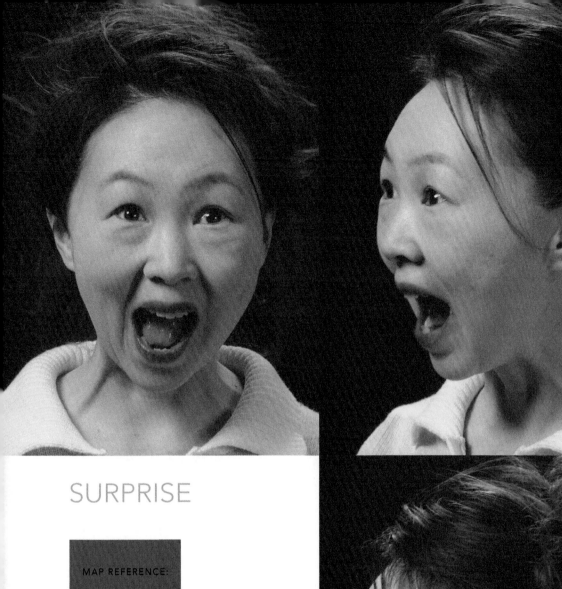
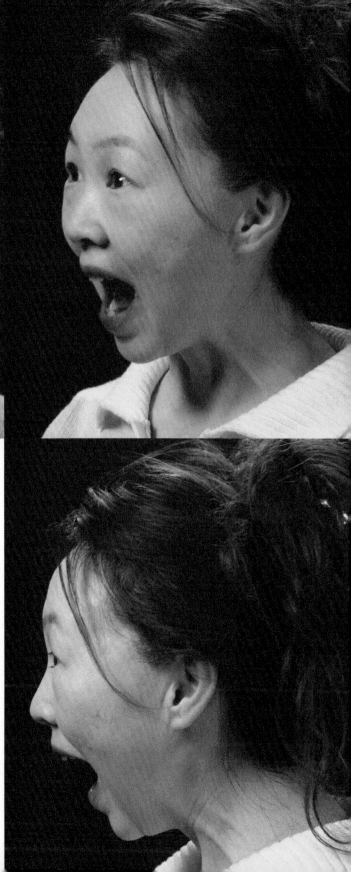

SURPRISE

MAP REFERENCE:

52

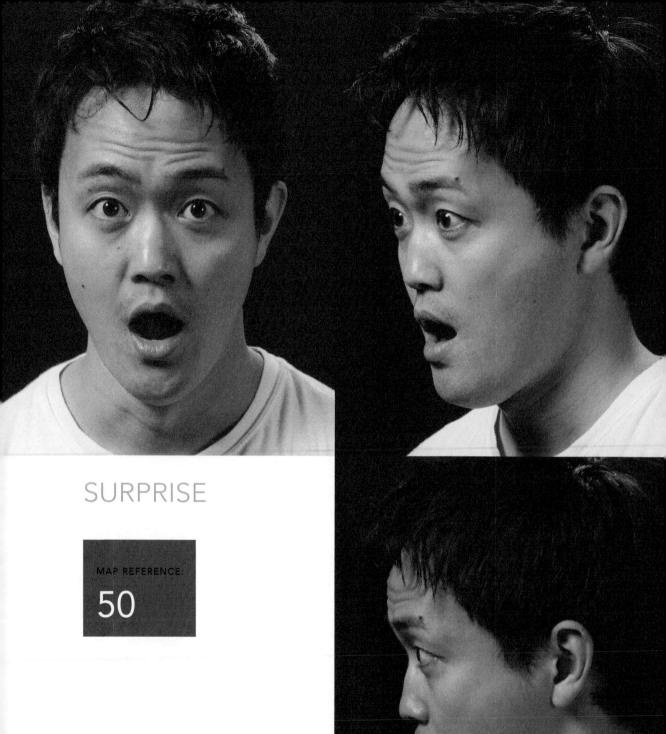

SURPRISE

MAP REFERENCE:

50

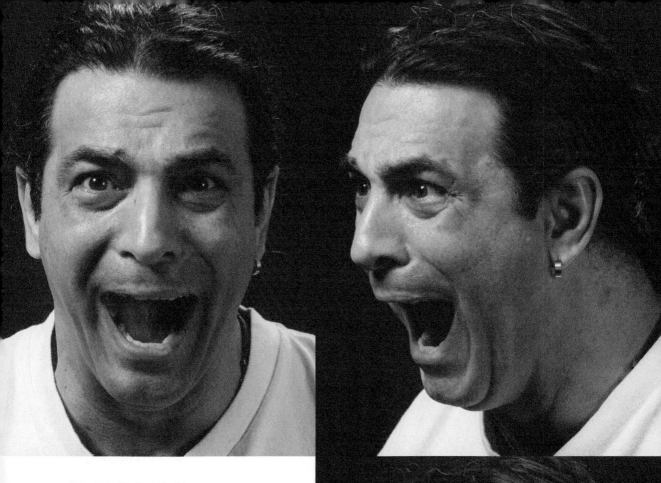
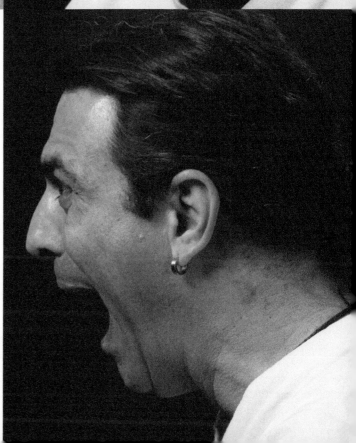

SURPRISE

MAP REFERENCE:

61

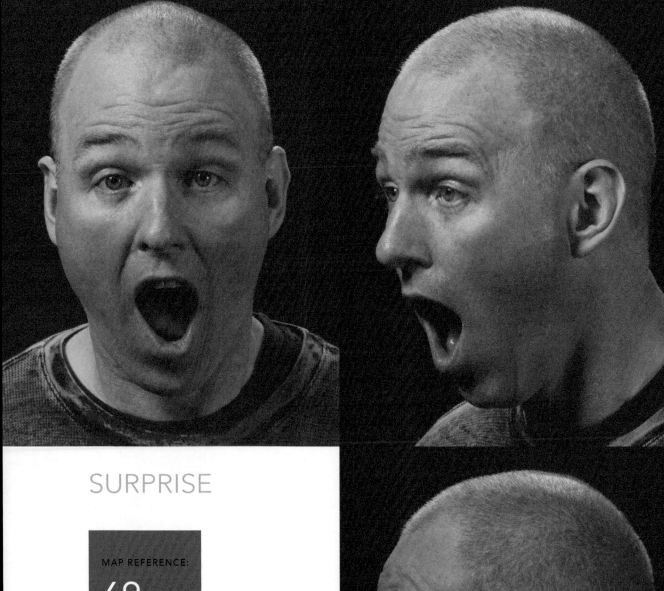

SURPRISE

MAP REFERENCE:

69

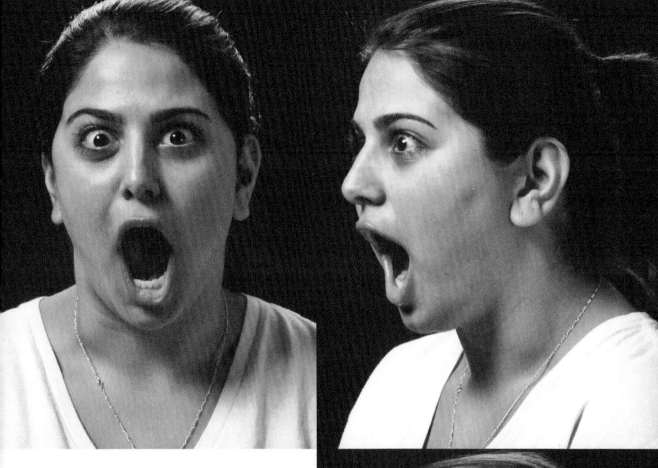

SURPRISE

MAP REFERENCE:

28

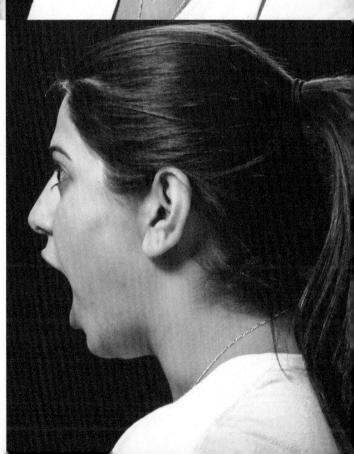

SCULPTING THE HUMAN HEAD

In this tutorial it is time to put all the things that have been talked about together and sculpt an entire head. You will be sculpting one of our models, a Latino male. We chose this individual because he possesses exceptionally well defined anatomical forms in his face.

Import the tutorial 4 base mesh into your sculpting application from the companion website:

/tutorials/tutorial4/starterhead.obj

Base mesh.

Prepare the reference photography in the way you prefer (print outs, image planes, etc.). The images can be found:

/tutorials/tutorial4/tut_4_front.jpg

/tutorials/tutorial4/tut_4_angle_fr.jpg

/tutorials/tutorial4/tut_4_side.jpg

/tutorials/tutorial4/tut_4_angle_bk.jpg

The base mesh will approximately match the proportions of the model minus hair volume to give you a bit of a head start.

Next, block out the basic skull forms that you learned in the first tutorial.

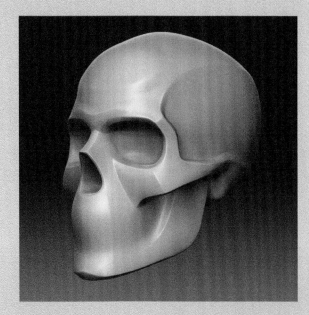

Generic skull form.

Carefully evaluate where the bone landmarks fall based on the photo reference. You will want to wind up with something along the lines of the image below.

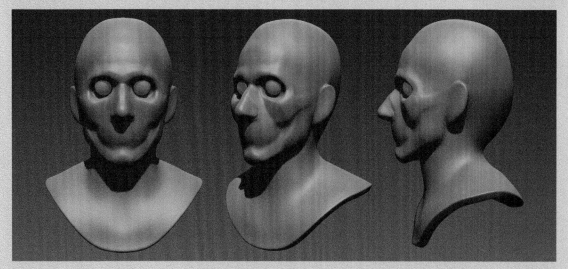

Step 1 goal.

Looking at the reference photos, you are trying to take your best educated guess where the bone forms lie. You will be constantly referring back to the photos as you add and refine the soft tissue, so don't be too worried.

Next, you are going to begin to construct the eye region keeping to basics at first. Follow along with the images below and your reference photography:

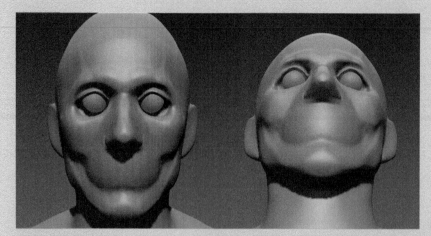

Upper lid.

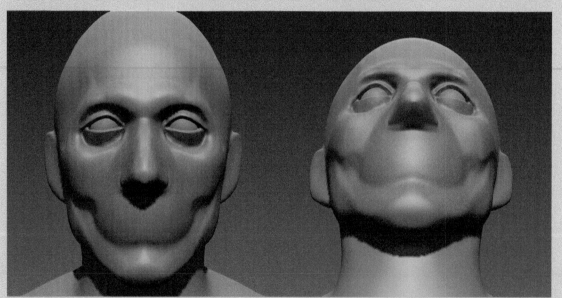

Lower lid.

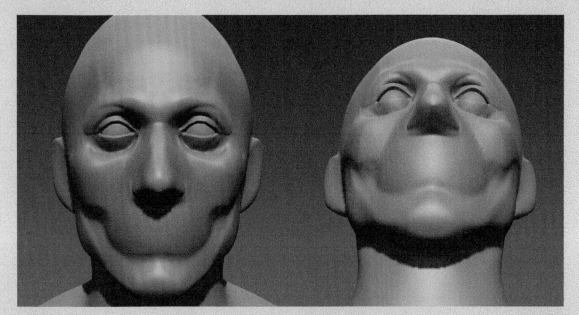

Above eye.

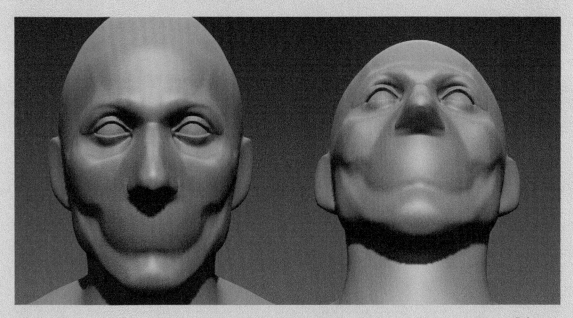

Below eye.

Now you will focus on the mouth area. As before, follow along the steps pictured below and refer to the model reference photography.

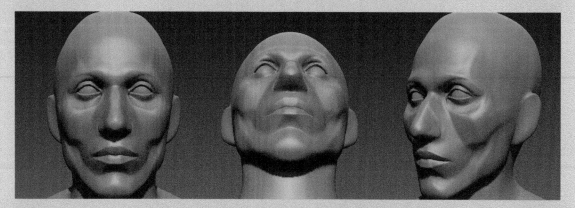

Lips part 1.

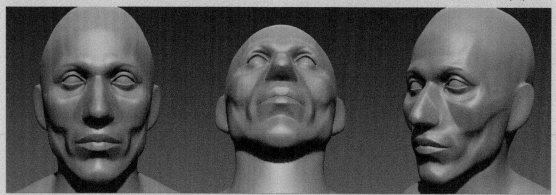

Lips part 2.

Now move onto the basic geometric forms of the nose:

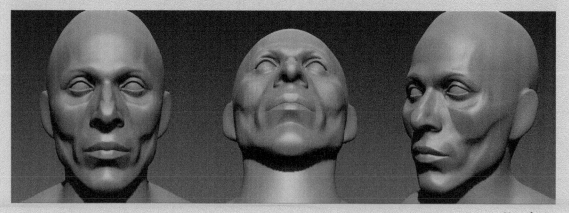

Nose forms.

From this point forward, you will be focusing on adding the more subtle details and attempting to capture the model's likeness as much as possible. One good technique for capturing the next level of detail without getting too bogged down in the fine details is to take a copy of the reference photos into Photoshop and use the median filter on them:

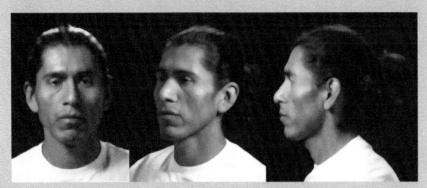

Detail reduced in source photography using median filter.

You'll need to experiment with the value you set in the filter—its effect will vary based on the image resolution. What this does is simplify form and highlight shape so you can focus on the next level of detail while avoiding confusing high frequency detail too early. Other filters can probably provide a similar result; you just want to wind up with a slightly less detailed painterly version of your images.

Using the median filtered source photos, start to refine the fleshy area below the eye, particularly the bulge of the orbicular muscle leading away from the tear duct.

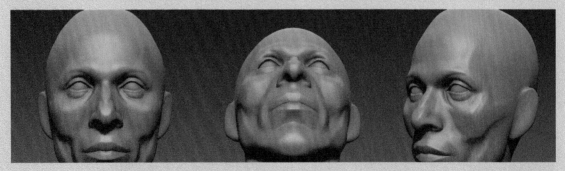

Evaluate progress.

Now, working downward add the nasal labial fold. While you're at it, examine the reference photography closely and you will notice the alaeque is visible on the surface of his face. Add that form as well:

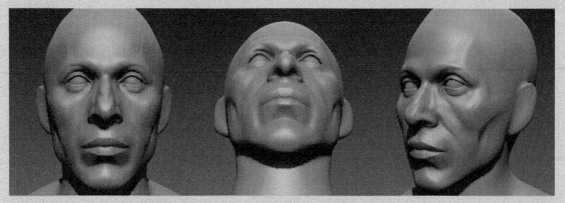

Next, add the form of the nasal labial fold.

Evaluate progress.

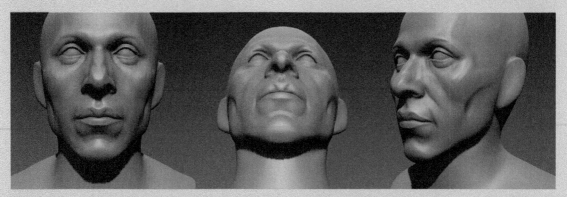

Continuing downward, add the next level of detail to the lips:

Lip refinement.

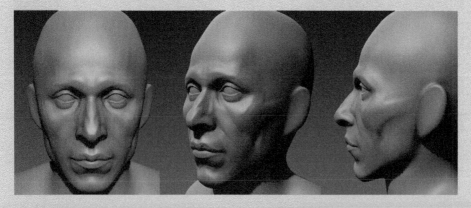

Forehead region.

Now address the forehead region, blocking in the brow region and the frontal eminence:

Next, refine the zygomatic and jaw region:

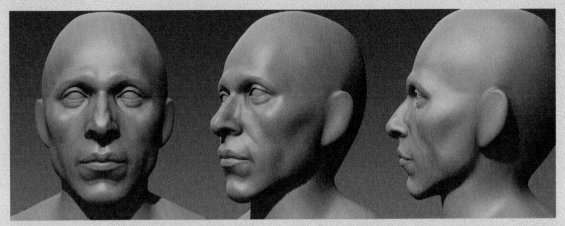

Zygomatic jaw region.

Now the basic forms of the ear:

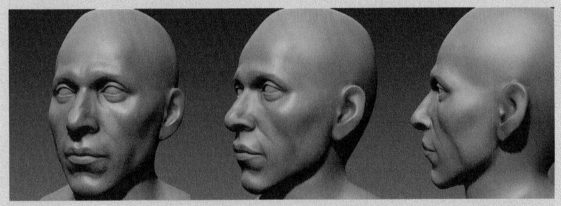

Basic forms of ear.

And refine:

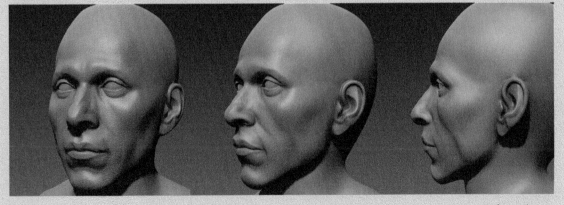

Refining the ear.

Before entering the final level of refinement, you should block in the hair form so that you can compare the overall proportions of your work to the reference photos.

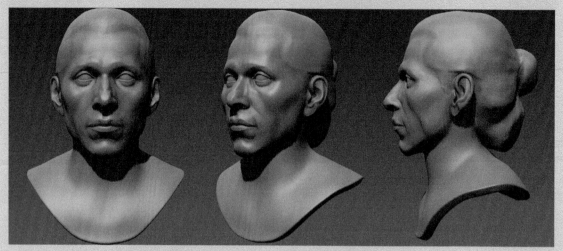

At this point, assess your portrait for likeness and anatomic forms. Make any corrections you feel you need before proceeding.

Basic hair form.

Now we'll walk through each region again and finalize the detail. In some steps the refinements are subtle.

Starting with the eye, examine the tutorial images (left is before refinement, right after) below as well as your source photos to soften any forms that are too strong as well as adding the next level of refinement.

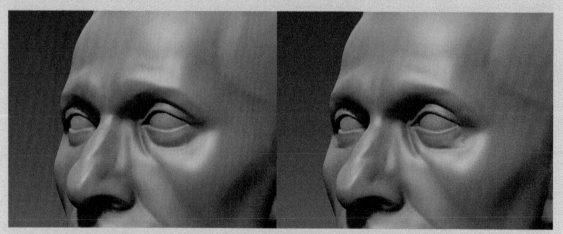

Refine.

The nose:

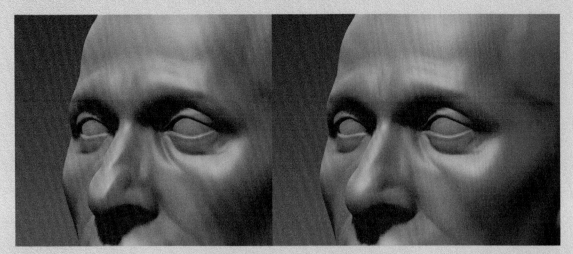

Nose refinement.

The mouth:

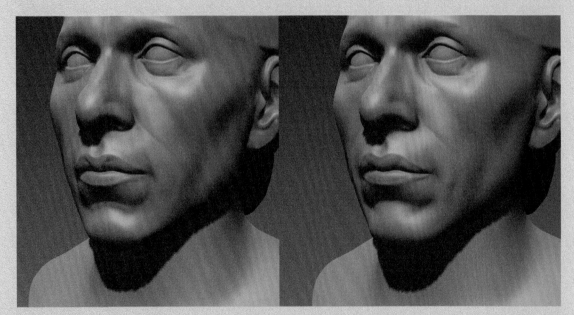

Mouth refinement.

The forehead:

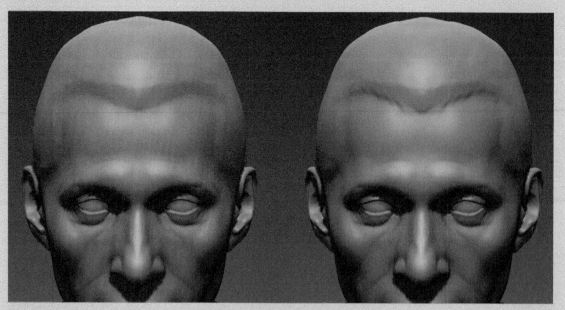

Forehead refinement.

The mouth:

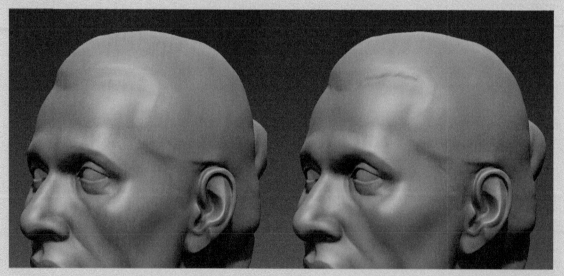

Forehead refinement.

The ear:

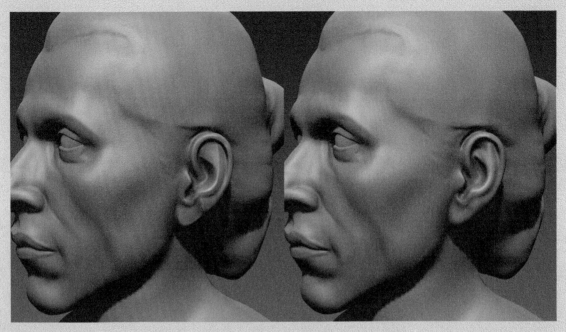

Ear refinement.

And finally, the jaw and chin region, paying attention to the flesh under the jaw that softens the jawline:

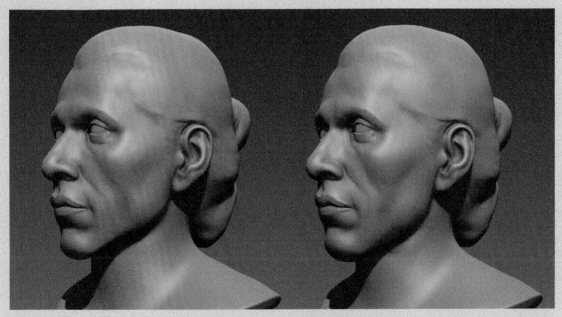

Jaw refinement.

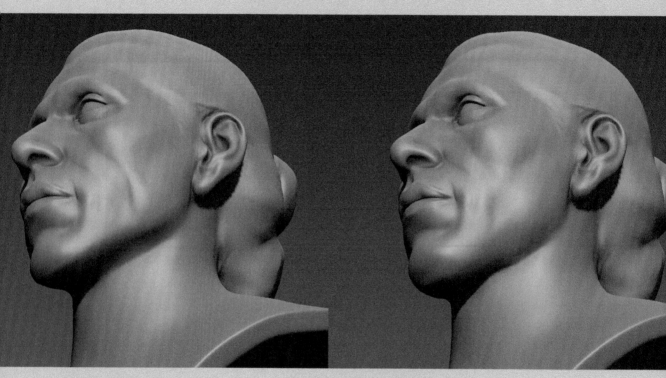

Refinement.

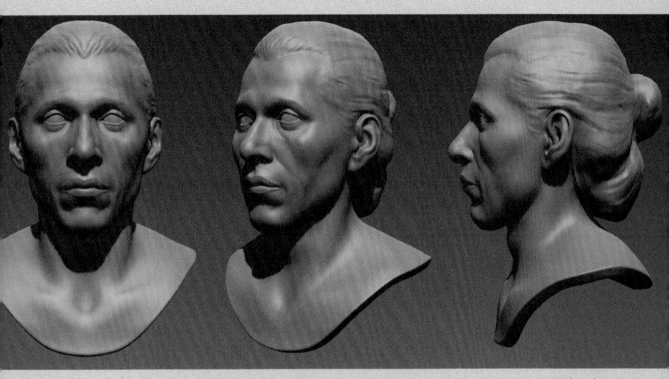

Final product.

With some additional refinement and detail added to the hair and neck
regions, hopefully you have something similar (or better!) than in the
image above.

INDEX

INDEX

CREDITS

p. 25 – Australian Aboriginal male skulll – Evan Matshes BSc, MD
Consultant Osteologist, Bone Clones

p. 29 – African American female skulll – Evan Matshes BSc, MD
Consultant Osteologist, Bone Clones

p. 33 – African American male skull – Evan Matshes BSc, MD
Consultant Osteologist, Bone Clones

p. 37 – African male skulll – Evan Matshes BSc, MD
Consultant Osteologist, Bone Clones

p. 41 – Asian female – Evan Matshes BSc, MD
Consultant Osteologist, Bone Clones

p. 45 – Asian male skull – Evan Matshes BSc, MD
Consultant Osteologist, Bone Clones

p. 49 – Male Asian robust – Karen Ramey Burns, Ph.D.
Forensic Anthropologist

p. 53 – American Indian female skulll – Evan Matshes BSc, MD
Consultant Osteologist, Bone Clones

p. 57 – European female skulll – Evan Matshes BSc, MD
Consultant Osteologist, Bone Clones

p. 61 – European male skulll – Evan Matshes BSc, MD
Consultant Osteologist, Bone Clones

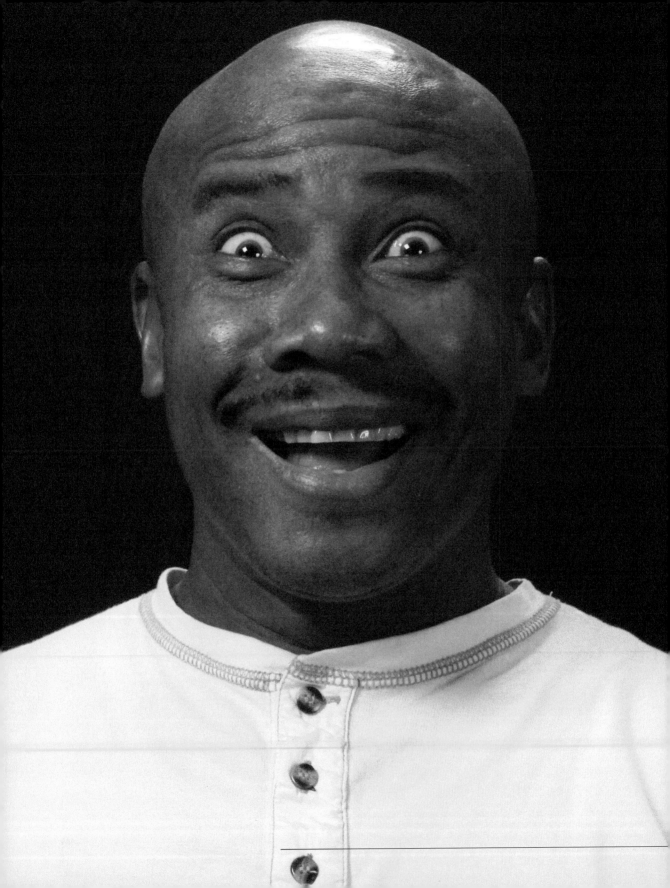

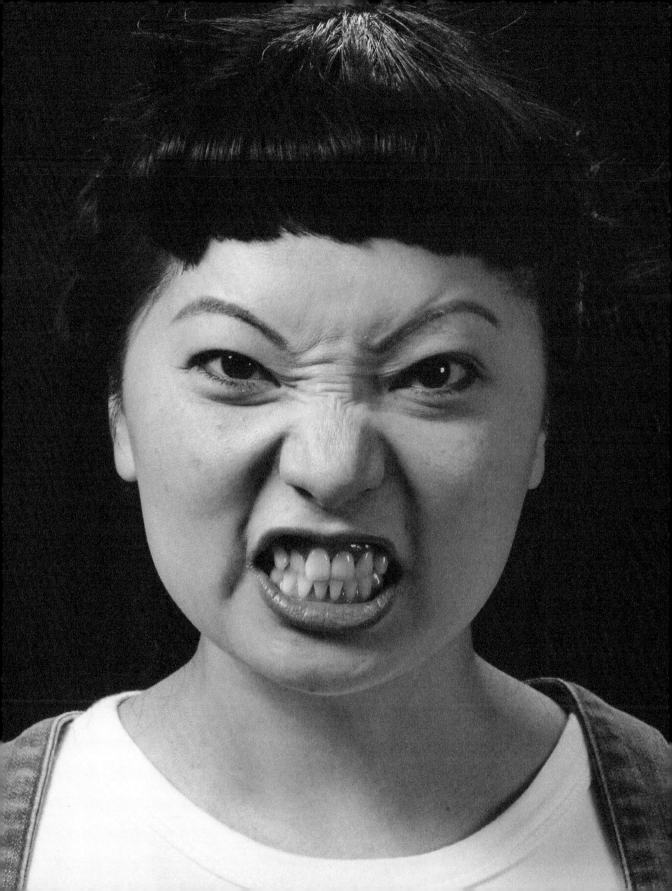

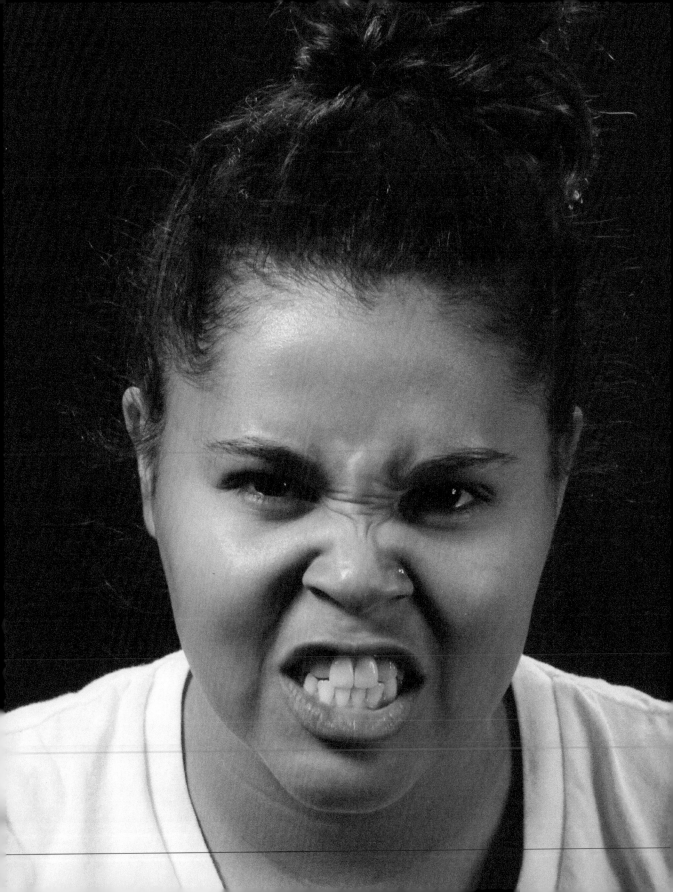

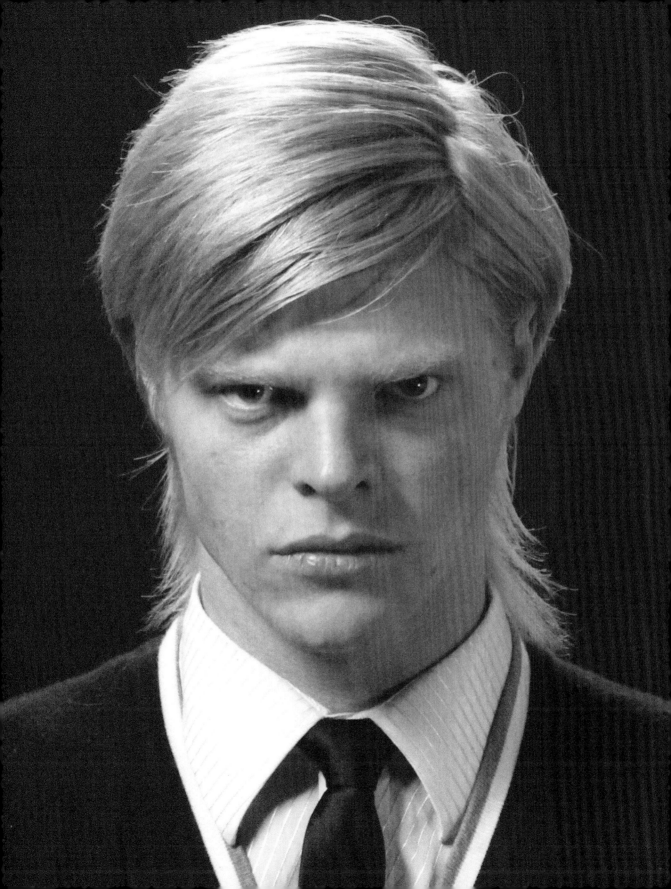

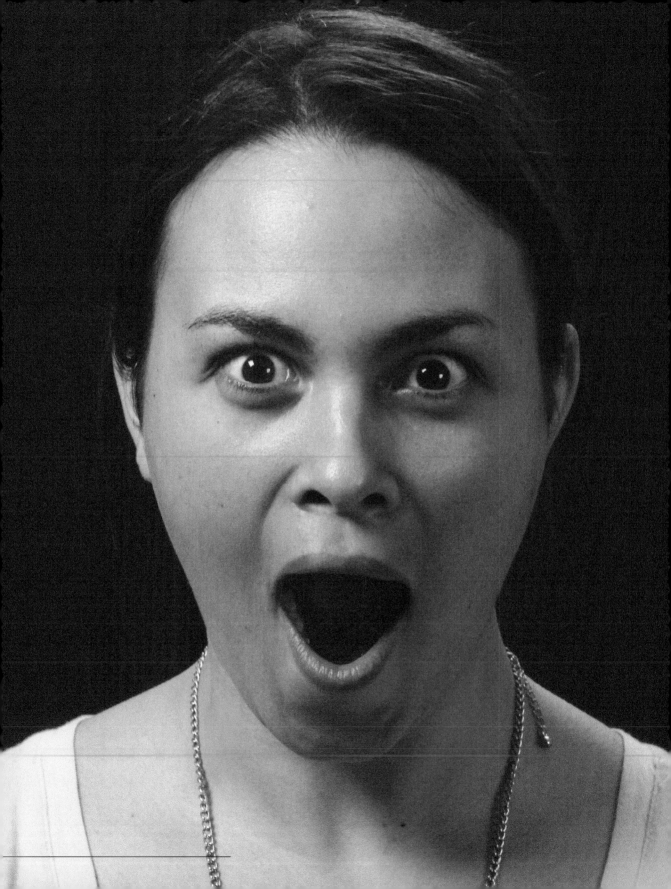

Printed and bound by CPI Group (UK) Ltd, Croydon, CR0 4YY

23/10/2024

01778231-0001